# PRINTS AND PRINTMAKERS OF TEXAS

Main Plaza.

Alameda.

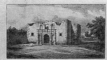

Alamo (1850)

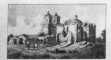

Mission de la Concepcion.

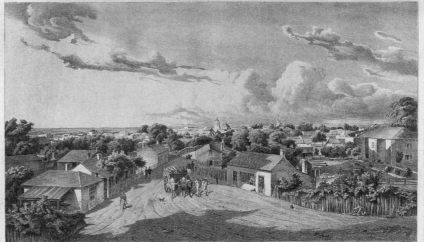

SAN ANTONIO DE BEXAR.

Mission San José.

The New Bridge.

San Pedro Spring.

Mission San Juan.

# PRINTS AND PRINTMAKERS OF TEXAS

❧

## Proceedings of the Twentieth Annual
## North American Print Conference

*Edited by*
*Ron Tyler*

Texas State Historical Association
Austin

*Library of Congress Cataloging-in-Publication Data*

North American Print Conference (20th : 1988 : Austin, Tex.)
  Prints and printmakers of Texas : proceedings of the Twentieth Annual
North American Print Conference / edited by Ron Tyler.
    p.     cm.
    Includes bibliographical references.
    ISBN 0-87611-137-1 (acid free paper)
    1. Graphic arts—Texas—Themes, motives—Congresses. 2. Photography—
Texas—Themes, motives—Congresses. 3. Texas in art—Congresses. I. Tyler,
Ronnie C., 1941–    . II. Title.
  NC135.T4N67 1996
  760'.09764—dc20
  96-13907

    CIP

  5  4  3  2  1                                        96  97  98  99  00

Published by the Texas State Historical Association in cooperation with the
Center for Studies in Texas History at the University of Texas at Austin.

Book design by Martin D. Kohout. Dustjacket design by David Timmons.

∞The paper used in this book meets the minimum requirements of the
American National Standard for Permanence of Paper for Printed Library
Materials, Z39.48—1984.

Frontispiece: *San Antonio de Bexar*, after Hermann Lungkwitz., ca. 1852. 17⁹⁄₁₆ x
19¹¹⁄₁₆ inches. Toned lithograph (hand colored). *Courtesy the Amon Carter
Museum, Fort Worth, Texas.*

# CONTENTS

# INTRODUCTION

## RON TYLER

For many years the myth and romance of Texas have been richly expressed in literature, film, music, and the visual arts, as well as in popular culture images of icons such as the bluebonnet and the armadillo. But Julian Onderdonk, who did the first bluebonnet paintings, was a relative late-comer to the state, being born in San Antonio in 1882, and the armadillo icon derives not from John Woodhouse Audubon, who first painted the critter in 1848, but from Jim Franklin's popular posters on behalf of the Armadillo World Headquarters, Austin's famous but short-lived counter-culture music hall of the 1970s. Scores of artists had preceded them into the state, documenting the people, the cities, the flora and fauna—every aspect of early Texas—and scores followed them as well. Literally dozens of scholars are now engaged in researching and reinterpreting various aspects of Texas's visual history over time. Therefore, the Texas State Historical Association is pleased to present *Prints and Printmakers of Texas,* consisting of papers read at the twentieth North American Print Conference, which the Association hosted in November 1988. The resulting work provides a fascinating look at the visual history of the state.

After Texas won its independence from Mexico in 1836, the new republic dominated headlines across the United States and became a decisive issue in the American presidential elections of 1840 and 1844. Unfortunately, none of the artists in the state at the time[1] chose to depict the great events of the revolution, so Katherine J. Adams describes the work of the anonymous and

---

1. William T. Ranney participated in the battle of San Jacinto and remained in Texas for perhaps six months but chose not to depict any of the historic events in which he took part. See Linda Ayres, "William Ranney," in Ron Tyler et al., *American Frontier Life: Early Western Painting and Prints* (New York: Abbeville Press, 1987), 79–80.

little-known caricaturists, lithographers, and engravers who introduced the new nation to the larger American public by means of imaginary graphic depictions. After 1845, as artists began to populate the newly admitted state, pictures of Texas poured from their sketchbooks and studios. Foremost among these new arrivals were a cultured and talented group of Germans in San Antonio who had fled the 1848 revolutions in their homeland. Ben Huseman and James Patrick McGuire and David Haynes tell of two different experiments in printmaking, as these newcomers to this aesthetic frontier applied their creativity and craftsmanship. Both resulted in unusual and significant but extremely rare images, many of which are published here for the first time.

Printmaking in the twentieth century provides an equally unusual view of Texas. While the majority of Americans saw the state as the home of ranches, oil wells, and politicians, native-born artists turned their attention to its many different cultures. Francine Carraro takes a look at the prints of Jerry Bywaters, well-known painter, teacher, and museum administrator, while David Farmer focuses on the women of the Dallas Printmakers Guild.

Photographers had reached Texas by December 1843, when a Mrs. Davis advertised her portrait-making abilities in the Houston *Morning Star*,[2] and, as Richard Pearce-Moses demonstrates in his summary of the creation of *Photographic Collections in Texas: A Union Guide*, the photographic record in Texas is extensive. Cynthia A. Brandimarte, Richard Cox, Kenneth B. Ragsdale, Roy Flukinger, and Peter H. Brink consider various parts of it in essays on the images of different photographers who have worked in the state. Brandimarte focuses on the ubiquitous pageants that were so popular at the turn of the century—and so poorly understood today. Richard Cox compares the powerful Dust Bowl images of Farm Security Administration photographers Dorothea Lange and Arthur Rothstein with Texas printmakers Alexandre Hogue, Merrit Mauzey, and Otis Dozier. Kenneth B. Ragsdale and Roy Flukinger tell the stories of W. D. Smithers, who chronicled the Big Bend region of Texas for decades, and Eugene O. Goldbeck of San Antonio, whose global vision led him to create some of the most interesting and historic panoramic photographs of the century. Peter H. Brink provides background on the creation of one of the most beautiful and important books to be published on a Texas subject, *The Galveston That Was*, especially how it came to contain the fascinating work of two such great twentieth-century photographers as Ezra Stoller, known for his architectural photography, and Henri Cartier-Bresson, considered a master at capturing the essence of ordinary people.

2. See David Haynes, *Catching Shadows: A Directory of Nineteenth-Century Texas Photographers* (Austin: Texas State Historical Association, 1993), viii.

Two of the last essays in the book deal with the printmaking explosion that occurred in Austin during the 1960s and 1970s. Nels Jacobson writes of the "maverick posterists" associated with the Austin music scene, while John Henry Fox describes the T-shirt revolution. The visual trail from Audubon to the Armadillo World Headquarters is a fascinating one to follow.

Ron Tyler
Austin, Texas

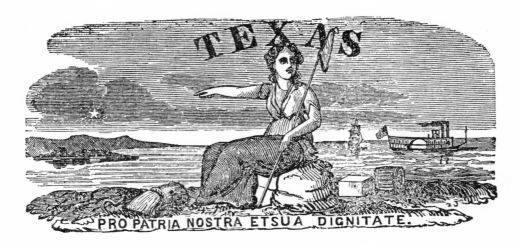

Wood engraved masthead, *Texas National Register*, Washington, Texas, April 10, 1845, by unknown artist. *Courtesy Texas Newspaper Collection, Center for American History, University of Texas at Austin.*

# Texas Impressions: Graphic Arts and the Republic of Texas, 1836–1845

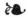

## Katherine J. Adams

The Republic of Texas produced and during its lifetime was the subject of printed images that are both rich in variety and surprisingly large in quantity. A review of these images helps characterize the native Texas press and reveals a nation whose citizens, landscape, and history were of popular interest to citizens outside its borders.

The Republic of Texas was launched in 1836 with a Declaration of Independence and Constitution and confirmed at the Battle of San Jacinto in April 1836. During its years as an independent nation, the Republic elected four presidents and organized a national government, gained diplomatic recognition from foreign nations, and tried to cope with the domestic and foreign issues and problems of massive debt, land policy, Indian affairs, and continuing hostilities with Mexico. These years also saw the Republic's population more than double, from approximately 50,000 in 1836 to 125,000 in 1845. The growth of urban centers in the Republic and, thus, the sites of its early Texas printers reflect the three main routes of settlers and travellers coming to Texas: overland from Natchitoches in Louisiana to San Augustine and Nacogdoches in East Texas; by river steamer up the Red River; and by sea via schooners and steamboats out of New Orleans to Galveston.[1]

One member of the caravan of westward-moving Americans who settled in Texas was the pioneer printer. Transient presses operated in Texas as early as 1813 and 1817, and between 1836 and 1845 permanent presses were in business at various locations in the Republic, including along the Gulf at Houston,

---

1. For an excellent introduction to the Republic of Texas see William R. Hogan, *The Texas Republic: A Social and Economic History* (Norman: University of Oklahoma Press, 1946); also see the article on the Republic in Walter Prescott Webb, H. Bailey Carroll, and Eldon Stephen Branda (eds.), *The Handbook of Texas* (3 vols.; Austin: Texas State Historical Association, 1952, 1976), II, 321.

Brazoria, and Galveston; in the east at San Augustine; in the northeast in Washington and Clarksville; and inland at Austin.[2]

These were newspaper printers and publishers, men who in Texas held a monopoly on mass communication in the areas they served and who faced the constant problems, familiar to their American and frontier counterparts, of getting paper, getting news, and getting paid. In addition to publishing newspapers, these printers also issued nearly all other Republic of Texas imprints, for theirs were the only presses available and they eagerly sought and gladly accepted orders for other forms of printing as a practical hedge against the uncertainties of frontier newspaper publishing. Newspaper offices, therefore, generated whatever homegrown graphic arts were produced during the years of the Republic.[3]

The imprints issued by these presses were practical in every respect, and their embellishment with illustration or typographic ornament was equally serviceable. The more than five hundred imprints issued during the life of the Republic are an assortment of government contract printing, handbills, broadsides, social announcements, pamphlets, books, business cards, receipts, and letter and billheads designed to announce, inform, and promote.[4] The graphic arts displayed in these imprints were not intended to stand alone as art or message but were used instead to serve as minor visual relief and embellishment to the more important written message in imprints. A look at Republic of Texas imprints, therefore, reveals no printed fine art, nor any example of original fine art reproduced by engraving or lithography as popular art in either book illustration or separate print. Indeed, the technique of engraving on steel is seen in only one Republic imprint, and there are no known lithographed images from Texas presses until 1855, nearly ten years after the Republic ceased to exist.[5]

What does exist, however, is applied art such as advertising cuts, newspaper mastheads, banknote engravings, and typographic ornamentation. Further,

2. For an overview of early printing in Texas plus two accounts of newspapers printed during the Republic years, see Thomas W. Streeter, *Bibliography of Texas, 1795–1845* (2nd ed.; Woodbridge, Conn.: Research Publications, Inc., 1983), 17–25, 187–200; and Marilyn Sibley, *Lone Stars and State Gazettes: Texas Newspapers before the Civil War* (College Station: Texas A&M University Press, 1983).

3. Streeter, *Bibliography of Texas*, 187; Sibley, *Lone Stars and State Gazettes*, 3–14.

4. The Texas imprints cited in Streeter's *Bibliography of Texas* have been reproduced on microfilm by Research Publications, Inc., of Woodbridge, Connecticut.

5. The 1855 broadside "Sam Recruiting after the injunction of secrecy had been removed," by Wilhelm C. A. Thielepape, is generally regarded as the first known lithograph produced in Texas. This broadside is in the Broadside Collection, Center for American History, University of Texas at Austin. See Ben Huseman, "The Beginnings of Lithography in Texas," published elsewhere in these proceedings.

with the exception of a few original woodcuts, the majority of these images and ornaments did not originate in the Texas Republic but were instead stock woodcuts and stereocuts acquired from type foundries such as the New England Type Foundry of Boston; Bruce's New York Type Foundry; the Farmer, Little & Co. Foundry of New York; and Vincent Figgins Type Foundry in London. Specimen books from these foundries contain cuts, typefaces, borders, and ornaments commonly used by Republic of Texas printers.[6]

The graphic arts appearing in imprints issued by Republic of Texas presses, therefore, can be characterized as follows: limited in technique largely to wood engraving; few in number; functional in purpose; and only occasionally of native design. Since this is quite likely the formula for graphic arts on many of the frontiers that gradually swept west during the nineteenth century, these images deserve attention both for their intrinsic interest as early Texas imprints and as guideposts to frontier printing beyond the borders of the Republic.

Advertising cuts were the images most frequently used on Republic of Texas imprints. These cuts originated in colonial America as miniature illustrations engraved on wood and used in newspapers to help sell goods and services. In 1820, Boston wood engraver Abel Bowen conceived the idea of syndicating stock woodcut engravings through the medium of stereotyping by type foundries. These stock cuts, designed by an engraver, cast in type metal by a stereotyper, and sold by a type founder to printers near and far, appeared in enormous variety. By 1830, type-specimen books offered cuts to suit every trade, profession, and pursuit, and Republic of Texas printers responded by buying and using them in newspapers and other functional imprints.[7]

As early as 1837, Houston's *Telegraph and Texas Register* used steamship, clipper ship, railroad, and house cuts in its advertising columns. A house cut, for example, ran with an ad for the Austin House, where visitors could expect to find all "the comforts of life and as many of the luxuries as can reasonably be expected in a country so new."[8] Ship cuts in the same paper promoted the steamship *Sam Houston* and its regular twice-weekly route between Houston

---

6. *Minor Specimen Book of Printing Types from the New England Type Foundry* (Boston: Chandler, Counsens & Co., 1868); *An Abridged Specimen of Printing Types Made at Bruce's New York Type-Foundry* (New York: Bruce's Son & Co., 1869); *Specimens of Printing Types, Ornaments, Borders, etc. from the Type Foundry and Printers' Warehouse of Farmer, Little & Co.* (New York: Farmer, Little & Co., 1874). For an excellent list of foundry specimen books, see Clarence P. Hornung, *Handbook of Early American Advertising Art* (2 vols.; New York: Dover Publications, 1953).

7. Hornung, *Early American Advertising Art*, I, xvii–xix; Carl W. Drepperd, *Early American Advertising Art* (New York: Paul A. Struck, 1945), introduction.

8. Houston *Telegraph and Texas Register*, Aug. 18, 1838.

and Galveston and the brig *Empressario,* which plied between Galveston and New Orleans. Railroad cuts were also common visuals used by Houston's Telegraph Press Office, which published the *Telegraph and Texas Register.* In addition to using one in a newspaper ad for Brazos and Galveston Railroad stock, the Telegraph Press Office also printed the same cut in that railroad's stock certificate and again on a stock certificate for the city of Sabine.[9]

The Clarksville *Northern Standard* in East Texas also used advertising cuts. A large and detailed cut of musical instruments appeared in a September issue in 1842 to advertise Mr. William Selfe's music lessons on flute, violin, flageolet, and key bugle. Above and below the music cut appeared a house cut advertising the Rapides Hotel in Alexandria, Louisiana, and a horse cut that gave notice that G. S. Young of Clarksville sought information on a strayed filly.[10]

Advertising cuts continued to be used throughout the life of Republic of Texas newspapers. Issues from the 1845 *Texas National Register* out of Washington, Texas, for example, frequently carry a cut depicting a runaway slave, as well as watch, spectacle, and masonic cuts. They also utilize a horse racing cut beginning in the June 5, 1845, issue to advertise the Washington Races scheduled for November and to announce the Fall meeting in Crockett, Texas, of the Crockett Texas Jockey Club.[11]

Despite their heavy reliance on stock foundry cuts for visual relief, Republic of Texas printers seem to have produced at least two examples of native illustration. The first is an advertising cut that appears in June 1844 issues of the *Civilian and Galveston Gazette.* The cut is of a saddle, which accompanies an announcement for the saddle and harness manufacturing business of J. W. Buerck of Galveston. The saddle is crudely drawn, suggesting that it was engraved on wood rather than on metal. In addition, it was used repeatedly by the Gazette office with the Buerck announcement at a time when elaborate and finely drawn saddle cuts were readily available through eastern foundries.[12]

A second original Republic of Texas image is from the masthead of the *Texas National Register,* a newspaper published first in Washington, Texas, then in Austin, for just more than a year, from December 7, 1844, until January 10, 1846. It depicts a woman draped in a flowing robe, with the liberty cap atop the pole in the crook of her arm, sitting at a shoreline with the products of

9. Ibid.; Brazos and Galveston Rail Road Company, stock certificate (Houston: Telegraph Press, 1839), listed as no. 230 in Streeter, *Bibliography of Texas;* Company of the City of Sabine, stock certificate (Houston: Telegraph Press, 1839), Streeter no. 329.

10. Clarksville *Northern Standard,* Sept. 3, 1842.

11. See, for example, the *Texas National Register* (Washington, Tex.), June 5, Aug. 14, 1845.

12. *The Civilian and Galveston Gazette,* June 1, June 12, 1844; Drepperd, *Early American Advertising Art,* [17].

agriculture and industry at her feet. Although this specific illustration is native to Texas, its substance and meaning are not. Figures such as this were common eighteenth- and nineteenth-century personifications of the United States. Indeed, this lady's republican sisters litter the pages of nineteenth-century type - specimen books and are seen especially often on banknotes, medals, textiles, and prints of the era.[13] This particular figure, with the name of her country arched over her head and a Latin phrase which loosely translates to "For Our Country and Its Glory" at her feet, points to a distant shore and, above it, a rising and beaming lone star. She points with pride of place and promise for future. She and her message quickly became obsolete, however, and she disappeared just one year after her first appearance. She is last seen in the final issue of the *Texas National Register,* which was published on January 10, 1846, just days after Texas legally entered the United States and relinquished forever her status as an independent republic.

In addition to using advertising cuts, printers in the Republic of Texas effectively used decorative borders and ornaments to give a unique look to social paper such as invitations and other announcements. These are typographic decorations, not illustrations, yet they provided the same visual relief as the miniature illustrations of advertising cuts. Like ad cuts, these borders, stars, rosettes, filigrees, curlicues, bars, arches, and fans were stock foundry cuts that printers bought for repeated use on various imprints. Unlike advertising cuts, however, ornaments could be combined, built, positioned, and layered into simple or elaborate configurations that embellished, and sometimes dominated, a written message.

Three examples suggest the craftsmenship and, perhaps, the excesses of Republic of Texas printers. The first is an 1839 invitation to a cotillion party to be held in the City Hotel of San Augustine. Printed by the *Red-Lander* Office of San Augustine, this invitation to a party designed "to trip the light fantastic toe," employs borders, a graceful arch, and the five-pointed lone star, a recognizable Republic of Texas emblem, to enhance its solicitation.[14] Another invitation, to a Fourth of July dinner and ball in Velasco, utilizes even more ornaments, to the degree that the message nearly becomes secondary to the decoration. The occasion that prompts this invitation is "the commemoration of the independence of our Mother Land," in other words, the United States. To emphasize the occasion visually, the printers in the Telegraph Office in

13. E. McClung Fleming, "The American Image as Indian Princess, 1765–1783," *Winterthur Portfolio,* II (1965), 65–81; E. McClung Fleming, "From Indian Princess to Greek Goddess: The American Image, 1783–1815," *Winterthur Portfolio,* III (1967), 37–66.

14. San Augustine, Cotillion Party [invitation dated May 23, 1839] (San Augustine: [*Red-Lander* Office?] 1839), not listed in Streeter. Copy available in the Center for American History, Caldwell Collection.

Houston employed the appropriate national patriotic symbol, the eagle, as well as borders and ornaments to form a graceful Greek temple symbolic of the democratic traditions honored by the citizens of the two republics.[15]

But a carrier's address from the January 1, 1842, issue of the *Galvestonian* shows the greatest degree of ornamentation. Carrier's addresses were annual greetings delivered each New Year's day to newspaper subscribers. They flourished in the United States during the eighteenth and nineteenth centuries as single-sheet newsprint and carried commentary in verse and illustration on the local and national social and political scene.[16] This one is festooned with beehives, eagles, and flower baskets in addition to regular typographic ornamentation. A few words from this address suggests its whole tone:

> Daily, before your door, as now
> Your Carrier makes his early bow,
> And tosses in the humid sheet
> With late intelligence replete,
> This tells you first what Congress' doing
> What mischief Mexico is brewing—
> How willingly they would invade,
> But are as yet somewhat afraid,
> Domestic this, but if you choose
> You here may read the foreign news[17]

At least two engravings appear in Republic of Texas imprints. The first is a two-plate schematic titled "Order of Encampment for a Regiment of Infantry" and "Order of Encampment for Two Squadrons of Cavalry," both of which appear in *General Regulations for the Government of the Army of the Republic of Texas*, published in 1839 in Houston by Samuel Whiting of the Houston *Intelligencer*.[18] These Texas Army regulations were based on the *General Regulations for the Army of the United States*, published in 1835 by the United States Department of War. The plates in the 1836 revision are identical to those in the 1835 original, though with the name "B. Chambers" written at their bottom.[19] The encampment

---

15. Velasco Association, 4th July Dinner and Ball [invitation dated May 28, 1838] (Houston: Telegraph Press, 1838), Streeter no. 306.

16. Mary T. Russo, "Carrier's Addresses 1720–1900: Stirring Newsboy's Stanzas Struck Responsive Chord with Patrons," *The Ephemera Journal*, I (1987), 33–36.

17. Address of the Carrier of the *Daily Galvestonian*, January 1, 1842 (Galveston: Printed at the *Galvestonian* Office, 1842), Streeter no. 517.

18. Texas War Department, *General Regulations for the Government of the Army of the Republic of Texas* (Houston: *Intelligencer* Office, 1839), Streeter nos. 372, 372A.

19. United States Department of War, *General Regulations for the Army of the United States* (rev. ed.; Washington: Authority of the War Department, 1836).

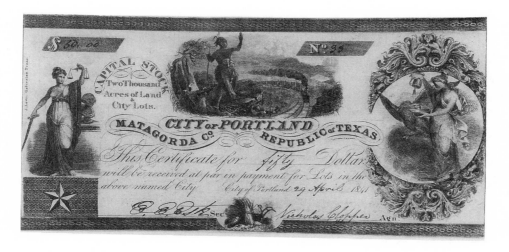

Steel engraved stock certificate, City of Portland, Texas, 1841. *Courtesy Broadside Collection, Center for American History, University of Texas at Austin.*

schematics in the 1839 Texas regulations are most likely U.S. prints bound into a book that is otherwise a Republic of Texas imprint.

Of greater interest is an 1841 City of Portland stock certificate, which has been called by eminent Texas bibliographer Thomas W. Streeter "the earliest example known of engraving done in Texas."[20] This image carries allegorical and emblematic illustrations typical of banknotes and stocks. Unlike most Republic of Texas currency and stocks, which were engraved by firms in New York, Philadelphia, or New Orleans such as Drapper, Toppan, Longacre & Co. and Rawdon, Wright, and Hatch, this one is signed J. Lowe, Galveston, Texas.[21] This is probably Joshua Lowe, an engraver who advertised his printing services in Galveston in 1840.[22] If this is the first and perhaps only engraving to come out of the Republic of Texas, it is an excellent example indeed, for banknote engraving was usually done on steel and required the skill to execute illustration and ornament too intricate to be copied by hand.[23]

20. Portland, Texas, Capitol Stock Two Thousand Acres of Land & City Lots (Galveston: J. Lowe, 1841), Streeter no. 450; Streeter, *Bibliography of Texas*, 144.

21. William E. Howard, *The Romance of Texas Money: A Story of Texas Money from Early Colonial Days to the Last Issue of the Money of the Republic* (Dallas: n.p., 1946), 4–16. Howard's book contains facsimiles of Republic of Texas currency.

22. *Brazos Courier* (Brazoria), Dec. 22, 1840.

23. David Stauffer, *American Engravers Upon Copper and Steel* (2 vols.; New York: Grolier Club, 1907), I, 209.

Images of the Texas Republic produced outside of Texas were not constrained by the inherent limitations of the pioneer press; instead, they reflect the broad range of graphic arts being printed in Europe and the United States. The quantity of printed illustrations in which the Republic of Texas serves as subject or target is surprisingly rich: it includes portraits of military and political heroes; eyewitness views of Texas towns, landscapes, and structures; scenes depicting the Texas Revolution; illustrations from Indian captivity narratives; emblematic banknote illustrations; anti-slavery tracts attacking Texas; political cartoon prints; comic almanac images; and illustrated songbook and sheet music covers.

Such a quantity and variety of print images were created for two reasons. First, Texas was a popular subject. The presence of an independent republic west of Louisiana and along the Gulf Coast and the Rio Grande was of enormous interest to Americans and Europeans alike, an interest that they demonstrated in a flurry of imprints describing Texas history, geography, economy, and character traits, and promoting travel and immigration to the Republic.[24] In addition, the Republic's very existence was tied to events of international importance, namely the successful revolution against Mexico, with its martyrs and heroes and the long-debated question of the extension of slavery, to which the possible annexation of Texas to the United States was so closely linked.[25] Second, the Texas Republic existed at the very time that the introduction of lithography was revolutionizing American printmaking. This relatively simple and direct method of making multiple copies permitted and encouraged the reproduction of a variety of graphic art forms, including book illustrations, advertisements, frameable portraits, political cartoons, and sheet music covers.[26]

Three very different types of illustrations suggest the variety and richness of graphic images of the Texas Republic. These illustrations, which run the gamut from fact to fantasy, are eyewitness and imaginary views published in books; comic and satirical images printed in almanacs or as political cartoons; and the romanticized illustrations found on sheet music covers.

As previously stated, the Republic of Texas was the object of enormous interest to Americans and Europeans, many of whom traveled to Texas to see for

24. For the names of accounts published by travelers to Texas see Streeter, *Bibliography of Texas*, and Marilyn McAdams Sibley, *Travelers in Texas, 1761–1860* (Austin: University of Texas Press, 1967).

25. Frederick Merk, *Slavery and the Annexation of Texas* (New York: Knopf, 1972).

26. Harry T. Peters, *America on Stone* (New York: Arno Press, 1976) 11–12, 20; William A. Murrell, *A History of American Graphic Humor* (2 vols.; New York: Whitney Museum of American Art, 1933), I, 115–116.

themselves, others to settle permanently. Both groups generated written accounts, some of which contained illustrations. These include accounts of travel and exploration, histories, guides for immigrants, novels, biographies, and Indian captivity narratives. Three of these, all published in the 1840s, contain important views of Texas towns.

The first is the *Map and Description of Texas*, published in 1840 in Philadelphia and written by Francis Moore Jr., editor of Houston's *Telegraph and Texas Register*. Moore, a native of Cambridge, Massachusetts, had an interest in the Republic's natural resources and history, and during the summer and fall of 1837, he printed a series of articles on the geography of the various counties in the Republic in the *Telegraph*. These were gathered and published in book form in 1840. This is an important Texas book, not only because it contained the first detailed accounts of the thirty-two counties then existing in Texas, but also because it carried eight engraved views of Texas towns and missions, including views of Goliad and San Antonio.[27] These views have long been thought to be based on sketches by William Bissett, a Scottish immigrant who was in Texas in 1838, possibly as part of a surveying crew. Two of the views, the San Antonio scene and a view near Austin, are signed by Bissett, and a third is marked "Eng. for Francis Moore, Jr." Recent research, however, calls into question the attribution to Bissett. Susan Schoelwer, in an article on Alamo views published in the *Southwestern Historical Quarterly*, especially questions the book's plate of the Alamo.[28]

A second book published in 1840 contains an even more important view of Austin. This image is the frontispiece in *Texas in 1840; or, The Emigrant's Guide to the New Republic*, a book attributed to A. B. Lawrence, the editor of the New Orleans *Picayune* and a Presbyterian clergyman. This illustration is the first printed view of the town of Austin. It is a hand-colored lithograph based on a sketch by Edward Hall, a speculator and purchasing agent for the Republic of Texas at New Orleans. His original sketch, which is housed in the Austin History Center at the Austin Public Library, identifies fifteen buildings in its view looking north from just across the Colorado River. These include the president's house; the temporary capitol; Bullock's Tavern; Samuel Whiting's printing office (Whiting published the previously discussed *Texas Army Regulations*); and other structures, including government offices and the

---

27. Francis Moore, *Map and Description of Texas* (New York: Tanner & Disturnell, 1840), Streeter nos. 1363, 1363A; S. W. Geiser, "Note on Dr. Francis Moore (1808–1864)," *Southwestern Historical Quarterly*, XLVII (Apr., 1944), 420–422 (hereafter cited as *SHQ*).

28. Susan Prendergast Schoelwer, "The Artist's Alamo: A Reappraisal of Pictorial Evidence, 1836–1850," *SHQ*, LXXXI (Apr., 1988), 424–426.

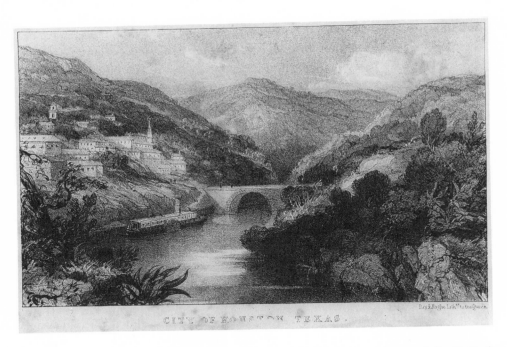

"City of Houston, Texas," from Matilda Charlotte Houstoun, *Texas and the Gulf of Mexico; or, Yachting in the New World* (London: John Murray, 1844). Lithograph by unknown artist, 3⅜ x 5⅞ inches, lithographed by Day & Haghe, London. *Courtesy Texas Collection Library, Center for American History, University of Texas at Austin.*

French Legation. The lithographer is J. Lowe, probably Joshua Lowe, the engraver of the Portland, Texas, stock certificate described earlier. Lawrence's book was reissued in 1842, 1844, and 1845, and some of these later issues contain the same view, though uncolored.[29]

Two other Texas cities are depicted in the two-volume *Texas and the Gulf Coast*, written by Matilda Charlotte Houstoun and published in London in 1844. This account of a journey to Galveston and its environs by a wealthy English couple includes a conventional sketch of the history of Texas as well as comments on Texas dress, profanity, courtesy, justice, slavery, idleness, food, whittling, sporting, and tobacco. Houstoun's volumes contain a number of images, including lithograph portraits of generals Santa Anna and Sam Houston

29. A. B. Lawrence, *Texas in 1840, or The Emigrant's Guide to the New Republic* (New York: William W. Allen, 1840), Streeter nos. 1361, 1361A, 1361B, 1361C; Amelia W. Williams and Eugene C. Barker (eds.), *The Writings of Sam Houston, 1813–1863* (7 vols.; Austin: University of Texas Press, 1938–1943), II, 27; V, 145.

and city views of Galveston and Houston.[30] These lithographs were done by Day and Haghe, a London lithography firm best known for the illustrations in George Catlin's *North American Indian Portfolio*.[31] It is difficult to believe that the views of Galveston and Houston are based on eyewitness rather than imaginary images. The Houston view in particular is a fabrication; later subsidence notwithstanding, there were no mountains in Houston in the 1840s.

Missions in the Republic of Texas were also the subject of illustrations in books published between 1836 and 1845. Francis Moore's *Map and Description of Texas*, for example, contains five mission views. Among the most frequently depicted is the Alamo, a historic and symbolic landscape that attracted attention immediately after the famous battle at its site. Views of the Alamo ruins appeared as early as the fall of 1838 with a watercolor by Mary Ann Adams Maverick, bride of Texas Revolution veteran Samuel A. Maverick. Recent research by Susan Schoelwer suggests that Mrs. Maverick's view influenced this image of the Alamo published in Moore's book. Although attributed to William Bissett, the unsigned frontispiece resembles Maverick's view in perspective and foreground detail, and Schoelwer has concluded that it was based on the Maverick sketch and not on another by Bissett.[32]

Another published view of the Alamo appears in Arthur Ikin's *Texas: Its History, Topography, Agriculture, Commerce, and General Statistics*, published in London in 1841. Ikin, the Texas consul in London, published this guidebook to encourage support for the Texas Republic. The image is a wood engraving by an unknown artist; it gives a romanticized view of the Alamo that is architecturally inaccurate in that it omits existing churchyard walls and windows and reinstalls statuary in the four niches in the church front. That this picturesque view of the Alamo and its sightseers is the only illustration in Ikin's book suggests that already this monument held considerable symbolic significance for the Texas Republic.[33]

Like views of the Alamo ruins, idealized scenes from the Texas Revolution made popular illustrations in books published about Texas during the Republic years. Two good examples are the battle views of the Alamo and of San Jacinto that accompany an 1837 account of the Revolution published in the

30. Matilda Charlotte Houstoun, *Texas and the Gulf of Mexico; or, Yachting in the New World* (2 vols.; London: John Murray, 1844), Streeter nos. 1506, 1506A.

31. William H. Truettner, "For European Audiences: Catlin's *North American Indian Portfolio*," in *Prints of the American West: Papers Presented at the Ninth Annual North American Print Conference* (Fort Worth: Amon Carter Museum, 1983), 25.

32. Schoelwer, "The Artist's Alamo," 424–426.

33. Arthur Ikin, *Texas: Its History, Topography, Agriculture, Commerce, and General Statistics* (London: Sherwood, Gilbert, and Piper, 1841), Streeter no. 1384; Schoelwer, "The Artist's Alamo," 424–426.

*History of South America and Mexico.* This volume was originally published in 1827 by Connecticut senator and author John Milton Niles. A new edition in 1837 added an account of the Revolution by Lorain Pease of Connecticut, whose son Elijah Pease supported Texas independence, fought in the Revolution, and later served as the state's governor.[34] The book's images are engravings by an unknown artist. Romantic and patriotic, they were intended to venerate the Texas cause and its fulfillment. They are complete with mounted combatants, flashing swords, gunsmoke, cannon fire, and flags, and thus fit perfectly with Pease's description of the battle of the Alamo as an event "which came near extinguishing forever the new risen star of Texas" and the Battle of San Jacinto as a "victory [that] stands alone in the annals of human warfare" to which history, "ancient or modern, presents no parallel."[35]

As unrealistic as these two illustrations may be, they nonetheless are based on actual events. Two illustrations that depict wholly fictional events set during the Texas Revolution are the two engravings in *The Female Warrior: An Interesting Narrative of the Sufferings, and singular & surprising adventures of Miss Leonora Siddons.* A total fabrication, this 1843 paperback was written by an unknown author using the pseudonym Leonora Siddons. According to her account, Leonora moved to Galveston and, after the death of her father, took up the cause of Texas liberty by dressing as a man and joining Houston's forces. Shot in the head during the battle near San Antonio, she is captured by Mexican troops and transported, near death, to Vera Cruz. With the assistance of a fellow prisoner, a Texas surgeon named Allen, Leonora nearly escapes during the trip, but the plot fails and she soon finds herself in front of Santa Anna accused of mutiny and murder. The general condemns her to 150 lashes on three successive days; if she survives this harsh punishment she is to be executed. When officers rip her clothes off to begin the punishment, Leonora is revealed as a woman. Santa Anna offers Leonora her life if she will become his mistress. She refuses him indignantly and is returned to jail. She soon escapes by scratching a hole in the wall with her fingernail and a file and saw conveniently left in the cell by a previous prisoner. By March 1843 she has rejoined friends in Mobile.[36]

---

34. John Milton Niles and Lorraine Thompson Pease, *History of South America and Mexico . . . To which is annexed, A Geographical and Historical View of Texas, with a detailed account of the Texian Revolution and War* (Hartford: H. Huntington, 1837), Streeter nos. 1285, 1285A, 1285B, 1285C, 1285D; Webb, Carroll, and Branda (eds.), *Handbook of Texas*, II, 351–352; *Dictionary of American Biography* (New York: Scribner's Sons, 1903), XIII, 522.

35. Niles and Pease, *History of South America and Mexico*, 325, 355.

36. Leonora Siddons, *The Female Warrior, An Interesting Narrative of the Sufferings, and singular & surprising adventures of Miss Leonora Siddons* (New York: E. E. & G. Barclay, 1843), Streeter no. 1460.

The Siddons piece, with its sensational illustrations and text, is an excellent example of the sort of cheap, paper-covered blood-and-thunder publication that flourished in the United States in the first half of the nineteenth century, antedating the dime novels of Beadle and Adams by more than thirty years.[37]

It is only a short step from this sensational paperback to comic almanacs, a similar form of popular literature featuring the authentic Texas hero Davy Crockett. Almanacs, introduced into the New World from England in the mid-eighteenth century, quickly became bestsellers everywhere, particularly on the book-starved frontier. They were at first designed to serve farmers through a composite of chronological devices, including a tabulation of days, weeks, and months, and an astronomical computation of the passage of time. Specialty almanacs appeared in the United States in the 1830s and 1840s. These include special-interest almanacs, which promoted the ideas and products of specific political, religious, labor, or fraternal groups; and comic almanacs, which featured wood-engraved cartoons and text that ran the gamut in humor from outlandish to uncouth to very low indeed.[38]

Comic almanacs flooded bookseller's shelves from 1840 to about 1900, and Davy Crockett, the backwoodsman, scout, Indian fighter, and congressman from Tennessee, was a natural for them. This heroic figure of legendary proportion first appeared in an almanac in 1835 and continued a popular almanac subject until 1856. Crockett's sudden and dramatic death at the Alamo in March 1836 further enhanced his legend, and almanacs were one of the main vehicles that kept it alive and expanded it even further.

The popular posthumous tales and images of Crockett are, of course, wholly fictional. The most important Crockett almanac relating to Texas is the 1836 publication from the "Go Ahead" almanac series. Crockett is pictured on the front cover, rifle at the ready and wearing some form of fur on his head, possibly a bobcat. His image, however, bears no resemblance to the actual man; indeed, it is a rendering of actor James Hackett as he appeared on stage as Colonel Nimrod Wildfire, Crockett's alter ego, in the 1831 James Kirke Paulding theatrical *Lion of the West*.[39] Inside the almanac are incredible tales of Crockett fighting grizzly bears and alligators, killing panthers, swimming the

---

37. Albert Johannsen, *The House of Beadle and Adams and Its Dime and Nickel Novels* (2 vols.; Norman: University of Oklahoma Press, 1950), I, 3.

38. Milton Drake (comp.), *Almanacs of the United States, 1639–1875* (2 vols.; New York: Scarecrow Press, 1962), I, ii–viii; Robb Sagendorph, *America and Her Almanacs: Wit, Wisdom, and Weather, 1639–1970* (Dublin, N.H.: Yankee, 1970), 236–240; Murrell, *American Graphic Humor*, I, 152–154.

39. Michael A. Lafaro (ed.), *Davy Crockett: The Man, The Legend, The Legacy, 1786–1986* (Knoxville: University of Tennessee Press, 1985), 103; Frederick S. Voss, "Portraying an American Original: The Likenesses of Day Crockett," *SHQ*, XCI (Apr., 1988), 475–476.

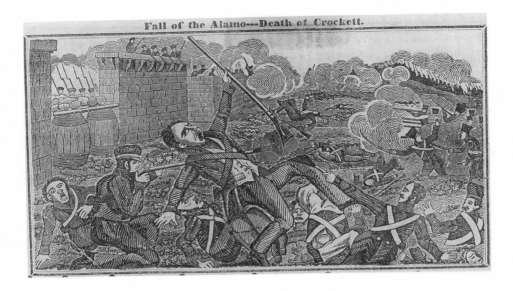

*Fall of the Alamo—Death of Crockett,* by unknown artist. Wood engraving, 3½ x 7 inches, from *Davy Crockett's 1837 Almanack of Wild Sports in the West . . .* (Nashville: Heirs of Col. Crockett, 1836). *Courtesy Texas Collection Library, Center for American History, University of Texas at Austin.*

Mississippi River, and hunting wild hogs, each accompanied by a wood-engraved visual rendition of the tall tale. There are three illustrations in this almanac that pertain specifically to Texas. One shows Crockett catching wild horses on the prairies of Texas. The image is accompanied by detailed instructions on how best to reconnoiter and lasso one horse from a herd whose "hoofs . . . may be compared to the loudest thunder." More interesting, however, are the almanac's two wood-engraved views of Crockett at the Alamo. The first one features Crockett in the thick of battle. He sports a military uniform, high boots, side whiskers, and a fur hat and is shown decapitating a Mexican soldier while simultaneously giving him a well-placed kick. The second image captures Crockett at the moment of his death. Still uniformed, but now lacking sword, boots, whiskers and fur cap, he falls with his rifle raised and a look of astonishment on his face. According to the narrative, Crockett went down fighting, a "smile of scorn" on his face. Firing four rifles, "with two men to load constantly . . . he fired as fast as they could load." Wounded twice, Crockett was one of the last to fall, his body surrounded by seventeen Mexicans whom he had killed with dagger, pistols, and rifle. In all, the narrative continues, Crockett had killed "no less than 85 men, and wounded 120 besides." And when Crockett's body finally was taken to the center of the Alamo to be burnt

with the other fallen heroes, the Mexican General Cos said, "So brave a man ought not to be burnt like a dog; but after a little hesitation he said, Never mind, throw him on. Thus perished Crockett, in a noble cause."[40]

The Texas Revolution received coverage in a second comic almanac published in 1836. The *Devil's Comical Texas Oldmanick* boasts that it contains comic engravings of all the principal events of Texas. This is not too far from the truth. In nineteen original cartoons plus assorted stock cuts, the men and events of the Texas Revolution, particularly Sam Houston, Davy Crockett, and Mexican generals Santa Anna, Urrea, Filisola, and Cos, are depicted in an entirely unflattering fashion.[41] This type of almanac relied on uncouth jokes and crude comic pictures and was representative of a type of cheap, illustrated, humorous printing which found wide acceptance in the United States from the 1830s through the 1860s. Turner and Fisher, the firm that issued this almanac, was one of the main sources for this type of literature. In business together from 1835 to 1849, Frederick Turner and Abraham J. Fisher published a variety of comic literature, including the Davy Crockett almanacs from 1839 to 1856 and *The Idle Hour Book, or Scrapiana,* an 1848 joke book that contained a fully illustrated biography of Crockett.

One of the hallmarks of this brand of comic press, especially later, was that the humor and drawings were crude, frequently exploiting ethnic stereotypes and physical peculiarities or disabilities in caricatures of their subjects. In both text and image *The Devil's Texas Oldmanick* employs this low humor. The cover, for example, shows a piratical Antonio López de Santa Anna with a noose around his neck and confined by the five-pointed Texas star. Other images depict Santa Anna as a youth burning frogs with a hot poker, with a caption that reads "Innocent Amusements of Santa Anna in boyhood." A third cartoon shows Davy Crockett "axing" his Mexican victims to glory.

Another image in the *Oldmanick* depicts the evacuation of Texas by the Mexicans under the command of Vincente Filisola, which occurred around San Antonio after the Battle of San Jacinto. The caricatures of both horses and civilians hardly suggest fear or flight and seem disinterested at best. Finally, in a scene titled "Houston's Address to His Army," the general speaks to a bedraggled assortment of ten men, including a drunkard, a deaf man, a gentleman with a pegleg, and a blind fellow with a fish on his head. Houston, the sword

40. *Davy Crockett's 1837 Almanack of Wild Sports in the West . . .* (Nashville: Heirs of Col. Crockett, 1836), Streeter no. 1194.

41. *The Devil's Comical Oldmanick. 1837. With Comic Engravings of All the Principal Events of Texas* (New York: Fisher & Turner, [1836]), Streeter no. 1195.

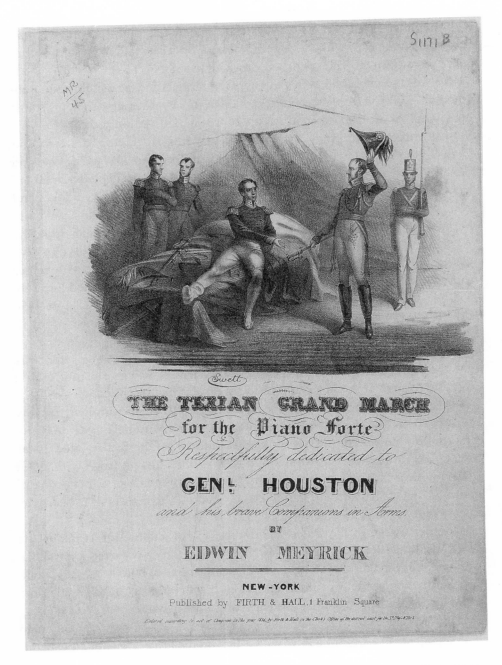

Cover to Edwin Meyrick, *The Texian Grand March for the Piano Forte* (New York: Firth and Hall, 1836), attributed to Anthony Fleetwood. Lithograph, 5³⁄₄ x 7¹⁄₂ inches. *Courtesy Texas Collection Library, Center for American History, University of Texas at Austin.*

of liberty in his hand, is saying, "Soldiers, there is the enemy—do you want to fight? Yes, well then let us eat our dinners and then I will lead you into battle."[42]

The Texas Revolution, specifically the surrender to Sam Houston of generals Santa Anna and Cos after the Battle of San Jacinto, is the subject of a third graphic image, this one a satirical print probably drawn by Edward Williams Clay for lithograph printer Henry R. Robinson. Both New Yorkers, Clay is best known for the numerous cartoons he drew for lithographic houses from the 1830s to the early 1850s, and Robinson was the most prolific of all printers of lithographic political caricatures and cartoons of that era.[43] This Texas image is one of many lithograph cartoons to appear during an era when United States commercial lithography was fostering new forms of graphic art. One of these was the separate comic print, a satirical art form that was perfect for social and political commentary and which found its first really popular national subject in the activities and policies of the Andrew Jackson administrations from 1828 to 1836. The new, simple, and cheap method of lithographic reproduction spawned a flood of these cartoons, each published on separate sheets varying in size and costing from twelve to twenty-five cents apiece.[44]

At least ten comic lithographic prints used some aspect of the Republic of Texas as their subject. In one image, Houston, well dressed in buckskin, his wounded ankle bandaged but bleeding, remarks to his two captives, "You are two bloody villains, and to treat you as you deserve, I ought to have you shot as an example." To which Santa Anna replies, "I consent to remain your prisoner, most excellent sir!!" followed by Cos, who states, "So do I most valiant Americano."

If lithography helped spawn an industry of comic prints, it also was one of the techniques of choice for another form of popular illustration: the sheet music cover. The publication of illustrated sheet music began in earnest in the United States around 1825. It flourished throughout the remainder of the century, recording political events, city views, performers, and military heroes as well as the sentiments, taste, and emotions of nearly a century. Illustrated covers were intended primarily as a sales device, and one of the most popular subjects was the military, including portraits of fallen heroes, pictures of volunteer

---

42. Ruth Webb Lee, *A History of Valentines* (New York: The Studio Publications, Inc., 1952), 39, 81; Murrell, *American Graphic Humor*, I, 154.

43. Peters, *America on Stone*, 337–338.

44. Murrell, *American Graphic Humor*, I, 108–110, 115–116.

militia, battle scenes, and views commemorating important military engagements.[45]

At least two pieces of sheet music published during the years of the Texas Republic carry illustrated covers with scenes from the Texas Revolution. One accompanies the 1841 *Texian Quick Step* by Francis Prentiss. The music is dedicated to Gen. Edward Burleson of the Republic of Texas, who is pictured, possibly during the Battle of San Jacinto, where he commanded the First Regiment of the Texas Volunteers. The illustration was intended to venerate his heroics. It was lithographed by the Boston firm of Thayer & Company, the business of Benjamin W. Thayer, an active Boston lithographer from 1840 to 1851.[46]

A second illustrated music sheet cover is the *Texian Grand March for the Piano Forte* published by Firth & Hall, a New York music store, warehouse, and piano shop that also published innumerable music sheets during its long existence. Its illustration, which shows the wounded Sam Houston accepting the surrender and sword of Mexican General Santa Anna, is probably the work of English lithographer Anthony Fleetwood, a master of lithography who was active in New York from 1828 to 1848.[47] The imprint date of 1835 is incorrect; the Battle of San Jacinto and the surrender of Santa Anna did not occur, of course, until April 1836. Unlike the comic renditions of Houston and Santa Anna in the almanacs and cartoon print discussed above, this image is intended to glorify General Houston and his victory. It is idealized in every respect. Houston is shown in a sparkling uniform, wounded but cleanly bandaged and lying upon a draped bed to receive the vanquished Mexican military commander. In reality, the surrender took place with Houston, his right leg shattered above his ankle, propped up under a tree after an eighteen-minute battle in the dirt and wet of the tallgrass prairie and swamps around Buffalo Bayou.

In conclusion, a large quantity of images, diverse in technique, content, and purpose, depicted the Republic of Texas during its brief lifetime. Those coming from Texas were products of a frontier press characterized by practicality of imprint and by the creative and liberal use of stock illustrations

45. Nancy R. Davison, *American Sheet Music Illustration: Reflections of the Nineteenth Century* (Ann Arbor: William L. Clements Library, University of Michigan, 1973), 5–6; Nancy R. Davison, "The Grand Triumphal Quick-Step; or Sheet Music Covers in America," in *Prints in and of America to 1850*, ed. John D. Morse (Charlottesville: University Press of Virginia, 1970), 258–259.

46. Francis Prentiss, *The Texian Quick Step* (Boston: Henry Prentiss, [1841]), Streeter no. 1392; Peters, *America on Stone*, 382–383.

47. Edwin Meyrick, *Texian Grand March for the Piano Forte* (New York: Firth & Hall, 1836), Streeter nos. 1171, 1171A, 1171B; Peters, *America on Stone*, 186–189.

and ornaments acquired from foundries outside of the Republic. Those print-
ed outside Texas with the Republic as the subject reveal a nation whose peo-
ple, cities and landscapes, and, particularly, recent history were important
and popular topics, ones that were depicted by the full range of the era's
printmaking techniques and in the popular graphic art forms and styles of
the day.

MAIN PLAZA.

San Antonio, Texas, le 10 Mai ___ 1856

Monsieur Armand Soubié

N.lle Orleans

Mon cher Monsieur

Je suis en posession de vos deux
amicales faveurs datées du mois passé, et je vous
suis bien obligé pour votre information.

J'avais envie de prendre le Steamer par
L'Havanne, mais j'ai changé mon idée, j'irai
par Louisville, Cincinati, Buffalo &c —

Vous ne saviez pas, que je fus père, mais
vous vous rappellerez bien, quand je vous
ai écrit, que ma belle soeur fut morte
en couche. et nous avons adopté le neveu
comme fils — il n'avait que dix jours, quand
sa mère est morte. Il a 22 mois. C'est un beau
& gros garçon, qui nous a fait beaucoup
de trouble, mais il nous fait beaucoup de
plaisir à present —

Vers le 18-20 Nous allons partir d'ici pour

*Main Plaza, San Antonio, Texas,* by Wilhelm C. A. Thielepape. Lithograph, 1855.
*Courtesy Collection of Western Americana, Beinecke Rare Book and Manuscript Library,*
*Yale University.*

20

# THE BEGINNINGS OF
# LITHOGRAPHY IN TEXAS

દુ✿

## BEN HUSEMAN

It is not certain who produced the first lithograph in Texas. Lithographs depicting Texas scenes appeared as early as 1818; however, these first imaginary views were produced in Europe.[1] Probably the first lithograph of a Texas scene that was made from an on-the-spot sketch is a view of Austin which serves as the frontispiece to *A History of Texas, or the Emigrant's Guide to the New Republic; being the Result of Observation, Enquiry and Travel in That Beautiful Country*, with an introduction by the Rev. A. B. Lawrence, first published in New York in 1845. The amateur artist was Edward Hall, a Texas land promoter and speculator from New Orleans. It is unclear whether or not the print was produced in Texas; the inscription at the bottom of the print credits "Lithog. by J. Lowe"—probably the New Orleans engraver by that name who advertised briefly as a bank note engraver with a Galveston address in 1840 and 1841. Galveston's port location would have made the importation of lithographic equipment feasible, but no other evidence suggests that Lowe brought a lithographic press to Texas. (In his Texas advertisements he always referred to the engraving process.)[2]

---

1. There are at least three different lithographs depicting the failed French colony known as Le Champ d'Asile (The Field of Exile), which was located near present-day Liberty, Texas. Created to help promoters raise funds in France for the French colonists in Texas, the lithographs are *Le Champ d'Asile Romance*, a sheet-music cover, impressions at the Beinecke Rare Book and Manuscript Library, Yale University, and in the Special Collections of the library of the University of North Texas, Denton; *Les Lauriers Seuls y Croitront Sans Culture* and *Colonie du Texas*, both in the Amon Carter Museum, Fort Worth.

The material included here was collected in preparation for the book *Texas Lithographs, 1818–1900*, by Ron Tyler, with research assistance by Ben Huseman. I am grateful to Ron Tyler, the director of the Texas State Historical Association, Austin, and to James Patrick McGuire of the University of Texas Institute of Texan Cultures for their assistance with this paper.

2. John Máhe II and Roseann McCaffrey (eds.), *Encyclopaedia of New Orleans Artists, 1718–1918* (New Orleans: Historic New Orleans Collection, 1987), 242. Lowe advertised from Galveston as early as October 24, 1840, and as late as May 11, 1841. See *Texas Sentinel* (Austin), Oct. 24, 1840; San Luis *Advocate*, May 11, 1841. The lithograph by Lowe could easily be confused with an engraving,

Given the invention of lithography by a Bavarian and the importance of German immigrant lithographers in the growth and development of lithography in America, it is not surprising that the first indisputable evidence of a lithographic press in Texas is associated with German immigrants.[3] The story of this press is complicated and cannot be fully appreciated outside its historical and cultural context.

On December 9, 1854, Douai and Riedner, the editors of the San Antonio German-language newspaper the *Staats Zeitung*, announced in their paper that in addition to having a printing press with complete capability to execute work in German, English, Spanish, and French, as well as other type fonts, they had just purchased a complete lithographic press. Therefore, they claimed, they were now in a position to prepare "all kinds of work, such as maps, charts, architectural plans, all types of cards, pictures, landscapes, caricatures, views, receipts, checks, bill-heads, labels, etc., with speed and economy in the most elegant style."[4]

The partnership of Douai and Riedner consisted of two German immigrants, Dr. Karl Adolf Daniel Douai and J. Martin Riedner, who had started their newspaper the year before, from an office on Commerce Street in what became the heart of San Antonio's German district. Little is known about Riedner, who seems to have played a secondary role in the partnership. Douai was a native of Altenburg in Lower Saxony and the descendant of a French refugee family. From 1838 to 1841, he had studied in Leipzig, where he had received a doctoral degree, and he had spent six years as a tutor in Russia. He also founded a *Realschule,* or modern secondary school, in his hometown. A free-thinking liberal, Douai had been arrested during the Revolution of 1848 on five counts of high treason. Although he was acquitted, he immigrated to the German settlement at New Braunfels, Texas, in 1852. He founded a short-lived private

and indeed it may have originally been engraved and then transferred to stone. On Edward Hall, see Amelia W. Williams and Eugene C. Barker (eds.), *The Writings of Sam Houston, 1813–1863* (7 vols.; Austin: University of Texas Press, 1938–1943), II, 27, III, 145; *Texas State Gazette* (Austin), Nov. 16, 1850.

3. Bavarian chemist Alois Senefelder invented the process of lithography in 1796; his *Complete Course of Lithography* was translated into English and published in London in 1819. See Michael Twyman, *Lithography, 1800–1850: The Techniques of Drawing on Stone in England and France and Their Applications in Works of Lithography* (London: Oxford University Press, 1970). George C. Groce and David H. Wallace, *The New-York Historical Society's Dictionary of Artists in America, 1564–1860* (New Haven: Yale University Press, 1957), confirm that a large number of lithographers working in the United States in the nineteenth century had emigrated from Germany. On Germans in Texas see Rudolph Leopold Biesele, *The History of the German Settlements in Texas, 1831–1861* (Austin: von Boeckmann-Jones Co., 1930), and Glen E. Lich, *The German Texans* (San Antonio: University of Texas Institute of Texan Cultures, 1981).

4. San Antonio *Staats Zeitung*, Dec. 9, 1854.

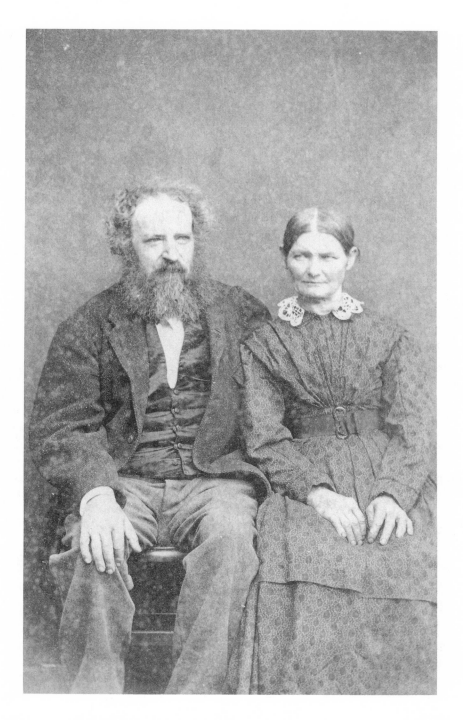

*Mayor and Mrs. Wilhelm C. A. Thielepape, San Antonio. Photograph, ca. 1867. Courtesy University of Texas Institute of Texan Cultures, San Antonio.*

school there before coming to San Antonio and going into business with Ried-
ner.[5]

On January 6, 1855, Douai and Riedner announced in English that they had
hired "a distinguished draftsman."[6] Wilhelm Carl August Thielepape, a native
of Webern, Hesse-Kassel, had probably first come to Texas in 1846 to visit his
brother, who was among the first settlers of New Braunfels. Thielepape had
returned to Texas from Germany with his wife and two daughters in 1850.
They settled in the port town of Indianola (Carlshafen), but in 1854 had moved
again, this time to San Antonio, where he had advertised in the *Zeitung* as an
architect, engineer, surveyor, and drawing instructor. Douai and Riedner met
Thielepape in the local male singing society, or *Männergesangverein*. Douai was
the chorus's conductor, and upon his recommendation Thielepape was named
"co-conductor" on account of his excellent tenor voice, musical ability, and ex-
perience.[7]

On October 20, 1855, after Thielepape had exhibited some of their litho-
graphs at the fall Agricultural Exhibition of Bexar County, Douai published an
account of their lithographic efforts in his newspaper:

One must know about the history of the beginning of the local lithographic estab-
lishment in order to value the achievements and merits of Mr. Thielepape. The estab-
lishment was founded by Douai & Riedner, by which the latter deluded his partner into
thinking that he completely understood the lithographic process and was able to pre-
pare by himself or with the help of a draftsman all the work orders needed in San

5. Robert E. Ward, *A Bio-Bibliography of German-American Writers, 1670–1970* (White Plains,
N.Y.: Kraus International Publications, 1985), 66; Kent Keeth, "Sankt Antonius: Germans in the
Alamo City in the 1850s," *Southwestern Historical Quarterly*, LXXVI (Oct., 1972), 191–195. See also
"Autobiography of Dr. Adolf Douai, Revolutionary of 1848; Texas Pioneer; Introducer of the
Kindergarten; Educator; Author; Editor, 1819–1888," trans. Richard H. Douai Boerker (typescript),
Center for American History, University of Texas at Austin.

6. San Antonio *Staats Zeitung*, Jan. 6, 1855.

7. Theodore Albrecht, "San Antonio's Singing Mayor: Wilhelm Carl August Thielepape,
1814–1904" (typescript), 1–5, University of Texas Institute of Texan Cultures, San Antonio. Dr. Al-
brecht is a music librarian and musicology teacher at Case Western Reserve University, Cleveland.
His paper is the best biography of Thielepape to date. Albrecht notes that the name "Thielepape"
is actually Finnish or Swedish; Thielepape's ancestors had immigrated to Germany sometime in
the seventeenth century. Albrecht also notes Thielepape's *Ein- und Mehrstimmige Lieder, mit Be-
gleitung des Pianoforte* (*Songs with Piano Accompaniment for One or More Voices*), 1840–1899, a manu-
script volume in the possession of Elinor Francisco of Wauconda, Illinois. According to Albrecht,
"the songs are not in the folk idiom, but rather are sophisticated art songs in the best nineteenth-
century German Romantic style." Thielepape's advertisement as an architect, engineer, and sur-
veyor ran regularly in the San Antonio *Staats Zeitung* beginning on April 22, 1854. Also see Martha
Utterback, *Early Texas Art in the Witte Museum* (San Antonio: San Antonio Museum Association,
1968), 32–33.

Antonio. We gave up the rest of our small savings to this project and warned him that by our unfamiliarity with lithography he took upon himself the responsibility of our ruin and that of our families. He brought a lithographic press from New Orleans and soon it became apparent that he understood very little about lithography. . . . Then several weeks later it also became apparent that all of the material that he had bought was more or less unuseable. Meanwhile Mr. Thielepape had come into partnership with us, but he originally knew nothing about lithography, but was instead a capable architect and surveyor. After months of study, numerous attempts (with the advice of a man who only understood how to draw on the stones) and with great effort and at considerable expense, he discovered the problems with the press and with the materials and improved them so well as to allow for the modest means available in San Antonio for orders. He practically reinvented the art of lithography, and was able to develop it to the point that now, six months after he started, he produces capable work in this field. Truly, only a German could do this, and for that reason, we find it just and reasonable that he did not receive a prize at a native exhibition. Then, is there nowhere in America a suitable place for this man?[8]

Douai and Riedner had dissolved their partnership on March 28 of that year and Douai had assumed sole financial responsibility.[9] In his autobiography, Douai recalled that "the lithographic equipment which Riedner had bought in New Orleans was old and not worth the small sum paid for it."[10] Apparently one of Thielepape's first attempts at lithography was to draw a map of San Antonio upon the stone. Douai believed that they could have netted a thousand dollars from the map, but the printing was a failure, as he discovered that the large stone upon which Thielepape was working was uneven. While Douai ground this stone for a second attempt (he wrote facetiously that "stone-grinding was my avocation"), Thielepape successfully completed another lithograph, a caricature entitled "Sam Recruiting, after the injunction of secrecy had been removed."[11] (A rare impression of the San Antonio map is in the Witte Museum in San Antonio; the Center for American History has an impression of the caricature.)

Douai and Thielepape announced the availability of the caricature in an advertisement that first appeared in the *Zeitung* on July 28, 1855. The lithograph was offered to customers at fifty cents, or four dollars per dozen.[12] Signed "W. T. Lith. San Antonio, Texas," the print pales in comparison with some of the contemporary lithographic caricatures produced on the East Coast.

8. San Antonio *Staats Zeitung*, Oct. 20, 1855.

9. English and German translations of the announcement, dated March 20, 1855, appeared in the San Antonio *Staats Zeitung*, Mar. 30, 1855.

10. "Autobiography of Dr. Adolf Douai," 117–118; Albrecht, "San Antonio's Singing Mayor," 8.

11. Ibid.

12. San Antonio *Staats Zeitung*, July 28, Aug. 4, Aug. 11, Aug. 25, 1855.

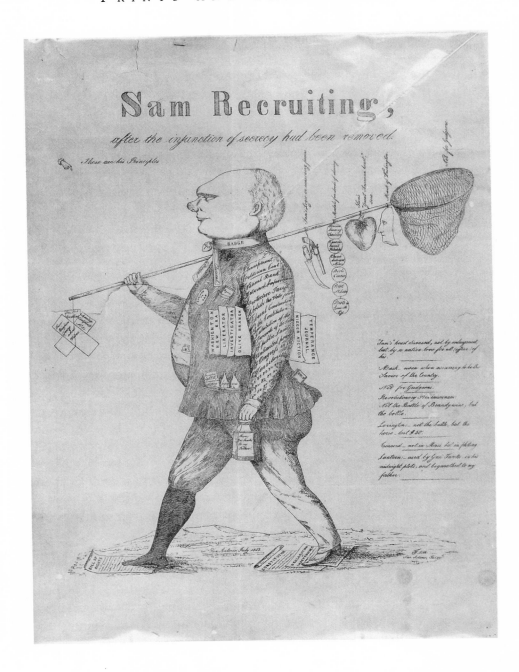

*Sam Recruiting, after the injunction of secrecy had been removed,* by Wilhelm C. A. Thielepape, 1855. Lithograph, *Courtesy Center for American History, University of Texas at Austin.*

Some knowledge of the political situation in Texas and the political persuasions of the men who produced it is necessary to understand the arcane symbolism of this caricature. Douai was not only a liberal, but an ardent abolitionist, and he was allied with the radical German Social Democratic Association. Courageously, or perhaps foolishly, he openly espoused his progressive and controversial theories and ideas in his newspaper. At the second annual *Texanischen Sängerfest* (Texas singing festival) held at San Antonio in May 1854, Douai and Thielepape had been among approximately 200 Germans who drew up a platform stating their political principles.[13] Although this "German convention" had declared that "The government of the United States is the best that has yet been created," they admitted that "it is as all existing things capable and in need of greater improvement."[14] Among the improvements they advocated were the abolition of the electoral college and a progressive income tax. One of their most naive and wishful demands was for "universal legal criminal and civil laws which through their simplicity and clearness shall be comprehensible by all citizens," in hopes "that the assistance of the lawyers [would] be rendered superfluous." They advocated public schools and universities, abolition of religious instruction and religious books from the schools, and suspension of Sunday Laws and Thanksgiving Days. They supported the idea that "Congress and representative assemblies shall not be opened with prayer," and also advocated the idea that "no preacher may be a teacher." Unsurprisingly, they called for the abolition of temperance laws, but they also supported the abolition of capital punishment. Slavery, they maintained, was "an evil, the endless explanation of whose principles the Democrats find necessary. However, as this concerns only a few states, we demand: That the National government shall not concern itself with the affairs of slavery, but when one of the states is convinced of the necessity of doing away with the evil, it can demand the assistance of the Federal Government in carrying into effect its decision."[15]

These political discussions, the platform of which was not unique to Douai and his friends but in fact quite similar to the ideals of other German organizations around the United States, probably encouraged Thielepape to decide to

13. Albrecht, "San Antonio's Singing Mayor," 5–6; *Neu Braunfelser Zeitung* (New Braunfels), Apr. 20, 1854; Ernest William Winkler (ed.), *Platforms of Political Parties in Texas*, Bulletin of the University of Texas no. 53 (Austin: University of Texas, 1916), 58–61.

14. The *Sängerfest* platform appeared in the *Neu Braunfelser Zeitung* (New Braunfels), May 19, 1854, and in the San Antonio *Staats Zeitung*. Also see Winkler (ed.), *Platforms of Political Parties in Texas*, 58–61. There is an English translation as well as a German copy in Sister Paul of the Cross McGrath, "Political Nativism in Texas, 1825–1860" (Ph.D. diss., Catholic University of America, 1930), 73–76, 195–199.

15. Winkler, *Platforms of Political Parties in Texas*, 60; McGrath, "Political Nativism in Texas," 74.

apply for American citizenship. Unfortunately for the Texas Germans, the existence of Douai's abolitionist newspaper and the publication did anything but help their cause.

The majority of Texans were pro-slavery or at least tolerant of it, and they did not appreciate a foreign element in their midst stirring up trouble. Douai and the "German convention platform" played into the hands of the Know-Nothings, a secret pro-Union nativist party that was on the rise in Texas and the rest of the nation. The party's official name was "the American Party" or "the American Order," but because it was a secret organization, its members would reply "I know nothing" when asked about it. The Know-Nothings wanted to change the naturalization laws so that foreigners would have to dwell in the U.S. for twenty-one years before being naturalized. The Know-Nothings particularly distrusted the Roman Catholic Church and feared papal interference in American politics. Although the secrecy and the xenophobic and anti-Catholic aspects of the party were important, much of its appeal was due to its neutral stand on slavery and its promise to preserve the Union.[16]

The Know-Nothings achieved their initial success in Texas in the municipal elections of 1854 and 1855 in San Antonio and Galveston, two cities where the foreign population was most concentrated. The Know-Nothings swept the December 1854 election in San Antonio, with not a single Catholic or naturalized citizen elected to office. The German and *Tejano* communities awoke to the new danger, but meanwhile, in June 1855, under the cover of the Democratic state convention at Washington-on-the-Brazos, the Know-Nothings held their own secret convention. They adopted a platform and made nominations for the state gubernatorial election, but their activities were soon made public. To stem criticism about their secrecy, the Know-Nothings themselves moved toward greater openness. On July 24, 1855, the most important figure in Texas politics, former President of the Republic and current State Sen. Sam Houston, openly declared his support for the Know-Nothing candidates and their principles.[17]

16. Ray Allen Billington, *The Protestant Crusade, 1800–1860: A Study of the Origins of American Nativism* (New York: Rinehart and Co., 1947), 380–430. See also Carleton Beals, *Brass-Knuckle Crusade: The Great American Know-Nothing Conspiracy, 1820–1860* (New York: Hastings House, 1960); W. Darrell Overdyke, *The Know-Nothing Party in the South* (Baton Rouge: Louisiana State University Press, 1950); Ira M. Leonard and Robert D. Parmet, *American Nativism, 1830–1860*, ed. Louis M. Snyder (New York: Van Nostrand Rheinhold Co., 1971), 85–105; and David H. Bennett, *The Party of Fear: From Nativist Movements to the New Right in American History* (Chapel Hill: University of North Carolina Press, 1988), 1–155. Also useful is Litha Crews, "The Know-Nothing Party in Texas" (M.A. thesis, University of Texas, 1925).

17. Crews, "The Know-Nothing Party in Texas," 66–102. Houston's letter of identification with Know-Nothingism was written from his home in Independence, Texas, on July 24, 1855, and

Houston, in aligning himself with the party, aroused the indignation of the entire German community. Thus, in Thielepape's lithograph, Houston is seen openly recruiting members for the Know-Nothing party. At first glance, one is struck by the ineptitude of the rendering. How much of the distortion is intentional may never be known, but it should be remembered that the pseudo-science of phrenology was popular at the time, and Thielepape probably intended the misshapen skull to denote a lack of intellect.[18] Over his right shoulder, Sam carries a "Net for Gudgeons," a gudgeon being a person who is easily duped or cheated. From the handle dangle the "Mask of Washington . . . worn when assuming to be the Savior of the Country" and Sam's "Great American heart, sore." (In the caption at right Thielepape expands on this: "Sam's heart diseased, not by enlargement, but by a native love of all (office) of his"—perhaps signifying a lust for power. Also dangling from the handle of the net are "Medals for deeds of daring" awarded to the Know-Nothings for "Convent burning [in] Charleston," "Churches burnt [in] Philadelphia," "Church destroyed [in] Mass[achusetts]," "Riots [in] Cincin[nati]," "Riot [in] St. Louis," and "Riots [in] Louisville, Ky." All of these refer to actual incidents in the 1830s, 1840s, and early 1850s involving anti-Catholic and anti-foreign mob violence.[19] Also suspended from the pole are a pistol and a knife, labelled "Sam's Logic, or reasoning powers." Houston had a reputation for settling differences by the use of force; in his younger days, he had wounded a man in a duel in Tennessee, and he had once caned a Congressman in Washington, D.C.[20] Suspended from the left tip of the pole are several papers inscribed "From Brigham Young about Wives," "Marriage Certificate No. 34," and "From Ned Buntline." All of these refer to Sam's failed marriage in Tennessee, his liaison with a Cherokee woman, and his current marriage to a much younger woman.[21] (Ned Buntline was the pen name of Edward Zane Carroll Judson, a prolific writer of dime novels and later an actor and friend of Buffalo

published in the *Texas State Gazette* (Austin), Aug. 18, 1855. It also appears in McGrath, "Political Nativism in Texas," 186–193. On Houston's relations with the Know-Nothing party, see Llerena Friend, *Sam Houston, The Great Designer* (Austin: University of Texas Press, 1954), 235–236, 239–243, 245, 292–296.

18. Phrenology held that analyzing the contours of the skull could reveal a person's disposition, character, and talents. A Viennese doctor, Franz Joseph Gall (1758–1828), argued that the physical formation of the skull was directly related to such things as intellectual capacity, religious beliefs, and propensity to criminal behavior. See the *Encyclopaedia Britannica*, VII, 973.

19. Billington, *The Protestant Crusade*, 53ff.

20. Friend, *Sam Houston, The Great Designer*, 14, 31–32. The unfortunate Congressman was William Stanberry of Ohio.

21. Ibid., 19–20, 28, 59, 97. See also Jack Gregory and Renard Strickland, *Sam Houston with the Cherokees, 1829–1833* (Austin: University of Texas Press, 1967), 32–54, 82–87.

Bill Cody. Buntline was reputed to have supported half a dozen wives, several of them simultaneously. He was an organizer of the Know-Nothing party in St. Louis and had stirred up a mob against the German element in that city.)[22]

Thielepape depicts Houston in a "Transparent Politician Coat," with various political references written on the sleeve. In his left hand he holds a "lantern used by Gui Taroke in his midnight plots, and bequeathed to my father." This is some reference to the secretive aspect of the order, for the party was criticized for its "dark-lantern" methods and mysterious plots.[23] Sam wears a clerical collar fastened by a lock labelled "oath," probably a reference to the religious oaths taken by all officeholders and by members of secret orders, to which the Social Democrats and Free-Thinkers objected.[24] He wears a patch or medal on his chest evidently awarded by "England to Sam." (While president of the Republic, Houston had been criticized for courting British favor to excite American jealousy and stimulate American annexation of Texas.)[25]

A hymn book protrudes from his chest pocket and a Bible from his hip pocket, satirizing Sam's recent conversion to the Baptist Church, under the civilizing influence of his young wife.[26] His former vices are alluded to by a pocket labelled "Revolutionary Remembrances," in which may be seen a bottle of brandy and a bottle of wine, further explained by the caption "Not the Battle of Brandywine, but the bottle." (Houston had been a notorious drinker in his younger days, and was reputedly called "The Big Drunk" by his Indian friends.)[27] Also in this "Revolutionary" pocket are notes, one labelled and captioned "Lexington: not the battle, but the horse—lost $50," and another for "Concord—not in Massachusetts, but in plotting."

The broadsides under Houston's arm reading "Liberator" (he was often styled the "Liberator of Texas"), "Nigger Auction," and "Temperance Journal" probably are intended to point out Houston's hypocritical positions on important issues such as slavery and prohibition.[28] At the bottom of the print, with

22. Don Russell, *The Lives and Legends of Buffalo Bill* (Norman: University of Oklahoma Press, 1960), 149–155, cites James Monaghan, *The Great Rascal* (Boston: Little, Brown and Co., 1952), on Buntline.

23. Billington, *The Protestant Crusade*, 418, 419.

24. McGrath, "Political Nativism in Texas," 76, quoting the platform: "Religion is a purely private affair." The platform called for abolishing the religious oath. On pp. 193–195, McGrath includes oaths taken by the Know-Nothing party, taken from the *Texas Republican,* July 18, 1857, and the *Texas State Times,* June 16, 1855.

25. Friend, *Sam Houston, The Great Designer,* 124–127, 129–131, 138, 155–156.

26. Marquis James, *The Raven: A Biography of Sam Houston* (Indianapolis: Bobbs-Merrill Co., 1929), 157. See also Gregory and Strickland, *Sam Houston with the Cherokees,* 70–81, and Friend, *Sam Houston, The Great Designer,* 97–99.

27. Friend, *Sam Houston, The Great Designer,* 29, 90–91.

28. Ibid., 201–202, 284, 285–286 (on slavery); 90–91 (on temperance and prohibition).

cutting irony, Thielepape shows Sam, with one booted foot and another bare black one, treading upon the Bill of Rights, the Constitution, and the Declaration of Independence. Perhaps here Thielepape attacks not only the hypocrisy of the Know-Nothings but also the incongruous foundations upon which the slave-holding Republic was founded.

The name "Sam" had subtle connotations for the Know-Nothing party. The name was often used to denote the presence of the party or to refer to its members. In some states, the party split into groups known as the "Sams" and the "Jonathans." The "Sams" were anti-Catholic and anti-foreign, whereas the "Jonathans" were primarily anti-slavery and not anti-Catholic.[29] According to Ira M. Leonard and Robert D. Parmet, two writers on American nativism, "The identity or whereabouts of 'Sam' was never made clear, but nativists used him to arouse interest, tantalize, and confuse. In 1854, several persons thought that 'Sam' actually existed, and that he was the old Texas hero, Sam Houston."[30] Thielepape's print clearly echoed this identification and probably helped popularize it.

By adopting the medium of caricature, Thielepape probably hoped to reach voters of several ethnic backgrounds. Only a few words were really necessary to convey its general message to his contemporaries, and it is perhaps significant that Thielepape's caricature appeared only, so far as is known, with English rather than German captions. Had it been circulated only in German, perhaps it would have offended even more people than Thielepape intended.

The rise of the Know-Nothings and the accusations of disloyalty and impropriety being hurled at the entire German community as a result of Douai's activities and the *Sängerfest* political platform stirred the more conservative majority of German Texans into political action. Instead of uniting under the ideals of the radical *Sängerfest* platform as Douai and probably Thielepape hoped, however, most Germans were driven further into the Democratic camp. Led by Dr. Ferdinand Lindheimer, the botanist and editor of the *Neu Braunfelser Zeitung,* they stressed their loyalty to their adopted state and country and moved quickly to distance themselves from the abolitionist Douai and the Social Democrats. Unlike Douai, they were willing to tolerate the institution of slavery for the sake of peace with their Anglo neighbors. In the New Braunfels paper, Lindheimer mounted vicious attacks upon Douai for disturbing the peace. As a result of the support of the Germans, *Tejanos,* and other

29. Bennett, *The Party of Fear,* 138–139.

30. Leonard and Parmet, *American Nativism,* 93. See also Friend, *Sam Houston, The Great Designer,* 243.

non-Anglos, the Democrats soundly defeated the Know-Nothings in the state elections.[31]

These growing personal attacks and his own ignorance of lithography probably prompted Douai to relinquish control of this aspect of his business and concentrate his energies on his own defense. Already, what little income the lithographic press brought in went solely to Thielepape. The mechanism had broken down many times, and Thielepape had had to rebuild it completely. Douai wrote, "It was only just that we entrusted him with the entire ownership of the lithographic equipment."[32]

On August 11, 1855, Thielepape announced that he had become sole proprietor of the lithographic establishment. He also advertised that he already had in the press maps of San Antonio, for which he was accepting subscriptions of one dollar each at his office on Galan Street, across from the Catholic church.[33] The original drawing for this map, in ink on linen, is preserved in San Antonio. Thielepape based it on a survey of the city made in 1852.[34]

Only one other lithograph signed by Thielepape is known. This is a letterhead depicting San Antonio's Main Plaza.[35] An advertisement for this print ran in the San Antonio *Zeitung* beginning on December 1, 1855.[36] Thielepape's view shows the west side of the plaza, with the old Church of San Fernando in the center. Martha Utterback, in her catalog of *Early Texas Art at the Witte Museum,* identified these buildings in a similar view by painter William G. M. Samuel. From left to right are the Cassiano house; the Bustillo-Garcia property, which was a fandango house in the early 1840s; Galan Street; the cathedral; Treviño Street; and the José Erasmo Seguín residence, which by the time of Thielepape's print was an auction house.[37] At the far left is a Mexican ox-cart and in the center a stagecoach, reminders of the primitive transportation in San Antonio and the absence of railroads. At about this time, Douai published a letter from a fellow German complaining about the inconvenience of travel in America and especially in Texas: "A Trip is truly torture, especially when one must use one of those vehicles which people here call 'stagecoaches'; one

---

31. Walter Prescott Webb, H. Bailey Carroll, and Eldon Stephen Branda (eds.), *Handbook of Texas* (3 vols.; Austin: Texas State Historical Association, 1952, 1976), II, 59; Crews, "The Know-Nothing Party in Texas," 68, 86–88.

32. "Autobiography of Dr. Adolf Douai," 118. See also Albrecht, "San Antonio's Singing Mayor," 8–9.

33. San Antonio *Staats Zeitung,* Aug. 11, 1855.

34. Thanks to James Patrick McGuire for this information.

35. *Main Plaza, San Antonio, Texas* (lithographed letterhead), San Antonio Museum Association.

36. San Antonio *Staats Zeitung,* Dec. 1, Dec. 8, Dec. 15, 1855, continuing regularly through Jan. 19, 1856.

37. Utterback, *Early Texas Art in the Witte Museum,* 4.

is so knocked about, that one arrives at one's destination half dead. . . . A trip with the Texas mail is truly no insignificant matter; one should always take out life insurance and make out a will beforehand."[38]

While Thielepape must have struggled to make a profit in the lithography business, his former partner was experiencing even greater problems because of his outspoken abolitionism. Merchants withdrew their advertisements from his newspaper, local rowdies threatened him with physical violence, and his German readers displayed their disapproval by cancelling their subscriptions. The paper failed in 1856.[39] Douai left Texas for New York, where he continued to work as a journalist and educator. A prolific writer, he was active in promoting the teaching of German and in popularizing the ideas of Karl Marx in America. He also reputedly introduced the kindergarten system to America.[40]

Although Thielepape apparently gave up the lithography business shortly after the demise of Douai's newspaper, his further activities and his friends and associates are of interest to students of the history of art and lithography in the state. He quit lithography either because the equipment was too worn or because he simply found other ways to make a living and did not have time to tinker with the old press.

During the same year as his lithographic endeavors, 1855, Thielepape surveyed the townsite of Uvalde. His architectural designs included the Comal County courthouse and other buildings in New Braunfels; and the German-English School, which he helped found, possibly the Menger Hotel, and the Casino Club building, formally opened in 1858, in San Antonio.[41] Founded by San Antonio's German immigrants, the Casino Club was the city's first exclusive social organization and theater. Thielepape was an active member and at one point president of the club. He may have first worked with Hermann Lungkwitz, Texas's first important landscape painter, while painting sets and backdrops for the club's theater in 1856.

Beginning in 1859, Thielepape and Lungkwitz worked with William DeRyee (1825–1903), a Bavarian chemist and photographer who had opened a studio in San Antonio in 1858. Until 1861, they toured towns in the Texas Hill Country and along the Mississippi and Ohio Rivers, giving magic lantern shows and holding exhibitions of their photographs and paintings. DeRyee and Thielepape evidently shared an interest in lithography; as early as August,

38. San Antonio *Staats Zeitung*, Nov. 25, 1854.

39. Webb, Carroll, and Branda (eds.), *Handbook of Texas*, II, 547. See also "Autobiography of Dr. Adolf Douai," (typescript) Center for American History, University of Texas at Austin.

40. Ward, *A Bio-Bibliography of German-American Writers*, 66; "Autobiography of Dr. Adolf Douai."

41. Albrecht, "San Antonio's Singing Mayor," 9, 10–11; Webb, Carroll, and Branda (eds.), *Handbook of Texas*, II, 826–827, III, 1055.

1858, DeRyee was experimenting with a process for reproducing photographs which he called "homeography"—actually a lithographic method.[42]

Another friend of Thielepape's, and a fellow associate of DeRyee, was Carl Gustav von Iwonski, an immigrant from Silesia, which then belonged to Prussia. Iwonski worked as an artist in the New Braunfels/San Antonio area and assisted DeRyee in his homeography experiments.[43] In 1857, he and Thielepape collaborated with Lungkwitz and others on the production of two comedies for the Casino Club.[44]

A lithograph of the founders of the *Germania Gesängverein* in New Braunfels, taken from a drawing by Iwonski, does not credit the lithographer, but judging by the superior execution of the print, it is unlikely that Thielepape did it.[45] Thielepape and Douai were leaders of similar men's choruses in San Antonio, and Thielepape was the founder and director of the *Beethoven Gesängverein*, later styled the *Beethoven Männerchor*, of San Antonio from 1865 to 1874. For some time the group rehearsed in Thielepape's home.[46]

When not engaged as surveyor, architect, engineer, theatrical scene painter, photographer, singer, or choral director, Thielepape worked as bookkeeper and artist for several San Antonio merchants. One of these was the brother-in-law of the Bavarian immigrant, merchant, and amateur artist Erhardt Pentenrieder, who used Thielepape's San Antonio letterhead idea but elaborated upon it considerably. Pentenrieder published at least three different versions of his own fancy San Antonio lettersheets, two of them dating from around 1856 and 1859 respectively. After Thielepape gave up lithography, Pentenrieder apparently had to send his sketches to a New York lithographer.[47]

42. James Patrick McGuire, *Hermann Lungkwitz, Romantic Landscapist on the Texas Frontier* (Austin: University of Texas Press, for the University of Texas Institute of Texan Cultures, 1983), 18, 19, 20–21; James Patrick McGuire, *Iwonski in Texas: Painter and Citizen* (San Antonio: San Antonio Museum Association and the University of Texas Institute of Texan Cultures, 1976), 18–20, 87; Utterback, *Early Texas Art in the Witte Museum*, 32; Webb, Carroll, and Branda (eds.), *Handbook of Texas*, I, 306. See also McGuire's essay on homeography in this collection.

43. See McGuire's essay for Iwonski's association with homeography.

44. McGuire, *Hermann Lungkwitz*, 30; McGuire, *Iwonski in Texas*, 29.

45. McGuire, *Iwonski in Texas*, 71, 74.

46. Douai had served briefly as director of the *Germania Gesängverein* in New Braunfels and was probably director of the San Antonio *Männergesang-Verein* when he first met Thielepape at a rehearsal in spring, 1852. With Thielepape as co-conductor and later principal conductor, the San Antonio group dwindled to a quartet by April 1855, mostly as a result of Douai's outspoken opposition to slavery. The Civil War put an end to the quartet, but Thielepape revived the idea of a men's chorus in 1865. Albrecht, "San Antonio's Singing Mayor," 4–5, 6–7, 14–15, 16–21; Biesele, *The German Settlements in Texas*, 222–223. See also Theodore Albrecht, "German Singing Societies in Texas" (Ph.D. diss., North Texas State University, 1975).

47. Utterback, *Early Texas Art in the Witte Museum*, 32, 44; Pauline A. Pinckney, *Painting in Texas: The Nineteenth Century* (Austin: University of Texas Press, 1967), 151; San Antonio *Express*,

Besides Thielepape, DeRyee, and perhaps J. Lowe of New Orleans, only one other lithographer is known to have worked in Texas prior to the Civil War. In 1855, the same year in which Thielepape produced his prints, a French lithographer named Joseph Paul Henri (Paul Henry) settled in northern Texas with a group of French, Belgian, and Swiss Fourier Socialists. This was Victor Prosper Considerant's utopian community at La Réunion, near the tiny settlement called Dallas.[48]

Before coming to America, Henry lived in Châtellerault, France. The son of a teacher, he worked as an engraver on metal and ivory and, according to one source, "In the line of ivory work his inventions of advanced processes and ingenious mechanisms won him a patent from the French government."[49] His preference for representative government reportedly led to his decision to immigrate to the U.S.[50] In early 1855, Henry, his wife, two sons, and daughter sailed from Le Havre to Boston. Another daughter was born on the voyage, and they named her Asia, after the ship they sailed on. From Boston they proceeded to New York, where Henry reportedly found employment as a lithographer with Endicott and Company, one of the leading lithographic firms in the country.[51] After a few months, the family joined Considerant's colonists headed for Texas. Henry's son, René Paul, who was five years old at the time, later recalled that one of the first locomotives for the Houston and Texas Central Railroad was on board their ship, but that once they reached Houston, they transferred to ox-drawn wagons for the journey to Dallas County. Apparently, their baggage included a complete lithographic press and several stones.[52]

The colonists at La Réunion did not follow Considerant's elaborate plans and had a rough time of it. Evidently a number of them had not realized how far in the wilderness their new homes would be located. The soil around the settlement on the Trinity was thin and rocky, and very few of the colonists knew anything about farming. In addition, poor financial management and

---

Nov. 10, Nov. 11, 1875. A photograph of Pentenrieder by Gustafson of San Antonio is in the Sophienburg Museum Association Archives, New Braunfels.

48. Philip Lindsley, *A History of Greater Dallas and Vicinity* (2 vols.; Chicago: Lewis Publishing Co., 1909), I, 485–497.

49. Ibid., II, 369. See also George H. Santerre, *White Cliffs of Dallas: The Story of La Reunion, The Old French Colony* (Dallas: Book Craft, 1955), 120; *Memorial and Biographical History of Dallas County, Texas* (Chicago: Lewis Publishing Co., 1892), 598.

50. *Memorial and Biographical History of Dallas County*, 598.

51. Lindsley, *History of Greater Dallas and Vicinity*, II, 369. The *Memorial and Biographical History of Dallas County*, p. 598, says that Henry "secured employment with the well-known artist, Brishan."

52. Lindsley, *History of Greater Dallas and Vicinity*, I, 495–496. Lindsley interviewed René Paul Henry in Lancaster shortly before 1909.

inadequate housing arrangements encouraged individualism and dissension. Although the people of Dallas County generally welcomed the new colonists, Know-Nothing newspapers such as the *Texas State Times* and the Austin *State Gazette* opposed the establishment of a new colony of foreigners, especially foreigners with socialist and abolitionist ideas. The colony broke up by 1858.[53]

Obviously, Henry had to put his lithographic equipment aside and concentrate on providing food and shelter for his family. His son remembered the terrible "blue northers" and recalled that his father's first house was made of three-foot-long oak boards, nailed crosswise.[54] Henry's wife died around this time. In 1857, he bought a small tract of farm land on Cones Creek, but in the 1860 census of Dallas County he listed his occupation as "lithographer."[55]

Henry and Thielepape probably never met, or even heard of each other, but they could have conversed about lithography, their European origins, their associations with socialism, and their undoubted aversion to the Know-Nothings. Henry's first work in Texas, like Thielepape's, seems to have been a political caricature.

In 1860, Henry lithographed a cartoon drawn by a multilingual Dallas–Fort Worth pioneer named John Jeremiah (James) "Coho" Smith.[56] The caricature was titled "The Union as it is." Although no impression or copy of this print has been located, it is known today through a description in the Dallas *Herald* on November 21, 1860:

> In a large rail pen are a flock of sheep, each representing a State. Texas has already jumped over the fence, and South Carolina following suit, and the whole of the others representing the Southern States, are anxious to follow. In the distance is seen Abe

53. Rondel V. Davidson, "Victor Considerant and the Failure of La Réunion," *SHQ*, LXXVI (Jan., 1973), 277–296; Webb, Carroll, and Branda (eds.), *Handbook of Texas*, II, 29. For attitudes of Texans toward the colony see William J. Hammond and Margaret F. Hammond, *La Réunion, a French Settlement in Texas* (Dallas: Royal Publishing Co., 1958), 63–84; Crews, "The Know-Nothing Party in Texas," 54–65; McGrath, "Political Nativism in Texas," 76–77.

54. Lindsley, *History of Greater Dallas and Vicinity*, I, 495–496.

55. The United States Eighth Census (1860), Dallas County, Texas, Population Schedules, p. 109, lists the following residents of dwelling no. 737:

Henry, Paul, male, age 42, born in France, lithographer
      Mary, female, age 18,        "       "
      Paul, male, age 15,         "       "
      Rene, male, age 9         "      "
      Asia, female, age 5, born at sea

I am grateful to Dr. Malcolm MacLean of the University of Texas at Arlington for bringing this reference to my attention.

56. See Coho Smith, *Cohographs*, ed. Iva Roe Logan (Fort Worth: Branch-Smith, Inc., 1976).

Lincoln, with his maul and wedges, exclaiming "Just as I expected." Another figure represents H. Ward Beecher, who with Edward Everett, is making tracks for a ship about to sail for England. In the foreground is a representation of Plymouth Rock, behind which crowds the British Lion, and Louis Napoleon is seen concealed behind a bank of earth, taking deliberate aim at the Lion with a rifle. The lithograph was executed by Paul Henry of Reunion, in this county, and is very well executed. The design was furnished by Mr. Coho Smith, forming one of a series of unique designs called Cohographs. Copies can be obtained at Mr. Baird's store.[57]

Because of his skill as an engraver, Henry was assigned during the Civil War to Tucker, Sherrod and Company pistol factory in Lancaster, about fifteen miles south of Dallas. The family moved to that town in August, 1863, and Henry worked there until he was reportedly conscripted into the ranks of the Confederate army.[58] From what is known of his later political affiliations, it is doubtful that he served the Confederacy with much enthusiasm. The later war years were also important for Henry on a personal level. His older daughter Marie married Julien Reverchon, a prominent original member of the La Réunion colony and pioneer Texas botanist, on July 25, 1864. Henry himself married Margaret Fletcher, a native of Scotland, on September 18, 1864.[59]

He undoubtedly suspended his lithographic activities during the war, when the Union blockade made it difficult to obtain supplies in Texas. After the war, he resumed his occasional lithographic work, but getting supplies must have remained a problem, in part because Dallas did not get a railroad until 1872.[60] In 1869, Henry once again teamed up with his friend Coho Smith, as reported in the October 16 Dallas *Herald*:

57. Dallas *Herald*, Nov. 21, 1860.

58. Lindsley, *History of Greater Dallas and Vicinity*, II, 369. See Webb, Carroll, and Branda (eds.), *Handbook of Texas*, I, 748.

59. The United States Ninth Census (1870), Dallas County, Texas, Population Schedules, p. 64, lists the following residents of dwelling no. 395:

Henry, Paul, Sr., male, age 53, born France, merchant
    Margaret, female, age 50, born Scotland, keeps house
    Paul, Jr., male, age 24, born France, Postmaster
    René,   age 20,   "           ", clerk
    Asia, age 15, born at sea

In "Henry, Joseph Paul," DeGolyer card file, Genealogy Department, Dallas Public Library. Marriage dates were written on the cards for Henry and his family, but no source is given.

60. For information on early railroad development in Texas see St. Clair Griffin Reed, *A History of the Texas Railroads, and of Transportation Conditions under Spain and Mexico and the Republic and the State* (Houston: St. Clair Publishing Co., 1941).

Coho Smith, well known to our citizens, in former days, is in our city, and will sketch the Races held yesterday and the day before, and also the Fair Grounds during the coming week. He has made arrangements with Paul Henry, of Lancaster, to lithograph both drawings. We don't know what he will sell the pictures at, but every body ought to have one.[61]

Unlike Henry, Thielepape and a number of other Germans managed to avoid conscription, but their Union sympathies put them in great danger. Texans who were loyal to the Union suffered considerably during the war, the most famous incident being the Battle of the Nueces in 1862, when about sixty young German Unionists were killed while trying to flee to Mexico.[62] According to Thielepape's descendants, he had to flee San Antonio by night, in a buggy, disguised as a woman, and assisted by Samuel Maverick and Dr. Ferdinand Herff, two of the city's most prominent citizens. Theodore Albrecht offers the convincing speculation that Thielepape fled to Eagle Pass and then into Mexico.[63]

After the Civil War, the American government found the Texas Germans useful. Since many of them had objected to secession and had not served in the Confederate army or government, they were often among the few Texans able to take the "ironclad oath" and, thus, among the only male citizens eligible to hold offices in the Reconstruction government. The San Antonio Germans suddenly emerged as powerful members of the community. Their predominance in the city's government earned them the derogatory title of "Casino Aristocrats," since so many of them belonged to the exclusive social club. Thielepape was appointed mayor of San Antonio by Col. J. J. Reynolds, the military commander of the district, on November 8, 1867. Carl von Iwonski served as tax collector and Erhardt Pentenrieder as a city alderman.[64] Thielepape's administration built new bridges, strengthened the public schools, negotiated with the military to keep the army depot in San Antonio, and made great efforts to secure for the city a railroad and a tract of land containing the source of the San Antonio River. Controversy over this last issue, however, led Gov. E. J. Davis to remove Thielepape from office on March 12, 1872. With Reconstruction at an end and the return of the Democrats to power in Texas, Thielepape and his family left for Chicago in April, 1874. He did not return to Texas during the remaining thirty years of his life.[65]

61. Dallas *Weekly Herald*, Oct. 16, 1869.

62. Webb, Carroll, and Branda (eds.), *Handbook of Texas*, II, 290, III, 255, 854.

63. Albrecht, "San Antonio's Singing Mayor," 11–12.

64. McGuire, *Iwonski in Texas*, 23, 28, 89; McGuire, *Hermann Lungkwitz*, 29–30, 32; Keeth, "Sankt Antonius," 191.

65. Thielepape's mayoral administration was at least partially vindicated in the 1890s, when the city finally purchased the same tract of land containing the headwaters of the San Antonio

The state's pictorial heritage is greatly indebted to the early German immigrants. Herman Lungkwitz, who had studied painting and drawing at the Dresden Academy, sent several of his sketches and paintings of Texas back to Germany to be lithographed. His lithographs of Fredericksburg, published in 1859, and San Antonio are among the finest of all lithographs of Texas. Lungkwitz apparently adopted Thielepape's letterhead view of the Main Plaza as one of the vignettes in his lithograph of San Antonio. Dr. Rudolph Menger, who was a young boy when Lungkwitz painted the scene, recalled in 1902 that the adobe house to the right of the oxcart in the central view belonged to Mayor Thielepape, who is the figure standing in the doorway.[66]

Like Thielepape, Henry apparently could not earn a living solely with lithography, but he too was a resourceful fellow. He and his sons operated a dry goods and general merchandise store and saloon in Lancaster for a number of years. Henry also had a branch store in nearby Hutchins, advertising regularly in Dallas's Republican newspaper, *Norton's Union Intelligencer,* as "Paul Henry, Wholesale and Retail Dealer in Groceries and Forwarding and Commission Merchant."[67] The remaining records often fail to differentiate between Paul Henry Sr. and Paul Henry Jr., and it is therefore difficult to distinguish the activities of the father and son. Some sources record Paul Henry Sr. as postmaster of Lancaster, others Paul Henry Jr.; perhaps both served in this capacity.[68] In 1872, one or the other was tried and acquitted in Lancaster for "fighting in a public place."[69] In the July 31, 1875, issue of the Dallas *Weekly Herald,* the editor announced that Paul Henry of Lancaster had presented him with several specimens of clay, which he had moulded into balls and fired in order to demonstrate its suitability for "the most beautiful pottery and fire brick." The editor noted that Henry "says it can be found in any quantity; and if so, it can be made a profitable thing."[70] Ten years later, ever optimistic about potential profit, Paul Sr. returned (if it was in fact he who had brought the clay) to the *Herald* office, this time with specimens of corn, which had a "stalk, shuck and

River, but for a much inflated price. Albrecht, "San Antonio's Singing Mayor," 16–19; Utterback, *Early Texas Art in the Witte Museum,* 32–33; *Freie Presse für Texas* (San Antonio), Apr. 14, 1874.

66. On Lungkwitz see McGuire, *Hermann Lungkwitz,* esp. p. 187, quoting Menger in the San Antonio *Daily Express,* Dec. 21, 22, 1902.

67. *Norton's Union Intelligencer* (Dallas), Sept. 2, 1871, Nov. 23, 1872.

68. Sources listing Paul Henry Jr. as postmaster of Lancaster are *Norton's Union Intelligencer* (Dallas), Sept. 2, 1871, and the United States Ninth Census (1870) (see note 59 above). Paul Henry Sr. is listed as postmaster in John H. Cochran, *Dallas County: A Record of Its Pioneers and Progress* (Dallas: Arthur S. Mathis Service Publishing Co., 1928), 155.

69. *Norton's Union Intelligencer* (Dallas), Jan. 27, 1872.

70. Dallas *Weekly Herald,* July 31, 1875.

grain of a dark red color."[71] Paul Sr. bought land in his later years.[72] The *Weekly Herald* announced on September 3, 1885, that "Mr. Paul Henry, the Republican postmaster at Lancaster, has been suspended for offensive partisanship, and his successor is Captain P. N. Taylor, a staunch Democrat and most excellent gentleman. . . ."[73] Paul Henry Sr. died in Lancaster at the age of seventy-four on December 18, 1890.[74]

Except for the isolated examples of the Germans in San Antonio and Paul Henry in Dallas County, lithography apparently did not gain a permanent foothold in Texas until the 1870s, when M. Strickland and Company, a Galveston bookbinding and stationery firm, added a lithography department. Miles Strickland, born in 1836 in Ontario, Canada, had begun work in the bookbinding, stationery, and printing business of his uncle in Mobile, Alabama, at the age of thirteen. After an 1857 tour of the Midwest and a brief residence in New Orleans, Strickland established his own business on the eastern end of Tremont Street in Galveston in 1858. With various partners, Strickland's business prospered. During the Civil War the firm moved to Houston, but it returned to Galveston in 1866.[75] In 1873, an experienced printer, Robert Clarke (born in Louisiana around 1838), bought a share of the business, which became known as Strickland and Clarke or M. Strickland and Co.[76] Apparently the

71. Ibid., Oct. 22, 1885.

72. Ibid., Sept. 20, Nov. 22, 1883.

73. Ibid., Sept. 3, 1885.

74. *Memorial and Biographical History of Dallas County,* 599.

75. Charles Waldo Hayes, *History of the Island and the City of Galveston* (1879; reprint, 2 vols.; Austin: Jenkins Garrett Press, 1974), II, 980. My account of the history of the Strickland firm(s) is also based in part on a survey of the following city directories: W. Richardson and Co. (comps.), *Galveston Directory for 1866–67* (Galveston: printed at the "News" Book and Job Office, 1866), 23; C. W. Marston (comp.), *Galveston City Directory, 1868–1869* (Galveston: Shaw and Blaylock, 1868), 65; John H. Heller (comp.), *Galveston City Directory, 1872* (Galveston: printed at the "News" Steam Job Printing Office, 1872), 125; Morrison and Fourmy (comps.), *Morrison & Fourmy's General Directory of the City of Galveston, 1882–1883* (Galveston: Morrison and Fourmy, 1882), 386, 431; *Morrison & Fourmy's General Directory of the City of Galveston, 1891–92* (Galveston: Morrison and Fourmy, 1891), 417; *Morrison & Fourmy's General Directory of the City of Galveston, 1892–1893* (Galveston: Morrison and Fourmy, 1892), 64, 428; *Morrison & Fourmy's General Directory of the City of Galveston, 1895–1896* (Galveston: Morrison and Fourmy, 1895), 274, adv. insert betw. pp. 274 and 275; *Morrison & Fourmy's General Directory of the City of Galveston, 1898* (Galveston: Morrison and Fourmy, 1898), 209; *Morrison & Fourmy's General Directory of the City of Galveston, 1899–1900* (Galveston: Morrison and Fourmy, 1899), 218.

76. "The Story of Clarke & Courts," undated newspaper advertisement from company files furnished by M. D. Hinkley, manager of Clarke & Courts Gift Shop, Galveston, in Amon Carter Museum files, Fort Worth. United States Tenth Census (1880), Galveston County, Texas, Population Schedules, City of Galveston (microfilm; National Archives), lists Robert Clarke, age forty-two, a native of Louisiana, printer, with a wife, three children, and three servants.

partners added lithography to their expanding business at this time, since several Mardi Gras souvenirs in the Rosenberg Library, dating from as far back as 1873, bear lithographed illustrations, some of which are inscribed "M. Strickland & Co."[77] In 1879, Galveston historian C. W. Hayes wrote of Strickland:

Not satisfied simply with the stationery and bindery business he added printing, and soon after lithographing to his other departments. Being a man of artistic taste, rare judgement, he determined to secure workmen of unquestioned skill in each department, and from the start do work equal to the best lithographic establishments in the country. No new feature or innovation has escaped his notice, while he has originated many new and attractive designs in the lithographic art. In the scope of his enterprise Mr. Strickland encountered many obstacles. The public were slow in appreciating the fact that work, they heretofore had been having done in New York, could be executed here as well, and with as much artistic skill and finish as it could be done in the cities of the North. In the spring of 1877 he purchased a large Hoe lithographing press, run by steam, and put it up in his lithographing department, the only one in the Gulf States.[78]

Certainly this was the first steam-powered lithographic press in Texas. According to another source, a crew of lithographers was brought in from New York to operate it and train other crews.[79]

By 1879, two of Strickland's six sons, John C. and William E. Strickland, were working in the business. John, the eldest, worked in the lithographing department as a "crayon artist" and was listed in later city directories as an "engraver" and "chief litho-engraver."[80] Hayes described him in 1879 as "displaying fine artistic ability" and stated that he was currently engaged in the

77. Ron Tyler to Ben Huseman, May 19, 1989.

78. Hayes, *History of the Island and City of Galveston*, II, 980–981.

79. "The Story of Clarke & Courts."

80. United States Tenth Census (1880), Galveston County, Texas, Population Schedules, City of Galveston, lists M. Strickland, age forty-two, with wife Susi and six sons: John, age nineteen, born in Texas, employed as a "crayon artist"; Willy, age seventeen; Charles, age thirteen; Samey, age eleven; Robert, age six; and Nichols, age three. See also *Morrison & Fourmy's General Directory of the City of Galveston, 1882–1883*, 386; *Morrison & Fourmy's General Directory of the City of Galveston, 1886–1887* (Galveston: Morrison and Fourmy, 1886), 364; *Morrison & Fourmy's General Directory of the City of Galveston, 1888–1889* (Galveston: Morrison and Fourmy, 1888), 369; Morrison and Fourmy (comps.), *Morrison & Fourmy's General Directory of the City of Galveston, 1890–1891* (Galveston: Morrison and Fourmy, 1890), 404; *Morrison & Fourmy's General Directory of the City of Galveston, 1892–1893*, 23; *Morrison & Fourmy's General Directory of the City of Galveston, 1895–1896*, 274, adv. betw. pp. 274 and 275; *Morrison & Fourmy's General Directory of the City of Galveston, 1898*, 209.

W. H. Coyle advertisement, from *The Industries of Houston*. (Houston: J. M. Elstner and Co., 1887). *Courtesy Houston Public Library.*

lithographic department. Another brother, probably William, was in the print-ing department, and according to Hayes, "Both are bright, active boys, full of ideas of their own, and not afraid to work. . . . The enthusiasm of the father in his business, reflected by his sons, making a harmonious blending of interests, at once beautiful as it is rare."[81]

Upon Miles Strickland's death, around 1881, his widow Sarah and sons succeeded him in the business, with Richard E. Koehler briefly serving as manager. By 1885, in addition to the Hoe power press, the Stricklands report-edly had one cylinder-power press and several smaller presses, two ruling ma-chines, and a complete bindery, with a nine-horsepower engine providing the power. The business had forty to fifty employees.[82] Late that same year, soon after the great fire in Galveston on November 13, M. Strickland and Co. pirat-ed itinerant artist Augustus Koch's recent bird's-eye lithograph of the city. In the Strickland version, the burned district was marked with red ink and no credit to Koch was indicated.[83]

The exact relationship between the Stricklands and the Galveston firm of Clarke and Courts is difficult to determine, but the latter firm, which is still in business today as a stationery and office supply dealer, traces its history back to Miles Strickland. George M. Courts, a native Texan and resident of Galves-ton already in the printing and stationery business with Robinson and Co., went into business with Robert Clarke in 1879.[84] For the next two decades, var-ious Strickland-owned companies and Clarke and Courts existed side by side. At some point, according to Clarke and Courts advertisements, they evidently acquired Strickland's steam press, and subsequently added two other stone presses; these three presses continued in operation until 1909.[85]

Clarke and Courts concentrated chiefly upon commercial job printing, turn-ing out certificates, business cards, invitations, stationery, etc., and they also manufactured blank books. They printed Texas city directories in the 1880s and 1890s for Morrison and Fourmy of Galveston, and the directories often includ-ed elaborate advertisement inserts printed in the Clarke and Courts shop. In 1890, they erected a five-story stone structure at Mechanic and Twenty-fourth

81. Hayes, *History of the Island and City of Galveston*, II, 981.

82. *Galveston: The Commercial Metropolis and Principal Seaport of the Great Southwest . . .* (Gal-veston: Land and Thompson, 1885), 130–131.

83. *Bird's Eye View of the Eastern Portion of the City of Galveston, with the Homes Destroyed by the Great Conflagration of November 13th, 1885,* (toned lithograph), Center for American History, Uni-versity of Texas at Austin.

84. "The Story of Clarke & Courts"; obituary of George M. Courts, typed "Galveston Tribune, January 30, 1917, p. 9," in biographical files, Rosenberg Library, Galveston.

85. "The Story of Clarke & Courts."

streets, which survived the 1900 hurricane and which the company still occupies, along with other branch locations around the state.[86]

The Stricklands and Clarke and Courts were the first of a number of successful commercial lithography firms in the state. The Texas businesses were smaller but similar to such large family-owned firms as the Ketterlinus Printing Co. in Philadelphia. It is significant that such businesses in Texas succeeded first in Galveston, which in the nineteenth century was the state's largest city and principal port. But other Texas cities were growing rapidly from the 1870s through the 1890s, and soon they could boast of their own commercial lithography establishments. In Galveston's rival Houston were

86. *Morrison & Fourmy's General Directory of the City of Austin, 1887–88* (Galveston: Morrison and Fourmy, 1887), adv. pp. 8, 9; *Morrison & Fourmy's General Directory of the City of Austin, 1889–90* (Galveston: Morrison and Fourmy, 1889), adv. opp. p. 9; *Morrison & Fourmy's General Directory of the City of Austin, 1891–92* (Galveston: Morrison and Fourmy, 1890), 8; *Morrison & Fourmy's General Directory of the City of Austin, 1893–94* (Galveston: Morrison and Fourmy, 1893), 330; *Morrison & Fourmy's General Directory of the City of Austin, 1895–96* (Galveston: Morrison and Fourmy, 1895), 8; *Morrison & Fourmy's General Directory of the City of Denison, 1887–88* (Galveston: Morrison and Fourmy, 1887), adv. opp. p. 9; *Morrison & Fourmy's General Directory of the City of Fort Worth, 1888–89* (Galveston: Morrison and Fourmy, 1888), adv. p. vii; *Morrison & Fourmy's General Directory of the City of Fort Worth, 1896–97* (Galveston: Morrison and Fourmy, 1896), adv. p. v; *Morrison & Fourmy's General Directory of the City of Gainesville, 1887–88* (Galveston: Morrison and Fourmy, 1887), adv. opp. p. 8; C. W. Marston (comp.), *Galveston City Directory, 1868–1869,* 26; *Galveston City Directory, 1872,* 44, 46, 110; Morrison and Fourmy (comps.), *Morrison & Fourmy's General Directory of the City of Galveston, 1882–1883,* 163, 171; *Morrison & Fourmy's General Directory of the City of Galveston, 1886–1887,* adv. betw. pp. 12 and 13, 123; *Morrison & Fourmy's General Directory of the City of Galveston, 1888–1889,* adv. betw. pp. iv and 13, 67, 130; Morrison and Fourmy (comps.), *Morrison & Fourmy's General Directory of the City of Galveston, 1890–1891,* adv. opp. p. 13, 140; *Morrison & Fourmy's General Directory of the City of Galveston, 1891–92,* adv. betw. pp. 12 and 13, 148, 156; *Morrison & Fourmy's General Directory of the City of Galveston, 1893–94* (Galveston: Morrison and Fourmy, 1893), 144, 153; *Morrison & Fourmy's General Directory of the City of Galveston, 1895–96,* 12, 114, 115, adv. betw. pp. 114 and 115; *Morrison & Fourmy's General Directory of the City of Galveston, 1898,* 45; *Morrison & Fourmy's General Directory of the City of Galveston, 1899–1900,* 47, 52; *Morrison & Fourmy's General Directory of the City of Houston, 1882–83* (Galveston: Morrison and Fourmy, 1883), 7; *Morrison & Fourmy's General Directory of the City of Houston, 1889–90* (Galveston: Morrison and Fourmy, 1889), adv. opp. p. xii; *Morrison & Fourmy's General Directory of the City of San Antonio, 1889–90* (Galveston: Morrison and Fourmy, 1888), adv. betw. pp. 14 and 15; Receipt of invoice in George Fuermann Collection, University of Houston Library.

Clarence Ousley, *Galveston in Nineteen Hundred* (Atlanta: William C. Chase Co., 1900), 234, lists the 1900 storm damage to Clarke and Courts as "Losses on stick [*sic*], first floor, only fifteen hundred dollars. Had losses to stock on fifth floor, owing to bursting of fire-extinguisher pipes, against which company has ample insurance. Working as usual. Started every wheel on Friday following storm. Company has large business in Louisiana, Mississippi, Arkansas, Texas, New Mexico, Arizona, and Indian Territory."

William H. Coyle, who first advertised as a lithographer in the late 1870s,[87] and the J. J. Pastoriza Printing and Lithographing Co., established in 1879 by Joseph J. Pastoriza and incorporated in 1890.[88] In San Antonio, which received its first railroad in 1877, the Maverick Printing House advertised lithographic work beginning in the 1880s, and was succeeded around 1897 by the Maver-ick-Clarke Lithographing Co., another venture of Robert Clarke of Clarke and Courts.[89] The Dallas Lithograph Co. was founded in 1884, incorporated in 1885, and advertised in the Dallas city directories as early as 1886 as lithographers and publishers with "Improved Mammoth American Steam Lithographic

87. William H. Coyle, a native of Louisville, Kentucky, arrived in Houston around 1868, serving first as foreman and later as superintendent of A. C. Gray's printing establishment. In 1877, he resigned and began his own small business as a steam book and job printer. Over the next few years, his business expanded rapidly. He specialized in railroad work, book and commercial printing, bills and checks with fancy escutcheons, cartouches, and other decorations. *Morrison & Fourmy's General Directory of the City of Houston, 1882–83* (Galveston: Morrison and Fourmy, 1882), 121, opp. xx; *Morrison & Fourmy's General Directory of the City of Houston, 1887–88* (Galveston: Morrison and Fourmy, 1887), 116, adv. pg. 28; *Morrison & Fourmy's General Directory of the City of Houston, 1889–90,* 128; *Morrison & Fourmy's General Directory of the City of Houston, 1900–1901* (Galveston: Morrison and Fourmy, 1900), 77; *Morrison & Fourmy's General Directory of the City of Houston, 1907* (Houston: Morrison and Fourmy, 1907), 119; Texas Publishing Co. (comp.), *Directory of the City of Houston, 1911–1912* (Houston: Texas Publishing Co., 1911), 418; R. L. Polk and Co. (comp.), *Houston City Directory, 1927* (Houston: R. L. Polk and Co., 1927), 689; *The Industries of Houston* (Houston: J. M. Elstner and Co., 1887); United States Tenth Census (1880), Harris County, Population Schedules (microfilm; National Archives). Examples of work by Coyle's establishment may be found in the George Fuermann Collection, University of Houston Library.

88. Receipt or invoice, Sept. 19, 1895 (George Fuermann Collection); *Morrison & Fourmy's General Directory of the City of Houston, 1882–83,* 233; *Morrison & Fourmy's General Directory of the City of Houston, 1887–88,* 248; *Morrison & Fourmy's General Directory of the City of Houston, 1889–90,* 283; *Morrison & Fourmy's General Directory of the City of Houston, 1900–1901,* 253, 410.

89. Rena Maverick Green, *Samuel Maverick, Texan: 1803–1870* (San Antonio: n.p., 1952), 58, 361, 363; S. C. Edward Heusinger, *Chronology of Events in San Antonio* (San Antonio: Standard Printing Co., 1951), 54; *Morrison & Fourmy's General Directory of the City of San Antonio, 1887–88* (Galveston: Morrison and Fourmy, 1886), 229; *Morrison & Fourmy's General Directory of the City of San Antonio, 1889–90* (Galveston: Morrison and Fourmy, 1888), 258; *Johnson & Chapman's General Directory of the City of San Antonio for the Year 1891 . . .* (San Antonio: Johnson and Chapman, 1891?), 275, adv. p. 35 (in back); J. A. Appler (comp.), *Jules A. Appler's General Directory of the City of San Antonio, 1895–96* (San Antonio: J. A. Appler, 1895), 415, suppl. p. 9; *Jules A. Appler's General Directory of the City of San Antonio, 1899–1900* (San Antonio: J. A. Appler, 1899), 388; San Antonio *Express,* Feb. [?], 1936; James P. McGuire to Bill Holman, Sept. 26, 1986, summarized the vertical file on Business at the San Antonio Public Library and the research of Marie Berry at the San Antonio Public Library and Bernice Strong at the Daughters of the Republic of Texas Library at the Alamo, San Antonio.

Presses and Machinery."[90] According to Paul Henry's son, the latter firm obtained his father's old lithographic press and stones, which he had brought with him from France.[91] Fort Worth, which did not receive its first railroad until 1876, was not to be outdone by Dallas, although the railroad reached the latter city in 1872. Fort Worth businessmen formed the Texas Printing and Lithographing Co., which was incorporated in June, 1888 .[92]

The relatively late development of Texas prevented its full participation in what has been called "the Romantic Age of Lithography" in the years before the Civil War. Unsurprisingly, Texas lagged behind the East Coast in the practice of pictorial lithography and in the development of commercial lithographic firms. Texas was still a sparsely populated Spanish frontier colony in 1818 or 1819, when Philadelphia artist Bass Otis produced what is thought to be the first lithograph executed in the United States.[93] The 1830s and 1840s saw the development of major lithographic firms in New York, Philadelphia, Boston, Baltimore, and other eastern cities, while the short-lived Republic of Texas (1836–1845) was fighting for its very survival and for international recognition. Generally, throughout the nineteenth century, the few hardy artists working in frontier Texas sent their sketches back east or to Europe to be lithographed. Until the 1870s, inadequate transportation facilities, particularly the lack of railroads, made obtaining lithographic equipment and essential supplies, like the special heavy Bavarian stones, very difficult. The population of Texas was

90. *Morrison & Fourmy's General Directory of the City of Dallas, 1886–87* (Galveston: Morrison and Fourmy, 1886), 11, 12, 86; *Morrison & Fourmy's General Directory of the City of Dallas, 1891–92* (Galveston: Morrison and Fourmy, 1891), 72, 130, adv. betw. pp. 196 and 197, 197; *The Evans & Worley Directory of the City of Dallas, 1897* (Dallas: Evans and Worley, 1897), 178, back cover; *Worley's Directory of the City of Dallas, 1898* (Dallas: John F. Worley and Co., 1898), 44, 158; *John F. Worley & Co.'s Dallas Directory for 1900* (Dallas: John F. Worley, 1900), 164; *John F. Worley and Co.'s Dallas Directory for 1901* (Dallas: John F. Worley, 1900), 197. The Dallas Historical Society owns a watercolor *Sketch of the Proposed Fair Grounds* designed by Sidney Smith and executed by "Joe Booker" for the Dallas Lithograph Co.

91. Lindsley, *History of Dallas and Vicinity,* I, 496.

92. *General Directory of the City of Fort Worth, 1886–87* (Fort Worth: Fort Worth Printing House, 1886), 75, 79, 83, 269; *Morrison & Fourmy's General Directory of the City of Fort Worth, 1888–89,* 122, 181; *D. S. Clark's City Directory of the City of Fort Worth, Texas, 1890* (Fort Worth: Texas Printing and Lithographing Co., 1890), 249, 291, adv. after title page and side lines throughout; *Morrison & Fourmy's General Directory of the City of Fort Worth, 1892–93* (Galveston: Morrison and Fourmy, 1891), 67–68, 302; *Morrison & Fourmy's General Directory of the City of Fort Worth, 1896–97,* 44, 331; Morrison and Fourmy (comps.), *Morrison & Fourmy's General Directory of the City of Fort Worth, 1899–1900* (Galveston: Morrison and Fourmy, 1899), 43, 213; *Morrison & Fourmy's Fort Worth City Directory, 1918* (Galveston: Morrison and Fourmy, 1917), 93.

93. Groce and Wallace, *The New-York Historical Society's Dictionary of Artists in America,* 480; Harry T. Peters, *America on Stone* (Garden City, N.Y.: Doubleday, Doran and Co., 1931), 303–304.

small, spread over a wide geographic area, and more practical items held priority over artistic luxuries. The Civil War further exacerbated the factors hindering lithography in Texas. Not until the last quarter of the century did the state develop successful commercial firms, when better transportation and larger population centers could support them.

A few foreign-born immigrants made some tentative efforts before the war. Generally better educated than the average pioneer and often holding unpopular political opinions, the early Texas lithographers had to supplement their work with other employment. Like their fellow pioneers, Texas's few lithographers often demonstrated the versatility and determination necessary for survival on the frontier.

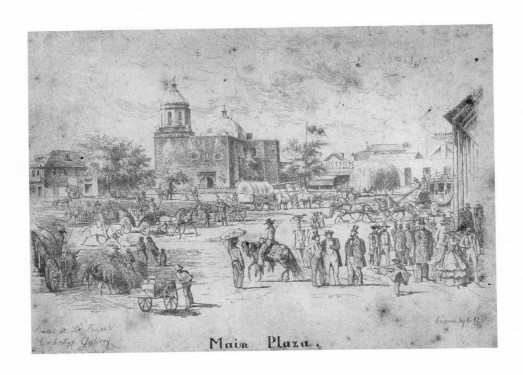

*Main Plaza* by Carl G. von Iwonski. Photographic print of engraving. Inscribed lower left "Printed at DeRyee's/Ambrotyp[e] Gallery/on 1st August 1858" lower right "Engrav. by C. G. I[wonski]." 3⅓ x 5½ inches *Courtesy Virginia von Rosenberg Lane, Austin.*

# William DeRyee, Carl G. von Iwonski, and Homeography, a Printing Process, 1858–1872

*James Patrick McGuire and David Haynes*

The local news column in the August 21, 1858, issue of the San Antonio *Daily Herald* first announced homeography, William DeRyee's new print-making invention to produce multiple copies of line drawings:

The Arts in San Antonio—Mr. [William] DeRyee, the Ambrotypist and photographist, has sent us a picture of the Main Plaza, taken by an entirely new process. As we understand it, he first causes a careful pencil drawing of the object to be made, and then by a chemical process multiplies copies of the same indefinitely. It is certainly quite an achievement in art.[1]

San Antonio's old Main Plaza, dating to the establishment of the Spanish town by immigrants from the Canary Islands in 1731, was a favorite subject for pioneer German artists in the mid-nineteenth century, whose most common rendering was a view facing old San Fernando church. The "Main Plaza" ($3\frac{1}{3}$ x $5\frac{1}{2}$ inches on 4 x $6\frac{1}{2}$-inch mount) mentioned in the *Daily Herald* was drawn by Carl G. von Iwonski (1830–1912), a native of Prussian Silesia, whose inscriptions, "Main Plaza," "Printed at DeRyee's Ambrotyp[e] Gallery the 1st of August 1858," and "Engrav[ed] by C. G. I.," appeared on the lower edge of the scene. Although the word "homeograph" did not appear in the inscription, the first sample of this "new art" was the joint effort of William DeRyee (1825–1903), a Bavarian immigrant chemist and pioneer photographer, and the artist Iwonski.[2]

1. San Antonio *Daily Herald*, Aug. 21, 1858.
2. Homeograph courtesy of Virginia von Rosenberg Lane, Austin, Texas; James Patrick McGuire, *Iwonski in Texas; Painter and Citizen* (San Antonio: San Antonio Museum Association, 1976), 71, no. 76.

This paper will attempt to define the process which DeRyee invented in San Antonio about 1858 and called homeography. Its use will be discussed below in context with rare and unique examples of prints by the inventor as well as by Iwonski and other artists such as Hermann Lungkwitz (1813–1891) and Wilhelm von Rosenberg (1821–1901). After the early 1870s, no examples of photographic printing of line drawings by artists associated with DeRyee have been identified. Altogether a small body of work, the art reproduced by the associated artists forms a unique historical, social, and political commentary on mid-nineteenth-century Texas.

Before discussing the career of William DeRyee, the remarkable inventor, mineralogist, chemist, photographer, and druggist who "invented" the printing process called homeography, it will be useful to review the history of photography.[3]

In August 1839, the first practical photographic process was publicly announced in France. The secret of the process had been bought by the French government from the inventors, Louis Jacques Mandé Daguerre and Isidore Niépce, and generously presented free to the entire world, with the exception of England, where Daguerre's agent had patented the process a few days before. Instruction booklets and equipment, under Daguerre's name, went on sale almost immediately.[4]

The daguerreotype was the kind of image generally called a camera original. The picture that the customer received was physically in the camera during exposure. Thus it was unique. To obtain another one just like it, the first had to be photographed itself. Today the negative/positive process universally used allows the photographer to make any number of prints for the customer from the single negative that is exposed in the camera. In most of the world, however, including Texas, there was no negative/positive process before the mid-1850s, so the concept of unlimited, inexpensive copies of a photograph from one sitting at a gallery simply did not exist.

There was a process available after 1841 which did produce a negative that was used to make positive prints: the calotype, invented by William Henry Fox Talbot in England. Negatives were made on paper, and prints made from

3. While the etymology of "homeography" is unknown, it is possible that "homeo" is from either Greek *hómoios*, like, or Greek *homós*, same. C. T. Onions (ed.), *The Oxford Dictionary of English Etymology* (Oxford: Oxford University Press, 1966).

4. The history of photography is so well documented that individual facts will not be cited. The sources used for this paper are Helmut and Alison Gernsheim, *The History of Photography* (rev. ed.; London: Thames and Hudson, 1969); James M. Reilly, *Care and Identification of 19th-Century Photographic Prints* (Rochester: Eastman Kodak, 1986); and Robert Taft, *Photography and the American Scene* (1938; reprint, New York: Dover, 1964).

them had a grainy quality caused by the fibers in the paper. Such images seemed pale and fuzzy compared to the daguerreotype. In addition, Talbot patented his process and scrupulously prosecuted anyone who used it without paying a fee. The rights for this process in the United States were purchased by the Langenheim Brothers[5] of Philadelphia, who sold the rights for Texas and four other southern states to Maguire & Harrington of New Orleans.[6] There is, however, no evidence to suggest that calotypes were ever made in Texas, and it seems very unlikely that any would have been. It is, perhaps, fair to characterize the average, educated Texan's concept of photography before 1856 as the production of small, unique pictures protected by glass and a case.

During the mid-1850s, the first practical (and unpatented) negative/positive photographic process totally eclipsed the daguerreotype. Invented in England by Frederick Scott Archer in 1851, the wet collodion process produced a negative on glass that could be used to make an unlimited number of prints. Wet collodion was, however, very difficult to manipulate, and it took several years before photographers felt comfortable with it.

The earliest widespread use of the wet collodion process produced an image called the ambrotype. These photographs superficially resemble daguerreotypes, because they are on glass and are almost always in the same kind of protective case, but they are actually underexposed collodion negatives on glass backed by black. The black backing reverses the tones in the negative, producing the impression of a positive image. Exactly the same method was used to produce the ferrotype, or tintype, and it was possible to make paper prints from properly exposed collodion negatives. The reasons that the ambrotype became popular first need not concern us here; it is only important to realize that it was almost 1860 before the public in Texas had any reason to associate photography with a negative/positive process that produced paper prints.

Robert Taft analyzed the type of photograph used as a basis for engravings in pictorial magazines in the late 1850s. His work showed that in 1856 81 percent were from ambrotypes, 11 percent were from daguerreotypes, and 8

5. One of the interesting sidelights of the history of photography in Texas is that William Langenheim, one of the great pioneers in the history of American photography, settled in Texas in the 1830s, fought in the Texas Revolution, and returned to the state in 1846. As far as is known, however, he made no pictures in Texas but returned to Philadelphia after a short stay. Walter Prescott Webb, H. Bailey Carroll, and Eldon Stephen Branda (eds.), *The Handbook of Texas* (3 vols.; Austin: Texas State Historical Association, 1952, 1976), II, 26.

6. Langenheim to Talbot, Nov. 18, 1849, Talbot Papers, Science Museum (London); *Affleck's Southern Rural Almanac . . . for 1851* (New Orleans: J. C. Morgan, 1850), 129.

percent were from paper prints. The next year the figures were 51 percent from ambrotypes, 46 percent from paper prints, 2 percent from daguerreotypes, and 1 percent from tintypes. In 1858 the paper photograph dominated with 95 percent, the other 5 percent being from daguerreotypes.[7] Even in the publishing centers of the east coast, paper photographs did not retire the ambrotype until 1858.

During the first decade of photography, hundreds of daguerreotypists toured the towns and villages of America—places too small to support a full-time "artist." America at that time was primarily a country of such places, so there was plenty of demand and plenty of money to encourage these traveling photographers.

As towns grew into cities, it was increasingly possible for a photographer to set up shop permanently in one place. The 1850s was such a time for places like Galveston, Houston, and San Antonio. One of San Antonio's early "permanent" photographers was William DeRyee.

William DeRyee was born in Würzburg, Bavaria, in 1825, the son of Nicholas and Augusta Düry.[8] He was educated at the Ludwig Maximilian Universität in Munich and participated in the Revolution of 1848. When it failed, he immigrated to New York through Holland and by 1849 was in Roane County, Tennessee, where he married Ida Mylius. There he developed what is alleged to be the first cottonseed-hulling machine and operated a cottonseed-oil press. During this period he also investigated some of the mineral deposits in Tennessee, North Carolina, and Virginia. Later the DeRyees spent a couple of years in central Alabama.

The exact date of DeRyee's move to Texas is unknown, but it probably occurred during the winter of 1857–1858. He first advertised the opening of his ambrotype gallery in San Antonio in mid-March 1858.[9] Ads and editorial

---

7. Taft, *Photography and the American Scene,* 126.

8. The original form of the name was probably a Germanized version of a French name, since Nicholas was French. Sometime between 1850 (U.S. Census, Roane County, Tennessee) and 1858 (San Antonio *Daily Herald,* Mar. 19, 1858), William apparently anglicized it to DeRyee. The facts of his life are taken from the following contemporary sources: *Daily Gate City* (Laredo), June 16, 1891; *Memorial and Genealogical Record of Southwest Texas* (Chicago: Goodspeed Brothers, 1894), 644–646; and *Caller* (Corpus Christi), May 24, 1903. Since DeRyee's death, some biographical material has been published by Samuel W. Geiser in *Field and Laboratory,* VII (Jan., 1939), 34; in Walter Prescott Webb, "Texas Collection," *Southwestern Historical Quarterly,* XLV (Oct., 1941), 190–191 (hereafter cited as *SHQ*); and in Webb, Carroll, and Branda (eds.), *Handbook of Texas,* I, 493. Frank Wagner of Corpus Christi has generously shared information he has collected over the years while preparing a biography of DeRyee.

9. San Antonio *Daily Herald,* Mar. 19, 1858.

mentions continued until May 1859, when the San Antonio *Daily Herald* announced that DeRyee had closed his gallery in preparation for a trip north.[10]

William DeRyee, like most of the small businessmen in Texas at the time, had an active imagination and was unfettered by truth-in-advertising legislation. His ads included such phrases as "largest photographic apparatus in the South," "finest assortment of cases, lockets, pins, etc. ever brought into the State," "facilities . . . are unrivalled," and "ten years experience in the best galleries in Europe and America."[11]

The last comment is particularly interesting. Nothing is known about where or when DeRyee learned photography, but a biography published before his death did not mention photography until after DeRyee arrived in Texas.[12] He had been in minor cities in Tennessee and Alabama for the previous ten years and had listed himself as a merchant in Tennessee in the 1850 census.[13]

About six months after DeRyee opened his gallery in San Antonio, he announced his new homeographic process.[14] Since homeography was always discussed in terms of multiplying images, modern workers have assumed that it was a photomechanical process—one that produces a printing plate entirely by the action of light and chemicals.[15]

Printing depends on physical or chemical separation on the plate between the area to be printed and the area not to be printed. This is accomplished by raising or lowering the material to be printed above or below the surrounding nonprinting area or by treating the material chemically so that the area to be printed attracts ink while the nonprinting area repels it.[16]

This presents no particular problem in printing words; an "a" is an "a" is an "a," and that "a" can be used over and over. Illustrations, however, are unique, and for each a drawing or engraving on stone, wood, or metal had to be individually prepared. The challenge, then, was to create a process that could transfer an existing drawing, painting, map, or other image onto a printing plate without having to redraw it or carve it.

It was obvious to most people working on this problem in the nineteenth century that the action of light on some light-sensitive material would provide

10. Ibid., May 6, 1859.

11. Ibid., Nov. 5, Nov. 9, 1858.

12. *Memorial and Genealogical Record,* 644–646.

13. United States Seventh Census (1850), Roane County, Tennessee, Population Schedules, 876.

14. San Antonio *Daily Herald,* Aug. 21, 1858.

15. Webb, Carroll, and Branda (eds.), *Handbook of Texas,* I, 493.

16. *The New Encyclopedia Britannica* (15th ed.), s.v. "printing."

the answer, and ultimately it did. But William DeRyee of Bavaria and Texas did not discover it.

The only surviving description of DeRyee's process simply said that "he first causes a careful pencil drawing of the object to be made, and then by a chemical process multiplies copies of the same indefinitely."[17] The three surviving identified homeographs, discussed below, all showed line drawings. In the known cases of multiple copies of continuous-tone works associated with DeRyee, no mention was made of the process he called homeography.[18]

In appearance, the homeographs are indistinguishable from paper photographs made by DeRyee and his various partners at the same time.[19] Extant samples are too rare to allow destructive chemical testing. Nowhere did DeRyee claim that his process involved a printing press; he simply claimed that it was a chemical process.

Therefore we must conclude that there was nothing new about DeRyee's "entirely new process." A normal wet collodion negative was made of a drawing instead of a person or landscape, and prints were made from the negative.

The public could easily associate the few paper prints they had previously seen with the word "photography" and believe that the yellow-brown multiple drawings were produced by a new process: homeography.

While the Eighth Texas Legislature was in session, from November 1859 to February 1860, DeRyee, in association with two others, operated a gallery in Austin. They also presented a magic lantern show on February 7, 1860.[20] A broadside advertising this performance mentioned that the show included portraits of members of the legislature. DeRyee and R. E. Moore published a set of photographs of these same men as *The Texas Album, of the Eighth Legislature, 1860*.[21]

17. San Antonio *Daily Herald*, Aug. 21, 1858.

18. Wm. DeRyee and R. E. Moore, *The Texas Album, of the Eighth Legislature, 1860* (Austin: Miner, Lambert, and Perry, 1860), was produced in multiple copies. A copy of a photograph identified as showing Twiggs's surrender was probably made by DeRyee and was surely made to sell to the public. The word "homeography" is not associated with either, or with any other contemporary continuous-tone photograph.

19. For the present study, homeographs were compared with photographs from about the same period using the methods in Reilly, *Care and Identification of 19th-Century Photographic Prints*, 60–68.

20. Texas Broadsides, Center for American History, University of Texas at Austin (hereafter cited as CAH).

21. Only three copies of *The Texas Album* have been located in Texas, two in the CAH and one in the Texas State Library, Archives Division. The article on DeRyee in the *Memorial and Genealogical Record* (p. 645) mentioned that the citizens of Austin sent a copy to President James Buchanan, but a vigorous search has failed to locate it. One copy is at the University of California at Berkeley.

That legislative session passed a special law authorizing the commissioner of the General Land Office to adopt the DeRyee method of duplicating drawings or to establish a photographic bureau.[22] In his biennial report, Francis White, the commissioner, concluded:

On inquiry, it was ascertained the Mr. D[eRyee] would charge the State $3,000 (three thousand dollars) for his secret and $500 (five hundred dollars) to instruct the office in its use. Apart from the fact that Mr. DeRyee had not obtained a patent for his asserted discovery; and that, by its use, the State might be involved in the infraction of some pre-existing right for which, perhaps, it would have to make compensation to someone else, the price was greater than I supposed the Legislature had contemplated and much beyond what I considered, under the circumstances, a reasonable or justifiable outlay for experimenting. I consequently declined making any arrangement with Mr. DeRyee.

White did establish a photographic bureau within the Land Office and reported that during its first eighteen months, fifty-three negatives of county maps had been produced, thirty of which were successful enough to produce satisfactory prints. The total cost of the bureau's operation for that period had been $3,744.33.[23]

When DeRyee returned from a tour up the Mississippi and Ohio Rivers in January 1861, he found the state in considerable turmoil.[24] During the next four months, Texas seceded from the United States and joined the Confederacy, Sam Houston was removed as governor, U.S. military property was surrendered to state troops, and the Civil War began.

With the coming of the Civil War, Texas faced a new set of problems. The United States no longer protected the Texas frontier. The Confederacy not only would not protect the frontier, but also demanded that the state provide men for the war. The state had no hard money and practically no credit. The Federal

Ernest W. Winkler, *Check List of Texas Imprints: 1846–1860* (Austin: Texas State Historical Association, 1949), 261.

22. H. P. N. Gammel (comp.), *The Laws of Texas 1822–1897* . . . (10 vols.; Austin: Gammel Book Co., 1898), V, 283–285.

23. Commissioners' Reports, 1845–1890, Texas General Land Office, Archives and Records Division, Austin, 87–88. Francis Menefee White (1811–1897) was born in Tennessee and moved to Texas in 1830. He participated in the Siege of Bexar and was elected to various county offices in the late 1830s. After statehood, White served during four of the first six legislatures as a representative from Jackson County. In 1857, he was elected commissioner of the General Land Office, serving until 1862 and again during Presidential Reconstruction. He retired from state service to farm and practice law. He died in Texana and was buried near Edna. Webb, Carroll, and Branda (eds.), *Handbook of Texas*, II, 894.

24. Indianola *Courier*, Jan. 5, 1861.

blockade made it difficult to ship cotton to European markets, and Union forces might invade at any time.

Added to these new problems was that Texas perennial, a weak governor balanced by an occasional legislature. In desperation, the Ninth Legislature created the Texas Military Board and gave it the power to use state resources to provide arms and munitions for the defense of the people. The board was composed originally of the governor, the treasurer, and the comptroller.[25]

Early in 1862 the Military Board, under the leadership of Governor Francis Lubbock, established a state foundry and a percussion cap factory.[26] William DeRyee was appointed superintendent of the cap factory and for the next two years spent most of his time producing millions of percussion caps for the war effort. His reports, however, did mention chemicals such as sulphuric acid, nitric acid, alcohol, and gold chloride, which were used for printing experiments.[27]

In December 1863, the legislature authorized the governor to issue up to $2,000,000 in bonds backed by cotton owned by the state and up to $2,000,000 in bonds redeemable in land scrip to buy the cotton.[28] None of the cotton bonds were sold, and no copies can currently be located.[29] It is possible that no such bonds were ever printed. But a single land-scrip bond has survived. It was printed by DeRyee, using the homeographic method, probably during late 1864.[30] In all likelihood these were the "cotton bonds" to which his biographical sketch referred.[31]

25. Gammel (comp.), *Laws of Texas*, V, 484–485, 499.

26. Charles W. Ramsdell, "The Texas State Military Board, 1862–1865," *SHQ*, XXVII (Apr., 1924), 253–275. Francis Richard Lubbock (1815–1905) was born in South Carolina and came to Texas in 1836. He was a merchant in Velasco and Houston during the 1830s and 1840s and also served as the comptroller of the Republic. One of the organizers of the Democratic Party in Texas, Lubbock was elected lieutenant governor in 1857. He was elected governor in 1861 and served on Jefferson Davis's staff during the last year of the war. After Reconstruction, he was elected state treasurer six times. Lubbock's memoir, *Six Decades in Texas*, was published in 1900. Webb, Carroll, and Branda (eds.), *Handbook of Texas*, II, 89.

27. Wm. DeRyee, "Explanation of Deficit in the Cap Factory," Texas Military Board Papers, Texas State Library, Archives Division, Austin.

28. Gammel (comp.), *Laws of Texas*, V, 663, 683–684.

29. *Southern Intelligencer* (Austin), Nov. 9, 1865.

30. Homeograph land-scrip bond courtesy of Virginia von Rosenberg Lane, Austin. A photostatic copy of this bond is in the Military Board Papers at the State Archives, and a photographic copy of it is in the University of Texas Institute of Texan Cultures in San Antonio (hereafter cited as ITC). The date is assumed because DeRyee signed his name as "Chemist Nitre & M[ining] Corps T[rans] M[ississippi] D[epartment]," and he was still at the cap factory as late as July 1864, according to a payroll in the Military Board Papers, State Archives.

31. *Memorial and Genealogical Record*, 645.

Apparently, when a cotton supplier appeared at the Rio Grande with cotton, he was given a certificate that could be redeemed for the land-scrip bonds. According to the report of the examination made of the Military Board by E. M. Pease and Swante Palm in October 1865, forty-five of the bonds, representing $41,570, were issued and delivered, and twenty bonds, for $14,580, were issued but not delivered.[32] By this date the war was over, and any certificates or bonds, delivered or not, were worthless.

After the war DeRyee opened a pharmacy in Corpus Christi and spent the remainder of his life actively involved in medical, geological, and mineral pursuits in Texas and northern Mexico. He was a principal in several mining ventures and completed a geological survey of Webb and Encinal Counties. He served as a Texas representative to the World's Industrial and Cotton Centennial Exhibition in New Orleans in 1885.[33] He maintained homes in Corpus Christi and Laredo, and died and was buried in the former city in 1903.

What of the artists associated with DeRyee in producing homeographs? Carl G. von Iwonski was among the first assistants DeRyee hired to work in his San Antonio Ambrotype and Melainotype Gallery. "Main Plaza," their first combined effort, was completed and announced to the public on August 21, 1858. Iwonski's engraving, unique in his oeuvre, captured in fine detail the busy commercial and social life of pre-Civil War San Antonio. In addition to the façade of the old Spanish parish church of San Fernando, Main Plaza was framed by businesses, including the auction houses of John Carolan and François Guilbeau. In addition to pedestrians, Iwonski illustrated all methods of transportation current in the frontier city, including horsemen, Mexican carts, a peddler's cart, an ox-drawn freight wagon, a hay wagon, a heavily hay-laden burro, an arriving stagecoach, and a lady's carriage. Ladies in fashionably wide skirts were escorted across the plaza by properly dressed gentlemen in top hats or by military officers. Other figures included a Mexican *vaquero*, a newspaper boy hawking his papers, and a *dulce* peddler with his tray balanced on his head.[34]

32. *Southern Intelligencer* (Austin), Nov. 9, 1865.

33. The name of this fair, which is called the New Orleans Exposition in most sources, was taken from DeRyee's admission ticket, courtesy of Mrs. Raymond Mosty, Center Point. An electrostatic copy is at the ITC.

34. San Antonio *Daily Herald*, Aug. 21, 1858. An engraving from Iwonski's "Main Plaza" was used as an illustration in *Frank Leslie's Illustrated Newspaper*, VII (Jan. 15, 1859), 102. It was subsequently published in William Corner, *San Antonio de Bexar* (San Antonio: Bainbridge and Corner, 1890); Mary Ann Guerra (ed.), *Sidney Lanier's Historical Sketch, San Antonio de Bexar* (San Antonio: privately published, 1980), among others, and was the illustration for Mayor and Mrs. Henry G. Cisneros's official Christmas card in 1981.

Although Iwonski was not identified in the advertisement in the *Daily Herald* on November 9, 1858, he was probably one of the "two excellent painters" assisting DeRyee, who possessed the "largest photographic apparatus in the South," to make "oil, crayon, pastel, and water-colored paintings" of various sizes on "canvas, copper, iron, paper, etc." The advertisement continued:

The combination of the photographic art, by which an exact likeness is obtained, and the skill of the painter, which gives the natural color, insures absolute accuracy, which can never be equalled by the unaided hand of even the best artist.

Ambrotypes and faded Daguerreotypes of departed friends are magnified and put in more permanent and effective shape by the same process.[35]

Iwonski was first named as DeRyee's assistant by the *Daily Herald* on February 9, 1859, when the editor called the public's attention to a picture of the two little daughters of John C. French "just completed by the joint labors of himself [DeRyee] and Mr. C. G. Iwanski [*sic*], a young German artist of much promise in our city." The picture was described as "highly beautiful, and alike creditable to both artists. We learn that some pictures executed by Mister Iwanski [*sic*] have been sent to Europe, where they have been highly complimented by Judges of art." Who was this young German artist whose name the editor consistently misspelled?[36]

Iwonski was born in Hilbersdorf, in Prussian Silesia, in 1830 and accompanied his parents, Leopold and Marie von Iwonski, to Texas fifteen years later. They were members of the large German colony sponsored by the *Adelsverein*, the Society for the Protection of German Immigrants to Texas. Little is known of Iwonski's early life, but apparently he took drawing lessons at a school in Breslau and in Texas after the family settled on a farm at Hortontown, a hamlet across the Guadalupe River from New Braunfels. Reputedly self-educated and possessing great natural talent, he received instruction from other immigrants, including Hermann Lungkwitz and Richard Petri (1824–1857), both professional artists from the Royal Academy of Art in Dresden who arrived in Texas in 1851. Thereafter, Iwonski's artistic and professional association with Lungkwitz and Petri (who drowned in the Pedernales River in 1857) continued until his repatriation to Germany in 1873. He died in Breslau (now Wroclaw, Poland) in 1912.[37]

35. San Antonio *Daily Herald*, Nov. 9, Nov. 13, 1858.

36. Ibid., Feb. 9, 1859.

37. Obituary of Carl G. von Iwonski, unidentified, undated German newspaper clipping, ca. 1912, Iwonski Files, ITC; Yanaguana Society, *Catalogue of a Loan Exhibition of Old San Antonio Paintings* (San Antonio, 1933), 11; McGuire, *Iwonski in Texas*, 11–13; McGuire, *Hermann Lungkwitz, Romantic Landscapist on the Texas Frontier* (Austin: University of Texas Press, 1983), 1–11. Friedrich Richard Petri (1830–1857) received his art education at the Royal Academy in his native Dresden,

The first evidence of Iwonski's artistic output dates from the mid-1850s, when be began drawing and painting portraits of German immigrants in New Braunfels. One of his first oil compositions, a landscape of a typical frontier farmstead, perhaps captured his father's home on the Guadalupe River. Others, including pencil studies of central Texas scenes such as Ernst Altgelt's Perseverance Mill at Comfort and a shinglemakers' camp on the upper Guadalupe, recorded a sketching tour undertaken around 1855 to Comfort, the westernmost German frontier village, with Hermann Lungkwitz, who also drew the mill. Thereafter, Iwonski produced almost a score of carefully detailed ink drawings of scenes from German plays enacted by the Amateur Theatre of New Braunfels between 1855 and 1857. One of his most noted pictures was a panorama of New Braunfels, printed in Leipzig in 1856 as a lithograph by J. G. Bach. The artist presented a pencil study of New Braunfels to Duke Paul of Württemberg, who visited the town during the spring of 1855.[38]

Notable among Iwonski's New Braunfels work were his genre scenes of German social life. A lithograph of the first German singing society, the *Germania Gesängverein*, organized at New Braunfels in 1850, was printed in 1857. Another, called "Neu-Braunfelsers" or "Texanische Volken," depicted fourteen men enjoying an afternoon in a saloon playing cards and engaging in conversation. Iwonski drew his own likeness at the card table. A third composition was an engraving of "Der Unvermeidliche," showing a group of six men in conversation around a tavern table. Again Iwonski included his own portrait. A distinctive feature of the artist's genre scenes, as well as of his sketches of

Saxony. Following the Revolution of 1848, Petri accompanied his sisters, Marie and Elise Petri Lungkwitz, and brother-in-law, Hermann Lungkwitz, to Texas in 1851. Forced to farm for a living on the frontier's edge at Fredericksburg, Petri executed studies of pioneer life, portraits of settlers, and a unique series of sketches of the Southern Comanches and other Indians who visited the community. Petri is said to have suffered from consumption and spent much of his life in poor health. He drowned in the Pedernales River late in 1857. See Mae Estelle Meyers, "The Lives and Works of Hermann Lungkwitz and Richard Petri" (M.A. thesis, University of Texas at Austin, 1933); William W. Newcomb Jr., *German Artist on the Texas Frontier: Friedrich Richard Petri* (Austin: University of Texas Press, 1978); Webb, Carroll, and Branda (eds.), *Handbook of Texas*, II, 367–368.

38. *Neu-Braunfelser Zeitung* (New Braunfels), Sept. 19, 1856; McGuire, *Iwonski in Texas*, 12–17, 37–38, 61–71. On April 20, 1855, the *Neu-Braunfelser Zeitung* informed the public that Duke Paul of Württemberg had arrived to "botanize" the area before traveling on to California and China. On June 1, the paper announced that Otto Beyer, a merchant on Seguin Street, would take a trip to Germany and that he was the owner of "an exact and correct view of New Braunfels and intends to have same lithographed in Germany." Beyer planned to offer copies of Iwonski's view for one dollar each.

the New Braunfels amateur theatre actors, was his accurate portrayal of each person in the composition.[39]

Although Iwonski announced his studio to the New Braunfels public in 1856 and tried earning his living through his art for a few years, he also assisted his family in farming and in the operation of a combined stage stop and saloon at the San Antonio–Austin crossing of the Guadalupe. His other early Texas activities are unknown, for the artist left no personal papers. Because of a severe prolonged drought, he and his parents moved to San Antonio in 1857 or 1858.[40]

The remainder of Iwonski's career in Texas was spent in San Antonio, where he and his parents were prominent members of the prestigious Casino Club of the city's large German colony. Always attempting to further his artistic career, Iwonski worked in DeRyee's studio beginning in 1858. There he learned the latter's homeographic printing process for line drawings. In addition to portrait commissions, the young artist also supplemented his income by teaching drawing and academic subjects at San Antonio's private German-English School from 1860 to 1871. (His Prussian passport protected him from conscription into the Confederate army during the Civil War.) In 1866 he became a business partner of Hermann Lungkwitz in a photographic studio which they operated for four years. A strong Unionist and Republican, Iwonski was appointed City Tax Collector from 1867 to 1870, during Radical Reconstruction.[41]

Most of what is known of Iwonski's activities in San Antonio in the years immediately preceding the Civil War involved DeRyee. In a series of mentions in the local news column of the *Daily Herald* during 1858 and 1859, DeRyee informed the public of his move from the second-floor skylight rooms above Burns's Grocery on Commerce Street near Main Plaza to a "splendid picture gallery" with skylight and ample side windows in the newly constructed French Building on the plaza, where he was reported to be "making improvements and discoveries in his art." There DeRyee and Iwonski remained, making photographs and painting portraits, until the late spring of 1859. The newspaper said that DeRyee made as many as ten to twenty pictures a day and had to turn customers away. Then, on May 6, the paper reported that he had moved the business to his home because "he intends to tour North this Spring."[42]

---

39. McGuire, *Iwonski in Texas*, 71. Two copies of "Neu-Braunfelsers," homeographs courtesy of Jo Adams, Houston, Texas, and Eva Woosley, San Antonio, Texas.

40. McGuire, *Iwonski in Texas*, 17.

41. Ibid., 17–32.

42. San Antonio *Daily Herald*, Apr. 13, Nov. 5, 1858, Jan. 5, Jan. 7, Jan. 15, Feb. 2, May 6, 1859.

As early as mid-January 1859, DeRyee informed his public that he intend-ed to spend a few weeks making pictures in Seguin. During June and July, DeRyee and Iwonski set up their studio in Nauendorf House at the market in New Braunfels, made photographs, sphaereotypes, and paneotypes, and ex-hibited a "stereoscopic panorama with views from all parts of the world, sculp-ture, etc."[43]

There is no evidence that Iwonski accompanied DeRyee to Austin later that year when the latter made photographs of members of the state legislature, published in a book in 1860. Nor did Iwonski tour New Braunfels and Austin with DeRyee, Wilhelm C. A. Thielepape, and Hermann Lungkwitz with their version of a magic lantern show, "the Mammoth Agioscop[e]," projecting life-sized portraits of Governor Sam Houston, members of the Eighth Legislature, and heads of government departments. Iwonski also remained in San Antonio while DeRyee, Lungkwitz, and Thielepape toured cities and towns along the Mississippi and Ohio Rivers with their magic lantern show during 1860 and 1861.[44]

As mentioned above, the first known homeograph was Iwonski's "Main Plaza" in August 1858. The second known sample of the technique, and the first which bears the inscription "Homeographed by Wm. DeRyee and C. G. Iwonski," dates from February 16, 1861. Immediately upon returning from his magic lantern tour in January, DeRyee may have reactivated his San Antonio studio in the French Building, although Iwonski may have operated it during his absence, and began making photographs, including scenes of the gathering of Texas State Troops and of a wagon train in front of the Plaza House in Main

43 Ibid., Jan. 15, Feb. 27, and May 6, 1859; *Neu-Braunfelser Zeitung* (New Braunfels), June 24, July 1, 1859.

44. *Neu-Braunfelser Zeitung* (New Braunfels), June 24, July 1, Sept. 16, 1859; Indianola *Courier*, Jan. 5, 1861; "Grand Exhibitions at Buaas' Hall with the Mammoth Agioscop[e]," broadside, *Intelligencer Print*, "The Latest News and the Best Picture is the Photochromatype . . . Gallery of the Fine Arts, Swenson's Building," broadside, CAH; McGuire, *Hermann Lungkwitz*, 20; Brownson Malsch, *Indianola, The Mother of Western Texas* (Austin: Shoal Creek, 1977), 142–143; Winkler (ed.), *Check List of Texas Imprints*, 233, 252.

Wilhelm Carl August Thielepape (1814–1904), a native of Germany, immigrated to Texas in 1846 and settled in Indianola, where he was an architect and surveyor. He later lived in New Braunfels and San Antonio, and designed the former city's first two-story courthouse. An early photographic and magic lantern show partner of William DeRyee, Thielepape accompanied him and Lungkwitz on a tour of the Mississippi River in 1860–1861. An opponent of slavery, he fled Texas during the Civil War. Later, Thielepape founded San Antonio's *Beethoven Männerchor*, a male chorus, and worked as a bookkeeper and artist. He served as Reconstruction mayor of San Antonio from 1867 to 1872. Thereafter he worked in Chicago until his death. See Wilhelm C. A. Thielepape File, ITC.

*The Main Plaza, San Antonio, as Held by the Texas Volunteers.* Homeograph by Carl G. von Iwonski. 6¼ x 8⅜ inches. *Courtesy Daughters of the Republic of Texas Library at the Alamo, San Antonio; Josephine Simmang Jones, San Antonio; and Virginia von Rosenberg Lane, Austin.*

Plaza as Texas prepared to join the Confederacy. "The Main Plaza San Antonio as held by the Texas Volunteers under Col. Ben McCulloch on the morning of the 16th February 1861" (6¼ x 8⅜ inches on 7⅛ x 8⁷⁄₁₆-inch mount), made from Iwonski's wonderfully detailed drawing, was printed in multiple copies for sale to the public. As in the case of all homeographs produced, the original pencil drawing did not survive.[45]

Dressed in every kind of winter civilian clothing, the heavily armed, flag-waving Texan troops milled around in front of the Plaza House on Main Plaza as they prepared to take control of Federal stores and posts on the western frontier from Gen. David E. Twiggs. Ben McCulloch, their commander and a Texas Ranger, with other commissioners, carried out instructions from the

45. Carl G. von Iwonski, "The Main Plaza San Antonio as held by the Texas Volunteers under Col. Ben McCulloch on the morning of the 16th February 1861."

Texas Committee of Public Safety during February and March. Iwonski witnessed this scene in San Antonio and also may have used DeRyee's photograph of it in composing his drawing.[46]

In March, Iwonski accompanied the Texan volunteers to Camp Las Moras near Fort Clark (Brackettville), where he sketched a scene of the soldiers butchering a hog by a wagon whose sheet was marked "US." This proved to be the first war sketch received by *Harper's Weekly*, which included the artist's slightly altered scene as an engraving in its June 15, 1861, issue. Its inscription read, "Bivouac of Confederate Troops on the Las Moras, Texas with Stolen U.S. Wagons, etc.—Sketches by a Member of the Corps." Unlike his drawing of the troops gathering in San Antonio, this scene was not homeographed by DeRyee.[47]

46. Ibid.; McGuire, *Iwonski in Texas*, 75–76. Born in Georgia, David E. Twiggs (1790–1862) followed an army career. In the Mexican War, he commanded the 2nd Dragoons under Zachary Taylor in northern Mexico and fought with Winfield Scott at Mexico City. After the war he was commander of the Department of the West and headquartered in San Antonio, where he surrendered Federal forces and stores to Ben McCulloch in 1861. Dismissed from U.S. service, he accepted a major general's commission from the Confederacy and commanded at New Orleans, but retired in 1861 and died in Georgia the next year. Webb, Carroll, and Branda (eds.), *Handbook of Texas*, II, 812.

Ben McCulloch (1811–1862) and his Texas troops forced Twiggs's surrender at San Antonio in February 1861. McCulloch was commissioned a brigadier general by the Confederacy and assigned to guard the Indian Territory. He won the Battle of Oak Hills in August 1861. Later he commanded in Arkansas, Louisiana, and Texas, but was killed on March 7, 1862. A Tennessee native, McCulloch fought with Houston at San Jacinto in 1836, was a surveyor, congressman of the Republic of Texas, Indian fighter and scout, Texas legislator (1846), and Ranger in the Mexican War. Later he was sheriff of Sacramento County, California, but returned to Texas and became a U.S. marshall and peace commissioner during the Mormon troubles. Webb, Carroll, and Branda (eds.), *Handbook of Texas*, II, 106.

47. *Harper's Weekly*, June 15, 1861; San Antonio *Alamo Express*, Feb. 18, 1861; McGuire, *Iwonski in Texas*, 76; Iwonski, "Camp Las Moras, C.S.A., 1861," Library of Congress, Washington, D.C. DeRyee and Iwonski had had previous dealings with *Harper's Weekly*; in November 1858, they were commissioned to make a daguerreotype of General Twiggs. See San Antonio *Daily Herald*, Nov. 5, 1858. Other engravings of San Antonio scenes, possibly from sketches by Iwonski, appeared in the magazine during the 1850s and 1860s, but the artist was not identified. *Harper's Weekly* published on March 23, 1861, two engravings which may also have been sketched by Iwonski: "Surrender of Ex-General Twiggs, Late of the United States Army, to the Texas Troops in the Main Plaza, San Antonio, Texas, February 16, 1861," and "The Alamo, San Antonio, General Twiggs's Head-quarters." Both were credited to "a government draughtsman."

The San Antonio *Express* noted on February 18, 1861, that McCulloch, "along with 400 troops under orders from the Safety Committee[,] took charge of Federal military stores and surrender of Federal troops at San Antonio." On March 20, the *Alamo Express* reported that "The brave men who went to take charge of Forts Clark and Duncan found it convenient to take advantage of the war times to forage upon the poor people along the route, by killing their hogs, etc." *Harper's Weekly*, in the June 15, 1861, issue, gave a more vivid description:

The artist's interest in politics and politicians began early and accounts for his use of the homeography process during the 1860s. The New Braunfels German newspaper noted in October 1857 that Iwonski had "drawn from memory" an excellent portrait of Governor Sam Houston, who had recently visited the town. Four years later, a San Antonio paper announced "Gov. Houston's Picture . . . taken from life during his late speech at Austin by Mr. Charles G. Ivonski [sic], of this city, which we consider the best picture of the old hero that we have seen." Undoubtedly, Iwonski drew Houston's portrait as the governor made his farewell address after refusing to take the oath of allegiance to the Confederacy. The paper said that the "cheapness at which the picture is afforded [fifty cents a copy] places it within the reach of all," and that it was "chemically multiplied by Wm. DeRyee."[48]

Iwonski appears to have abandoned photography during the Civil War. After the war, in 1866, he established a studio with his fellow artist and friend Hermann Lungkwitz. Both had been closely associated with William DeRyee before the war and had learned photography from him. Lungkwitz and Iwonski's first studio was in the Masonic Hall, but they soon moved to rooms over Bell Brothers' Jewelry Store on Commerce Street, where they remained until they dissolved the partnership in 1870. Both were accomplished artists, Iwonski in genre and portraiture and Lungkwitz in landscape, and they called their business "day work," routinely making carte-de-visite portraits of local citizens and visitors. It was in their Commerce Street studio that Iwonski produced homographs of his unique political caricatures in support of the Republican Party during Reconstruction.[49]

A Rebel Bivouac in Texas. We publish on page 375 a picture of a Rebel Encampment in Texas, from a sketch sent us by a gentlemen [Iwonski] whose secessionist views are beyond question. He writes;

After the surrender of San Antonio by General Twiggs, State troops were organized in order to take possession of the forts occupied by the U.S. Army. The above is a true picture of a portion of said State troops encamping on the Las Moras, near Fort Clark, on their way to the upper posts (Hudson, Lancaster, and Davis). The picture ought to speak for itself. We need not remind that the "U.S.'s" and the "Q.M.D.'s" imply their former owners; and add, furthermore, that no white man in these diggins will be astonished to see the poor Mexicans do all the "hauling of wood and drawing of water," the Dons being engaged in smoking cigarritos, eating sardines, drinking Pat's "Favorite," superintending the killing of a stray pig, etc., etc. A lineal descendant of Montezuma stands sentinel, by order No. 1: "Put none but true Southerners on guard tonight."

48. *Neu-Braunfelser Zeitung* (New Braunfels), July 24, Oct. 2, 1857; *Tri-Weekly Alamo Express* (San Antonio), Apr. 10, May 3, 1861; McGuire, *Iwonski in Texas*, 71. The dim, rephotographed copy of Iwonski's portrait of Houston was later used by other artists painting portraits of the old hero, including William H. Huddle, Robert Jenkins Onderdonk, and Henry McArdle. All credited Iwonski with the original drawing. Photocopies courtesy of the Archives, San Antonio Museum Association, and the Daughters of the Republic of Texas Library at the Alamo, San Antonio.

49. San Antonio *Daily Herald*, Jan. 10, Jan. 15, 1866; San Antonio *Express*, Apr. 15, 1934; San Antonio *Evening News*, Dec. 25, 1940; Meyers, "The Lives and Works of Hermann Lungkwitz and

With his father, Leopold, Iwonski joined the Unionist Party, composed mainly of freedmen, foreign-born immigrants, and opponents of secession, in 1865. With the arrival of Federal occupation troops that summer, father and son registered as voters and became prominent participants in Unionist Party activities in the Alamo City. With the advent of Congressional Reconstruction in 1867, both qualified for the "iron-clad oath" and continued active in the Radical wing of the newly created Republican Party in Bexar County. Leopold von Iwonski served as Bexar County treasurer from 1867 to 1872, and his son was appointed by the military government as San Antonio's tax collector from 1867 to 1870. When Leopold died in office in 1872, the administration of Gov. E. J. Davis made an abortive effort to appoint Carl to the post.[50]

Iwonski brought his considerable creativity and imagination into play when drawing caricatures for the local Republicans. On August 9, 1867, the local Republican newspaper, the *Daily Express*, announced his first effort, which marked the end of Presidential Reconstruction as military appointees filled public offices in Texas.

THAT 'PAS DE DEUX.'—Mr. Iwonski, the artist, has produced a caricature of the anticipated exit of the Mayor and County Judge, which has made the whole town laugh. Hand-in-hand these two worthies perform a *pas-de-deux* from the courthouse building; a gentleman, who looks a good deal like Judge [August] Siemering, furnishes the music, while in the door stands a military gentleman, broom in hand, sweeping out any quantity of worthless scrip.

Richard Petri"; McGuire, *Iwonski in Texas*, 21–22; McGuire, *Hermann Lungkwitz*, 27–30. Iwonski may have withdrawn from the photographic business as early as December 1869. On the 20th of that month, his mother wrote to a friend that "Karl has removed himself from his partners for an indefinite time, in order that he might spend more time with his training." Marie von Iwonski to Hedwig [von Hugo, Mrs. Kirt Motrity von Boenigk], Dec. 20, 1869, New Iwonski Data File, ITC, courtesy of Carol Haseloff Harmon, Quinlan, Texas.

50. San Antonio *Daily Herald*, Dec. 25, Dec. 28, 1865, Jan. 24, 1868, Dec. 18, 1870, Oct. 17, 1872; San Antonio *Daily Express*, Nov. 29, 1867, Jan. 24, 1868, July 3, July 8, 1871, Sept. 4, Sept. 5, Sept. 13, Oct. 16, Oct. 17, 1872; *Freie presse für Texas* (San Antonio), Oct. 19, 1872; Bexar County Commissioners' Court Minutes, 1868–1876, Books 2A, 3A; "Oaths and Bonds," 2–9/908, Texas State Library, Archives Division, Austin; James P. Newcomb Papers, San Antonio Public Library; McGuire, *Iwonski in Texas*, 23–24.

Edmund J. Davis (1827–1883), a Floridian by birth, moved to Texas in 1838, studied law, and practiced in south Texas. Prior to the Civil War, he was a deputy customs collector, district attorney, and judge. Opposed to secession, he chose exile and commanded a Unionist Texas cavalry unit in Mexico and Louisiana for the U.S. Army. An active Unionist and Radical Republican leader after the war, Davis was a delegate to the conventions of 1866 and 1868–1869, and advocated unrestricted black suffrage and other radical measures, including dividing Texas into three states. Elected governor of Texas in 1869 by the Radical Republican Party and its allies, Davis served until 1874. Thereafter he practiced law in Austin and served as a Republican leader in state politics until his death. Webb, Carroll, and Branda (eds.), *Handbook of Texas*, I, 469–470.

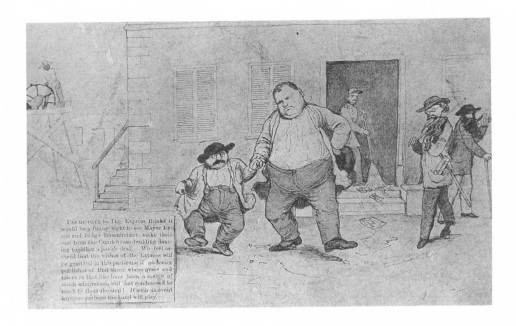

*Pas de deux*, by Carl G. von Iwonski. Photographic print of line drawing, $3^1/_8$ x $4^5/_8$ inches. *Courtesy Swante Palm Collection, Harry Ransom Humanities Research Center, University of Texas at Austin.*

A day later, the paper, edited by Siemering, noted that "the County Treasury has suffered severely since Mr. Iwonski's *Pas-de-deux* made its appearance."[51]

Included in the composition of the homeograph of "Pas de Deux" ($3^1/_8$ x $4^5/_8$ inches on $3^7/_8$ x $4^7/_8$-inch mount) was the following, set in type at the lower left:

*Pas de deux:* The Express thinks it would be a funny sight to see Mayor [J. H.] Lyons and Judge [John] Rosenheimer make their exit from the Court-house building dancing together a *pas de deux*. We feel assured that the wishes of the Express will be gratified in this particular if the senior publisher of that sheet whose grace and talent in that line

51. San Antonio *Daily Express*, Aug. 9, Aug. 10, 1867; McGuire, *Iwonski in Texas*, 25, 82. August Siemering (1828–1883), a native of Brandenburg, Germany, immigrated to Texas in 1851 as a refugee of the Revolution of 1848. While teaching school in Sisterdale and Fredericksburg during the next decade, he became active in liberal anti-slavery politics. Although he served as a lieutenant in the Confederate Army, Siemering became an ardent Republican after the war and established San Antonio's *Freie Presse für Texas* and the *Daily Express* to support the party. He was a gifted writer who also wrote novels, and his columns reflected his knowledge of the German classics. Siemering was a Republican political leader and held public offices until his death. Webb, Carroll, and Branda (eds.), *Handbook of Texas*, II, 609.

have been a source of much admiration, will but condescend to teach them the step! If such an event happens the band will play.

Holographic inscriptions made by Congressman Edward Degener of San Antonio to Swante Palm of Austin added, "Negro, ring the Alamo Bell," "Judge Rosenheimer—Mayor Lyons (the Druggest [*sic*],) Editor Siemering fiddling, Passing off is Genl. [William B.] Knox."[52]

Undoubtedly Iwonski received much praise from his political friends for his first caricature. In February 1868 his talents were once more in demand. His "Answer of the Germans to the Above" ($3\frac{1}{4}$ x $4\frac{1}{4}$ inches), a homeographed sketch, was pasted to the front page of each copy of the San Antonio *Daily Express* on February 8. Prompted by a bitter, race-baiting political campaign between the Republicans and their opponents, Iwonski's caricature responded to an appeal for support by the Conservatives and Democrats.

On February 5, editor Siemering had set the stage for Iwonski's composition:

Drawing the Curtain over the Past—[Thomas J.] Devine and his crew have drawn the curtain over the past, but it is only high enough to cover the glorious records of General Sigle, Carl Shurtz and their brave followers [as] they look over the top and see "the brave Southern forefathers who fought nobly at New Orleans." It covers the chain marks on the limbs of Mr. [Ferdinand] Simon and other victims of Devine, . . . The curtain covers the Nueces massacre when some 60 Germans were butchered. . . .[53]

The next issue of the *Express* alerted the electorate: "German Citizens—We will publish an able communication in tomorrow morning's issue from a 'German Citizen,' in reply to the [San Antonio] *Herald* address to the Germans of Bexar [County]. It is rich in truth and to the point."[54]

52. Homeographs "Pas de Deux," courtesy of Swante Palm Collection, Harry Ransom Humanities Research Center, University of Texas at Austin (hereafter cited as HRC), and "The Democrats Going out of office," James Patrick McGuire, San Antonio. McGuire's copy of the homeograph does not contain the figure of a man at right with a walking stick which is seen in the Palm Collection copy.

53. San Antonio *Express*, Feb. 5, 1868. Thomas Jefferson Devine (1820–1890) migrated from his native Nova Scotia to Florida and Mississippi and then came to Texas in 1843. He began public service as city attorney in San Antonio from 1844 to 1851, became district judge, and was a delegate to the Secession Convention in 1861. Appointed a member of the Committee of Public Safety, he demanded the surrender of General David Twiggs and all Federal troops and stores in Texas. During the war, Devine served as a Confederate state judge for the Western District of Texas and carried out a Confederate diplomatic mission to Mexico. He was briefly imprisoned after the war and charged with treason in the U.S. courts. (Jefferson Davis was the only other former Confederate also charged with treason.) In 1873, Devine was appointed a justice of the Texas Supreme Court but later practiced law and promoted railroads until his death. Webb, Carroll, and Branda (eds.), *Handbook of Texas*, I, 495.

54. San Antonio *Express*, Feb. 6, 1868

*Answer of the Germans to the Above.* San Antonio *Express*, Feb. 8, 1868. *Courtesy San Antonio Museum Association.*

The *Herald*'s appeal from the Conservative Union Reconstruction Party to the German voters was reprinted in its entirety in the *Express* on February 8. In it the Germans were called "fellow-citizens" and urged to support the "white-man's ticket" in the forthcoming election. Blacks were categorized as ignorant Negroes who did not know the "first letter of the English alphabet." The *Herald* urged a vote against the "adventurous vagabonds, of the 'carpet bag' estates, who favor negro supremacy for the sake of the spoils," who could flee the state if things did not work to their advantage, leaving behind the Texans who were a "ruined wreck of their former selves."

From that point, the *Herald* heightened its appeal, warning voters that Texas might become another San[to] Domingo, where all industry and prosperity had withered. "Shall our State be so placed under a band of ignorant Africans, and *worse white men,* as to jeopardize capital, and drive away from us all railroad, telegraphic and manufacturing investments? . . . Do you wish to expel and stay from emigration to Texas the free born white men of the North and all Europe?" The diatribe ended by asking for all to vote against radicalism, to restore the state to its normal place in the Union, and to return to prosperity, peace, and harmony without "negro supremacy."[55]

Editor Siemering of the *Express* described Iwonski's cartoon:

ANSWER OF THE GERMANS TO THE ABOVE. On our first page we print a picture, executed by Mr. Iwonski, which is a complete answer to the appeal to the Germans by the murderers' apologist [the *Herald*].

The picture represents [Judge Thomas J.] Devine appealing to a German to join hands with him in putting down the Union party; old [Samuel A.] Maverick stands by watching the effect of Devine's appeal; [Col. James R.] Sweet of the Herald is attempting to draw the curtain over the past, but does not succeed. The Union-loving German points to the past—represented by the hanging and shooting of loyal Germans, and to our loyal fellow-townsman, Mr. [Ferdinand] Simon, lingering in the dungeon in which he has been cast by the arch-traitor Devine. The picture is a perfect study. The figure representing the German will readily be recognised as "Michel."

The picture speaks for itself, and needs no more explanation.[56]

---

55. Ibid., Feb. 8, 1868.

56. Ibid.; McGuire, *Iwonski in Texas,* 26, 82. Homeographs and newspapers courtesy of San Antonio Museum Association and the late Mary Vance Green, San Antonio.

Samuel Augustus Maverick (1803–1870), a legendary San Antonio and pioneer Texas figure, moved to Texas from his native South Carolina in 1835, fought in the Texas Revolution, signed the Texas Declaration of Independence in 1836, and became mayor of San Antonio in 1839 and 1840. Captured during Mexican Gen. Adrian Woll's invasion of Texas in 1842, Maverick was released the next year, served in the Texas Congress, in the state legislature from 1853 to 1862, and as one of the state commissioners who accepted General Twiggs's surrender in 1861. A county was

A third homeographed caricature, "Our Platform" ($3\frac{1}{8}$ x $4\frac{5}{8}$ inches on $3\frac{7}{8}$ x $4\frac{7}{8}$-inch mount), soon appeared in the bitter campaign. On February 21, 1868, the *Express* editor noted that "The last illustration by Professor Iwonski is more effective if possible than the answer of the Germans to the rebel appeal in the murderers' apologist," and that

"Our Platform" represents all the malignant rebels, the disappointed office-holders, and a few renegade Yankees who "can't go the nigger," holding up a platform, upon which stands poor little Charley Fischer, in an attitude of fear and trembling. The actors of the past *pas-de-deux* supply the music, while the two prominent figures of the "German Answer" carry the American banner at half mast. The fertility of the artist's brain is equal to [Thomas] Nast of Harper's Weekly celebrity, and we will hear "more richness" before the campaign is over.[57]

Edward Degener of San Antonio, a leader of Texas's German Radical Republicans, inscribed a copy of this homeograph to Swante Palm of Austin and included detailed identification, on the reverse, of the figures in the composition. Most were featured in the artist's "German Answer":

Democrat Party. Political Carr. [sic] San Antonio 1868—seen from left side A. S. [sic] Maverick—carrying flag—Mayor [J. H.] Lyons playing flute, Judge [John] Rosenheimer ("the Bullfrog") is drumming. Judge [T. J.] Devine with flag—Platform borne by Genl. [W. B.] Knox, City Engineer [G.] Friesleben, Dr. [Henry P.] Howard. On Platform Watchmaker [C. F.] Fisher (Candidate for the Legislature) on the platform is standing rather unsteady.[58]

named in Maverick's honor, and the word "maverick" derives from the myth of his ownership of all unbranded cattle. Webb, Carroll, and Branda (eds.), *Handbook of Texas*, II, 161.

In 1873 Iwonski executed a posthumous oil portrait of Samuel A. Maverick upon the request of his family, who had been impressed with the artist's caricature of their father in 1868. Mary Maverick Sammons later recalled "that Ivonski [sic] was a German artist and very bitterly set against the South. My father, Judge [T. J.] Divine [sic] and [P. N.] Luckett were appointed a committee to receive Government property in the Alamo Building, from Gen'l. Twiggs, and Ivonski drew a picture of a German hanging on a tree, to represent the actions of the South against the Union men; a great many Germans being Union men. The picture was so well drawn that my family asked Iwonsky [sic] to paint a picture of my father for us." Mary Maverick Sammons to Frederick Chabot, 1933, in *Texas Letters* (San Antonio: Yanaguana Society, 1940), 176.

57. San Antonio *Express*, Feb. 12, 1868; McGuire, *Iwonski in Texas*, 26, 82–83. Homeograph courtesy of Swante Palm Collection, HRC.

58. Ibid. Edward Degener (1809–1890), a native of Brunswick, Germany, served in the legislature of Anhalt-Dessau and was a member of the first German National Assembly at Frankfurt-am-Main during the Revolution of 1848. As a refugee in 1850, he came to Sisterdale, where he farmed. An outspoken opponent of slavery, he was imprisoned in San Antonio during the Civil War, and two of his sons were killed in the Nueces Massacre in 1862. Thereafter Degener was a member of the Conventions of 1866 and 1868–1869, a U.S. Representative from 1869 to 1871, and served on the San Antonio City Council until 1878. Webb, Carroll, and Branda (eds.), *Handbook of Texas*, I, 482.

To what extent Iwonski's artistic efforts, one pasted to the front page of the *Express* and the others probably distributed by hand, aided the local Republicans in the emotional election of 1868, when Radical Reconstruction replaced officeholders appointed during President Andrew Johnson's presidential program, is unknown. Certainly his editorial caricatures focused political issues for German American voters who bitterly recalled their mistreatment during the Civil War. In comparing his work to that of Thomas Nast, whose political cartoons in *Harper's Weekly* reached a national audience, Siemering paid him a high compliment.

Iwonski's identifiable portraits of local Democrat officeholders caught the attention of the public, and his use of "Michel," a figure symbolic of the honest, sturdy German, was not lost on German Republican voters. Iwonski witnessed a period of intense social and political change, and his thought-provoking compositions helped the electorate make decisions at the polling place. As did Nast's, Iwonski's caricatures amused, enraged, informed, ridiculed, and brought about change.[59]

Whatever Iwonski's personal thoughts may have been, he continued making sketches for his Radical friends. On December 17, 1868, Reconstruction Mayor Wilhelm C. A. Thielepape of San Antonio noted that "I have seen Iwonsky [*sic*]—he's at work to make several designs." Only two other homeographed political caricatures by the artist have been identified after that date: "The West is Kicking and Braking [*sic*] her Traces" (3½ x 4¾ inches) and "The Proposed New State of Cajuta [Coyote?]" (2¾ x 3¾ inches). Their exact dates are unknown, but both relate to debates over the proposed division of Texas into multiple states at the Constitutional Convention of 1868–1869.[60]

The convention which met at Austin was called to formulate a state constitution in compliance with Congressional Reconstruction to readmit Texas to the Union. Nullification, secession, and slavery were repudiated, and all citizens, including freedmen, who were given the right to vote, were recognized

---

Swante (Svante) Palm (1815–1899), a native of Sweden, was a reporter who fled his homeland under government disfavor. In Texas after 1844, Palm engaged in business with his nephew, S. M. Swenson, and headquartered in Austin after 1850. There he was an alderman, justice of the peace, postmaster, and vice-consul for Sweden, which later knighted him. An avid book collector, Palm left his library to the University of Texas. Webb, Carroll, and Branda (eds.), *Handbook of Texas*, II, 326–327.

59. Joanna Craig, "Thomas Nast: Conflict and the Political Cartoonist," *Texas Historian*, XLVII (Jan., 1987), 18–21.

60. Wilhelm C. A. Thielepape to James P. Newcomb, Dec. 27, 1868, James P. Newcomb Papers, San Antonio Public Library; Homeographs "The West is Kicking and Braking her Traces," "The Proposed new State of Cajuta," courtesy of Swante Palm Collection, HRC.

as equal before the law. Jacob Kuechler, the brother-in-law of Iwonski's business partner Hermann Lungkwitz, was a delegate to the convention and later was appointed and then elected general land commissioner under Gov. E. J. Davis, Texas's first Republican chief executive, from 1870 to 1874.[61]

Edward Degener, a member of the Texas Constitutional Conventions of 1866 and 1868–1869, and U.S. Representative from 1869 to 1871, claimed credit for inspiring Iwonski's caricatures dealing with the issue of division of the state. In his inscriptions to Swante Palm, he wrote "designed by Hon. E. Degener of San Antonio" or "plan[n]ed by Hon. E. Degener" on each homeograph. And Degener noted on the reverse of "The West is Kicking and Braking her Traces" that

> Genl. 'Jack [Andrew Jackson] Hamilton' drives three abreast the old state of Texas. The East and Middle draws well enough but the West is kicking and braking her traces! 'Middle' rears and neighs at the West for her unruly behavior. Political carricature [sic] during the session of the Legislature of Texas 1868. by Ivonski [sic] of San Anto[nio] by [sic] planed [sic] by Hon. E. Degener.

On its lower front edge, Degener wrote, "R. Roadeway [?] the bond [?] to hold Texas together." On the reverse, he inscribed "The Proposed New State of Cajuta," "Political Carricature [sic] by Ivonski [sic] designed by Hon. E. Degener of San Antonio. The Proposed new state of Western Texas is bound down by chains by the 'Austin Ring'—and Cajuta feels uncomfortable (Cajuta being the name given to that New State by Genl. Jack [Hamilton])."[62]

Whether Iwonski visited Austin during the sessions of the convention or personally knew A. J. Hamilton is unknown. Hamilton, a native of Alabama, came to Texas about 1846, served as attorney general in 1849, as a Texas legislator in 1851 and 1853, and as a U.S. Representative in 1859. A strong Unionist, he protested against secession and chose exile in 1862. Abraham Lincoln appointed him military governor of Texas during the war, and Andrew Johnson appointed him provisional governor in 1865. Defeated in the gubernatorial

---

61. Webb, Carroll, and Branda (eds.), *Handbook of Texas*, I, 398–399, 975. Jacob Kuechler (1823–1893) received his education at the University of Giessen in his native Germany and came to Texas in 1847 as a colonist of the Society for the Protection of German Immigrants to Texas. After his experiment with a utopian colony (Tusculum) failed, Kuechler became a surveyor in Fredericksburg. There he married Hermann Lungkwitz's sister-in-law, Marie Petri. Kuechler opposed secession, survived the Nueces Massacre, and spent the war years as an exile in Mexico, where he was a surveyor. He returned to become a delegate to the Convention of 1868–1869 and was appointed (and later elected) general land commissioner from 1869 to 1874. Later, he operated a private surveying and land company, and worked for the Texas and Pacific Railroad. Webb, Carroll, and Branda (eds.), *Handbook of Texas*, I, 975.

62. Homeographs courtesy of Swante Palm Collection, HRC.

election the next year, he served on the Texas Supreme Court and was defeat-
ed by E. J. Davis in the gubernatorial race in 1869. Known as "Colossal Jack,"
Hamilton played a leading role as a moderate Republican in the constitutional
convention which met on June 1, 1868.[63]

Hamilton opposed the division of Texas at the convention, especially the
plans of the Radicals, led by Davis, to create a State of West Texas, derisively
called the State of Coyote, with San Antonio as its capital and with a thinly set-
tled but largely foreign-born population, which might maintain Radical Re-
publican rule. The convention spent much time in 1868 and 1869 discussing
various proposals for dividing the state, and Hamilton was credited with de-
feating all of them. Degener, a Radical from San Antonio, probably inspired
Iwonski to prepare his two political caricatures in response. Why the future
German American congressman used the term "Cajuta" rather than coyote or
*der Praeriewolf* or *Steppenwolf,* the correct translations, in his inscriptions to
Swante Palm, is unknown.[64]

Iwonski's cartoons showed Colossal Jack attempting to keep the "West
Texas" horse in its traces with "East Texas" and "Middle Texas" as he attempt-
ed to defeat the proposals of divisionists. In his pocket is a whiskey bottle, an
allusion to his reputation as a heavy drinker. Iwonski's second cartoon showed
a coyote attached by a ring in his nose to Austin (Degener's "Austin ring") at-
tempting to pull away. No other commentary on the artist's homeographed
caricatures has been found, and their influence on the politicians is unknown.

Only two other drawings by the artist survive as photographic prints, and
neither dealt with local political affairs. The first was probably inspired by the
editor of the San Antonio *Express,* who called upon Iwonski to give the public
a sample of his talent in caricaturing the Franco-Prussian War.

What would the world be without jokes, was the querry [sic] that presented itself
to our mind, as we read in the dispatch that came to us: That "Bourbaka was marching
upon Berlin." Visions of the eminent fightist [Napoleon III], who threw his adversary
down on top of himself, and defiantly put his nose between his teeth, rose before us,
but failed to become a parallel case to that presented of Bourbaki [sic] marching upon
Berlin.

---

63. Webb, Carroll, and Branda (eds.), *Handbook of Texas,* I, 759–760; John L. Waller, *Colossal
Hamilton of Texas* (El Paso: Texas Western Press, 1968); Ernest Wallace, *The Howling of the Coyotes:
Reconstruction Efforts to Divide Texas* (College Station: Texas A&M University Press, 1979).

64. Wallace, *The Howling of the Coyotes.* Wallace's is the most complete discussion of proposed
plans to divide Texas. Opponents of division termed the efforts of its advocates the "howling of
the Coyotes."

Where is our young and talented friend Iwonski, who is so good at charaturing [*sic*]? We beg of him to give the subject a graphic aspect with his ready pencil, and yet the irrepressible sons of fun will have their jokes, even at French expense.[65]

No caricature resulted, but "Dictation of Terms in Franco-Prussian War" ($4^3/_4$ x 5 inches on $7^1/_8$ x 9-inch mount) commemorated the defeat of France by the German states. Iwonski's pencil study, in photocopy, exhibits his accurate portrayal of the German emperor, military commanders, and Bismarck preparing to sign the capitulation of Paris on January 18, 1871. The study was made in preparation for a huge, swiftly painted rendering, which was exhibited at San Antonio's Casino Hall during a spirited victory celebration by the German colony on January 31, 1871. A grand torchlight parade, fireworks, speechmaking, and "jollification" ended with the curtain raised to reveal Iwonski's composition, which inspired "from a thousand throats the glad huzzas." The audience honored Iwonski with a "spirited 'Hoch' for his 'superb painting.'"[66]

The last known photographic copy of a drawing, "Marie and Leopold von Iwonski" ($3^7/_8$ x $4^3/_4$ inches), was made by Iwonski following a study tour to Berlin in 1871. The artist's mother was shown sewing before an open window while her husband quietly smoked his pipe. The artist must have treasured this scene of German tranquility, for his father died late in 1872. Shortly thereafter, Iwonski accompanied his widowed mother back to their Fatherland, where they lived out the remainder of their lives.[67]

Although Iwonski was the most prolific user of DeRyee's homeographic process, other artists associated with both men also produced prints. Hermann Lungkwitz, an academy-trained landscapist from Dresden and Iwonski's long-time friend and photographic partner, photographically reproduced at least two of his drawings, "The Dr. Ernst Kapp Home, Sisterdale, Texas" ($6^1/_4$ x 9 inches) and "Ernst Altgelt's Perseverance Mill, Comfort, Texas" ($5^1/_2$ x $9^1/_4$ inches). Both studies were done a few years after Lungkwitz's arrival in Texas in 1851 and may have been photographed years later, either when Lungkwitz

65. San Antonio *Express*, Jan. 7, 1871.

66. *Freie Presse für Texas* (San Antonio), Jan. 31, 1871; *Flake's Daily Bulletin* (Galveston), Feb. 4, 1871; San Antonio *Express*, June 24, 1928; photocopy courtesy of Archives, San Antonio Museum Association. The original painting on cotton muslin, which hung in the Casino Hall until the 1920s and was thought to be lost, was recovered and given to the Sophienburg Museum and Archives, Inc., in New Braunfels, in the mid-1980s.

Iwonski's pencil study for the painting was copied in 1871 by Franz Hanzal (1830–1906), who joined the Lungkwitz & Iwonski photographic studio in San Antonio in 1869 and operated it after the two principals departed about 1870. McGuire, *Iwonski in Texas*, 21.

67. McGuire, *Iwonski in Texas*, 84; homeographs courtesy of Mrs. H. B. Dickinson, Helotes, Texas, and James Patrick McGuire, San Antonio.

became associated with DeRyee's magic lantern shows in the late 1850s or when Iwonski became his business partner after the Civil War.[68]

"The Dr. Ernst Kapp Home," a preliminary sketch, was made as early as 1853 when the artist visited Sisterdale, accompanied by his brother-in-law Richard Petri and Iwonski. It and other scenes and activities of Dr. Kapp's were produced as a lithograph by G. Kraetzer of New York for an advertisement, "Dr. Ernest [sic] Kapp's Water-Cure, Comal County, Texas." Of the thirteen scenes incorporated into the lithograph, only this one, shown at top center in the border of the finished product, survived in photographic copy. Another border scene, of the bathhouse, exists in the original pencil drawing. Lungkwitz's carefully detailed landscape showed the entire Kapp family at lunch on the lawn in front of the main house and included the smokehouse, spring house, and other outbuildings. It is one of Lungkwitz's earliest Texas works and marked the beginning of his career as the founder of Texas landscape painting.[69]

Lungkwitz's second sketch, preserved only in photographic copy, was of Ernst Altgelt's Perseverance Mill in nearby Comfort during the artists' excursion to the Guadalupe Valley in what was then western Comal County (later Kendall County). Lungkwitz had frequently chosen water-powered mills as subjects during his sketching journeys to the Alps in the 1840s, and Altgelt's mill in Texas received the same attention. Altgelt, also a German immigrant, platted the community of Comfort and established its first industry, a gristmill and sawmill, to attract settlers. Built on Cypress Creek in 1855, the structure which Lungkwitz sketched soon washed away in a flood. The first graphic illustration of the new frontier village, Lungkwitz's view included the mill and a few simple pioneer homes with a landmark hill, called the "Rigi" by the settlers, in the background. No other photographed or homeographed study by the artist exists.[70]

---

68. McGuire, *Hermann Lungkwitz,* 180, 182, nos. 200, 216; Guido Ransleben, *A Hundred Years of Comfort in Texas; A Centennial History* (San Antonio: Naylor Co., 1954), 29–30. Homeographs courtesy of Comfort Museum and Roy Perkins, Comfort, Texas.

69. Ibid.; Samuel Wood Geiser, "Chronology of Dr. Ernst Kapp (1808–1896)," *SHQ,* L (Oct., 1946), 297–300; Webb, Carroll, and Branda (eds.), *Handbook of Texas,* I, 937–938. Ernst Kapp (1808–1896), a native of Bavaria and graduate of the University of Bonn, was a student of Hagel and Carl Ritter. Kapp wrote several books on geography, history, and philosophy, and advocated liberal government. He came to Texas in 1849 as a political refugee of the Revolution of 1848. His water cure sanitorium, unique in Texas, attracted German patrons who had patronized similar spas in Europe. It closed with the outbreak of the Civil War, and in 1865 Kapp and part of his family returned to Germany, where he died in Düsseldorf in 1896.

70. For information on Ernst Altgelt, see Henry B. Dielmann, "Emma Altgelt's Sketches of Life in Texas," *SHQ,* LXIII (Jan., 1960), 363–384; McGuire, *Hermann Lungkwitz,* 182, no. 216; Crystal

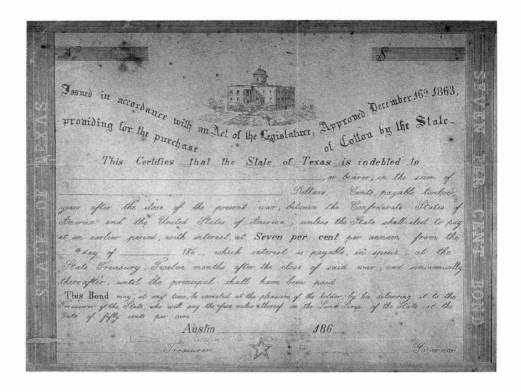

*State of Texas Seven Per Cent Bond.* Homeograph by William DeRyee from a drawing by William von Rosenberg, c. 1864, 7¼ x 9¼ inches. *Courtesy Virginia von Rosenberg Lane, Austin.*

By the time Lungkwitz reproduced more than 100 Texas county maps as the first official photographer of the General Land Office from 1870 to 1874, the term "homeography" was no longer in use. Land Commissioner Jacob Kuechler, his brother-in-law, had a wooden photographic studio with overhead and side glass panels constructed on the rear of the imposing Land Office building and spent liberal amounts of public funds to equip it. Copies of Lungkwitz's work form part of the archives of that state agency.[71]

William von Rosenberg (1821–1901) was the only other Texas German immigrant artist whose work, a carefully drafted land-scrip bond (7¼ x 9¼

Sasse Ragsdale (ed.), *The Golden Free Land: The Reminiscences and Letters of Women on the American Frontier* (Austin: Landmark Press, 1976), 132–155; Ransleben, *Comfort in Texas*, 29–30.

71. McGuire, *Hermann Lungkwitz*, 32–35.

inches), often called a "Cotton Bond" and discussed above, DeRyee repro-
duced homeographically. Rosenberg's excellent penmanship was evident in its
drafting, and he inscribed "Original by W. von Rosenberg" on the lower left
edge. Educated as a surveyor and architect in Berlin, Rosenberg, like Lungk-
witz, came to Texas with his family as a refugee of the Revolution of 1848. At
first he attempted farming in Fayette County, then became a draftsman in the
Texas General Land Office in 1856. Named chief draftsman four years later, he
served until 1867, interrupted only by two years as a topographical engineer in
the Confederate Army. Thereafter he operated a private land agency and was
a civic leader in Austin until his death.[72]

Rosenberg, accomplished at drawing, began sketching views of Austin
soon after his arrival in the mid-1850s. The State Capitol was one of his fa-
vorite subjects and was included in his draft of the land-scrip bond in 1864.
Production of the bond was DeRyee's last identified commercial use of any
photographic process. Fortunately for future generations and art historians,
homeographed copies of the work of these pioneer artists survived as testi-
mony to their productivity, curiosity, and ingenuity. The body of their output

---

72. Dale U. von Rosenberg, "A biography of William von Rosenberg," MS (1984), William von
Rosenberg File, ITC; Louis E. Brister (ed. and trans.), "William von Rosenberg's *Kritik:* A History
of the Society for the Protection of German Immigrants to Texas," *SHQ,* LXXXV (Oct., 1981),
161–186; (Jan., 1982), 299–318; (Apr., 1982), 409–422.

The bond read "State of Texas" and "Seven Per Cent Bond" on its left and right edges, respec-
tively. Its text read:

Issued in accordance with an Act of the Legislature, Approved December 16th 1863, providing for
the purchase of Cotton by the State.

This Certifies that the State of Texas is indebted to _____, or bearer, in the sum of _____ Dollars,
_____ Cents, payable twelve years after the close of the present war, between the Confederate States of
America and the United States of America, unless the State shall elect to pay at an earlier period, with in-
terest, at SEVEN PER CENT per annum, from the ___th day of _____ 186_, which interest is payable, in
specie, at the State Treasury, Twelve months after the close of said war, and semiannually thereafter,
until the principal shall have been paid.

THIS BOND may, at any time, be canceled at the pleasure of the holder, by his delivering it to the
Treasurer of the State, who will pay the face value thereof in the Land Script of the State, at the rate of
fifty cents per acre.

Austin _____ 1860

_____ Treasurer _____ Governor

Inscribed at the lower right was "Homeographed by W. DeRyee, Chemist Nitre & M. Corps
T.M.D."

For a summation of the work of the Texas Military Board in the months following the end of
the war, see the report by E. M. Pease and Swante Palm in the *Southern Intelligencer* (Austin), Nov.
9, 1865. See also Swante Palm Papers, CAH.

provides a rare insight into the social, political, and cultural events and conditions which they experienced.[73]

Interestingly, personal ties developed among the artists, all German immigrants, who used DeRyee's process. Both Iwonski and Lungkwitz were actively associated in business with him before the Civil War and continued their careers in their own studio in San Antonio during Reconstruction. When Lungkwitz moved to Austin to become official photographer of the General Land Office in 1870, he became acquainted with former chief draftsman Rosenberg in the small but active Austin German colony. During the Civil War, several of Rosenberg's children worked under DeRyee in the percussion cap factory. And the Rosenberg and Lungkwitz families strengthened their ties when one of Lungkwitz's twin daughters, Helene, married Rosenberg's son, Ernst Johann, in 1879.[74]

By the early 1870s, the use of DeRyee's homeographic printing process ceased. Iwonski, the artist most closely associated with DeRyee, left Texas, and other artists turned to other formats. DeRyee followed commercial and other pursuits in south Texas and maintained a lifelong interest in chemistry and mineralogy. Homeography was soon forgotten by the public. Only rare samples, now faded yellow brown, survived in widely scattered collections, and old newspapers which recorded its use were consigned to dusty archives. The issues which Iwonski addressed in his political caricatures, the most numerous surviving homeographs, became part of Texas's Reconstruction history.

DeRyee's process was used to popularize the political ideas of the Radical Republicans during Reconstruction, to provide information on contemporary landscape and city views, to commemorate historic figures and events as Texas entered the Civil War, and to give nostalgic views of social and domestic life. Perhaps most important, the public could afford homeographed copies of the artists' original sketches. In addition, DeRyee recognized that

73. Homeograph courtesy of Virginia von Rosenberg Lane. Rosenberg's "City of Austin," drawn as a view south from Hugh Tinnin's place in 1856, is from the collection of Texas Memorial Museum, University of Texas at Austin. "The Capitol in the City of Austin," a view from the south, was likewise completed in 1856. Both are now in the CAH.

74. Payroll for Percussion Cap Factory, August 1863, Papers of the Military Board, Texas State Library, Archives Division; McGuire, *Hermann Lungkwitz*, 38.

DeRyee, facing a manpower shortage, did not hesitate to employ child labor in the state's cap factory. William von Rosenberg's two oldest sons, Charles (b. 1850) and Arthur (b. 1851), were listed on its payroll in 1863. On February 28, Charles was paid $14.25 for filling 14,250 caps during eighteen days that month. DeRyee's own minor children, Emil (b. 1850) and Charles (b. 1855), likewise filled caps, with his wife, Ida, acting as the "superintendent of the cap filling section" in 1864. See Ordnance Stores—Percussion Cap Factory, Papers of the Military Board.

the process could be used to produce economical multiple copies of documents such as the Texas land-scrip bond. DeRyee's homeographic invention briefly flourished and disappeared, a testament to the creative atmosphere afforded an experimenter on Texas's mid-nineteenth-century western frontier.

Students at the West Texas Normal and Business College, Cherokee, Texas, ca. 1900. *Courtesy Center for American History, University of Texas at Austin.*

# Immaterial Girls: Prints of Pageantry and Dance, 1900–1936

 è·

## Cynthia A. Brandimarte

P hotographic prints taken of young women in diaphanous dresses and gossamer gowns, poised, some indoors, some outdoors, in symmetrical formation and ranging in date from approximately 1910 to 1930, have long posed a problem for interpreters of the Texas scene (fig. 1). Beguiling images, they appear frequently in collections of Texas views. Unfortunately, those same collections fail to attach meaningful captions to the images, often noting only their uniqueness and frivolity.

Such an image appears in *Dallas: The Deciding Years,* a line of white-robed dancers holding a daisy chain and punctuated by a pair of dancers reclining on the floor. The author's caption reads: "Some veterans say this is Miss Hart's dancing class. Everybody liked to dance . . . nearly everybody."[1] This hardly illuminates the subject. Likewise, even contemporaneous commentary about the images was no more informative. The University of Texas yearbook, *The Cactus,* illustrated its 1925 issue with sprightly dancers poised out-of-doors in a tree-filled setting; the caption explained, "After looking at these pictures we don't wonder that the boys take to the woods in the spring."[2] Images like these

1. A. C. Greene, *Dallas: The Deciding Years, A Historical Portrait* (Austin: The Encino Press, 1973), 153. The author is grateful to those who so generously contributed information to this research: Claire Kuehn, formerly of the Panhandle-Plains Historical Museum, Canyon; Peggy Riddle, formerly of the Dallas Historical Society, Dallas; and Tom Shelton of the Institute of Texan Cultures, San Antonio. Thanks to Ellen Brown of the Texas Collection at Baylor University, Waco, and Dr. James Conrad of the Gee Library at East Texas State University, Commerce, the author had access to exceptional collections relating to the pageantry movement in Texas. Metta Nicewarner of the Blagg-Huey Library at Texas Woman's University, Denton, and her staff, Kim Grover-Haskin, Christina Cowan, and Peg Rezac, deserve special thanks for their prompt and cheerful response to the author's inquiry.

2. *The Cactus* (Austin: University of Texas, 1925), n.p.

are far from unique and motivated by much more than simple "frivolity." These prints of young women dressed in flowing, loose fitting gowns of white document the pageantry and dance movements in Texas. In 1912, one observer of the movement asserted that Americans had gone "pageant mad."[3] Three years later, a drama critic noted that "[a]mong the social developments of the past ten years none has been more significant than the rapid growth of pageantry. . . . It is now a commonplace that the pageant is a potent instrument in the social programme."[4] From coast to coast, Americans sponsored historical, civic, patriotic, and allegorical pageants that celebrated liberty and justice or, just as frequently, current issues like scientific achievements, rural progress, railroads, and suffrage. "How-to" books were published on successfully producing pageants, and more than 200 articles on pageantry had appeared in periodicals by 1914. But this important episode in American culture has long been neglected in our writing of Texas history.

What was a "pageant"? Definitions abounded. One writer defined a pageant as "a dramatic representation of several scenes, either tableaux or miniature integral dramas which are unified by prologues."[5] Another interesting definition (or arguably un-definition) stated that a pageant is "some sort of a dramatic production on a large scale, differentiated from a play by the large number of participants, by a general looseness of structure and vagueness of underlying idea, and by the absence of plot."[6] Vague, indeed. But the American Pageant Association, founded in 1913, outlines a pageant as "the drama of the history of life of a community. As such, its interest is based upon community character-development. It may be given complete dramatic and realistic presentation, with added symbolic interludes or dances; and it is generally divided into a series of related scenes or episodes."[7]

Lest students of the movement think that a pageant was spontaneous "fun," they should consider the elaborate lists and charts included in pageant handbooks. These manuals offered advice on how to organize pageant fund raising, ticket sales, and police assistance, as well as how to produce costumes, instruct dancers, and rehearse chorus and orchestra. The American Pageant

3. Adelia Belle Beard, "The American Pageant," *American Homes and Gardens*, IX (July, 1912), 239, as quoted in Trudy Baltz, "Pageantry and Mural Painting, Community Rituals in Allegorical Form," *Winterthur Portfolio*, XV (Autumn, 1980), 211.

4. Thomas H. Dickinson, *The Case of American Drama* (Boston: Houghton Mifflin Co., 1915), 160, as quoted in Baltz, "Pageantry and Mural Painting," 212.

5. Esther Willard Bates, with an introduction by William Orr, *Pageants and Pageantry* (Boston: Ginn and Co., 1912), 7.

6. Esther Willard Bates, *The Art of Producing Pageants* (Boston: Walter H. Baker Co., 1925), 1.

7. Ibid.

Association published outlines of history, from "Mound Builders" to "American Amalgamation," that pageant planners could use as guides for their narrative episodes.[8] And accounts of Texas pageants confirm that much work and planning went into these elaborate shows. On the University of Texas campus in the spring of 1916, one witness observed:

> For weeks practically the entire student body had been busy preparing for possibly the greatest spectacular event that has ever successfully been staged in the history of the University. For weeks fantastically garbed groups of students had been busy practicing the parts that had been assigned to them by the various instructors who had these groups in charge.[9]

At the College of Industrial Arts in Denton (now Texas Woman's University), three different departments collaborated on a pageant: the Departments of Expression, Music, and Physical Training. Over 200 students participated: the College Orchestra played throughout the program; voice students sang; and members of the Art Department designed costumes, color schemes, and promotional postcards.[10] Indeed, much effort had to be "mobilized" in order to produce all the necessary elements of a pageant: the music, text, dance, artwork, costumes, personnel, and promotion.

Certainly, these pageants in Texas and elsewhere did not arrive suddenly and full-blown during the first decade of the twentieth century; instead they had precedents in earlier public celebrations including historical orations, displays of relics, monument building, and processions (fig. 2). But in addition to these more serious forms of celebrations, towns "made merry" with carnival parades, fireworks displays, dances, and athletic competitions.[11]

The more frivolous festivities caused alarm among two groups of town leaders: genteel reformers and progressive recreation reformers. The genteel reformers were members of a civic elite who saw trouble in what they perceived as a growing commercialization and lack of serious purpose in civic festivities and their carnival-like atmosphere. Added to these genteel reformers were the progressive recreation reformers who likewise noted the problem of

8. See David Glassberg, "American Civic Pageantry and the Image of Community, 1900–30" (Ph.D. diss., Johns Hopkins University, 1981), figs. 1 and 2, Supplements to the American Pageant Association Bulletins Nos. 11 and 19 respectively. See also pageant manuals which contain elaborate instructions for organizing and managing pageants. Since the presentation of this paper, this dissertation has been revised and published as David Glassberg, *American Historical Pageantry: The Uses of Tradition in the Early Twentieth Century* (Chapel Hill: University of North Carolina Press, 1990).

9. Austin *American*, Apr. 23, 1916.

10. *The Lass-O* (Denton), Apr. 28, 1916.

11. Glassberg, "American Civic Pageantry," 7–45.

Parade float of the William Cameron Lumber Company, Waco, Texas, ca. 1910.
*Courtesy Texas Collection, Baylor University.*

the mass of Americans' lack of wholesome holiday pastimes.[12] Together, their concern sparked and fueled the pageantry movement.

In Texas, pageantry most frequently took the form of four types of performances: the "allegorical" or the "symbolic" pageant; a general classification, the "civic" pageant (developing a social or civic ideal); the Elizabethan or Shakespearean pageant; and finally the historical pageant.

One of the grandest allegorical pageants was held on the campus of the College of Industrial Arts in Denton, where on May 3, 1917, thousands witnessed "The Awakening of Spring" in which 230 women danced. Promoting the upcoming pageant, the community's newspaper published the narrative:

A young hunter wanders into a haunted grove where the winter bower of the Goddess of Spring is hid. Weary from his day's hunt, he drinks at the spring among the

12. Ibid.

ferns, then throws himself down a mossy bank and sleeps. The magic water transports him to the realm of fancy, and the awakening of Spring is revealed to him.

At the charmed hour of twelve, Pan dances in and, with his piping, awakens Spring and all the emotions and joys 'that tend upon her state.'

The March Winds rush on, sweeping the Dead Autumn leaves away. April dances in with the Raindrops. One Raindrop finds a shell containing the water of eternal life; this she gives to April. The Raindrops are scattered by the Sunbeams bursting upon them. With the water of eternal life, April and the Sunbeams awaken Spring from her long sleep and lead her to her throne.

First to pay homage to Spring are the Green Leaves and the summer Breezes. Then Flora comes with her attendants bearing gifts of flowers. Joys attends upon Spring, bringing the children after them. The children play their games before Spring and dance for their "Maypole" dance. The shades of Evening and the Imps of Darkness drive the children home. The God of Love is piped in by Pan, and after Love comes the shepherds and the shepherdesses. After dancing for Spring, they wander off over the hills. One shepherd and shepherdess remain in the grove. She sees the flower that Love has, and asks the shepherd for it. The shepherd offers her other flowers, but she will be content with none but Love's flower. The shepherd tries to get it, but Love eludes him. At last, Love tips his arrow with the flower and lets it fly to the shepherd. Wounded by Love's shaft, the shepherd takes the flower from the arrow and gives it to the shepherdess.

Pan then pipes the Queen of Spring and her attendants over the hills to bless all the earth.

It is now day-break, and a young girl comes into the grove looking for the first blossom of May. Her song awakens the hunter. He finds for her the first spring flower and they wander away in the path of spring.[13]

The Denton pageant was typical of many allegorical pageants which took place in the spring and celebrated the transition of the seasons. Such pageants were variously called spring festivals, May festivals, or May Fetes and were held on college campuses and school grounds (fig. 3). East Texas State College offered a 1929 May Festival announcing that "Greek Myth Is Theme." In Commerce, Texas, over 250 college and grade school students danced the Persephone myth dressed as Grecian maidens and goddesses, gowned in white, just a few months before Black Thursday.[14]

---

13. Denton *Record Chronicle*, May 3, 1917. In addition to allegorical, civic, Elizabethan, and historical pageants in Texas, oral history reveals that religious pageants were also held in the state. To date, no radical political pageants have been found to have taken place in Texas. For an example of such a pageant held elsewhere, see Linda Nochlin, "The Paterson Strike Pageant of 1913," in *Theatre for Working-Class Audiences in the United States, 1830–1930*, ed. Bruce A. McConachie and Daniel Friedman (Westport, Conn.: Greenwood Press, 1985), 87–95.

14. *The East Texan* (Commerce), Apr. 29, 1929.

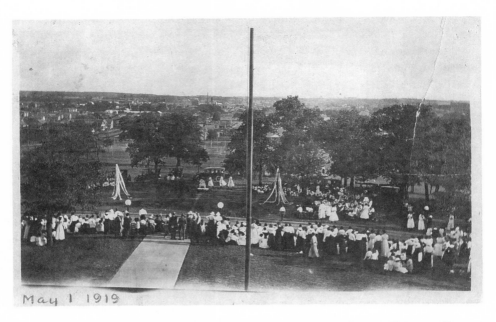

May 1 1919

May Festival on the campus of the College of Industrial Arts, Denton, Texas. *Courtesy Texas Women's University, Denton.*

What was the source of this Greek imagery? And what was its appeal to late nineteenth- and early twentieth-century Americans and Texans? The American Renaissance was a movement that found expression in this country's art and architecture from approximately 1876 to 1917. The word "Renaissance" referred to the Italian revival of classical antiquity in art, architecture, and letters which had occurred in the fourteenth through the sixteenth centuries. Greek and Roman art had provided the original sources for the Renaissance.[15]

At the turn of the century, American students were encouraged to model their art work on classical statuary; plaster casts were incorporated wholesale into American museum collections; and even amateur artists were encouraged to paint classical figures on vases and plates. The homage paid to Greek culture took many forms. In sport, the Olympic Games were revived in 1896. Greek design inspired furniture design as well as architecture. This looking to the past for inspiration characterized the genteel tradition of American Victorians who believed that civilization had progressed to the pinnacle of their own

15. See Brooklyn Museum, *The American Renaissance 1876–1917* (Brooklyn: Brooklyn Museum, 1979).

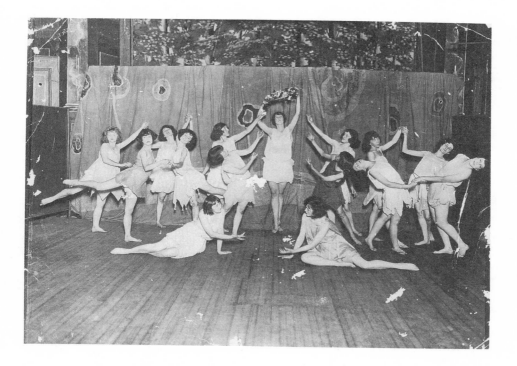

Dancing class, Eulogy, Texas, ca. 1925. *Courtesy Texas Collection, Baylor University, Waco.*

present and that as inheritors of the past they could select the best of the past for their own purposes. The "best" often meant Greece.[16]

The Greek goddess represented the ideal for late nineteenth-century Americans. She served as a counterpoint to the moral ennui and crass materialism that many culture critics observed in American life. One such critic stated, "[t]he Greek in his glory was visual-minded with acute sensibility to the power of form, color, movement. This day of glory has not arrived with the American, who finds more pleasure earning a dollar. . . . So long as acquisitiveness is the main characteristic, a race can have no culmination of artistic perfection. The pageant is a reaction against hustling, individual money-grabbing. . . ."[17] These "immaterial girls" became the visual and thematic common denominator in the pageantry movement (fig. 4).

16. Howard Mumford Jones, *The Age of Energy: Varieties of American Experience, 1865–1915* (New York: Viking Press, 1971), 216–258.

17. Ralph Davol, *A Handbook of American Pageantry* (Taunton, Mass.: Davol Publishing Co., 1914), 95.

Not all references to Greek life returned to classical antiquity, however. Other strong elements in the pageantry movement included the issues of folk cultures and ethnicity. Greece, Sweden, Ireland, Japan, and other countries were represented as folk cultures. For reformers, folk dancing had a valuable lesson. Folk dances should be taught to American children (who on the evolutionary scale were equated with simple folk) because "[t]hese coordinations are historically old. They are the kind of movements that have meant success. They are the kind of movements because of which our forefathers survived. The man who could run and jump and throw was better fitted to survive than the man who could not do these things. . . ."[18] In this post-Darwinian age, many believed that if children experienced their past via these folk dances, they would be prepared for their future. In other words, they would evolve. So folk dances and ethnic costuming became important elements of many types of pageants, especially at Elizabethan festivals and May fêtes.

Allied with folk cultures was the issue of ethnicity. Historical pageantry, in which various ethnic groups appeared as early settlers of the community or, in the finale, as later immigrant groups who were cheerfully embraced by the community, depicted all groups peacefully joining the community, experiencing neither hostility nor prejudice. Civic pageants also used ethnicity, capitalizing on the cosmopolitan impulse and ethnographic curiosity of the Victorians, while providing a metaphor of community during a decade of great immigration into the United States. One such pageant featured over 400 University of Texas students, who staged a performance at Clark field on April 6, 1914. The costumed students represented six countries—Sweden, France, Italy, Russia, Greece, and America—and performed dances characteristic of each country. Some of the students also gave the popular aesthetic dances "The Golden Butterfly" and "The Firefly."[19]

The Young Women's Christian Association held a similarly cosmopolitan and ethnic pageant at UT in 1912; an identical one was held in 1914 in Denton at the College of Industrial Arts. In Austin, 150 young women formed the cast of the pageant, the purpose of which was to acquaint the audience with the YWCA and, thus, create interest in its work. Embodying the "Spirit of Womanhood," the prologue told the audience what Christianity had done for women. Scenes from China, India, and South America were followed by one set in Japan as "girls in gay kimonos played games under an arbor covered with blossoming vines and hung with bright Japanese lanterns, while cherry

18. Luther H. Gulick, *The Healthful Art of Dancing* (New York: Doubleday, Page and Co., 1910), 182.

19. *The Cactus* (Austin: University of Texas, 1914), n.p.

trees in full bloom filled the background." The pageant closed with the "Association Spirit" enthroned and surrounded by the girls from all the nations, "their bright costumes intermingling, their voices raised in a missionary hymn, set to the music of 'The Pilgrims' Chorus.'"[20]

A more overtly topical manner in which the idea of ethnic community "played" was in the civic pageant entitled "The American Girl on Trial." In turn, representatives from Russia, France, Japan, and Great Britain approached the American girl as she sat drinking tea, reading magazines, or engaging in other "frivolous" recreations to accuse her of not doing her part in "the great world war." The Spirit of the YWCA arrived to agree with the other plaintiffs, but also to assert that a few American women had awakened to the war effort (this tableau featured one of the awakened showing another how to roll bandages). In the final tableau, Columbia appeared, surrounded by students of the College of Industrial Arts offering their work to the Red Cross.[21]

An easily recognizable pageant type was the Shakespearean or Elizabethan pageant. The year 1916 marked the 300th anniversary of William Shakespeare's death. In honor of the Bard's tercentenary, pageants were held from coast to coast. Beginning a week-long celebration of scholarly lectures on the life and works of Shakespeare and performances of his plays, the University of Texas staged what was billed as "a monster pageant" on April 23, Shakespeare's birthday. The Austin *Statesman* described the event:

Like a huge thread of iridescent sheen—animated, exuberant, sparkling—symmetrically interwoven with the verdant trees and multitudes of gaily attired Elizabethan citizens, the radiant Shakespearean pageant moved sedately with dramatic and comic pantomime in a winding course over the university campus Saturday evening from 6 until 7:30 o'clock.

Each of twelve groups of actors performed a scene from the plays, either in pantomime or recitation. Jesters and minstrels accompanied the parade of masked actors. When the last scene ended, the group disbanded and rushed to Clark field where "a long file of beautifully dressed girls marched in and executed with supple grace the old Morris dances." Four hundred university men, dressed as sailors, entertained the crowd of 5,000 with "The Sailor's Hornpipe Dance." Following this, the nine muses regaled Shakespeare with a graceful dance. The evening ended, according to the *Statesman*, with "[h]ilarious fun, rollicking mirth, cheerful banter, confetti, heavy drinking of soft cider, [and] dancing on the smooth field."[22]

20. *The Cactus* (Austin: University of Texas, 1913), 201–202; *The Lass-O* (Denton), Nov. 12, 1914.

21. *The Lass-O* (Denton), Nov. 2, 1917.

22. Austin *American*, Apr. 23, 1916.

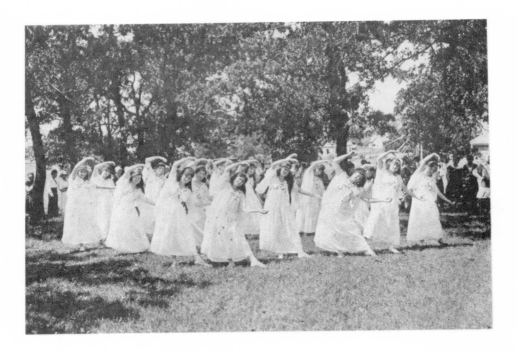

Shakespearean Pageant, College of Industrial Arts, Denton, Texas, May 22, 1916. *Courtesy Texas Women's University, Denton.*

Likewise in Denton, students staged an outdoor anthology of some of Shakespeare's plays. And although the student newspaper promised several days before the May 22 pageant that the students were preparing to "present a spectacle such as has never before been seen in Denton or among the colleges of the Southwest," the elements of the celebration sound remarkably familiar: Morris dances, English folk dances, scenes from *A Midsummer Night's Dream* and *The Tempest*, among others, and plenty of white-robed dancers.[23]

What was the appeal of these Elizabethan pageants? Pageantry-movement reformers appreciated the colorful processions and lively folk dances of Elizabethan England for several reasons. These pastimes offered colorful and worthwhile alternatives to the constraints of industrialism and the reckless revelry of commercial amusements. Just as significantly, however, by drawing upon the source of the celebrations, Elizabethan England, reformers used these pageants to reinforce the country's Anglo-American identity without attacking the Anglo-American heritage of Puritanism and hard work.[24]

23. *The Lass-O* (Denton), May 5, 1916.
24. David Glassberg, "Restoring A 'Forgotten Childhood': American Play and the Progressive Era's Elizabethan Past," *American Quarterly*, XXXII (Fall, 1980), 351–368.

The historical pageant offers a vehicle for exploring how Texans celebrated their past. San Antonians paraded in "Fiesta" and reenacted the Battle of the Alamo in the late nineteenth century.[25] During the course of this relatively discrete pageantry movement of the early twentieth century, Texas entertained a variety of "pasts." Commemorating its American past, Austinites of 1915 held a Columbus Day pageant at Wooldridge Park. The festivities included the singing of the national anthem and the raising of the flag, followed by an address by Gov. James E. Ferguson and a series of chronological tableaux depicting events in the life of Christopher Columbus: his departure from Spain, his discovery of America, and his return to Spain. Columbia appeared and was joined by the Goddesses of Liberty and Peace. The singing of "The Star Spangled Banner" and the lowering of the flag closed the ceremony. Sponsored by the Knights of Columbus and its women's auxiliary, the pageant adopted a national past for its theme.[26]

Less than one month after Austin's Columbus Day pageant, Waco offered a decidedly Texas past as the theme of its pageant. The pageant's subject was not the discovery of America, but rather the discovery and development of Waco, from the murder of Philip Nolan in 1801 until the 1915 present. The city's unique history, however, was also portrayed as archetypal, in standard pageant form. In a revealing disclaimer, the program preface stated: "Since in pageantry minutes must represent years, the typical is to be desired rather than the actual, and truth in a large measure rather than photographic accuracy of detail."[27]

Throughout the eight episodes, sprites danced and women in classical garb posed during "symbolic interludes," integral parts of the pageant composition. It was these symbolic interludes, represented by the "immaterial girls," which helped to create a sense of continuity in the history of the community. American pageant masters claimed that the allegorical transitions, along with the future scenes, were the uniquely "American" contribution to pageantry.[28]

25. Bill Green to Cynthia Brandimarte, Nov. 4, 1988.

26. Austin *American*, Oct. 13, 1915. Probably the most spectacular pageant ever planned in Texas, "The Pageant of Austin," was scheduled for earlier that year, April 26 through 29. One of the foremost American pageant masters, William Chauncy Langdon, wrote the script, and Frank LeFevre Reed, University of Texas music professor, wrote the music. (These materials are housed at the Austin History Center and the Center for American History at the University of Texas, Austin.) "The Pageant of Austin" was to be held at the newly completed Colorado Dam. Just before the pageant, however, a heavy rain fell on Austin and the consequent flooding canceled the pageant. To date, no information has been located that the pageant ever took place. This pageant is the subject of further research.

27. Mrs. J. M. Hale, "Preface," in "Historical Pageant of Waco, Texas Cotton Palace" [Nov. 6, 1915], n.p., Texas Collection, Baylor University, Waco (cited hereafter as TC).

28. Glassberg, "American Civic Pageantry," 116.

That sense of continuity of the past and the present was the essence of historical pageantry in the 1910s:

This, in brief is the early history of Waco. Today there is a magnificent city where the Indians once had their village. Philip Nolan is forgotten, the old ferry is obliterated, many of the landmarks are gone, but now and then the old citizens can point to structures and places which by tradition connect the Old Waco with the New.[29]

And the symbolic interludes assured spectators that despite changes in a "town's shape and circumstances, the same underlying 'emotional substance' . . . remained."[30]

In order to see what often happened to historical pageantry after World War I, consider the YWCA Pageant of Waco presented in May 1923.[31] Having become a kind of "fill-in-the-blank" pageantry, the YWCA's pageant organization could clearly be taken to other locations far from Waco and overlaid onto those distant communities' histories. Such was often the case when commercial production companies entered the community historical pageant market in the 1920s. The Waco pageant was produced by the John B. Rogers Producing Company, which sent its pageant-masters on jobs throughout the United States and Canada and, in effect, borrowed its pageant format from the published guidebooks and pageants of dramatists and recreation workers written before the war.[32]

A look at the 1923 Pageant of Waco reveals a trend in pageants during the 1920s. During the 1910s, the didactic allegory represented by the "immaterial girls" was integral to the thematic continuity of the pageant; but in the 1920s, the allegorical figures were used for their value as large-scale spectacle. The Rogers Company's community pageants employed elsewhere the same readymade spectacular scenes used in the Waco pageant: Creation, Prophecy of Time, the Masque of Nations.[33] Under the direction of this national pageant company, Texas history became but a loose background for special effects.

Besides these types of pageants there were other whimsical ones, like the reenactment of the current issue of the very popular women's magazine, *The*

29. James Hays Quarles, "Historical Sketch," in "Historical Pageant of Waco," n.p.

30. Glassberg, "American Civic Pageantry," 272, quoting William Chauncy Langdon, "Lecture notes for Course on Pageantry, University of Illinois, 1918," in W. C. Langdon Papers, Harris Collection, Brown University.

31. See "Young Women's Christian Association offers the Pageant of Waco, Under Supervision of John B. Rogers Producing Company, Cotton Palace, Waco, Texas, May 18–19 [1923]," Cotton Palace files, TC. The pageant program shows that the interchangeable and large-scale sequences "overwhelmed" the historical episodes.

32. Glassberg, "American Civic Pageantry," 233.

33. Ibid., 245–246.

*Ladies' Home Journal*, of November 1917, presented not a month after the preparedness pageant, "The American Girl on Trial." The students used the different columns of the *Journal* to inspire some of their tableaux. The idea was essentially to present from cover to cover the pages (including the advertisements) of the magazine.[34]

Compared with some of the allegorical, patriotic, and whimsical pageants, the East Texas State College pageant of 1930 appears mundane, efficient, and economical. The pageant theme was "Betty in Healthland." The pageant was set in a garden, where a little maid, Betty, is seeking health in Fairyland; the guardian of Health guides her through the seasons and teaches her what to eat and drink and how to take care of herself in order that she may be happy and healthy. There were group dances performed by the Physical Education students and the familiar cast of characters—raindrops, rainbows, and snowflakes—but there were also the more practical and necessary fruits and vegetables, home-grown staples for a people learning the lesson of limits, the note struck by the Depression.[35]

The extravagances of past years were curtailed by more than just imagination. Certainly much of the money behind the elaborate and costly pageants of the 1910s and 1920s was more difficult for some communities to raise by 1930. For example, throughout the 1920s, in conjunction with the Cotton Palace celebration, Waco children had been involved in their own pageants. Themes of "Flowerland," "Cinderella," and "Revels in a Doll Shop" had entertained the crowds during the decade. But in 1930, instead of planning, staging, and constructing props and costumes for a new pageant, the planners opted to present an anthology of past pageants.[36]

But even before 1930, the knell may have been sounding. In 1925, the children of Waco had presented a pageant entitled "An Evening with the Stars." Again, the audience saw the familiar cast of the ever-popular moonbeams and starlights, but they also witnessed a few less-abstract references to stars. Children no longer dressed up as Truth and Purity; they mugged like Gloria Swanson, Charlie Chaplin, Lillian Gish, and Buster Keaton.[37] Indeed, the burgeoning entertainment industry was beginning to offer an enjoyable and alluring

34. *The Lass-O* (Denton), Nov. 30, 1917. The students even enacted the magazine's advertisements, dressing like "Cream of Wheat" and "O'Cedar Mop," for example. By comparing the description of the pageant, as published in the newspaper, with the actual November 1917 issue of the *Ladies' Home Journal*, one can see that the students did not exactly represent the magazine's contents.

35. *The East Texan* (Commerce), Apr. 18, Apr. 30, 1930.

36. See programs of various years in the Cotton Palace files, TC.

37. See "'An Evening With the Stars' featuring Three Hundred Waco School Children in the Texas Cotton Palace Coliseum," Cotton Palace files, TC.

alternative to the pageant form, a kind of community theater without community.

Certainly the pageant form was not dying altogether. Austin, for example, began an annual pageant in 1929, and seven years later "The Cavalcade of Texas," a historical pageant, played to large crowds at the Centennial in Dallas. Like other post-war pageants which overlooked European roots and stressed their pioneer identity, "Cavalcade's" cast of cowboys and Indians had traveled considerable iconographic distance from earlier allegorical pageantry.[38] By the 1936 "Cavalcade," historical pageantry had turned from community theater and entered the realm of tourism. Today, tourists and Texans alike can attend the annual summer pageant entitled "Texas!" performed in the literal and metaphoric depths of Palo Duro Canyon.

In partial summary, the pageantry movement in Texas during the early decades of the twentieth century had its roots in the nineteenth-century civic celebrations like historical and patriotic orations, parades, and tableaux. The pageants produced in the state were generally allegorical, civic, Elizabethan, or historical in type and often associated with a college or university whose faculty saw the educational value of the exercises. Texans, like other Americans, actively participated in this popular educational and recreational movement, which had its own literature and experts during its heyday. The movement continued into the 1930s, declined after World War II, and experienced a brief revival in the late 1940s and early 1950s.[39]

The focus of this paper has been the visible image of the Greek models in flowing garments: they were the central image in allegorical pageantry; appeared in the variety of civic pageants; were incorporated easily and enthusiastically into Shakespearean and Elizabethan celebrations; and represented an overarching symbolic framework for the historical pageants, carrying the message of continuity between episodes of the pageants and between the episodes of the community's history. They became the central figures in a range of public performances.

And even though these gowned women were used during the 1920s less as emotional transitions and more as mere dramatic spectacle, not as integral to the historical pageants as they once had been, the images persisted into the 1920s and 1930s. The "immaterial girls" survived not only in their "traditional"

38. Centennial Photographic files, Dallas Historical Society, Dallas, Texas. The author is grateful to Peggy Riddle, who made these collections available for research.

39. Glassberg, "American Civic Pageantry," 250–252. That is not to say, however, that pageants no longer take place in Texas or elsewhere in the United States. For example, the Austin *American-Statesman* (Nov. 26, 1988) reported the Rivercenter Christmas Pageant in San Antonio. For a list of similar civic celebrations, consult current issues of *Texas Highways* magazine.

way but also in a new form, allying themselves less with classical civilizations and more with modern dance.

Via the pageantry form, the genteel reformers and the progressive recreation reformers had legitimized theatrical dancing as an art form, a status that it had never enjoyed before.[40] In the pageantry movement, dance and dancing had served as an effective means of *community expression*. Dance innovators like Isadora Duncan helped to popularize the dance as a legitimate form of *self-expression*. In 1922, University of Texas women formed a club for the purpose of learning and performing aesthetic dances; the following year they named it the Orchesus Dance club, using the Greek word meaning "to dance."[41] The 1929 East Texas State University Greek pageant credited Duncan with making famous the dance of grief that was performed on their Commerce campus.[42]

The skirts had shortened on the "immaterial girls," and the poses were more animated than Columbia or the Statue of Liberty. But the images as preserved in the prints remain equally captivating, essential windows into early twentieth-century American and Texas culture.

40. See Nancy Lee Ruyter, *Reformers and Visionaries: The Americanization of the Art of Dance* (New York: Dance Horizons, 1979).

41. *The Cactus* (Austin: University of Texas, 1924), 285.

42. *The East Texan* (Commerce), Apr. 29, 1929.

"Election Day in Balmorhea," 1938. Lithograph, 11 x 15³/₄ inches. *Photograph by Reinhard Ziegler, courtesy Jerry Bywaters Collection on Art of the Southwest, the Jake and Nancy Hamon Arts Library, Southern Methodist University, Dallas.*

# Jerry Bywaters:
# A Texan Printmaker

❧

## Francine Carraro

O n November 25, 1934, the Dallas *Morning News* pictured a group of artists in their twenties, dressed in their "Sunday best" and appearing very serious. The eleven men and eighteen women were members of the Dallas Artists League who were receiving local and national recognition as practitioners of a regionalist aesthetic. Pictured were Jerry Bywaters, Alexandre Hogue, Everett Spruce, Otis Dozier, William Lester, Bertha Landers, Esther Webb, Velma Davis, and others who were anxious to prove their worth and determined to be recognized as professional artists. The *Morning News* referred to these ambitious young people as "artists of the rebellion" and "exponents of the new freedom."[1]

Not only was Jerry Bywaters (1906–1989) one of the progressive artists involved in the Dallas Artists League, but he was also the author of that Dallas *Morning News* article. The scope of Bywaters's long career in the arts is beyond the reach of this paper. In addition to producing a body of work including landscapes, portraits, murals, and lithographs, Bywaters wrote a weekly art column for the *Morning News* from 1933 to 1939. He also taught in the Art Department of Southern Methodist University for forty years without interruption and was director of the Dallas Museum of Fine Arts from 1943 to 1964. His accomplishments were significant. His roles as artist, arts administrator, art critic, and art educator are seamlessly connected. Just as the subjects of his art grew out of the region, his public efforts were devoted to the arts and artists of the Southwest.

The years 1933 to 1941 were Bywaters's most productive period as an artist. Although he worked in a variety of media, printmaking was of great importance

---

1. Dallas *Morning News*, Nov. 25, 1934.

to him as a means of reaching a wide audience. He was instrumental in encouraging other artists of the region to use prints as a means of expression. Like many other artists of the Depression decade, Bywaters viewed printmaking as a viable way to offer affordable and accessible original art work to the public.

Bywaters's contributions as an artist and leader in the Dallas art community were recognized as early as 1933, when *Art Digest* announced that "Bywaters isn't a 'comer' in Dallas,—he has 'arrived.'"[2] Bywaters's emergence on the Dallas art scene began after he graduated from Southern Methodist University in 1926 with a degree in literature. As editor of the *Crimson Colt*, a campus magazine, and as a contributor to the *Southwest Review*, a literary publication, Bywaters cultivated an interest not only in the written word, but also in typography, layout, and graphic design.

After graduation Bywaters began a two-year self-styled study of art by traveling throughout France, Spain, and Mexico. He studied briefly with John Sloan at the New York Art Students League and hobnobbed with leading American Impressionists at the art colony in Old Lyme, Connecticut. From these diverse artistic climates, Bywaters gained new insights and learned important lessons, but the most important instructions came when Bywaters stood at the bottom of the scaffolding watching Diego Rivera paint a mural in Mexico City. In a 1928 article for the *Southwest Review* Bywaters wrote, "Diego Rivera has taught me a lesson I had not learned elsewhere in Europe or America. I know now that art to be significant, must be a reflection of life; that it must be a part of a people's thought. If I had Rivera's insight, I might have learned my lesson sitting and studying my dog or by looking at a tree in the backyard."[3] These ideas became a firm foundation upon which Bywaters built his aesthetic.

From his studio in Dallas's Bluff View Heights, designed by young Texas architect O'Neil Ford, Bywaters looked to his own backyard for the subjects and substance of his art. As he set about establishing his own career as an artist, Bywaters found his contemporaries had similar interests. Old college friends Henry Nash Smith and John Chapman were finding literary means to explore and express the life of the Southwest. The hub of the art community was located around the Dallas Art Institute and the Civic Federation on Alice Street, where the atmosphere was charged with discussions about the importance of creating significant art from one's own environment. Bywaters and

2. "Dallas Annual," *Art Digest* (Apr. 1, 1933), 11.

3. Jerry Bywaters, "Diego Rivera and Mexican Popular Art," *Southwest Review*, XIII (July, 1928), 480.

other young Dallas artists were certainly finding inspiration in the familiar subjects of Texas rural landscape and urban scenes.

Because of his ability as an art critic and his standing in the art community, Bywaters emerged as a spokesman for the band of young artists. He succeeded in finding the means to promote the art and artists of the region in the midst of the Great Depression, when the chronic shortage of art patronage was aggravated by economic conditions. Although at the time Dallas had few art galleries and a very small art audience, Bywaters was resourceful in finding new ways to present art to the public. Inspired by the success of the Washington Square Outdoor Show founded by John Sloan, Bywaters directed the Dallas Artists League in the presentation of the Alice Street Carnival in 1932. The open-air art exhibition and sale proved a successful and entertaining means to introduce art to the public and grew into an annual event.

In 1932, believing that art education was the key to developing art audiences, Bywaters began to publish *Contemporary Art of the South and Southwest*, a high-quality magazine dedicated to promoting the art of the region. The publication was modeled on *Mexican Folkways*, a magazine edited by Diego Rivera which focused on the art, architecture, culture, and people of Mexico. Although the Dallas-based magazine was published for only one year, it was an important organ for the promotion of the art and aesthetic of a small but cohesive art community. The Dallas artists sold their original lithographs at modest prices at the Alice Street art fairs and their prints were showcased in each issue of *Contemporary Art of the South and Southwest*.

The interest in printmaking by Dallas artists was part of an emerging national interest in the medium during the 1930s. The relatively simple and inexpensive medium of lithography was tailor-made for the needs of both artists and art collectors in the wake of the Depression. Bywaters and Alexandre Hogue led the way in Dallas by entering prints in local competitive exhibitions. Bywaters later recalled that "Mauzey, Hogue, Bowling, Brown were some of the first artists to own their own lithograph presses and produce their own prints."[4] Because there was little information available, few presses, and even fewer printers, the transfer print was the immediate and accessible solution for Dallas artists.

One of Bywaters's first known attempts at lithography was "Lunch Table," shown in an exhibition of sixty works by Dallas artists at the Dallas Women's Club in 1932. "Lunch Table" is a still life of fruit composed in a Cubist manner. The table is tilted dangerously and the composition includes a cat that is

4. "Twelve from Texas: Portfolio of Lithographs" (Dallas: Southern Methodist University Press, 1952), foreword by Jerry Bywaters.

responsible for the chaos of the scene. Bywaters was a timid Cubist, however, who allowed the scene to be grounded in realism.

Interest in printmaking in Dallas dates from 1934, when Bywaters reported in his newspaper column that a notable print collector had moved to Dallas. Mrs. A. E. Zonnes arrived in Dallas from Minneapolis with a collection of over three hundred original prints. Artists represented in her collection included Piranesi, Rembrandt, Canaletto, Daumier, Picasso, Matisse, Laurencin, Pennell, Kent, Rivera, Bellows, Sloan, Marin, and Bacon, among others. Bywaters realized that a serious collector of prints was of great benefit to Dallas artists. He wrote, "If the presence of one print collector in Dallas can lead to the development of the interest among others that collector is apt to be Mrs. A. E. Zonnes."[5] Indeed, she was one of the founders of the Dallas Print Society.

In the same article Bywaters recounted the burgeoning interest in printmaking by Dallas artists. In the fall of 1934 the State Fair included a touring art exhibition titled "50 Prints of the Year." That same year the Dallas Museum of Fine Arts presented a show of prints on loan from a private collector in California, and the Highland Park Galleries occasionally had print shows from the Southern States Art League. Despite these signs of interest, Bywaters complained that "Dallas has not yet shown itself overly receptive to the idea of producing and collecting prints," and he reminded his audience that "the print is the most inexpensive means of collecting art."[6]

Two months later Bywaters made this announcement in his newspaper column: "Opening today is a huge exhibition of lithographic prints that fills every gallery on the 9th floor of the Dallas Power and Light Building."[7] The Dallas Museum of Fine Arts was located at that time in the Dallas Power and Light Company building in downtown Dallas. The new museum director, Lloyd Rollins, arrived in Dallas on November 15, 1934, and within a month curated an impressive exhibition of printmaking in America. The exhibition of more than two hundred lithographs by leading American artists was met by an enthusiastic audience and press. "American Lithography from 1830" included works from the 1830s to the 1930s, including prints by Currier and Ives, James Whistler, Joseph Pennell, George Bellows, Thomas Hart Benton, Raphael Soyer, Max Weber, and Rockwell Kent, but with a special emphasis on contemporary printmakers, including several young Dallas artists. Alexandre

5. Dallas *Morning News*, Oct. 21, 1934.
6. Ibid.
7. Ibid., Dec. 9, 1934.

Hogue's transfer lithograph "Moonlight" pictured Rancho de Taos in dark, rich tones.

In assessing the exhibition Bywaters asserted that "Many of the ablest contemporary painters of this country who have done important work in lithography, bring to this art something of the largest spirit of painting, better draughtsmanship, emphasis on design and an originality of concept."[8] In his praise for the exhibition Bywaters took the opportunity to deliver an art history lesson on printmaking techniques and printmakers. He concluded that lithography is a truly American art form and that collectors should seriously consider purchasing original prints because they are comparable in price to "a pair of shoes or a supper and dance."[9] Harry Carnohan, artist and art critic for the Dallas *Journal*, found the exhibition a positive influence on local artists. Writing from the perspective of years of experience in Paris, Carnohan urged artists to come back to their "promised land" of America for artistic fulfillment. He lauded the prints in the exhibition for their "definitive muscular structure and real human appeal."[10]

The exhibition not only presented excellent examples of prints for Dallas artists to study, but also served to intensify discussion of their own presentation on the local scene. In February 1935, a few months after the exhibition closed at the Dallas Museum of Fine Arts, a group of artists, print collectors, and print enthusiasts formed the Dallas Print and Drawing Society, dedicated to the production, promotion, and distribution of original prints. The group met once a month at the Museum with Mrs. Zonnes presiding. Bywaters later related the history of the Print Society: "An original membership of forty laymen launched a serious program of study which included demonstration lectures, exhibitions, movies, and personal appearances of leading artists; the group acquired prints, awarded print prizes at exhibitions, and commissioned artists to execute prints for distribution for the Society."[11]

Bywaters often lectured at meetings of the Print Society and occasionally spoke on WFAA Radio about prints and print collecting. The Print Society also invited such national art figures as social realist painter and muralist George Biddle to lecture on the virtures of producing and collecting prints. Before a large Dallas audience Biddle extolled the affordability and multiplicity of prints. Other speakers included FitzRoy Carrington, curator of prints at the

8. Ibid.

9. Ibid.

10. Dallas *Journal,* Nov. 22, 1934.

11. Jerry Bywaters, "A Note on Lonestar Printmakers," *Southwest Review,* XXVI (Autumn, 1940), 63–64.

Boston Museum of Fine Arts and editor of *The Print Collector's Quarterly*. The Print Society was also instrumental in obtaining an exhibition of sixty-eight prints from the Chicago Society of Etchers for the Dallas Museum of Fine Arts.

Bywaters's efforts to promote printmaking and print collecting were paralleled by his improving ability as a printmaker. He worked in small scale, black-and-white, traditional crayon-drawing lithographs in small editions. His 1935 lithograph "Gargantua," in an edition of fifty, won the prize for prints in the competitive Allied Arts Exhibition of 1935 at the Dallas Museum of Fine Arts. The work represents the realistic style for which Bywaters became known. Bywaters simply drew the image on a piece of transfer paper and contracted a local printer to produce a lithograph of the image. Prints allowed Bywaters a degree of humor or satire which were off limits for the more serious medium of painting. "Gargantua," a caricature of an overstuffed Victorian house, effectively used exaggeration. Bywaters found humor in the eclectic mix of architectural styles that dotted the Texas landscape, saying, "No greater paradox has ever been seen on the Texas plains than Gothic Cathedrals serving as courthouses, or wives of ex-cowhands speaking French in the Chinese drawing rooms of Romanesque mansions."[12]

When the Dallas *Morning News* invited Alexandre Hogue to critique Bywaters's prize-winning print, he used the opportunity to humble his friend and colleague. Hogue wrote, "As for the visual qualities I would say Bywaters' values are poorly organized and spotty. . . ." Hogue's disapproval of Bywaters's technique was tempered by appreciation of his ". . . ability to draw human traits into inanimate things. . . ."[13] Bywaters saw a house as a kind of portrait of the people who lived there and "Gargantua" was not his first attempt to make a general statement about the people of the region by picturing the architecture. Bywaters's earlier lithograph of an "Old Victorian House" was shown in his solo exhibition at the Joseph Sartor Galleries in Dallas in April 1933.

Bywaters poked fun at stuffy high culture in a lithograph titled "Opera at Popular Prices." This 1936 work is a cartoon of a traveling opera company's performance in Dallas. The scene is drawn from the distant vantage point of the cheap seats, from which the melodramatic action on stage is barely visible through a screen of bobbing heads, ceiling fans, and light fixtures. Bywaters pictured his friend Otis Dozier among the characters in the balcony. "Opera at

12. Carl Zigrosser, "Prints in Texas," ibid., 54.
13. Dallas *Morning News*, Mar. 24, 1935.

Popular Prices," produced in an edition of thirty, was sold at the Alice Street Carnivals.

In 1936 Bywaters took a position at Southern Methodist University as instructor of painting, drawing, graphic design, and commercial art. In exploring the practical applications of art to daily life, Bywaters also became interested in book illustrations. He believed that the fine quality of the illustrations are an important aspect of printmaking.

Bywaters illustrated several books by Texas authors and in 1936 the Lawrence Gallery of Dallas presented an exhibition of his drawings and publications. *With Milam and Fannin* by Herman Ehrenberg is the memoir of a Prussian immigrant who responded in 1835 to the call for volunteers for the Texan army and found himself in Texas under the commend of Gen. Edward Burleson. Ehrenberg's adventures in Texas were first published in Germany in 1843; nearly a century later Herbert P. Gambrell at Southern Methodist University prefaced the volume and reissued the book in English. Bywaters also illustrated two children's books, *Wagon Yard* and *Tell Us About Texas*, by August Johnson.

*Tales of a Mustang* by J. Frank Dobie, published in 1936 by the Book Club of Texas, was praised at the time as the "first complete Texas product" and the "most artistic piece of book making yet produced by a Texas Press."[14] Dobie collected and embellished folk tales about mythological horses on the prairie and commissioned Bywaters to illustrate the text. The simple silhouettes of streamlined ponies effectively conjure the stories of ghostly steeds. At this time Bywaters also completed a color block print of a white horse in an edition of fifty.

Bywaters illustrated *Devil in Texas* by Frank Goodwyn, a handsomely designed book of stories told by ranch hands and camp cooks about southwest Texas ranch life. Other books illustrated by Bywaters included *Early Times in Texas* by John C. Duval, *Naturalists of the Frontier* by Samuel Wood Geiser, and *Big Spring: The Casual Biography of a Prairie Town* by Shine Phillips. Bywaters supported the efforts of the Texas authors to preserve folktales and folk histories as a grassroots artistic expression.

In 1936 the Dallas Museum of Fine Arts presented an exhibition of Texas publications and illustrations by Texas artists. Bywaters's illustrations were exhibited along with drawings by Alexandre Hogue for *The Flavor of Texas* by J. Frank Dobie. Also included in the exhibition were illustrations by Ben Carlton Mead, Harold Bugbee, Granville Bruce, Aubrey Streater, and others.

---

14. Sarah Chokla, "Book-Printing in Texas," *Southwest Review*, XXI (Apr., 1936), 321.

"Texas Courthouse," 1938, Lithograph, 20 x 13⅞ inches. *Photograph by Reinhard Ziegler, courtesy Jerry Bywaters Collection on Art of the Southwest, the Jake and Nancy Hamon Arts Library, Southern Methodist University, Dallas.*

Bywaters wrote at the time, "Certainly there has been no dearth of recent Texas publishing ventures . . . and although printing as an art has not yet become a custom in the state, there have been many publishers and authors who have dug in their pockets to commission Texas artists to illustrate published works. . . . So it is that another branch of art, the illustration of Texas material by Texas artists has come into being with distinct possibilities."[15]

The interest in folklore and Texas history clustered around the 1936 Texas centennial celebration. Just as the state was becoming aware of its own unique history and character, Texas artists were identifying the land and people of the state. The Centennial Exposition in Dallas focused the nation's attention on Texas and spotlighted the work of Texas artists.

A new permanent facility for the Dallas Museum of Fine Arts was constructed in Fair Park for the Exposition and was completed on June 1, 1936, just in time to open an impressive exhibition specially selected to give proud Texans a large overview of the history of art and a comprehensive survey of the art of their state. The large exhibition was assembled by Richard Howard, the newly installed director of the Dallas Museum of Fine Arts, and Robert Harshe, director of the Art Institute of Chicago. Paintings, sculpture, and prints by artists from the Renaissance through the twentieth century were on display, with special galleries devoted to American Scene painters, Southwestern artists, and Texas artists. Printmaking was well represented. A large gallery was devoted to the works of Texas artists James Brooks, Peter Hurd, Bertha Landers, Blanche McVeigh, and E. M. Schiwetz; another was filled with the lithographs of George Bellows and a large exhibition of historic prints. Texas audiences had the opportunity to see original prints by such masters as Durer, Mantegna, Van Leyden, Rembrandt, and Claude Lorraine. Modern artists Matisse, Kollwitz, Rouault, Picasso, Duran, and others were also represented in the large exhibition of prints.

The June 1, 1936, issue of *Art Digest* was devoted entirely to the Centennial Art Exhibition and Texas artists. In addition to extensive coverage of the exhibitions of painting and sculpture, the magazine featured the print exhibitions, stating, "America has seen in the last decade a revival of lithography as a graphic medium suited to the American temper."[16]

Texas artists were also featured in another national arts magazine. Early in 1936 *Prints Magazine* sent questionnaires "To museum directors, print curators, collectors, critics, and artists throughout the United States asking them to

15. Dallas *Morning News,* Aug. 30, 1936.
16. "The Print Display," *Art Digest* (June 1, 1936), 32.

105

name the artists they would consider most noteworthy."[17] The June 1936 issue was devoted to the results of the survey, which found great printmaking activity across the country, not just in the major cities of the East. The survey found that the establishment of local print clubs and societies stimulated print-making in all parts of the nation.

In June 1937 Samuel Golden, president of the Associated American Artists in New York, came to Dallas to view the prints of artists for possible inclusion in a new series of published reproductions. The Associated American Artists promoted the production of prints at affordable prices. Established in 1934, the venture sold original prints for five dollars each through leading department stores such as Marshall Field and by mail order. Golden was impressed by the quality and diversity of the printmaking efforts of Dallas artists and pro-claimed them "one of the major sectional developments of American art."[18] This praise was sufficient to prompt Dallas artists to make a larger commit-ment to the medium of printmaking.

At the time of Golden's visit, the Dallas Museum was presenting an exhibi-tion of one hundred original prints from the Associated American Artists. Bywaters's review of the show included praise for "a revolutionary departure for the distribution of original art in America in that these examples are the work of some of the leading American artists and are sold at a price no greater than that of a good book, a theatre or concert ticket."[19] Bywaters viewed origi-nal prints as a viable means to present art of quality to a broad public at low cost.

Interest in printmaking was sufficiently high that in November 1937 the Dallas Print Society opened a commercial gallery called the Print Center, adjoining the John Douglass frame shop on Cedar Springs Road. Alexandre Hogue designed the modern, well-lighted space and supervised the operations of the gallery. The sales gallery carried a large stock of historic and contempo-rary prints, but its primary purpose was to promote the sale of works by local artists. Although the gallery survived only one year, it became the center of printmaking activity among Dallas artists and helped to establish an audience and patronage for original prints.

As the number of printmakers in the region increased, "the more adventur-ous Dallas artists," according to Bywaters, banded together in May 1938 to form an organization modeled after the Associated American Artists.[20] They

---

17. *Prints Magazine* (June, 1936), cited in Clinton Adams, *American Lithographers 1900–1960* (Albuquerque: University of New Mexico Press, 1983), 153.

18. Dallas *Morning News,* June 6, 1937.

19. Ibid.

20. Bywaters, "A Note on Lone Star Printmakers," 64.

"Mexican Lily Vendor," 1938. Lithograph, 11 x 7⅞ inches. *Photograph by Reinhard Ziegler, courtesy Jerry Bywaters Collection on Art of the Southwest, the Jake and Nancy Hamon Arts Library, Southern Methodist University, Dallas.*

called themselves the Lone Star Printmakers. This group of men produced and published portfolios of their own prints and circulated touring exhibitions of the original prints for four years. Bywaters explained that an "exhibit of thirty unframed black and white prints was offered to any regional museum, college, or study group willing to purchase one print and pay the small express charge necessary to secure the exhibit from the previous exhibitor."[21] The first folio of prints by fifteen artists was exhibited at twenty-three locations throughout Texas, Colorado, Oklahoma, and Louisiana in 1938. One hundred and eighty-four prints were sold from the tour, with Riveau Bassett and Jerry Bywaters having the greatest number of individual sales. Later in 1939 a separate group of women printmakers formed a group known as the Printmakers Guild because they were excluded from the Lone Star Printmakers.

The circuit exhibitions served to expand the audience for the work of Jerry Bywaters, Alexandre Hogue, Charles Bowling, Tom Stell, Otis Dozier, E. G. Eisenlohr, Olin Travis, William Lester, Peter Nichols, Everett Spruce, Harry Carnohan, Mike Owen, H. O. Robertson, John Douglass, Riveau Bassett, and Merritt Mauzey, all of whom were members of the Lone Star Printmakers. A second portfolio of thirty prints was published in 1939, and by its third year the group also included Ward Lockwood, Don Brown, Edmund Kinzinger, and William Elliott.

The Lone Star Printmakers caught the attention of Carl Zigrosser, a New York print dealer known nationally for advocating printmaking as a democratic medium for distributing high-quality art to the public. Zigrosser managed the Weyhe Gallery and sold prints from the Lone Star Printmakers portfolios on consignment. He demanded high standards in print quality and content. The author of several books on the history of printmaking, Zigrosser visited Dallas in 1939 when he was making a survey of printmakers in the United States on a Guggenheim fellowship. After interviewing Bywaters, Zigrosser wrote a lengthy article in 1940 for the *Southwest Review* on contemporary printmaking in Texas. Zigrosser admired the tenacity of the small group of printmakers. He found the Dallas artists the strongest in Texas, because "they are articulate and banded together, and because they have had understanding and sympathetic advocates in the press."[22] Zigrosser highlighted Bywaters's prints in the article and proclaimed that "Bywaters has passed through the experimental stage and has arrived at a sound and effective conception of graphic art."[23]

21. Dallas *Morning News,* Nov. 13, 1938.
22. Zigrosser, "Prints in Texas," 55.
23. Ibid., 58.

Through Zigrosser, Bywaters located a professional printer, Theodore Cuno of Philadelphia, to help him produce fine quality prints in traditional crayon lithography. Cuno was a respected printer who worked with a number of the nation's best artists from the basement of his modest rowhouse in Philadelphia. His careful attention to detail and technical ability resulted in prints of better quality on better paper. Bywaters and Cuno never worked together in person but rather by mail. The long-distance printing process was arduous. Cuno shipped grained stones to Bywaters in specially constructed boxes. After the artist completed his drawings he shipped the stones back to the printer. Cuno sent proofs to Bywaters for his approval and finally printed the editions. The delay was considerable but the results were worth the effort. Later Bywaters worked with Laurence Barrett of Colorado Springs. Bywaters's prints sometimes have the initials "JB" in the lower right corner and are always signed, numbered, and titled in pencil. Some, but not all, of Bywaters's prints also have a printer's mark.

From 1937 to 1942 Bywaters grew in confidence and ability as an artist. His prints, paintings, and murals from this period are indicative of a mature artist. The subjects and style of his work closely fit his ideas of a regionalist aesthetic. Bywaters found printmaking a fitting vehicle for his regional themes and a convenient way to reach the public. The informality of prints was perfect for art that dealt with everyday aspects of the local environment. "Election Day in Balmorhea," a 1938 print in an edition of fifty, is reminiscent of the best genre scenes of George Caleb Bingham. In this work Bywaters documents democracy in action on the steps of the general store in Balmorhea, Texas. Art historian Rick Stewart places this work "in the tradition of Mark Twain or Will Rogers."[24] Bywaters's prints are narratives with the leaven of earthy humor and insight into the character of the region.

Bywaters's portrait of western life entitled "Ranch Hand and Pony" was exhibited at the 1938 Venice Biennial Exposition of American Graphic Art. Zigrosser wrote Bywaters that he liked the piece very much.[25] Among Bywaters's best images from this period is "Country Store, Hye, Tex.," in an edition of thirty, a sympathetic presentation of country life. This lithograph pictures an elaborate false front on a main street of two stores, a telephone pole, and a windmill.

---

24. Rick Stewart, *Lone Star Regionalism: The Dallas Nine and Their Circle* (Austin: Dallas Museum of Art, Texas Monthly Press, 1985), 94.

25. Carl Zigrosser to Jerry Bywaters, Mar. 3, 1941, in Jerry Bywaters Research Collection, Southern Methodist University.

"Mountains Meet the Plains," 1940. Lithograph, 7³⁄₈ x 13¹⁄₂ inches. *Photograph by Reinhard Ziegler, courtesy Jerry Bywaters Collection on Art of the Southwest, the Jake and Nancy Hamon Arts Library, Southern Methodist University, Dallas.*

One of Bywaters's most popular prints of the period was "Texas Courthouse," produced in 1938 in an edition of fifty, which is an elongated composite of the Wise and Denton County courthouses. This synthesis of forms makes a humorous statement about the pompous buildings that preside in the squares of small Texas towns. "I had always been interested in architecture, both early and contemporary," Bywaters later wrote, "as the tangible reflection of peoples and times. So it was logical for me to record old buildings graphically, but I adjusted their character—making courthouses taller because they dominated the little towns on the flat farmlands. . . . In the lithograph 'Texas Courthouse' I attempted a sympathetic synthesis of all such intriguing structures."[26]

In addition to his interest in old buildings, Bywaters was fascinated by the "vast area extending from Marathon and Alpine south for some seventy miles to the bend in the Rio Grande River. . . ."[27] He traveled to the Big Bend of

26. "A Retrospective Exhibition: Jerry Bywaters" (Dallas: University Galleries, Southern Methodist University, 1976), 18–19.

27. Ibid., 28.

Texas on several sketching and photographic trips with Dozier and Hogue. Bywaters used lithography as a means to depict the dramatic landscape of this area of Texas in works such as "Adobe House and Ovens" (1939), which pictures the man-made buildings of molded adobe blending harmoniously with the surrounding landscape. The shapes of the distant mountain range are repeated in the adobe houses and outdoor bread ovens.

In 1937 Bywaters produced a small watercolor called "Terlingua Graveyard." Bywaters recognized the adobe tombstones, wooden crosses, and handmade shrines as a significant folk art. The work is an acknowledgment of a unique cultural expression as well as an appreciation of sculptural form. Two years later Bywaters reworked the image into a lithograph called "Mexican Graveyard, Terlingua," in an edition of twenty-two.

In a review of the second portfolio produced by the Lone Star Printers, the Dallas *Morning News* spotlighted Bywaters as a printmaker "whose four lithographs in this series continue to heighten his artistic stature."[28] Bywaters's prints in this portfolio reflect his travels to New Mexico and Colorado in such works as "House in Taos," "Mexican Graveyard," "Negro Girl," and "False Fronts Colorado." He searched for the American vernacular and found an artistic vocabulary in views of small town mainstreets. "False Fronts Colorado," in an edition of twenty-two, received a prize at the Dallas Print Society 's first statewide juried competition in 1941. Later in the 1940s Bywaters completed oil paintings of similar themes.

His prints from this period also include figure studies. "Mexican and Maguey" and "Mexican Lily Vendor" are stylistically akin to the work of Diego Rivera, but Bywaters demonstrates his own unique ability to capture solid form with a few well-placed lines. These works are simple statements of character types that identify the region for Bywaters. Bywaters painted "Mexican Mother" in 1933 and returned to the same subject in lithography in 1936.

In November 1937 Bywaters's solo exhibition at the Lawrence Galleries in Dallas was praised for catching "the spirit . . . of the locality."[29] The works in the exhibition documented his excursions to Colorado, Montana, and New Mexico, as well as the Big Bend and Panhandle area of Texas. The next year Bywaters had a solo exhibition at the Hockaday School in Dallas, where Alexandre Hogue was director of the art department. The exhibition included ten pastels, five watercolors, three oils, and nine original prints: "Ranch Hand

28. Dallas *Morning News,* Oct. 15, 1939.
29. Ibid., Oct. 31, 1937.

"On the Ranch," 1941. Lithograph, 9½ x 12½ inches. *Photograph by Reinhard Ziegler, courtesy Jerry Bywaters Collection on Art of the Southwest, the Jake and Nancy Hamon Arts Library, Southern Methodist University, Dallas.*

and Pony," "Election Day in Balmorhea," "North Texas Railroad Station," "Gargantua," "Old Clown," "Boneyard," "Opera at Popular Prices," "Mexican and Maguey," and "Mexican Mother." The exhibition included both a print and a watercolor titled "Boneyard," as well as a drawing called "Mrs. Bush's Place"; all three works are similar in subject matter. An unkempt farm house is surrounded by a broken windmill, a blasted tree, and a useless fence. Broken-down Model As are reminders of better times. The rural theme emblematic of the Depression era was a subject that continued to interest Bywaters. Incidentally, Bywaters designed, set the type, and printed the catalogue for the Hockaday show.

Bywaters traveled to far west Texas and continued to turn his attention to the land. Increasingly he pictured the landscape as vast and indomitable. For Bywaters the Big Bend area of Texas offered "the artist an endless variety of

plant and earth forms. . . ."[30] His 1939 painting "Century Plant, Big Bend" is a carefully composed interpretation of the region, a synopsis of the lessons he learned from close observation of the landscape. The muted colors of the desert are harmoniously balanced and the sculptural form of the century plant virtually dances with the repetition of shapes and the rhythm of lines. Oliver Larkin wrote of this painting in *Art and Life in America*, his 1949 survey of American art, "Perhaps Orozco suggested to Jerry Bywaters how the shapes of cactus could be made to writhe against Texas cliffs. . . ."[31] Bywaters reworked the popular image in a lithograph that, although simple in line, has the strength of the painting.

Bywaters also produced a print based on one of his most important paintings, the 1939 oil "Mountains Meet the Plains." Bywaters conceived of this work as an epic vision of a great sweep of landscape. The painting was first exhibited at the 1939 State Fair exhibition, an invitational show at the Dallas Museum of Fine Arts. A contemporary critic wrote that "without doubt the most impressive painting is Jerry Bywaters' West Texas landscape, 'The Mountains Meet the Plains [*sic*].' There are many larger but none so dramatic in interest, so right in realization. The vast stretches of hills and valley, farm land, pasture, rocky terrain, and sharp slopes are strangely exciting."[32] The October 28, 1939, issue of *Art in America* reproduced the painting with the caption "expansive landscape interpreted by a Texan."[33] The monumentality of the painting translated well into a black-and-white print. Bywaters viewed the lithograph as a means of offering the image to a wider audience.

In 1941 Bywaters completed a study, a print, and a painting of a composition that summarizes his vision of ranch life in Texas. The "Study for On the Ranch" in conte crayon and white tempera on brown paper locates the subject and identifies the essential mood of the final painting. The black-and-white lithograph, in an edition of twenty, demonstrates the strength of the composition without the support of color. The painting of the same subject received a $250 purchase prize in the 1942 Allied Art Exhibition at the Dallas Museum of Fine Arts. In oil and tempera, "On the Ranch" pictures a carefully arranged still life of ranch paraphernalia against a vast West Texas landscape. No human is in sight, yet the evidence of man's intrusion on the land is visible. Bywaters selected objects which he calls the "visible totems" of ranch life,

30. "A Retrospective Exhibition: Jerry Bywaters," 28.

31. Oliver Larkin, *Art and Life in America* (New York: Holt, Rinehart, and Winston, 1949), 414.

32. Dallas *Morning News*, Oct. 8, 1939.

33. *Art in America* (Oct. 28, 1939), 18.

including barbed-wire fences, scraps of corrugated tin, an Indian arrowhead, a discarded cow bell, and a rusted gun. The natural objects presented in the composition are equally lifeless and hard: a dry horse skull, a dead mesquite, and a thorny prickly pear. In the black-and-white lithograph the strength of the forms remains.

The 1942 painting "Houses in West Texas, Big Bend" is a clear artistic statement about the region which was of the utmost importance to Bywaters. The landscape characterizes the Southwest, and adobe architecture is identified with the region. The lithograph of the same composition was produced in 1943 in an edition of fifteen.

The people of the region also served as subjects of Bywaters's art. "Navajo Man, Shiprock" is a monumental figure. This work, remarkable for its succinct characterization of a Southwestern type and its strong three-dimensionality, was shown at the Texas State Fair art exhibit in 1940. Bywaters later completed a lithograph of the same subject in an edition of twenty-five. The portrait of a native American is a clear expression of Bywaters's desire to locate indigenous subject matter.

Bywaters realized that oil paintings were the works by which he would ultimately be judged as a serious and professional artist. Paintings, however, are one of a kind and not easily available to the public. Bywaters's populist leanings prompted him to work in media that would be more accessible to the public. In addition to the production of prints and book illustrations which allowed wider distribution of his art, Bywaters also produced murals under the auspices of the Federal Art Projects from 1934 to 1942. Bywaters saw murals as a counterpart to prints in that a large number of people have access to prints by their multiplicity and affordability and to murals by their location in public places. He believed that his paintings, prints, and murals were equal and integral parts of a concerted effort to bring meaningful art to the public.

Based on his enthusiasm for the New Deal art projects and the regional interest in printmaking, Bywaters summarized his thinking in a 1940 article titled "Toward an American Art." He believed in the continued progress of American art and in an American School of Painting. "It is a conclusive fact," Bywaters wrote, "that Americans have never seriously produced or been actively interested in art as widely as today." He added, "we know that we have been present at the beginning of an era which expresses much of our way of life, our own way of thinking and our own American spirit."[34] Bywaters's

34. Jerry Bywaters, "Toward an American Art," *Southwest Review*, XXV (Jan., 1940), 142.

paintings, prints, illustrations and murals contributed to the spirit and the development of a school of regional art in America.

Summer Harvest, by Stella LaMond, 1940. Lithograph, 10 x 12$^{5}/_{8}$ inches.

# The Printmakers Guild and Women Printmakers in Texas, 1939–1965

### ❧

## David Farmer

L ate in 1939, a group of artists in Dallas began planning an organization that would be unique in the annals of American printmaking. When they formed it the following year, they named it the Printmakers Guild, with the purpose of selecting, showing, and selling their prints as widely and economically as possible. Consequently, from 1940 through 1965 the Printmakers Guild successfully circulated and sold its members' work through many American cities. While the phenomenon of circulating print shows was not unusual at this time, the Printmakers Guild made history not only with the quality of work it promoted but also in the fact that for all but its last season its membership was limited to women.

Each year throughout its active life the Printmakers Guild arranged for shows of its members' work to travel the country on carefully managed circuits. At the same time, every member of the Guild was engaged in full-time professional activity centering mainly in art education, and in some cases its members were holding several jobs as our nation continued to work its way out of the Great Depresssion. Yet these artists found time to produce enough new prints each year to maintain their Guild membership, to contribute to the running of their organization, to develop and nurture lasting friendships and professional associations, and to derive a great deal of personal satisfaction in doing so.

In the history of American printmaking, the activity and accomplishments of the Printmakers Guild were unusual for several reasons. First, it formed in a part of the nation that did not have a long tradition of artistic printmaking. Second, it was created for the dual purpose of educating people about prints while offering work for sale throughout the nation in a most economical way that did not depend on selling an annual gift print to non-artist members or publishing a portfolio of its members' work. Third, the Guild was founded to

provide selected women printmakers in Texas with the means to show and distribute their work.

That fact alone may seem strange for several reasons: first because women artists gained little recognition as a distinct group in the late thirties. In addition, no other organized group of printmakers in America has ever limited its membership to women.

The restriction of membership in the Printmakers Guild to women was in response to the founding in 1938 of the Lone Star Printmakers. Among the sixteen initial members were Bowling, Bywaters, Dozier, Hogue, Lester, Carnohan, Douglass, Mauzey, Spruce, Stell, and Travis. The purpose of this new organization was to issue a portfolio of its members' prints, organize exhibits of their work, and circulate travelling shows from which prints would be offered for sale.[1]

Anyone familiar with the Texas art scene in the 1930s knows that the Lone Star Printmakers included no women artists during its four-year history. Herein lies the starting point of our story, for by 1938 some very good women printmakers were located in north Texas. Furthermore, there was a significant amount of regional interest in prints and printmaking in the 1930s and 1940s. Print exhibitions were organized in Dallas by art associations; Dallas collectors interested in prints met and formed their own society; and artists like Alexandre Hogue, Jerry Bywaters, Otis Dozier, and Merritt Mauzey not only were actively producing prints, they were also teaching the art of printmaking to others.[2]

The earliest example in Dallas of a significant public exhibition of contemporary prints came in November 1932, with the Dallas Art Association sponsoring a show of paintings, drawings, and prints from the private collection of Mrs. Leslie M. Maitland. The occasion was the opening of the association's "New Quarters" in the Dallas Power and Light Building. The exhibit drew a record 1,000 viewers to its Sunday opening, thereby gaining positive local and national attention. The section devoted to modern prints was notable, containing work by such artists as Jose Clemente Orozco, George Bellows, Wanda Gag, Pablo Picasso, Arthur Miller, Rockwell Kent, Arthur B. Davies, Louis Lozowick, Richard Day, Arnold Ronnebeck, Howard Cook, Paul Landacre, Birgen Sandzen, and Mary Bonner. The exhibit of these prints alone would have been a significant event in any part of this country, but they hung boldly in the same show with prints by old masters such as Dürer and Rembrandt.[3]

1. Rick Stewart, *Lone Star Regionalism, The Dallas Nine and Their Circle* (Austin: Texas Monthly Press, 1985), 91–93.

2. Ibid., 46–47, 89–92.

3. A rare four-page printed listing of the Maitland collection on exhibit is in the Bywaters Collection, Southern Methodist University, Dallas. Reviews of the show appeared in the Dallas *Morning*

Other developments at this time include the 1934 print exhibition staged by Lloyd Rollins, the new director of the Dallas Museum of Fine Arts; the formation in 1935 of the Dallas Print Society under the leadership of Mrs. A. E. Zonne; the establishment of the Print Society's Print Center at 2213 Cedar Springs Road; and, of course, the formation of the Lone Star Printmakers.[4]

When it became clear that women printmakers would not be invited to join the Lone Star group, several knew what action to take: they would form their own organization and limit its membership to women. In a spirit of independence and with the shared belief in their artistic talents, the eight founders began discussing plans for their own group late in 1939 and then formed it in November 1940.

If there were strong negative feelings at the time about not being included in the Lone Star Printmakers, the surviving Guild members have now mellowed. Elizabeth Walmsley laughed when questioned about the potentially sensitive subject of rejection by the Lone Star group. She underscored the women's desire to prove themselves in a national forum, to help educate others about prints and printmaking, to offer their work for sale, and to do so in a spirit of good will.[5] The spirit that prevailed at the organizational meeting of the Printmakers Guild was apparently a positive one of getting on with a project the members were confident would succeed.

The first meeting was held in Stella LaMond's home at 3211 Westminster, surrounded by noteworthy gardens designed and installed by Miss LaMond herself.[6] The plan for the Printmakers Guild was ambitious and yet uncomplicated: at an early fall meeting each member was to pay modest dues and submit at least two new prints for inclusion in the forthcoming circuit of shows. The edition size for new prints had to be sufficient to assemble several complete sets of the members' new work to travel on exhibition and sale circuits.

At first there were fewer circuits, but as membership grew so did the circuits, until they reached five. One set of prints moved up the eastern part of the United States, one up through the Middle West, another out west, the fourth around Texas, and the fifth around Dallas. Showings were arranged with local art associations, libraries, civic groups, schools, colleges, and universities, with each season's tour beginning late in September and ending the next spring, usually in April.[7]

---

*News* (cited hereafter as *DMN*), Nov. 21, 1932, and in the Dallas *Times Herald* (cited hereafter as *DTH*), Nov. 22, 1932.

4. Stewart, *Lone Star Regionalism*, 89–93.

5. Elizabeth Walmsley to David Farmer, Aug. 23, 1988, interview.

6. *Better Homes & Gardens*, XXV (Sept., 1947); *DMN*, Sept. 26, 1948.

7. Florence McClung to David Farmer, Aug. 7, 1987, interview.

Two membership meetings were held each year. At the September meeting, the main business was to pay modest dues, show the new prints for the coming season, and assemble the cases that would tour. Officers were elected at the spring meeting, and reports were made on the tours which had just ended.[8] While the surviving minutes document only the twice-yearly business meetings at a member's home (usually followed by refreshments), in April 1941, the Guild met in Virginia Hall at Southern Methodist University for a dinner and business session. Having been formed only six months earlier, the group was clearly in a formative stage. In the Dallas *Morning News,* Louise Gossett noted that the "Guild organized this season for the purpose of studying and exhibiting prints. [It] will map out a schedule of activities for the 1941–42 season and will discuss entrance requirements for new members."[9] Within its first few months, however, the Guild had already caught the attention of the press and museum officials, for Gossett noted in her article that Guild members would exhibit thirty prints at the Dallas Museum from April 21 to May 2.

From this beginning the matter of separate circuits developed. Each circuit was to be managed by a different member, who would be responsible for arranging the schedule of showings. The only stipulations the Printmakers Guild made about its shows was that the sponsoring organization in each community pay the shipping expenses to the next stop on the venue and that one print per showing be purchased, either by a visitor to the show or by the sponsoring group.

As familiarity with the work of the Printmakers Guild grew through successive annual showings around the country, several members found their work selling consistently from year to year in specific communities. For example, Barbara Maples recalls that when the Guild's western circuit reached Pocatello, Idaho, each year, an order would come for one or more of her prints.[10]

In time there were five sets of prints circulating each year around the country, and this continued for twenty-five years. There was surprisingly little damage or loss with all the handling of prints by so many people unpacking and packing the Guild's prints all around the country. The prints were hinged in mats of a uniform size that fit snugly in shipping boxes made of stiff pressed board. The box lids were held in place by straps with buckle clasps. Railway Express was the preferred means of shipping. Once in a while a print

8. Printmakers Guild Minutes, Manuscript Collection, DeGolyer Library, SMU (cited hereafter as MC).

9. *DMN,* Apr. 1, 1941.

10. Barbara Maples to David Farmer, Aug. 17, 1988, interview.

was handled carelessly and sent back for re-matting. Then, in 1960, the prints on the eastern circuit nearly met with a disastrous end. Hazel McGraw was responsible for this set of prints and wrote as follows:

> Sorry that Frances Bishop's mat was damaged so badly. I had the prints in a gallery in Woodstock [New York]—a very lovely old red barn. A bad storm blew up suddenly and several prints were blown down, but Frances' mat was the only one damaged. That terminated our show as a portion of the roof was blown away.[11]

Chance played only a small part in the success of the Printmakers Guild, for its eight founding members were highly motivated and set an example for those who joined later. The founders were Stella LaMond, Lucile Land Lacy, Bertha Landers, Mary Lightfoot, Verda Ligon, Blanche McVeigh, Coreen Mary Spellman, and Lura Ann Taylor (later to become Lura T. Hedrick). The level of activity they engaged in is proof of their energy and drive. These women were mostly in their early thirties, so they had already earned their academic degrees, studied art, and were establishing their careers.

A good example is Coreen Spellman, who was born in Forney, Texas, on March 17, 1905. She earned her bachelor's degree from Texas State College for Women in 1925 and then went immediately to Columbia Teachers College in New York City, where she received her master's degree in 1926. In the summer of 1927 she studied at Harvard University on a Carnegie Scholarship, and in 1928 and 1929 she returned to New York to study at the Art Students League. More summer study came in a watercolor class with Charles Martin in Provincetown in 1933. Then, in 1941 and 1942, she earned her M.F.A. degree from the University of Iowa.[12]

In 1946, Spellman was elected president of the Printmakers Guild, and by this time the membership had grown to thirty. During her term, she instituted the practice of including short biographical sketches of each artist whose work travelled on exhibit.[13]

Many of Spellman's lithographs demonstrate a traditional sensitivity to the medium, derived only from careful work at the stone, laying in shading and a variety of tones as demonstrated in her 1955 lithograph "Antonia." Similar sensitivity is found in her lithograph "Old Livery Stable, Las Vegas, New Mexico." This print won the Elisabet Ney Museum Purchase Prize in the 1950 Texas Fine Arts Association exhibit. Before 1950, Spellman's prints had already been recognized by the TFAA with first prizes in 1945 and 1948 and an honorable mention in 1946.

11. Hazel McGraw to Ann [Gantz], Aug. 29, 1960, in Printmakers Guild Papers, MC.
12. Biographical data sheets, 1942, 1945, in Bywaters Collection, SMU.
13. Printmakers Guild Minutes, May 26, 1946, MC.

Camp Howze, by Coreen Mary Spellman [n.d.]. Lithograph, 13 x 9 inches.

Spellman used architectural elements not only in "Old Livery Stable" but again in "Weighing Station, Krum," which toured on the 1946–1947 Guild circuit.[14] It was also reproduced in a Dallas *Morning News* article on September 26, 1946. In these prints, Spellman was clearly working in a regional genre that adopted ordinary structures found in Southwestern communities. While this regional approach to subject matter had been introduced to Texas earlier by Jerry Bywaters, Otis Dozier, and Merritt Mauzey, Coreen Spellman applied her own style, defined by a firm sense of linear form. In her architectural subjects we find a clean, unfussy presentation rendered with a sure hand at the lithographic stone. Her "Old Inge House" won the Southwest Review Prize in the 1949 Southwestern Exhibition of Prints and Drawings.[15] With this print, she also caught the attention of the artists who formed the Lone Star Printmakers. Although the Lone Star group had ceased to exist four years after its founding in 1938, its organizers had planned a portfolio of offset prints which was eventually published by Southern Methodist University Press in 1952 as *12 From Texas: A Portfolio of Lithographs.* Spellman's lithograph of the Inge house made her the only woman artist whose work was included in this portfolio.

As "Antonia" demonstrates, Spellman did not limit herself to interpreting structures and buildings, nor did she confine herself to one style of working on the lithographic stone. In "Josephene" we find an effective and balanced use of liquid tusche with the lithographic crayon. This print won the Leon A. Harris prize of $75 in the 1951 Southwestern Exhibition of Prints and Drawings.[16]

Finally, a most unusual lithograph of Spellman's deserves attention here. It is titled "Camp Howze" and set in the camp in Gainesville which housed German prisoners from Rommel's Afrika Korps.[17] Spellman performed volunteer work at Camp Howze during World War II. Among her other wartime activities were the making of posters for the Red Cross and for bond drives, assembling and hanging art exhibitions for the Denton U.S.O. and for Camp Howze, and assembling and matting gift exhibits for Army hospitals.[18]

Spellman's lithograph "Camp Howze" is an intriguing work with an unusual perspective. It is presented as if through the men's eyes while they stand on a balcony watching two women cabaret dancers below. The men view the scene with detachment, dispassionately removed, almost as if the dancers are specimens for observation.

14. *DTH,* Sept. 27, 1946.

15. Typed list of Spellman's prizes and awards, in Bywaters Collection, SMU.

16. Ibid.

17. Arnold P. Krammer, "When the Afrika Korps Came to Texas," *Southwestern Historical Quarterly,* LXXX (Jan., 1977), 239–282.

18. Biographical data sheet, 1945, in Bywaters Collection, SMU.

Another prolific and widely recognized founder of the Printmakers Guild was Blanche McVeigh, born in St. Charles, Missouri, in 1895. After an unhappy stint as a teacher in the First Ward Elementary School on Belknap Street in Fort Worth, she sought other outlets for her creative energy. She subsequently studied at the St. Louis School of Fine Arts, the Art Institute of Chicago, the Pennsylvania Academy of Fine Arts, and the Art Students League. McVeigh spent most of her printmaking career in Fort Worth, where in 1932 she and Evaline Sellor established the Fort Worth School of Fine Arts in the Little Theatre building behind the Women's Club.[19]

The school was near a black neighborhood, and from this and her interest in the music of Negro spirituals, Blanche McVeigh developed a large series of regional prints with black subjects. While these prints are given to stereotyping and sentimentality, they were widely popular and took their share of prizes. It was also during this period that McVeigh moved from etching into aquatint, one of the most difficult printmaking media to master. For a number of her aquatints McVeigh drew upon scenes in New Mexico near Santa Fe and Taos. "Adobe Houses" is a good example of her somber and rich New Mexico aquatints. This print travelled on the 1946–1947 Guild circuit.

McVeigh was at her best in the 1944 aquatint "Decatur Courthouse," which took first prize in the Fourth Annual Texas Print Exhibition. The $100 purchase prize was given by Neiman-Marcus and the Dallas Print Society.[20] This print compares favorably with Jerry Bywaters's "Texas Courthouse," done six years earlier. The Library of Congress purchased "Decatur Courthouse" for its permanent collection, and other works of McVeigh's were selected each year between 1939 and 1944 as among the 100 Best Prints designated by the Society of American Etchers.[21] In 1951, McVeigh was elected president of the Printmakers Guild,[22] five years after John Taylor Arms, writing in the *Encyclopedia Britannica Yearbook*, placed her among the handful of American printmakers who had produced some of the best prints of recent years. When McVeigh wrote to Arms after learning of his recognition and praise, she received this response:

I have always been a great admirer of your work and am very proud of the examples of it I possess. I have hoped that some day I might meet and know you, because

19. Fort Worth *Star Telegram* (cited hereafter as *FWST*), June 21, 1970.
20. Fourth Annual Texas Print Exhibition, brochure, in Bywaters Collection, SMU.
21. *FWST*, June 21, 1970. See also the list of honors and prizes, Blanche McVeigh Papers, Archives of American Art, Library of Congress.
22. Printmakers Guild Minutes, May 27, 1951, MC.

someone who does that kind of work must, I think, be a grand person. Now I know you are. Thanks an awful lot, Miss McVeigh.

<div align="right">

Most sincerely yours,
John Taylor Arms[23]

</div>

Of the two surviving founders of the Printmakers Guild, Lura Ann Hedrick and Bertha Landers, only Landers is still active as an artist. In a telephone interview in November 1988, she said she stopped making prints as long ago as the 1950s, but she is still working with watercolors.[24]

Born in 1911 in Winnsboro, Texas, Landers earned her bachelor's degree in art in three years at Sul Ross College in Alpine. She moved to Dallas and then attended the Colorado Springs Fine Arts Center in 1938 and the Art Students League in 1939.[25] With a strong recommendation from Otis Dozier, she won a scholarship in 1940 to return to the Colorado Springs Fine Arts Center, where Lawrence Barrett was teaching lithography and also printing the work of visiting artists and students.[26]

In discussing her first venture in lithography at Colorado Springs, Landers recalls her concern at not being strong enough to handle the heavy stones. Barrett was quietly reassuring, saying, "Don't worry, I'll take care of that for you."[27]

When the 1940 session ended, Landers headed back to Dallas to work at the Dallas Public Library, but she arranged for Barrett to continue printing her lithographs. He would send her a stone, ground on both sides so she could make two different drawings on it, packed in a special wooden box that would protect the image surfaces. Landers would create two images on the same stone in Dallas and ship the stone back to Colorado Springs for Barrett to pull proofs. When the proofs reached Landers, she would call Barrett to discuss any adjustments she wanted. He would make them and pull another proof, finally getting ready to print the edition.[28] Following this routine for over a decade, Barrett printed lithographs for Bertha Landers, usually in editions of twenty-five.

An excellent example of the results of this collaboration is "Market Day," which took the Fort Worth Art Association Prize in the Fourth Annual Texas Print Exhibition in 1944.[29] Landers also worked less frequently with serigraphs. "Ad Infinitum" qualifies as one of her best serigraphs. She first painted this image in oils and submitted the canvas, indicating clearly that it was

23. John Taylor Arms to Blance McVeigh, Aug. 13, 1946 (microfilm, Archives of American Art).
24. Bertha Landers to David Farmer, Nov. 7, 1988, interview.
25. Biographical data sheet, Bywaters Collection, SMU.
26. Landers to Farmer, Nov. 7, 1988, interview.
27. Ibid.
28. Ibid.
29. *DMN*, Nov. 14, 1944.

not for sale, to the Corpus Christi Art Association for a juried show. The association soon called her and asked to buy it. She began to cry, knowing she could not refuse the request, even for a piece she liked so much. It was then that she decided to render the image as a print. Difficulties arose in printing the image, however, so the edition was limited to five.[30]

In a recent conversation, Landers identified this serigraph as one of the key prints she will include in the slide set she submits for consideration by the National Museum of Women in Art.[31] During her association with the Printmakers Guild, she recommended and then prepared a three-page description of graphic processes that was included in each set of prints that travelled. She wrote concisely and clearly about relief, intaglio, planographic, and silkscreen printing.[32]

Lucile Land Lacy was another founder of the Guild. At the time she was head of the art department at Mary Hardin Baylor College in Belton, Texas. She had already earned her undergraduate degree from Baylor College and then went to study in Chicago and at Columbia University in New York.[33] At Baylor, Lucile Lacy taught both Barbara Maples and Lucille Jeffries, who would later be invited to join the Guild. By 1947, Lacy's name does not turn up in the minutes of the Guild, and by May 1950, the minutes record the passage of a motion to invite Lacy and Bertha Landers to exhibit with the Guild once more.[34]

Prints by Lucile Lacy are not easily located, but two in particular demonstrate her competence in serigraphy as well as lithography. The first is a silkscreen titled "Canned Geraniums," in which her use of color and line is fresh and arresting. While the perspective in this print carries the eye past the door to the far end of the wooden porch, the brilliant potted flowers keep pulling the viewer back to the foregound.

In the lithograph "Left Side of the Tracks," the use of the railroad tracks to isolate the cluster of buildings in the background is an effective device, balanced by the vertical elements of the poles and signs. This is another ordinary scene with regional flavor, yet dignified by the artist.

If information about Lacy and her prints is sketchy, we know much more about Stella LaMond. She was born in Morganfield, Kentucky, and attended the Thomas School in Detroit, Michigan, in 1913 and 1914. She also attended Peabody College in Nashville from 1924 to 1926, earning her bachelor's degree,

30. Landers to Farmer, Nov. 7, 1988, interview.
31. Ibid.
32. Description of graphic processes, n.d. (mimeograph; in possession of author).
33. Esse Forrester O'Brien, *Art and Artists of Texas* (Dallas: Tardy Publishing Co., 1935), 140.
34. Printmakers Guild Minutes, May 28, 1950, MC.

and Columbia University in 1929 and 1930, receiving her master's degree. In the summer of 1944, after she had already begun teaching at SMU, she studied at Cranbrook Academy in Michigan.[35] Within three years of coming to SMU she was named chair of the art department, a position she filled for twenty years.[36]

The influence of Cranbrook, with its strong tradition of fine arts and crafts, on LaMond was significant. She became especially interested in the integration of arts and crafts into the total environment of one's life. She believed that her house, gardens, textiles, ceramics, paintings, and prints should all function together in a cohesive way, and apparently they did.

LaMond's interest in a variety of media is reflected in the range and diversity of her prints. In 1940 and 1941, she was working on lithographs such as "Summer Harvest," "Mission Church, Ranchos de Taos," and "Abandoned," which evokes an atmosphere found in some of Thomas Hart Benton's prints. The color serigraphs "Lillies" and "Sand Pit" date from 1943 and 1947 respectively. LaMond's captivating still-life color woodblocks, such as "Bouquet" and "Tulips," are brilliant in their handling of a difficult medium.

Mary Lightfoot, another founder of the Guild, was born in Ravenna, Texas, and earned her bachelor's and master's degrees from Texas State College for Women. She taught ceramics and ceramic sculpture at Crozier Technical High School in Dallas. Her lithograph "Road to Riverby" shows the influence of Merritt Mauzey, who may well have printed it for her. Another lithograph titled "Texas Ranch" presents the world of armadillos and rattlesnakes long before they became the Texas icons they are today. What is more, in this image Lightfoot shows each of these two strange and well-armored creatures attempting to let the other pass by. Anyone who has observed these animals in the wild will understand the dynamics here.

Verda Ligon was born in Dallas and studied at the Detroit School of Fine Arts and the Phoenix Art Institute in New York City.[37] She earned her bachelor's degree from SMU and taught in the Dallas Public schools for forty years.[38] Her woodcut "Canna Lilly" shows much skill, balance, and restraint. The image rests simply on a sheet that allows generous blank space around the lush flower.

By the 1942–1943 season, membership in the Printmakers Guild had grown from eight to fifteen with the addition of some printmakers with a considerable

---

35. Biographical data sheet, 1945, in Bywaters Collection, SMU.

36. *DTH*, May 26, 1959.

37. Biographical data sheet, 1945, in Bywaters Collection, SMU.

38. *DMN*, Nov. 29, 1978.

Evening Sky, by Constance Forsyth, [n.d.]. Lithograph, $11\frac{5}{8}$ x $15\frac{3}{4}$ inches.

range of skills.[39] One of these was Barbara Maples, who was born in Temple, Texas, in 1912. At Mary Hardin Baylor College, she studied with Lucile Land Lacy. Maples would go on to become a printmaker, a jewelry maker, an artist with wood, and to teach in the Dallas schools, the Dallas Museum of Fine Arts, and at SMU.

Maples earned her master's degree at Columbia University and then studied in the summers at the Colorado Springs Fine Arts Center. It is interesting to note the connection between this institution and printmaking in Texas. Otis Dozier taught there, and in addition to Bertha Landers and Barbara Maples, a number of other Guild members studied there, including Florence McClung and Elizabeth Walmsley. Furthermore, Ward Lockwood, who established the program in printmaking at Colorado Springs, later chaired the art department

39. The membership may have been larger by this time, but the minutes are incomplete. At any rate, the work of fifteen artists was shown on the 1942–1943 circuit. Mimeograph list, in possession of Paul Harris.

at the University of Texas, where he hired Constance Forsyth to launch the printmaking program.[40]

Barbara Maples still recalls her first experience in studying lithography with Lawrence Barrett at Colorado Springs, and that experience was very different from that of Bertha Landers. Barrett was a stickler for traditional and painstaking techniques of lithography. Thus, he required his students to work at a stone for several days to create one image, starting with a fine pencil and laying in the background very carefully. Only then could they pick up the next finest pencil. Students were not permitted to use a lithographic crayon until they had proven that they were adept in the use of pencil on stone.

Before coming to Colorado Springs, Maples had worked at lithography in Merritt Mauzey's studio in an informal and largely unsupervised way. She quickly tired of Barrett's routines and considered quitting until she shared her frustration with Otis Dozier, who was teaching at Colorado Springs at the time. Dozier told her to go to the studio at night and work in different ways on the stone. He then gave Maples a list of experimental methods in creating a lithographic image, including highlighting by scraping through a layer of liquid tusche with a razor blade or other tool, and then working in the exposed area with litho crayon or with pencil. Maples recalls that Dozier's list of experimental techniques was long. He then told her how to get into the studio after hours and cautioned her to put her stone away before leaving.[41]

Maples followed Dozier's advice, and once again the magic of lithography was renewed for her. Clinton Adams notes that Barrett was willing to discuss experimental techniques with faculty members and visiting artists such as Adolf Dehn and Dozier, and he was quite willing to print lithographs for them that were created using such experimental methods. He imposed traditional techniques and limitations on his students, however.[42]

When Maples came back to Dallas, she once again began working in Mauzey's studio on weekends. She recalls carrying her portfolio and taking the streetcar out to the end of the line near Hillcrest and Daniel and then walking the rest of the way to Mauzey's garage studio on Stanford. Mauzey was a very serious student of lithography and would later win a Guggenheim to study its techniques. Not only did he teach Maples more about the medium, he also printed for her, as he did for Elizabeth Walmsley and presumably a number of other Dallas artists.

40. See my article, "Constance Forsythe: Printmaker," *The Tamarind Papers*, XII (1989), 46–54.

41. Barbara Maples to David Farmer, Aug. 17 and 24, Sept. 14, 1988, interviews.

42. Clinton Adams, "Rubbed Stones, Middle Tones and Hot Etches—Lawrence Barrett of Colorado," *The Tamarind Papers*, II (Spring, 1979), 38.

It is fortunate that a good number of prints by Maples can be located for study because they demonstrate the range of techniques that characterized the work of a number of members of the Guild. Early in the 1940s, Maples worked in lithographs, etchings, and aquatints and then moved to serigraphs in the 1950s, as did others. This was a significant transition, for it reflects some decline of interest in lithographs in the 1950s and the rise of interest in a relatively new process, the silkscreen. Furthermore, the difficulty of getting lithographs printed in Dallas surely contributed locally to the move towards serigraphs.

One of Maples's early prints is "Road to the Mountains," an accomplished aquatint. Another early print is "Sea Mood," also an aquatint employing a variety of techniques to develop different textures. Her favorite cat, which Otis and Velma Dozier gave her, plays a key role in a number of her prints, including "Nickie in a Net," an etching which travelled in the Guild show in 1954–1955.[43]

In time, Maples built a cabin in Colorado not far from Cripple Creek, where she would work in the summertime. There she found the sources for such prints as "Moonlight Over Rosemont, Colorado" and "High Meadows." Among Maples's block prints are "Gulf Scene," which travelled with the Guild show in 1959–1960 and "Fruit," which travelled in 1953–1954.

Another artist who was invited to join the Guild soon after its founding is Elizabeth Walmsley. She was born in Ohio and earned a bachelor's degree in architecture at Washington University in St. Louis and a master's at Texas State College for Women. In Walmsley we also find another north Texas connection with Colorado Springs where she studied at the Fine Arts Center. Before moving to Dallas, Walmsley had her own interior design business in St. Louis. Then she joined the faculty at SMU, where she taught for the rest of her career.[44]

In 1946, Walmsley was elected secretary of the Printmakers Guild, and in 1949, she was elected president, serving for two terms.[45] Mauzey printed lithographs like "Hall Street Houses" and "Changing Neighborhood." Walmsley was unable to handle the stones and thus arranged for Mauzey to pick them up at her home and take them back to his studio to print. After the edition was printed, he would clean the stones and bring them back to be reused.

Walmsley's serigraphs are as strong as some of the lithographs. "Blue Mountains" is still a favorite of the artist's, along with "Red Mountain," which she considers her best serigraph. "Patterns" is another fine example of her work.

43. "Texas Printmakers, 1954–55, Prints in This Portfolio," n.d. (original mimeograph sheet, in possession of author).

44. Biographical data sheet, n.d., in Bywaters Collection, SMU.

45. Printmakers Guild Minutes, MC.

Another artist invited to join the Guild shortly after it was formed was Lucille Jeffries. Because she died so young, in her thirties, little is known about her. We do know that she grew up in Mission, Texas, in the Rio Grande Valley and earned a bachelor's degree at Mary Hardin Baylor, where she studied art with Lucile Land Lacy. She also earned a master's degree at Columbia University in 1939. Jeffries began her career at Mary Hardin Baylor, where she taught for three years. She moved to Dallas in 1936 to teach at Mount Auburn School.[46]

While I located no photographs of Lucille Jeffries, almost better than a good photograph is an undated watercolor self-portrait she titled "Dammit—t'hell—Woman," in which she wears a bold plaid skirt and red sweater and stands with one foot up on a stool, smoking a cigarette and looking defiantly straight at the viewer.[47] Lucille Jeffries's work was especially familiar to Dallas viewers from its inclusion in the Texas General shows and her prize-winning watercolors in the Allied Arts competitions in 1939, 1940, and 1941. Jeffries also won prizes in the Texas Fine Arts Association show in 1941.[48]

In the medium of prints, Jeffries produced both block prints and lithographs. Her block print "Young Rancher" is reminiscent of some early work by Roderick Mead in New Mexico. In it her cousin is profiled against a West Texas ranch background. The entire scene is printed in a single light brown tone. Her lithographs are strong, bold prints, especially those she did in Colorado, like "Golden Cycle Mill," "Harvest," "Cripple Creek," and "Leadville."

One of the liveliest sources of information on the Printmakers Guild has been Florence McClung, who turned ninety-three in July 1988. She was born in St. Louis, and with a double major earned bachelor's degrees in art and English and in education from SMU in 1939. She did graduate work in art under Alexandre Hogue in 1940 in the Taos program run by the Texas State College for Women. In 1941, she studied lithography under Adolf Dehn at Colorado Springs. For thirteen years she was head of the art department of Trinity University in Waxahachie, commuting each day from her home in Dallas.[49]

McClung speaks vividly of her experiences with Dehn. He was clearly astonished by McClung's early skill at the lithographic stone, but before he praised her technique he chose to put her off guard. She found his gruff questioning about how she achieved a certain effect of clouds and rain in one of her lithographs disturbing. She has not forgotten the incident yet, nor has she forgotten Dehn's indiscreet attentions to some of his female students. She recalls how he slipped away from group picnics with a student from time to time.

46. *DTH,* Nov. 2, 1941.
47. Private collection.
48. *DTH,* Nov. 2, 1941.
49. Florence McClung to David Farmer, Apr. 15, 1987, interview.

[Taos], by Florence McClung, [n.d.]. Woodblock print, 14 ⁷⁄₈ x 17⁷⁄₈ inches.

Thus, when Dehn invited McClung to come to his cabin one evening to discuss her "progress as a printmaker," she made a plausible excuse to stay away. Recent reading of some of Dehn's correspondence in the Archives of American Art confirms what McClung had determined for herself many years ago about Dehn as a womanizer.

Early study in the Southwest and her visual appreciation of the region led to McClung's return in the summers, when her husband would take time off from his cotton business to lead groups of Boy Scouts on encampments. In Taos she met Ila McAfee Turner and Gene Kloss, who have remained good friends to this day. Her prints from the Rocky Mountains are numerous, with "Nature's Mood" a good example of her New Mexico lithographs. "Taos Scene" is a bold and accomplished woodcut, but the artist discounts it as something she dashed off hurriedly.

McClung had an eye for the countryside over which she drove on her way to Waxahachie. She rendered scenes like "Mechanized Farm," based on a nearby corn-shelling operation to which she took her students on sketching trips. "Home Front" is another regional scene, a strong lithograph selected by Artists for Victory for their America in the War show in October, 1943. This was a landmark exhibit, in which the 100 prints selected for inclusion were shown simultaneously in twenty-six locations around the nation. After the show ended, the Library of Congress asked for one of each print and thus assembled the only extant complete set from an important event in American printmaking history.[50] Florence McClung's prizes and solo shows were numerous, and she figured prominently in the Texas art scene.

In closing, I want to discuss some images by two more artists. One of these is Mary Doyle, who was born in Stephenville and educated at Texas State College for Women. She taught in the schools in Dallas, as well as at the Dallas Museum of Fine Arts.[51] She was especially committed to the role that art could play in helping underprivileged children break some of the shackles that had kept their families from reaching their full potential.[52] She was invited to join the Printmakers Guild in 1953 and the print she submitted that year, "Honeydew Mellon," sold out while the show was still on circuit. The serigraph was the medium Mary Doyle worked in when she was not painting. Her skill in silkscreening prints is revealed not only in "Honeydew Melon" but also in "Still Life With Grapes," "Ice Box Melon," and "Texas Oranges."

Emily Rutland was born in 1894 on a cotton farm near Taylor, Texas, in Williamson County. She married "off the farm" to take up life on another in the Robstown area. Her formal art training consisted of several months with artist-teacher Xavier Gonzales, a few lessons with Cyril Kay Scott, three two-week sessions with Frederick Taubes, and two weeks with watercolorist Jacob Getlar Smith.[53]

Rutland caught the attention of Aline Kistler, the editor of *Prints,* as well as of Carl Zigrosser. In responding to an inquiry from Zigrosser, she wrote:

> I haven't much to say for myself. Am only a cotton farmer's wife, was born and grew up on the farm. Have lived all my life there, with the exception to two winters spent in San Antonio where I studied art for two terms of four months each, drawing from life. We also had a two weeks' course in design. I used only pencil, charcoal, and conte crayon. Then from that foundation I worked alone, here on the farm, drawing our horses, cows, etc.[54]

---

50. Ellen G. Landau, *Artists for Victory* (Washington: Library of Congress, 1983).
51. Mary Doyle to David Farmer, Aug. 15, 1987, interview.
52. *DMN*, Mar. 8, 1961.
53. Biographical data sheets, 1945 and 1950, in Bywaters Collection, SMU.
54. Carl Zigrosser, "Prints in Texas," *Southwest Review,* XXVI (Autumn, 1940), 51.

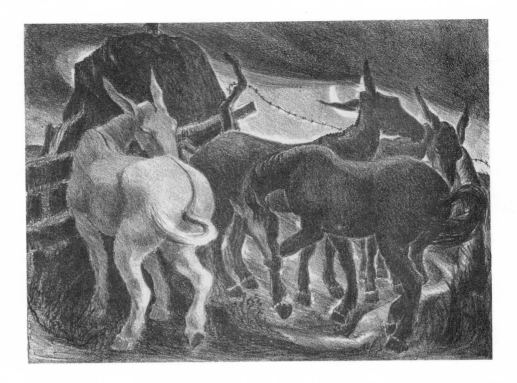

Ouch! Mosquitoes!, by Emily Rutland, 1944. Lithograph, 10½ x 11⅝ inches.

Amy Freeman Lee wrote of Rutland in a 1949 exhibit catalogue:

Since Mrs. Rutland has been and is almost totally preoccupied with her immediate surroundings so characteristic of the farmlands near Robstown, Texas, she has applied three of the basic prerequisites of fine art: First, she has the good common sense to paint that with which she is most familiar, and the result is work which shows she knows her subject thoroughly. Second, as all good poets, she has the capacity to see the universal in the particular, for when you look at one of her mules, horses or cows you see the genus in its entirety. Third, she furthers her poetic traits by having the capacity to see the magic in the commonplace: to her the corral, the farm and the barnyard have a special beauty all their own.[55]

Particularly strong lithographs by Rutland are "Friends," "Baby White Face," "Cattle Getting Up in the Morning," "A Cold Wind," and "Ouch!

55. Joseph Polley Paine, *The Texas Fine Arts Association Presents Oils and Lithographs by Emily Rutland* (Austin: Elisabet Ney Museum, 1949), unpaged folder.

Mosquitos!" These lithographs are especially difficult to find nowadays, and it is still not known who printed them for Rutland while she worked on a small farm near the Texas Gulf Coast. Limited space precludes discussion of Printmakers Guild members Bess Hubbard, Veronica Helfensteller, Janet Turner, Constance Forsyth, Lia Cuilty, Grace Crockett, and others. In closing, however, we must note some late changes that came about in the organization. In 1952, the membership voted to change its name to Texas Printmakers, which they felt was more accurate. Nevertheless, it has caused a little confusion, for it was not always clear to others that the two groups were identical in membership and purpose. Then, in 1962, the minutes begin to reflect discussions about opening up the membership to men. This was done in 1964, when Paul Harris was invited to join. The 1964–1965 season turned out to be the organization's last. It disbanded by general agreement. Artists like Janet Turner and Bertha Landers had moved as far away as California, and the general interest in prints had waned. Stella LaMond, who had been instrumental in bringing the organization together, took the lead in suggesting that it was time to retire the travelling print boxes. As the boxes came back to Dallas at the end of the 1964–1965 season, they were opened one last time and many of the members present traded prints with one another, as they had done for twenty-five years.

A quarter of a century is a significant lifespan for an organization that was run on volunteer time. Throughout its existence, the Printmakers Guild had successfully circulated its members' prints around much of this country, with varying degrees of success in sales. When we think of prices ranging from four to ten dollars, we wonder why they did not sell out every one of the five circuits every year. Part of the answer lies in the hierarchy of American printmaking. It is accurate to say that the majority of the members were competent printmakers whose main occupation was art education. A handful gained international reputations as printmakers as well. Others achieved national recognition, while still others functioned in a more limited sphere. As a group, the Printmakers Guild did not set trends in terms of a regional art movement. Nevertheless, I would suggest that some of its members, like Forsyth, Turner, McClung, McVeigh, Landers, Walmsley, and Rutland, would have been considered for membership in the Lone Star Printmakers had it survived more than four short years and changed its attitudes about women artists.

I trust that the founding of the National Museum of Women in Art in Washington will lead to the rediscovery of other members of the Printmakers Guild in addition to Bertha Landers, and that these fascinating, intelligent, capable, and motivated women, who charted their own course on the American printmaking scene for a quarter of a century, will receive the attention they deserve.

Woman of the High Plains, Texas Panhandle. Dorthea Lange, 1938. Photograph, 8 x 10 inches. *Courtesy Library of Congress.*

# Dust Bowl Realism: Texas Printmakers and the FSA Photographers of the Depression

Richard Cox

Texas in the 1930s summons up images of dust: swirling dust, dust-covered farms, dusty farmers, dusty children, tumbleweeds blowing across dusty roads, and midday skies darkened with huge clouds of dust. That such storms never blew over most of the mammoth state of Texas in the 1930s does not change the perception that they did. Enough of Texas—specifically the large Panhandle section—did suffer grievously from the dirty yellow storms of the mid-1930s to feed the myth that the state's 267,000 square miles were turned into a vast graveyard. Such are the myths that nourish art, in this case the flourishing art of the Dust Bowl. The Dust Bowl became one of the catchwords of the 1930s, a principal symbol of that anxious, troubled decade, a term almost synonomous with the Great Depression. Skilled image makers—writers, filmmakers, musicians, and artists—had a hand in this. A special contribution to the history and lore of the Dust Bowl came from printmakers and photographers. In Texas never more than a small number of artists were involved, but they were intense and in most cases able chroniclers of distress. Alexandre Hogue, Merritt Mauzey, Otis Dozier, and Dorothea Lange traveled to the Panhandle area and made important images of the northwest Texas counties afflicted by the dust storms.

The printmakers Hogue, Dozier, and Mauzey were native Texans; the photographers Rothstein and Lange were not. The printmakers and the photographers apparently did not cross paths during these years, although they must have been aware of each others' work.[1] They shared basic goals: to leave a real and searching picture of life in Dust Bowl Texas that would touch the emotions of the viewer and advance their careers. They intended to extend their audience

1. Articles by Jerry Bywaters and others in the 1936–1940 issues of *Southwest Review* showed no sign that the Texas painters knew or cared about the activities of the FSA photographers.

beyond the elite community of fellow artists, collectors, and connoisseurs who normally patronize printmakers. Both the photographers and printmakers wondered about their ability to move public opinion. They also were aware of the problems of lifting their documentary pictures to the level of art. Altogether, the record these image-makers left demonstrates the powers and limitations artists faced when confronting the dramatic events of the Great Depression.[2]

The Dust Bowl, of course, was painfully real to the counties of northwest Texas. During and just after World War I, through a belt of over a hundred counties stretching from central Kansas to North Texas, farmers, lured by quick profits from the swollen international demand for grain and cotton, plowed much of the thick-rooted buffalo grass that had coated the Great Plains for several generations. Even when the prices for wheat and corn plummeted in the late 1920s, the mindless plowing continued. Beginning in 1933, consistently heavy winds blew away the rich topsoil of the region; these winds eventually turned into fierce dust storms, known as the "black blizzards," which darkened the skies and buried houses, barns, farm machinery, and animals. Wheat, corn, and cotton plants choked and wilted like politicians after losing campaigns. Flash floods, howling snow blizzards, and insect attacks added to the woes. Farmers lost their small farms to the banks. Many of the farms had been mechanized before the Depression, reducing farmers to tenant status by the 1930s; these "suitcase farmers" were doubly vulnerable and even more pathetic players in the Dust Bowl drama. Without their own farms and with tenant work hit-or-miss, many Texans and Oklahomans were forced onto the roads leading to New Mexico, Arizona, California, and Oregon. Upwards of 350,000 migrants (how many were Texans from the Panhandle region is not clear) headed west to meet their glory and sorrow, to encounter what John Steinbeck called *The Grapes of Wrath*.[3] By the end of the 1930s, the whole saga of the Dust Bowl—the storms, the dispossessed farmers, the stream of migrants—had become a favored subject for American novels, movies, songs, magazine photo-essays, and art.[4]

2. For a good account of the particulars of the Dust Bowl years, see Paul Bonnifield, *The Dust Bowl: Men, Dirt, and Depression* (Albuquerque: University of New Mexico Press, 1979).

3. Among the works dealing with the Dust Bowl in the late 1930s were Pare Lorentz's film *The Plow That Broke the Plains* (1936); John Steinbeck's novel *The Grapes of Wrath* (1938), and the film version, directed by John Ford and starring Henry Fonda, which went into production almost before the book was published; the Dust Bowl scenes of numerous New York City painters and printmakers, including Arnold Blanch, William Gropper, and Adolf Dehn, which drew crowds at the Associated American Artists Gallery in New York in 1937; the *Life* photo series on conditions in the Dust Bowl region by Margaret Bourke-White; and numerous songs by Woody Guthrie.

4. The best account of Lange's life and career is Milton Meltzer, *Dorothea Lange: A Photographer's Life* (New York: Farrar, Straus, Giroux, 1978), 146–150. More biographical detail is found in

Tractored Out, Hall County, Texas, by Dorothea Lange, 1938. Photograph, 8 x 10 inches. *Courtesy Library of Congress.*

Dorothea Lange came from California to document this dramatic phenomenon. In two separate trips in 1936 and 1937, she crisscrossed the northern counties of Texas. Her 1936 stay was brief. She took a small number of photographs, mostly iconic closeups of old farmers in the southwestern and northwestern parts of the state. She saw enough to know she wanted to return, which she did in May 1937. Her second trip was carefully planned and financed to study the conditions that produced the tide of migrants who had for several years been pouring into central California. Lange and her husband, Paul Taylor, a rural sociologist from the University of California, took Route 80 into Texas from New Mexico. Soon after entering the state, she learned that one of those rare but devastating heavy rain storms that punctuated the drought-stricken state in the Depression had closed the highways and roads to her destination, the Panhandle, so she drove east to Abilene and then north

Karin Becker Ohrn, *Dorothea Lange and the Documentary Tradition* (Baton Rouge: Louisiana State University Press, 1980), 53–99.

through Hall and Childress Counties. Later that summer she circled back and made her way to the heart of the Panhandle, into Swisher, Ochiltree, Oldham, and Dallam Counties, taking dozens of photographs that documented the hardcore Dust Bowl conditions.[5]

In photographs such as "Abandoned Farm Near Dalhart, Texas" and "Portrait of the Dust Bowl," Lange revealed the aftereffects of the "black blizzards." The land was battered and made barren by drifts of sand and dirt. Fence posts were bowed and a moonscape was formed by the sum of the natural disasters. One of her most powerful images of this bleak distress was "Tractored Out, Childress County, Texas." This photograph was apparently taken around noon; by the time Lange set up her graflex on top of her old Ford, the freshness of the morning had gone. She freezes the hard white light of the cloudless sky against the distant farmhouse. It is not really much of a farm, just a patch of wood on the horizon of the plain. One's eye moves slowly from the meandering S-shaped furrows of plowed dirt to the abandoned farmhouse, which the viewer senses is a surrogate human victim, a substitute for the farmers who have been banished from their home and work. The title gives away the meaning. It is not just the fickle working of nature that has brought on this tragedy. It was the chronic mistreatment of the land, the careless plowing by big absentee landowners who with their new tractors and combines pushed the small farmers into the insecurities of tenancy. With their blind faith in machinery and in their haste to make big profits, they plundered the soil. This land, which once flowed with milk and honey, now flows with bitter tears. In "Tractored Out, Childress County" and other landscape photographs by Lange there is a vastness, a stark melancholy that envelops this tortured land; endless miles and miles of such farms apparently exist beyond the limits of the scene pictured in the Childress County photograph.[6]

In many of her 1937 photographs, Lange brought attention directly to the human victims of the Dust Bowl. "Tenant Farmers Without Farms—Hardeman County" is among her most famous pictures of human misery. In a shack

5. Meltzer, *Dorothea Lange*, 172–175. Roy Striker, who headed up the FSA in Washington, sent Lange to gather material on tenant farming in order to convince skeptical congressmen to pass new farm legislation. With Striker's approval, she made up a travel plan in the spring of 1937. "She was to start South via Arizona and New Mexico, photographing the RA projects en route, then cover tenancy in South Texas, move up to Central Texas, and from there into Oklahoma, across Arkansas, and down into Mississippi, Alabama, and Georgia. . . . Toward the end of the trip he wanted her to stop in Washington to go over films and captions" (p. 170).

6. In *An American Exodus: A Record of Human Erosion* (New York: Reynal and Hitchcock, 1939), Lange and Taylor supplied the caption that accompanied "Tractored Out, Childress County, Texas": "Tractors Replace Not Only Mules, But People. They Cultivate To The Very Door of the Houses of Those Whom They Replace" (p. 73).

on a country road outside Acme, Texas, Lange and Taylor found seven young tenant farmers, the oldest of them thirty-three, each trying to support a family on fifteen to twenty dollars a week. They occasionally helped harvest wheat, did day labor in the surrounding towns, and intermittently took in a little money from the Works Progress Administration (WPA). Nothing was steady, especially the WPA relief, and their income had fallen so sharply that they could not pay the poll tax which Texas required as a precondition to voting. Lange's series of photographs of these luckless men reveals their bitterness and frustration; men still young with muscles like steel showing though their overalls, but with failure mirrored on their faces. They do not begin to understand the complicated economic conditions that have left them without land, income, and basic citizenship rights.[7]

Women were victims, too, as Lange revealed in several pictures, including the epic Panhandle image "Woman of the High Plains." The plaintive closeup study recalls an earlier California photograph, "Migrant Mother" (1936), which brought Lange national acclaim. In "Woman of the High Plains," a strong white light, against which the farm woman's head and shoulders emerge, falls evenly thoughout the picture. She is stiffly positioned and the camera is brought in tight to the figure. Charlie Chaplin's golden rule applies here: for comedy keep the shot a long one, but move the lens up close if you want to evoke tragedy. The woman is raw-boned, lean and strong but terribly worn—worn beyond her years. Her life is hemmed in by debts and worry, Lange discovered. Her future is summed up in her own words: "If you die you are dead, That is All."[8]

In the seminarrative sequence of Lange's Texas photographs, she moved from the abandoned farm families to the uprooted men and women heading west. The largest number of the 1937 pictures were of the migrants, the flood-tide of humanity who took old cars and trucks or hitched rides on Highways 80

7. "Snatches" of the farmers' comments jotted down by Taylor and Lange, and quoted in Meltzer, *Dorothea Lange*, 174:

The big landowners are on the WPA Committee and they want us cut off so we can work for them a few days at $1.50 a day harvesting their wheat. But if a man gets a job, he'll lose his WPA card. It'll take him a month to get back on WPA after the work is over, and another 20 days until he gets his first check. He'll lose 50 days for a few days work.

The Chamber of Commerce and the newspapers brag on the town and brag on the country. It's ok for health, and the soil's good. But the poor people don't get none of the money for the wheat. They'll have a fair crop this year, but we won't get $10 cash out of it, and the groceryman will get that.

None of us vote. It costs us $3.50 poll tax for a married man and wife to vote in Texas.

We used to go to church when we had better clothes. These are our Sunday clothes. All of us and our families together haven't spent $40 on clothes in the past year.

If we fight, who we gonna whup?

We were born at the wrong time. We ought to have died when we was young.

8. Quoted in Lange and Taylor, *An American Exodus*, 101.

and 54 leading out of Texas and Oklahoma. Examples include "Family Scene, Somewhere Between Dallas and Amarillo," "Family Walking on Highway, Oklahoma Panhandle," "Family on the Road," "Migratory Laborer and Family—Perryton Texas," and "Three Generations of Texas." These migrant-theme photographs, and indeed all of Lange's photographs of Texas, were about survival. They were stark, unpicturesque photographs, without the melodrama of Steinbeck's *The Grapes of Wrath*.[9] But they are, just as surely as the novel, about the American Dream—the American Dream under threat in the Depression. Did Lange sense on her field trips into Texas and Oklahoma and central California that the dream of a life of independence and self-reliance, of living close to the bounty of nature had been snuffed out? Are the farmers and the migrants beaten as well as battered? Have they given up their feelings for Texas? Or are they chasing the American Dream anew out in California? Honest observers can disagree on these questions as they look through the many published photographs Lange produced in the 1930s. Her pictures do not have the obvious manipulative emotional qualities of Margaret Bourke-White's photographs of the distress of sharecropper farmers of the Deep South, for instance.[10] Lange's captions are objective and documentary. Her point of view, her ideology, can be best understood by examining her connection to the national program of New Deal reform, as I will do below.

The Texas printmakers Merritt Mauzey, Alexandre Hogue, and Otis Dozier kept their sights on Texas subjects: on the ravished countryside of the northern counties and on the Texas people who stuck it out through the long drought of the 1930s. Hogue is the most renowned of the Texas artists of the 1930s. Raised in Texas, he began his career as a painter in New Mexico and returned to his native state to get involved with the Texas Regionalist movement, centered in Dallas, as a painter and lithographer. He was perhaps the first artist to make the Dust Bowl his central subject matter, in such paintings as "Drought Stricken Area" (1932), "Dust Bowl" (1933), and "Drought Survivors" (1936).[11] In "Dust Bowl," the viewer is thrust into a wasteland, the former range lands ravished by barbed-wire fences and plowed fields before the drought ever turned the rich soil into sand. Now the fence falls into disrepair, the tractor marks lead nowhere, and the hoofprints of the cattle are swallowed up by the drifts

9. Steinbeck's *The Grapes of Wrath* has been the subject of much critical discussion. Two good examples are found in Warren French, *John Steinbeck* (Boston: Twayne, 1975); and Howard Levant, *The Novels of John Steinbeck: A Critical Study* (Columbia: University of Missouri Press, 1983).

10. For an interesting discussion of Bourke-White's photo-essays for *Life* in the Great Depression, see Vicki Goldberg, *Margaret Bourke-White, A Biography* (New York: Harper and Row, 1986), 79–109.

11. Hogue said his reconstructions were based on real experiences: "I saw the whole works with my own dust-filled eyes. . . ." Quoted in Lea Rosson DeLong, *Nature's Forms/Nature's Forces, The Art of Alexandre Hogue* (Tulsa: Philbrook Art Center, University of Oklahoma Press, 1984), 19.

❧

of sand. The sun rests on the tangent of the horizon along with the shadowed farmhouse, and a great bank of orange-black clouds suggests the immediate aftermath of a dust blizzard.

"Mother-Earth Laid Bare" is, as Rick Stewart has noted, a more overt commentary painting, depicting "an abandoned farm set against a high horizon. The topsoil has been washed away to reveal the underlying clay which includes the suggestion of a sleeping female figure nestled among the folds of the exposed earth. A broken and useless plow in the foreground completes the picture."[12] "End of the Trail" (1934) was the one lithograph that came out of Hogue's preoccupation with the Dust Bowl theme in the mid-1930s. It is another scene of the ruined grasslands of the Panhandle region; the plow, so often in American art the symbol of fecundity and man's rational control over nature, is a destructive emblem in "End of the Trail"; the skull and the fence also symbolize pain and ruination brought about by the folly of soil abuse by the grain farmers. Hogue's art is intense, angry, and moralistic, with a strong sense of theater. Selective lighting, skewed perspectives, hyper-realistic details where the textures of sand and wood and metal wire are accented, and, most of all, the use of baldfaced symbols (a feature of other American regionalist artists such as John Steuart Curry)[13] took Hogue's art away from the bland, descriptive realism of many of the other Texas Scene artists.

Merritt Mauzey produced more images of Dust Bowl Texas than Hogue (Mauzey was primarily a printmaker while Hogue was mostly a painter), although he never achieved Hogue's national reputation.[14] Mauzey was raised on a cotton farm in Oak Creek Valley in West Texas, cattle country at the turn of the century. He worked on cotton farms as a youth and owned one of his own just after World War I before moving to Sweetwater, Texas, to work as a clerk in a small cotton firm in the 1920s. Serious health problems forced him to move to Dallas just before the Depression. Later he joined up with the Lone Star Printmaking group and attracted the attention of Carl Zigrosser, one of the leading American printmaking curators, then at the Philadelphia Museum of Art.[15]

Mauzey knew firsthand the triumphs and defeats of farming in the drought sections of Texas. He had suffered through the "parched years, the

12. Rick Stewart, *Lone Star Regionalism: The Dallas Nine and Their Circle, 1928–1945* (Dallas: Texas Monthly Press, 1985), 97.

13. Joseph S. Czestochowski, *J. Steuart Curry and Grant Wood: A Portrait of Rural America* (Columbia: University of Missouri Press, 1981), esp. 43–121.

14. Hogue's "Drought Survivors" appeared in *Life* magazine on June 21, 1937, and in the same year he was commissioned by *Fortune* magazine to create a painting on West Texas as part of an article on the Gulf Oil Corporation.

15. Zigrosser profiled Mauzey in his *The Artist in America: Twenty-four Close-ups of Contemporary Printmakers* (New York: Alfred A. Knopf, 1942), 138–144.

insect invasions and the sudden floods" of the region. In a series of letters to Zigrosser beginning in 1939, he provided lengthy descriptions of his prints based on these experiences. A few will suffice here: In "Rows End," "a man and his wife have stacked arms, placed hoes across the stump in surrender. . . . the soil has eroded and worn out. Dust Storms have done their evil deed. War clouds gather on the horizon."[16] In "Neighbors," Mausey observes that "some farmers succeed, some fail, some have superior equipment, and land."[17] We see survivors, specifically one lonely heroic figure, who dominates the landscape. Another farmer struggles manfully to wrest some productivity from the beaten soil in "Grandpa Snazzy." These are cotton fields, and, as Mauzey said, "cotton people have generally bitter, tragic lives,"[18] a reality even before the disasters of the Depression dust storms.

Few of the pictures of the Dust Bowl in Texas by Lange, Mauzey, and Hogue were mere documents. Behind the images were creative, inspired artists, with strong personal, social, and ideological forces providing the stimulus for the work. Mauzey, for instance, took it as his mission to authenticate the special north Texas experience. He meant by this not just life in the Dust Bowl, but experiences all the way back to the years just after the turn of the century when he was a boy living in Nolan County. His lithograph "Prairie Ghost" revived memories of his youth, of the times he would shimmy up windmills to clean off the snow so these picturesque ghosts of the prairie would function.[19] Mauzey believed he knew the lay of the land as few other Texas artists did. He aimed to tell the sustained story of his native state, to write a novel with lithographs that, as he told Zigrosser, "would be full of romance, life, action, moods, drama, laughter, seasons."[20] A most ambitious project, to be sure, and not one he was fully up to when he began his first series in 1939.

16. The full quote: "I wanted to tell the plight of the cotton raiser in this one, one of despair, of tragedy, one of poverty so prevalent. The man and wife have stacked arms, placed hoes across the stump in surrender since the soil has eroded and worn. War clouds gather on the horizon. The hog and dog are further desolation symbols." Merritt Mauzey to Carl Zigrosser, n.d., in Carl Zigrosser Correspondence, Special Collections, Van Pelt Library, University of Pennsylvania, Philadelphia.

17. Mauzey to Zigrosser, n.d.

18. Ibid.

19. Mauzey described his memories of his youthful work: "It was my job to keep up the farm windmill as a kid—to grease and repair it, keep the snow off. These windmills looked like ghosts silhouetted against the dark sky. Often the drills would break down in cold weather." Ibid.

20. Mauzey wrote to Zigrosser that "In doing the Cotton Series in lithography, I realized how diverse were the conditions of the cotton belt, and so I tried to get the important points in cotton from planting to export. I feel the series of ten covers that pretty thoroughly but of course the subject-matter is endless. It seemed to me it was a great field, with its surface never scratched by art. Full of romance, life, action, moods, drama, tragedy, laughter, seasons." Zigrosser, *The Artist in America*, 140.

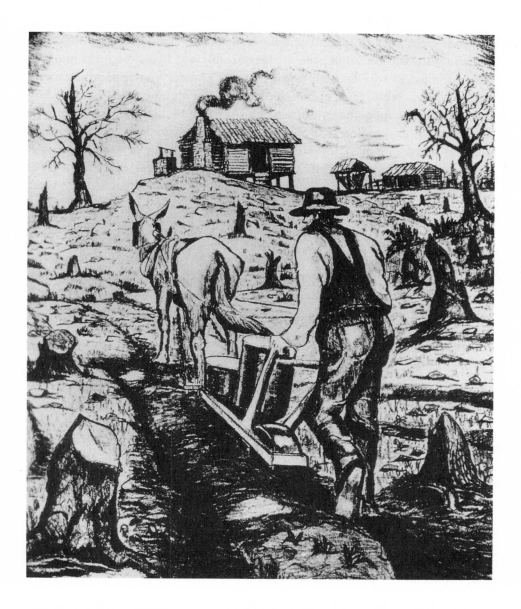

Grandpa Snazzy, by Merritt Mauzey, 1938. Lithograph, 12 x 10 inches. *Courtesy Mary Flory, New Orleans.*

Aside from the natural disasters the farmers had come to expect, they had to cope with the consequences of the unstable worldwide cotton market, where the prices rose and fell (mostly fell, in Mauzey's own painful experience) unpredictably. Such tribulations tested the mettle of the farmers, but there was more: lung and eye diseases brought on by prolonged exposure to the dust, not to mention work injuries which could force premature retirement, as in the case of Mauzey himself. Occasionally in his prints, Mauzey examined more subtle ailments: the ongoing psychological and sociological disorders like clinical depression and the high incidence of divorce in the Dust Bowl years.[21]

Yet it was the brighter side of life in the West Texas High Plains that ultimately interested Mauzey the lithographer. Despite the odds, he argued, the human spirit often did triumph. What may have seemed a wasteland to an outsider was regarded as a land of opportunity for those deeply attached to the land. The hard times made the survivors stronger, more sincere, honest, loving, and sharing. They were brought to a mystical closeness to the soil, and emerged hardy and self-reliant. "These Texans were the last of the American frontiersmen," Mauzey wrote to Zigrosser in 1940, ". . . the best people on earth and the backbone of the nation. They offered a lesson to all this world of the soft living into which we have fallen, human models for the old European countries now embroiled in war."[22] As a deeply religious man, Mauzey believed that Texas brought on an awareness that "from the earth man sprang and to it he must return at God's pleasure. The Texans' one-hundred percent faith in the Deity, the Lord and Master, was their greatest asset."[23] As an artist slowly developing his creative gift, Mauzey was persuaded that he had to honor these Texas heroes in his prints and dramatize how frontier Texas, democratic America, and western Christian civilization all came together in the bodies and souls of these cotton farmers.

Alexandre Hogue did not share Mauzey's adoration of the pious and suffering Texas farmer. As Mauzey was a homespun folk philosopher, Hogue was a hard-bitten, unsentimental intellectual. A student of history, Hogue was one of the few artists of the Lone Star Printmaking group who really understood the intricacies of rural economics (or at least thought he did). For the

21. Mauzey brought up the psychological and social traumas of the Dust Bowl period in writing about the lithograph "Uncle Fud and Aunt Boo" (1940).

Aunt Boo "represents the sturdiness of women folk, her husband is listless. The wife goes on with courage and faith, working with understanding for her husband. She is loyal, and doesn't know that divorce is more typical of the cotton raisers than for any other class of workers in Texas." Mauzey to Zigrosser, n.d.

22. Ibid.

23. Ibid.

Prairie Ghost, by Merritt Mauzey, 1939. Lithograph, 14 $^3/_8$ x 9 $^5/_8$ inches. *Courtesy Mary Flory, New Orleans.*

*Southwest Review* he wrote about the ecological disaster that was Dust Bowl Texas, for which he held man, not "mother nature," primarily accountable. Thoughtless exploitation of the land by a generation of greedy farmers, big and small alike, had brought on the calamity.[24] He felt a special betrayal since he held cherished memories of a childhood on his uncle's cattle ranch near Dalhart; such ranches and the surrounding buffalo grass that extended (in the eyes of a small boy) to infinity had been plowed under and fenced off during the 1920s by the grain farmers.[25] For Hogue, when he returned as a mature artist in the early 1930s to Panhandle Texas, there could be no deja vu.

In a way, Hogue's paintings, graphic art, and numerous writings turned into moral sermons on conservation and original sin, angry condemnations of greed and stupidity. Speaking as if from the pulpit probably came naturally to Hogue; moral Calvinist earnestness pervaded the Hogue family, and a sense of man's inherent weakness was drilled into Hogue by his Presbyterian minister father. Add to this an innate stern manner and an acquired scholarly arrogance and it is not surprising that at times Hogue's personality tested the patience of the other artists in the Lone Star group.[26] It is instructive that Hogue rarely pictured the wheat and corn farmers, the tenants, the day laborers, and the hard-pressed wives and children of these workers. Perhaps he did not want to risk sentimentalizing them, or making the viewer feel too sorry for their situation, since he believed that they had at least partly brought on their own misery, and that someone had to pay a price for the despoiling of the pastoral paradise that had been the Texas Panhandle of the 1910s.

Hogue's hardened attitude may also help us understand his point of view on what had become a burning issue in the 1930s: the responsibility of the artist for social reform. Hogue did hope to interest Texans in soil erosion policies, but unlike Lange and the other FSA photographers, he was only marginally connected to the New Deal. He apparently did not even share the general enthusiasm of the regional artists for the liberal aims of the Roosevelt administration. He was wary of outsiders and distrustful of do-gooder bureaucrats; perhaps he possessed the legendary Texas frontier distrust of government, or maybe he had the modern artist's determination to be free of any and all authority.[27] He

24. DeLong, *Nature's Forms/Nature's Forces*, 20–24; Stewart, *Lone Star Regionalism*, 97.

25. Alexandre Hogue to Matthew Baigell, June 14, 1967, quoted in DeLong, *Nature's Forms/Nature's Forces*, 7.

26. Willard Cooper to Richard Cox, Mar. 21, 1980 (interview). Cooper recalls conversations with Don Brown, his teacher at Centenary College, about Hogue's irascible personality. Brown and Hogue were members of the Dallas Nine in the 1930s.

27. Hogue did paint a mural for the Treasury Section of Painting and Sculpture in 1939, but otherwise steered clear of the New Deal programs; he felt "disenchanted by government patronage of the arts." DeLong, *Nature's Forms/Nature's Forces*, 27

certainly did not feel a duty to celebrate the suffering Texas farmer or to concern himself in his art with what happened to those migrants who fled the Dust Bowl for California. What tempered his streak of pessimism and moralizing tone was his aesthetic sensibility. In the stark, bleak, vast spaces of Panhandle Texas he saw a "wonderful emptiness, a terrifying beauty."[28] The almost biblical simplicity and uncluttered design of the forbidding, dust-caked Texas landscape gave Hogue a curious sense of pleasure; it certainly stimulated him, as the charming, picturesque, and false impressionistic landscapes of the 1920s seen in the paintings and prints of the Houston artists did not.[29] He even developed a formula of sorts for his fellow Dallas regionalists to give their movement a unique, authentic, truth-telling form: works dealing with rural Texas should have strong, spare, linear drawing, a vast sense of space, and clear expressionistic color; an austere, honest style that might not attract polite collectors but would respect the integrity of the Texas scene.[30] Hogue agreed with Jerry Bywaters that modern Parisian still-lifes and abstractions were inappropriate for the Texas artists.[31] He was looking for a strong, dramatic, "significant" subject matter, in the great tradition of the Old Masters, around which to build a vital, enduring Southwest school of art.[32] Thus his art became a blend of realism, symbolism, and personality.

Dorothea Lange brought to Texas and her Texas photographs a powerful social conscience and an intense feeling for those suffering from the Depression all over the nation. She wanted to use her camera to record and explain the plight of the poor in California and Arizona, Alabama and Mississippi, and Oklahoma and Texas. To nudge or shove public opinion in the direction of reform was the reason she took up documentary photography in the 1930s.[33] Lange's abstract sympathy for the downtrodden little man had numerous sources, including her polio handicap, her education in the Jewish settlement houses of Lower East Side New York, the sights of souplines and Hoovervilles in San Francisco at the onset of the Great Depression, and her

28. Quoted in DeLong, *Nature's Forms/Nature's Forces*, 19.

29. Alexandre Hogue, "Progressive Texas," *Art Digest*, X (June 1, 1936), 17–18.

30. DeLong, *Nature's Forms/Nature's Forces*, 17–18, 21.

31. Ibid., 11.

32. Hogue, "Progressive Texas," 17–18. DeLong gives a good comparative analysis of Hogue's Texas Regionalism and other strains of regional art in Depression America. DeLong, *Nature's Forms/Nature's Forces*, 23–25.

33. Ohrn, *Dorothea Lange*, 22–25. Lange had been a commercial studio portrait photographer in San Francisco during the 1920s.

close relationships with strong-willed men such as Maynard Dixon, Paul Taylor, Roy Striker, and Ben Shahn, among others, throughout the 1930s.[34]

Aside from her general zeal for social reform, when Lange came to Texas in 1937 she had a specific and well-defined goal: to trace the origins of the California migrant workers. It was not just her concern, for by the late 1930s the migrant saga intrigued reformers and non-reformers, liberals and conservatives alike. The national media (*Time, Life, Fortune, Colliers,* and *Newsweek* magazines; novelists such as Steinbeck; filmmakers John Ford and Pare Lorentz; and singers like Woody Guthrie) lavished attention on the sharecroppers, the tenant farmers, and the migrant families seen on the highways heading west. Lange's desire to understand the ins and outs of the epic migrant phenomenon was shared by her new husband, Paul Taylor, whose influence on the photographer cannot be overestimated. Taylor taught rural sociology and economics at the University of California and probably knew more about the West Coast migrant worker problem than anyone else. He was driven to see the system reformed, to get legislation passed that would protect the simple farmer, the land, and the water from the greed of the rich and the powerful.[35] With the Roosevelt administration supplying funds for field work, the Taylor-Lange collaboration became a potent force by the close of the Depression; it had already produced results (new farm legislation) in the San Joaquin Valley in 1935 and 1936.[36] As Lange and Taylor headed back to Texas on the way to the Deep South in 1937, they believed that photographs could dramatize, to humanize and mobilize the national conscience against the injustices visited upon the simple farmer. They approached the Panhandle region with great anticipation in May 1937.

To Lange and Taylor the Texas Panhandle farmers were one part of the California migrant puzzle, not significantly different from or more interesting than the displaced corn farmers of Nebraska or the cotton laborers of Mississippi. All were exploited by big-business agriculture, by modern machinery, and abuse of the soil. This national tale of woe was brought together in her pictures and his short text for *An American Exodus* (1939). The gist of the book was that beleagured farmers in the Deep South, the Midwest, and the Southwest had no choice but to seek a better life in the west beyond the great

34. Maynard Dixon, the Western landscape painter and social realist artist, was Lange's first husband (1920–1935). He encouraged her entry into social documentary photography. She married Taylor after her divorce was final in 1936. Roy Striker headed the Farm Security Administration, for which other photographers, including Ben Shahn, Arthur Rothstein, Walker Evans, and Russell Lee also worked.

35. Robert Coles, *Dorothea Lange, Photographs of a Lifetime* (New York: Aperture Monograph, 1982), 17.

36. Ibid., 18. Taylor was working for the Federal Emergency Relief Agency in 1935 and 1936.

mountain chains.[37] So the pain of the woman in the Texas high plains and the idle, sullen laborers of Hardeman County is to be understood in the bigger picture of the national economy. As we reexamine Lange's Texas images in this light we are almost surprised that she did not follow the specific migrant path of her sharply-revealed Panhandle individuals. Did they drive or hitch their way to California? How long did it take? Did they end up in Bakersfield or Fresno? Lange did not try to analyze in her pictures the reasons why many Texas and Oklahoma farmers did not make the exodus to the west. Local customs and idosyncrasies did not concern her. Nor was she searching for an appropriate style to fit the Texas subject matter, as Hogue urged the Southwest regionalists.

Those who make pictures select, omit, and edit, which brings up a fundamental question regarding all these documentary imagemakers of the Panhandle: how close to the truth of the Texas Dust Bowl experience did the photographers and the painters come? In what ways did their goals as "penetrating realist recorders" of Texas conform or clash with their instincts as artists? Did their prints and photographs illuminate or obscure? Looking through their work, it seems fair to say that theirs was a selective realism. They told an accurate story, but it was only part of the story of North and West Texas in the Depression.

They say the camera does not lie, that among picture-making methods it has the unique ability to leave indisputable evidence of time and place. Certainly Lange's photographs gave incontrovertible proof of human suffering and endurance during the Dust Bowl era. Lange's photographs of the Panhandle were not composites; they were not unduly contrived, and they were never doctored in the darkroom.[38] So we are persuaded that these pictures of Childress, Hall, Swisher, and Hardeman Counties are accurate records, pure social facts. Still, there was much about life in that part of Texas that Lange did not shoot. She and her husband overlooked other aspects of the tragedy. The periodic floods, the terrible winter blizzards, the attacks by grasshoppers and army worms, even the howling dust storms themselves, did not show up in her 1937 photographs. She and Taylor also passed by the more pedestrian but still-relevant problems of the Dust Bowl era: the tangled politics of the various relief programs that hampered reform, the quarrels between local and federal officials about how to proceed with soil management and relief for the suffering. These,

37. *An American Exodus* was organized in six sections tracing the origins and conditions of migrant labor in the 1930s: "Old South," "Plantation Under the Machine," "Midcontinent," "Plains," "Dust Bowl," and "Last West."

38. Coles, *Dorothea Lange*, 23–25, 31–33.

of course, were not easy matters to dramatize in photographs, but they were crucial elements in the Dust Bowl equation.[39]

Lange also overlooked other sectors of the Texas Panhandle economy, such as cattle ranching, the oil business, and the various forms of commerce within the small towns and several cities. She ignored the fairly normal fabric of life in the lean years of the 1930s in dozens of Panhandle communities like Hartley, Dumas, Stratford, Wheeler, Canyon, and Pampa, not to mention Amarillo: things like high school football games, families enjoying the movies, listening to the radio, playing dominos, telling jokes.[40] These were all instances of ordinary living, proof that the spirit of comradeship persisted in the churches, schools, and homes of the area despite the Dust Bowl conditions. The friendly culture that kept most Panhandle Texans reasonably content, or at least resolved to stick it out until things got better, did not surface in Lange's photographs of the dispossessed. It is not entirely surprising that Lange did not fill in the big picture. She was not in Texas long enough (only around ten weeks) and not always at the right times (the worst of the "Black Dusters" and the insect attacks came between 1933 and 1935). When she and Paul Taylor were in the Panhandle it was with a narrow interest, to track the California migrant farmers back to their origins, which left them blind to many other sides of the Dust Bowl phenomenon. Finally, perhaps, Lange was hampered by the nature of documentary photography. The camera clicks, the prints are made, and momentary truth is captured. But what about nuances of the truth and historical perspective, the need to examine how social and economic problems evolve over time?

As examples of truth-telling art and as profound interpretations of history, the lithographs of Alexandre Hogue and Merritt Mauzey had their limitations as well. Hogue and Mauzey overlooked many of the same routine Dust Bowl experiences (life in the small towns, for instance) as did the photographers. The two printmakers had less excuse than Lange, since they were Texans who lived in Texas during the 1930s and had easy access to all areas of the Panhandle. With Mauzey, part of the problem was timing. By the time he launched his first series of prints in 1939, the Dust Bowl was practically over as a compelling subject. After 1937, there were no more big storms, and by 1940 the farmers were either figuring out ways to reclaim the soil or were heading to the cities to work in defense plants.[41] With Hogue, we might ask if he had a sufficient appreciation of the subject's complexities to be rightfully called a definitive interpreter of Dust Bowl Texas. He was more talented than prolific. Mauzey certainly made enough prints, nearly a hundred between

39. Bonnifield, *The Dust Bowl*, writes of these aspects. See also Pauline Robertson, *Illustrated Tales Tracing History in the Texas Panhandle* (Amarillo: Paramount Publishing Co., 1976), 97–101, 328–330.

40. Bonnifield, *The Dust Bowl*, 185–202.

41. Ibid.

1939 and 1944, but were they strong enough to tell the story in a convincing way? By his own admission, Mauzey was a printmaker of limited skills at the time.[42] Too often, alas, he gave mundane form to dramatic events as he grappled with the difficult techniques of his craft. Lastly, could it be that the Texas chauvinism of Hogue and Mauzey, the need to fashion a Texas-Southwest regionalist art, led to a colorful but inflated realism that was no more complete or profound than that of the come-and-go photographers such as Lange?

The Texas printmakers prided themselves on being artists, and artists are supposed to be poets, imaginative creators able to produce resonant images. By training they exaggerate; they cannot be bound to the same strict standard of documentary truth as photographers. But the comparison between the photographers and the printmakers gets muddled here, for Lange was a serious "artist" too. She may have spent more time than she cared to admit thinking about light, shapes, angles, patterns, and the print quality of her photographs. Her best photographs have a distinct artfulness: the angle of the camera in "Tractored Out, Childress County," which captures the contoured designs of the plowed fields and the patterned rows of dirt that appeal to the eye like patterns of crewel embroidery; the strong, sculpted face of the "Woman of the High Plains" and the way she was positioned off-center to become a timeless frontier icon.[43]

Like most artists, Lange had a romantic streak. Her photographs were an act of self-discovery. Her biographers tell us that her travels through the remote rural areas were in part a way to combat her personal loneliness and isolation and an escape from the conventional family duties she found so burdensome.[44] Traveling also put her in step with many American artists and writers during the 1930s who found that by taking to the road and discovering America through pictures and stories they could duplicate the pioneer adventure.[45] It was a path for those who wanted to understand the beleaguered nation during the Great Depression, better than sitting at home in the studio. It might lead to self-respect. Lange and Hogue and Mauzey were all restless activists and intense artists with a hunger for the truth, even if the latter ultimately eluded them. They left glimpses of history, fashioned icons for an age, and invested an era with poetic significance.

42. Quoted in Zigrosser, *The Artist in America*, 141.

43. William Stott writes of the pathetic human quality and the aesthetic beauty that intermingle in some of Lange's best photographs, such as "Migrant Mother" and "If You Die, You're Dead." The latter picture "is certainly a portrait less ambiguous than many of Lange's, though the woman's desperation is somewhat balanced by the force and eloquence of her gesture, the lean power of her long naked arms, and the puzzling tension in her mouth (is she going to weep or spit?)" Stott, *Documentary Expression and Thirties America* (New York: Oxford University Press, 1973), 229.

44. Lange struggled to balance the demands of painting and career. After marrying Paul Taylor she placed the three children of her first marriage in three separate foster homes, and saw little of them from 1936 to 1940. Meltzer, *Dorothea Lange*, 137–138.

45. Stott, *Documentary Expression and Thirties America*, 240–244.

"Avery Tractor Pulling Wagons, Marfa, Big Bend," by W. D. Smithers, ca. 1918. Photograph. *Courtesy Smithers Collection, Ransom Humanities Research Center, University of Texas at Austin.*

# W. D. SMITHERS:
# PICTORIAL CHRONICLER OF THE
# BIG BEND COUNTRY OF TEXAS

ह्ल

### KENNETH B. RAGSDALE

Recollections of Bill Smithers remain one of my cherished posses-
sions. His kindness, generosity, knowledge, and total commitment
to his craft are qualities all too seldom met with in twentieth-centu-
ry scholarship.

Our friendship began on the morning of June 7, 1966. I was in Alpine,
Texas, collecting material on the Terlingua quicksilver mines. Practically
everyone I interviewed offered the same suggestion: "See Smithers the photog-
rapher. He's been around a long time and knows more about this country than
just about anybody." Their instructions were easy to follow: "Go down Hol-
land Avenue 'til you come to that little house with a yard where a lot of cactus
is growing. His name is on the sign on the front porch." The inscription told
the whole story: "W. D. Smithers, Writer-Photographer."[1]

Smithers greeted me cordially. He obviously recognized in me, a graduate
student doing Big Bend research, a kindred spirit. He responded to my ques-
tions with knowledge and enthusiasm. But as the interview progressed,
Smithers exhibited an annoying habit. In response to each of my questions, he
would jump up from his chair, search through stacks of boxes, and return with
a handful of photographs to illustrate his answers. Smithers's thoroughness
was not fulfilling my needs; I was seeking verbal data, not visual illustration.

But as I bid Smithers farewell that June morning, I carried with me valuable
research data, plus the additional information that his entire photographic col-
lection, totaling some 8,000 prints and negatives, was for sale. I had no way of
knowing that this last bit of information was probably the most valuable re-
search data I would ever collect.

---

1. W. D. Smithers, *Chronicles of the Big Bend* (Austin: Madrona Press, 1976), xi–xii.

Returning to Austin, I shared this information with history professor Joe B. Frantz, who instituted negotiations with the University of Texas administrative hierarchy. With minimum discussion and paper exchange, thanks largely to Chancellor Harry Ransom's astute executive assistant Frances Hudspeth, the deal was made. The University agreed to pay Wilfred Dudley Smithers his asking price of $20,000 for approximately 8,000 photographs, each with negatives and extensive captions, plus some 2,000 handwritten and typed pages of manuscript material. This was in addition to various items of photographic equipment Smithers had used during his six decades of professional activity. Needless to say, the University got a bargain. But most importantly, both parties were equally pleased with the transaction. To Smithers, the acquisition of his collection by a single academic depository represented the fulfillment of a life's work. And during the remaining fifteen years of his life, he continued to contribute voluntarily to the collection.

The collection is divided into thirty-two title groups which focus primarily on northern Mexico and the Big Bend region of Texas. The seven major groups are military activities (horse cavalry, mechanized cavalry, and military aviation), civilian aviation, Mexican revolutions and border troubles, Mexican religion and culture, Big Bend ranching, border trading posts, and desert plant life. The three largest categories are Early Aviators and Aerial Pictures (819 prints), Mexican Archaeology (1,015 prints), and Mexican Religion (1,629 prints). Through this collection of data, both visual and verbal, our knowledge of the Southwestern Borderlands is being greatly expanded.

In order more fully to appreciate and understand, as well as evaluate, this trove of information, it is necessary to peer behind the camera, if you will, and learn something of the man that created this collection. In any creative endeavor, the artist and his cultural environment must be viewed as the singular matrix from which his product emerges. Other scholars share this view. The biographers of L. A. Huffman, the pioneer photographer of the Great Plains, wrote that the "background of understanding begins with the man himself and requires a knowledge of something more than the photographic techniques used in securing the pictures. One needs to know something of the man's activities outside of his profession and, above all, something of those personal peculiarities which set one individual apart from another."[2] Bill Smithers was indeed an "individual apart."

Smithers was born in San Luís Potosí, Mexico, in 1895, the son of an American mining company bookkeeper. He attended a Mexican school in San Luís

2. Mark H. Bacon and William R. Felton, *The Frontier Years: L. A. Huffman, Photographer of the Plains* (New York: Holt, 1955), 50.

Airplane with Cavalry, by W. D. Smithers, ca. 1920. Photograph.*Courtesy Smithers Collection, Ransom Humanites Research Center, University of Texas at Austin.*

Potosí for three years before the family moved to San Antonio, Texas. He reentered school there, but four years later economics forced his withdrawal. His subsequent literary and journalistic achievements, however, belie his meager formal training. Yet during this period Smithers was being subjected to cultural forces that would place an indelible mark on his later work. "Our years there [in San Luís Potosí] were strongly Mexican in orientation," he wrote later. "Mexican rural enterprise surrounded us, and many of our family habits reflected not American but Mexican tradition."[3] Understandably, then, Mexican topics—the culture, folk culture, religion, archaeology, and revolutions—comprise approximately one half of the collection.

Yet San Antonio was to become the second great wellspring of inspiration of Smithers's photojournalism career. Its cultural environment too was strongly Latin. But other local factors, the military especially, would greatly influence his work.

In 1910, at the age of fifteen, Smithers became an unpaid apprentice to two San Antonio photographers who taught him the basics of his craft. There was

3. Smithers, *Chronicles of the Big Bend*, 3.

one assignment as an apprentice he would long remember. At 9:30 a.m. on March 2, 1910, Smithers was allowed to squeeze the bulb on an 8 x 10-inch view camera that recorded Lt. Benjamin Foulois standing before a primitive bi-plane on the Fort Sam Houston parade ground. A few minutes later, the young lieutenant made history; his takeoff marked the beginning of United States military aviation. Years later Smithers wrote: "It was on March 2, 1910, when I decided that I wanted to be a photographer and free-lance news re-porter, not to work for a newspaper and get stories where they sent me; but to go where I thought [there] was a good story."[4] He would find many good sto-ries.

Shortly after moving to San Antonio, Smithers made the acquaintance of Juan Vargas, a 114-year-old Zapotec Indian, who fascinated the youngster with stories of his experiences. Vargas's death in 1910, however, altered Smithers's professional objectives. "Thinking of all the things this old man had seen that could never be recaptured," Smithers wrote, "I began to feel that my photography should direct itself to historical and transient subjects—vanish-ing lifestyles, primitive cultures, old faces, and odd unconventional profes-sions. Before my camera I wanted to see huts, vendors, natural majesties, clothing, tools, children, old people, [and] the ways of the border. I was to find all of these and more in the Big Bend."[5] It was the military, however, that took Smithers to his photographic promised land.

To earn a living while learning his craft, Smithers found employment dri-ving horse-drawn vehicles in San Antonio. His skill in handling horses and mules ultimately led to his military affiliation. Before World War I, the army relied almost entirely on horsepower, and four remount stations supplied the animals. Smithers joined the Fort Sam Houston unit in 1915; a few months later he was assigned to a civilian pack train "eagerly headed for the bandit plagued border, never without camera and note pad."[6] This assignment took Smithers through southwest Texas, into New Mexico, and eventually to Dublan, Chihuahua, where the Pershing expedition was headquartered.

Life with the pack train fulfilled Smithers's professional objectives in abun-dance. He wrote later: "For me, the . . . pack train offered opportunities for countless fascinating observations, some of which I found time to photograph. A photographer couldn't ask for better subjects than the packer and cavalry life, or the natural beauties of the Big Bend."[7]

4. Mary Katherine Cook, "W. D. Smithers, Photographer-Journalist" (M.A. thesis, University of Texas at Austin, 1975), 17.

5. Smithers, *Chronicles of the Big Bend*, 9.

6. Ibid., 16.

7. Ibid., 29.

Law Officers at Boquillas, by W. D. Smithers, ca. 1929. Photograph. *Courtesy Smithers Collection, Ransom Humanites Research Center, University of Texas at Austin.*

Some of Smithers's rarest and most unique photographs were taken during his civilian pack train assignment. He documented in infinite detail every aspect of the horse cavalry's role in national defense, a mission long since relegated to military history. It was also during this assignment that Smithers recorded the cavalry's early and highly unsuccessful experiments in mechanization. Combined, these pictures document an important facet of early twentieth-century military history.

America's entry into World War I offered Smithers another view of the military. After enlisting in the army in April 1917, he subsequently transferred to the Signal Corps and was assigned to Rockwell Field in San Diego, California. His photographic expertise garnered him this assignment; he taught fighter pilots aerial gunnery using the recently developed camera gun. Although Smithers's photographic record of this experience is minimal, it had a profound impact on him. Aviation emerged as a dominant theme in his work

during the 1920s and 1930s, partially through his bizarre association with the United States Army Air Corps.

Following his discharge in 1919, Smithers, however, rejoined the civilian pack train again serving in the Big Bend region. In retrospect, this was indeed a fortunate assignment for the young photographer. The border was seething with unrest, changes were in the offing, and with camera in hand he documented a tragic yet important era of that region's history: Mexican bandit raids along the Rio Grande, launching the 1919 Border Air Patrol, ransoming the army flyers lost in Mexico, cavalry maneuvers, and liquor smuggling during Prohibition.

In 1921, Smithers returned to San Antonio to pursue a career as a freelance photojournalist. His clients included the San Antonio *Light,* the San Antonio *Express,* and the Underwood and Underwood news service. With San Antonio emerging as an important military aviation center, aviation became a major topic of his news coverage. He photographed Lt. James H. (Jimmy) Doolittle's arrival following his record-setting cross-country flight, the arrival of the first around-the-world flyers in 1926, and the activites of Katheryn and Margery Stinson, who operated a flying school for British pilots near San Antonio. It was during this period that Smithers pioneered a new facet of his profession: aerial photography. With the strictly illegal and unofficial cooperation of the Army Air Corps, Smithers gained aerial coverage of the first experiments in the use of parachutes at Kelly Field. His friend and pilot was a young lieutenant named Claire Chennault, who would later organize the legendary "Flying Tigers" and command the Fourteenth Air Force during World War II.

Smithers's early success in this field resulted from a camera he designed and constructed specifically for aerial photography. Discovering early on that the propellor blast against the camera bellows greatly reduced the field of coverage, he constructed a camera with a wooden cone that was unaffected by the wind. The commander of the photo section at Kelly Field quickly recognized the superior quality of Smithers's work and often borrowed his negatives to print "official" Army Air Corps photographs.

Smithers's unofficial affiliation with the Air Corps had vast and unexpected ramifications. This unique association eventually led to the Air Corps establishing an emergency landing field in the Big Bend region from which Smithers would record some of his most spectacular aerial views. The catalyst was the Escobar Rebellion.

During the 1920s, Smithers made regular monthly trips to the Big Bend gathering material for feature articles. On the April 1929 trip he arrived at Castolon on the morning following an attack by a band of Mexican rebel soldiers on the nearby Johnson trading post. Smithers proceeded to that outpost, interviewed

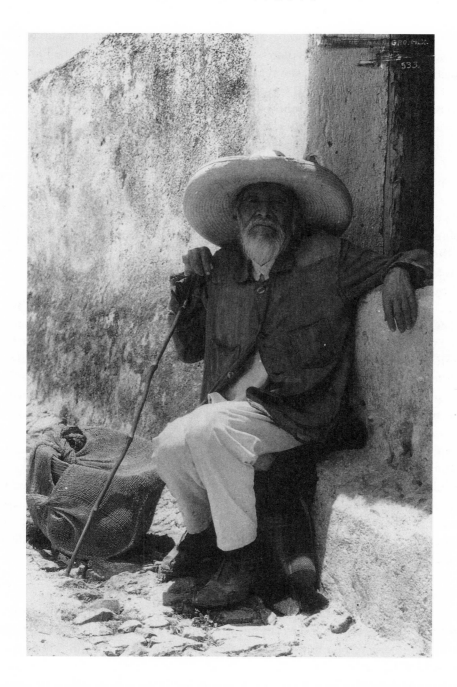

"El Viejo," by W. D. Smithers, n.d. Photograph.*Courtesy Smithers Collection, Ransom Humanites Research Center, University of Texas at Austin.*

the Johnsons, made some photographs, and rushed back to San Antonio to file his story. En route a devious plan began to take shape in his mind; the Johnson ranch raid seemed to forecast a return to the era of border depredations. If he could persuade the Army Air Corps to establish an emergency landing field in the Big Bend to protect the ranches and trading posts, he would also have immediate access to military aircraft to shoot aerial photographs of some of the Southwest's most spectacular scenery.

After filing his story with the San Antonio *Light*, Smithers presented his proposal to an old Air Crops friend, the Eighth Corps Area air officer at Fort Sam Houston. It worked, especially since the Air Corps was already considering establishing a Big Bend landing field. When Smithers offered the use of Johnson's ranch, the deal was done. On April 21, 1929, the first airplane landed at the Big Bend airfield; Smithers was there to welcome the pilot, Lt. Thad Foster, another old friend.

Smithers moved his operation to the Johnson ranch in 1930; his first chore was to construct a totally unique darkroom. With the aid of Elmo Johnson and a Mexican laborer, he designed and constructed a half-dugout adobe darkroom. In lieu of a controlled light source, as well as running water and refrigeration, he installed a window on the north side of the building to admit sufficient sunlight to make enlargements. Using this changing light source, he learned through experimentation to vary the exposure time in accordance with the time of day. The military soon learned of this remote facility and began sharing enlarger time with Smithers. The Army Air Corps photographic teams mapping the United States-Mexican border frequently used Smithers's darkroom to field-test their work, as did the National Guard reconnaissance units that landed at the Big Bend airfield. Smithers explained later that, in appreciation of his cooperation, "they would load up their planes with [government issue] photographic supplies for my darkroom," including "rolls of enlarging paper thirty-six inches wide and 100 inches long," which he used in compiling a pictorial history of the lower Big Bend area.[8]

Smithers felt he produced some of his best work in this primitive facility. For about two years, he enjoyed the best of two worlds, photographically. Living within wading distance of Mexico, he developed a close rapport with the Mexican people still living in the most primitive conditions. He spoke their language, learned their names, and shared their folk secrets as did few people outside their native culture. Smithers claimed that in a year he had visited every home in Mexico within fifty miles of the Johnson ranch. His pictorial studies of the people, their dwellings, their life-style, and their folkways

8. W. D. Smithers to Kenneth B. Ragsdale, Aug. 27, 1975.

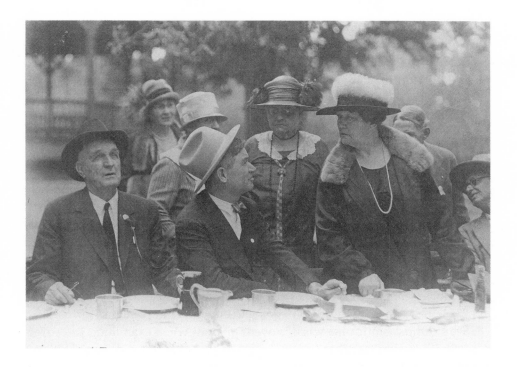

"Will Rogers et al.," by W. D. Smithers, October 30, 1926. Photograph.*Courtesy Smithers Collection, Ransom Humanites Research Center, University of Texas at Austin.*

reveal the fulfillment of a professional commitment inspired by his childhood friendship with Juan Vargas. And through the cooperation of the Army Air Corps, Smithers was able to add a new dimension to man's view of one of America's last frontiers.

The foregoing is a brief overview of Smithers's career as a photojournalist. Much, however, has been omitted: repeated trips to Mexico to photograph religious and archaeological sites; traveling with circuses to document that phase of show business; photographing Gutzon Borglum's daily carvings of the preliminary Mount Rushmore sculpture ("... he studied my photographs of his work more than the sculpting itself"); completing the McDonald Observatory telescope assignment after others had failed; his lifetime studies of the curanderos (Mexican folk healers) and avisadores (message senders); and sending news dispatches from the Big Bend to San Antonio via carrier pigeon. These, like all other facets of his work, fall within the scope of his professional credo: preserving a photographic image of that one brief moment in time.

For Smithers, the image, that bit of action or impression frozen in time by the camera's shutter, was the sole objective of his some seven decades of professional activity. His reaction to the death of Juan Vargas in 1910 had deemed it so. Photojournalism was his profession; art and commerce never entered into his calculations.

Yet, in any assessment of Smithers's work, his visual legacy must be examined within the total context of early twentieth-century photography. One critic writes that unlike E. O. Goldbeck, another San Antonio photographer and Smithers's contemporary, "Smithers was not a commercial photographer; his sense of worth was bound up in providing a historical record rather than a business service. As the country moved [forward]...Smithers simply could not resist looking back.... His intention at all times was to preserve a story rather than create one."[9] His lifelong commitment to that singular objective never allowed Smithers to accumulate any appreciable personal wealth. When presenting him his first payment from the University of Texas, I asked, "Bill, this is probably the most money you have ever had at one time. Does this mean you are going to retire?" He responded, "Heck no. I'm going to buy me a new camera."[10]

This enthusiasm for his work is ever apparent when examining the collection. Smithers was fascinated not only by the photographic process, but by the subjects he chose; his interest, not commerce, made the determination. Smithers loved airplanes, the cavalry, border life, all aspects of nature, and above all the Mexican people and their culture. This personal philosophy is most evident in his studies of the Mexican goat herders along the Rio Grande. For example, where Dorothea Lange would have seen abject poverty and hopelessness in their primitive dwellings, Smithers recognized cleanliness and order. Where Russell Lee would have photographed the Mexican child with her pet goat as an act of social protest, Smithers was celebrating the beauty and innocence of childhood. Thus, in every topic he examined, he saw its individual worth, importance, and uniqueness.

When considering the technical aspects of Smithers's work, we must admit that his skill often fell short of his ambition. Many images are not clearly focused; others lack sufficient contrast to be aesthetically appealing; few negatives show any evidence of cropping. Yet when viewing the collection in its entirety, and considering the adverse conditions under which he worked, these shortcomings seem unimportant. One scholar who made a careful study of the collection writes: "His equipment . . . [was] largely homemade and

9. David Pyle, "The Ethnographic Photography of W. D. Smithers," in *Perspectives on Photography*, eds. Dave Oliphant and Thomas Zigal (Austin: Humanities Research Center, University of Texas, 1982), 150.

10. Smithers to Ragsdale, Dec. 16, 1967.

makeshift. He rarely had anything resembling a permanent darkroom. Even in the last years of his photographic career, he did his laboratory work before daylight in his kitchen. The film, paper, and chemicals he used would be considered almost unworkably slow by today's standards; and they were always at the mercy of the tortuous Big Bend heat."[11]

Yet despite these technical and, for most practical purposes, unimportant flaws, Smithers compiled a remarkable body of data. And in a final assessment one salient fact must not be overlooked: it stands alone as a visual and verbal document of the Southwest Borderlands. There is just nothing else like it.

11. Cook, "W. D. Smithers, Photographer-Journalist," 11.

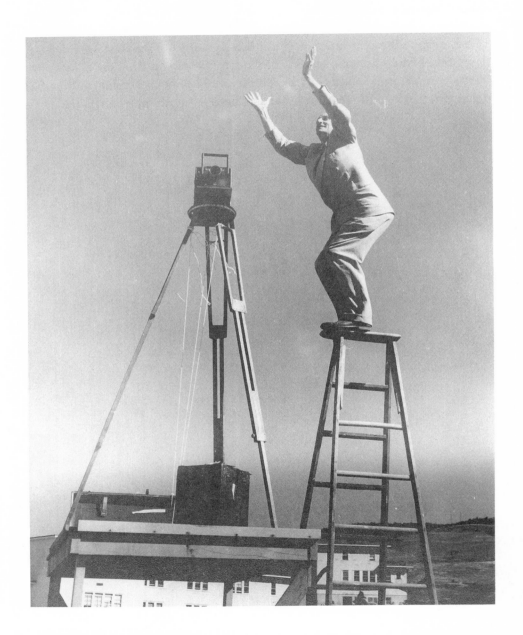

"E. O. Goldbeck on Ladder, Pepperell Air Force Base, Newfoundland." Photograph.
*Courtesy Photography Collection, University of Texas at Austin.*

# THE PANORAMIC PHOTOGRAPHY
# OF E. O. GOLDBECK

ॐ

## ROY FLUKINGER

There are few photographers of any discipline or historical era whose photographs continually elicit the strong personal responses that come from viewers of the work of Eugene Omar Goldbeck. Those responses may evoke a wide range of emotions, from joy to awe to an almost universally affable consternation (something along the lines of a "Just what did he do here?"), but his work continues to fascinate the audience. There is something about Goldbeck and his photographs which continues to draw the viewer, be it their scale, their imposition, their contradictory complexity of subject matter and simplicity of composition, or merely their uncompromisingly direct and overwhelming humanity.

Goldbeck himself reduced this explanation down to a motto and a dictum. The latter was a simple postulation: "Whenever they tell me I can't do something I get interested; never tell me I can't do something." The motto was even less complicated, at least on the surface: "Only a crazy man would do what I do!"

He carried both with him throughout his ninety-five years of life, summary statements that continue to describe the photographer and his life's work. And while his longevity and ceaseless energy undoubtedly contributed to his ascendancy among the ranks of commercial photographers who have worked in America since the 1840s, his popularity among those who utilize his archive continues to increase as his images continue to challenge and excite us. Perhaps no Texas photographer so willed his character and beliefs into the very fabric of his photographs.

It only took a single decade for Eugene Omar Goldbeck to decide upon a professional career in photography. On a spring day in 1901, the industrious ten-year-old stepped into a San Antonio street and snapped a candid photograph of

President William McKinley, who happened to be visiting Goldbeck's home town. Goldbeck had planned the shot well: he borrowed his brother's Bullseye camera, learned its particular technical qualities and limitations, found his location, and timed his move for the most advantageous moment. The resulting image met young Goldbeck's expectations and set him to seriously considering a photographic career.

During the next twenty years, E. O. Goldbeck learned his craft through hard work and experience. He also began to learn the rudiments of the business of photography as well. He sold snapshots to friends and teachers. He learned what types of photographs local merchants would purchase to promote or advertise their business. Early aviation events at the nearby airfield, early automobile races at the fairgrounds, news and sporting events—all were suitable subjects for making sales to the local newspapers. He was learning to sell both his photographs and himself, a knowledge which he retained throughout his career.

Goldbeck began his professional travels in 1914 with a trip to the opening of the Panama Canal. Future expeditions included Alaska and the West Coast, where he honed his talents as a "kidnapper"—that is, a traveling photographer who took group and commercial photographs under no purchase obligation from his subjects. The successful kidnapper photographed what he felt the potential customer wanted and then relied on the final print plus his own salesmanship to make the sale. Goldbeck was successfully pursuing such a career in Seattle when America entered World War I.

Always an outspoken patriot, Goldbeck decided to enter the U.S. Army. He joined the Signal Corps at Post Field, Oklahoma, determined to become a combat photographer. The Army had different ideas, however, and passed the energetic young photographer from camp to camp, while utilizing his talent to document stateside military life. His attempts to transfer to the European theater failed, and he was eventually assigned to the Signal Corps's School of Photography at Columbia University. By the war's end, he had become a more experienced photographer anxious to make his mark in his chosen profession.

Throughout the eight decades of his professional career, Goldbeck worked with a wide variety of photographic equipment and materials. The hundreds of thousands of negatives in his archive range from small, commercial dry-plate sizes to large, specialized sheet-film measuring over twenty inches on a side. He also carried a motion picture camera on his trips and took many thousands of feet of film of historic or timely events, such as the eruption of the Hawaiian volcano Kilauea in 1924 and Charles Lindbergh's 1933 departure

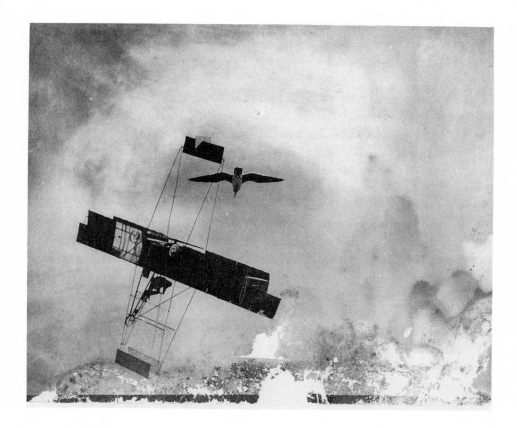

"Bird and Airplane," by E. O. Goldbeck, ca. 1912. Photograph. *Courtesy Photography Collection, Center for American History, University of Texas at Austin.*

from Panama carrying the first air mail from the Canal Zone to Washington, D.C., and New York City. The motion picture news agencies of the day paid well for such footage. Finally, during the last thirty years of his life, Goldbeck also amassed a personal collection of several thousand 35-mm color slides made during the course of his travels.

Despite the incredible technical and commercial variety in his work, Goldbeck became most famous for one format of imagery: the panoramic photograph. That this type of print overshadows the other aspects of his career is unfortunate, but does not lessen his talents or the quality of his vision. Indeed, prints of this format were the backbone of his business for over sixty years, far longer than any other format he employed. In the final analysis, it is

most appropriate that he be remembered primarily for his panoramas, not only because they met the commercial and professional demands of his business, but also because they matched Goldbeck's expansive vision of the world.

It is important to note, however, that E. O. Goldbeck did not invent panoramic photography. Rather, he has become one of the most productive heirs to a tradition that goes back to the early days of photography.

In the decades following photography's public announcement in 1839, many practitioners began experimenting with ways to achieve panoramic effects. The solution for some was a simple masking of a single negative or the cropping of a print to increase the horizontal line of the image. Many nineteenth-century photographers made a number of sequential exposures, choosing to produce the panoramic effect by mounting the final plates or prints in a matching, end-to-end alignment. The most serious development in panoramic photography, however, began in the 1840s, with the invention and subsequent refinement of cameras which incorporated a revolving apparatus.

By the 1910s, when Goldbeck had become interested in this format, two types of panoramic cameras had evolved. One was a large-view camera which had one of three plate sizes: 7 x 17, 8 x 20, or 12 x 20 inches. This model was often referred to as a "banquet" camera, since it was ideal for photographing large groups in banquets or other social occasions. Goldbeck used the banquet cameras for a number of commercial jobs during the 1920s and 1930s.

The second type of panoramic camera was more complex, because it involved synchronized rotation between the camera and the film. During the 1910s, it developed into the Folmer Graflex Cirkut Camera, a large tripod-mounted camera which turned around a toothed, circular base. Film height could vary from six to ten inches, while the camera was capable of exposing part or all of the twelve-and-a-half-foot length of film. Thus, as its name implied, the Cirkut was capable of covering up to 360 degrees or more in the course of a single exposure, as well as producing a sizable negative which afforded excellent resolution and detail for either expansive landscapes or the faces of every individual in a group portrait.

With his interest in panoramic photography growing and military life behind him, the years following the Great War were momentous ones for Goldbeck. In 1921, with his young wife, Marcella, he returned to San Antonio and founded his own photographic company, the National Photo Service. It later adopted its present name, the National Photo and News Service, and for over six decades lived up to its motto: "We cover the United States and then some."

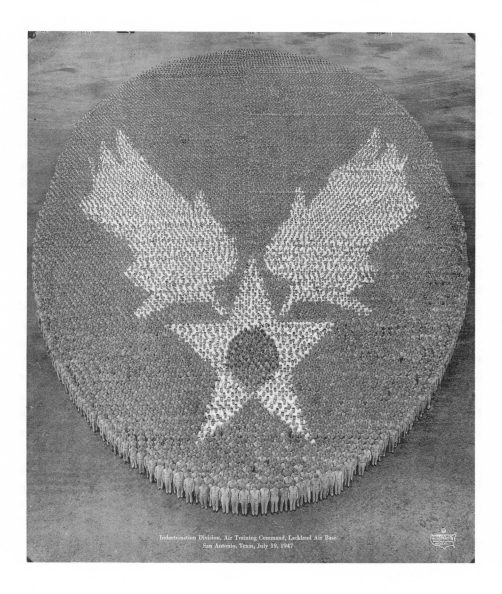

"Lackland Air Force Base, San Antonio, Living Insignia," by E. O. Goldbeck, 1947. Photograph. *Courtesy Photography Collection, Center for American History, University of Texas at Austin.*

Specializing in panoramas, yet maintaining his high degree of flexibility in all photographic formats, Goldbeck spent the first twenty years turning the National Photo and News Service into a successful commercial agency: an accomplishment achieved with the same planning, creativity, and hard work that had marked his earlier years. He maintained his contacts with the military, arranging to travel through Army bases in approximate three-year cycles while photographing commercial establishments—employees, buildings, working environments—and accepting public relations and advertising jobs as well. He remained an active member of the American Legion, photographing all aspects of their annual conventions, including the celebrated ninth meeting, which returned to the battlefields of Europe and was held in Paris, France. And he began increasing his image bank of popular "birdseye" panoramas of notable cities and places throughout the world.

During the 1930s, the size of Goldbeck's operation increased along with the frequency of his global adventures. He expanded his travels and those of his staff to include not only the customary military groups but also the entire companies of most Civilian Conservation Corps camps throughout the United States. In 1937, he toured the Pacific and the Orient. The trip provided him with many new scenic panoramas, including views of Japan and the Great Wall of China. It also provided him with many harrowing adventures: surveillance by the Japanese intelligence service; a brush with death during the bombing of Shanghai; and a tension-filled operation to smuggle his film out of Japan. The expedition so affected Goldbeck that he cabled President Roosevelt to warn him of the threat of war with Japan, a warning which unfortunately would prove to be too correct.

During World War II, Goldbeck curtailed his travel but not his patriotism. While his sons served in the military, Goldbeck continued to take unit photographs and manage portrait facilities at various Army installations in or near Texas. He supplied military intelligence in Washington, D.C., with over 160 pounds of prints which he had taken on his last tours of the Orient. He also maintained his network of staff photographers around the country so that the National Photo and News Service was able to supply critical news photographs as needed.

In the decades that followed, Goldbeck remained active past the age when most men retire. As always, he photographed military units from Alaska to the Panama Canal Zone. In 1947, he completed his largest "living insignia," involving 21,765 men, a 200-foot tower, and nearly two months of planning, for the Indoctrination Division of the Air Training Command at Lackland Air Base in San Antonio. His travels took him to other parts of the world, where he recorded new panoramic vistas.

The later decades of his life brought additional changes, but not in the basic speed or complexity of his work. He gradually passed on many areas of the business, first to one of his sons and later to his grandson, Edward, who still runs the Goldbeck Company in San Antonio. By 1971, the company had gradually phased out military groups in favor of the more lucrative high school and college group panoramas. Concurrently, E. O. Goldbeck began to devote more time to large panoramas in color. He travelled extensively, adding a couple more around-the-world journeys to his record and constantly adding to his extensive archive of color landscapes and cityscapes. He often bragged that he had retired at least three separate times, only to come back "because I discovered that the photography bug was still biting me."

As his business acumen made him look toward the future, so Goldbeck's pride in his work made him pay attention to the past. In 1967, following the loss of several thousand of his earlier negatives due to deterioration and improper storage, he arranged for the Harry Ransom Center to acquire his entire archive. In doing so, however, he did not sever his relationship with the University or his collection; Goldbeck remained completely accessible to the staff and patrons who sought him out for information, criticism, reminiscences, and not a little tale-telling. Indeed, it is entirely correct to say that he remained one of the few living links between the current generation and the earlier historical eras of American photography. To spend time with E. O. Goldbeck was to experience in flesh and blood a rare connection with the spirit of photographic enterprise that impelled the medium throughout the nineteenth century and into our own twentieth.

Although he had to abandon his plans for trips to Antarctica, the only continent he had never photographed, and across Siberia by train, he continued to blanket the United States and various parts of the world, producing more intricate color panoramas. The Laguna Gloria Art Museum in Austin produced his first retrospective exhibition in 1983, the first time in his career that he had ever seen any of his prints presented in frames and window mats. He collaborated on a retrospective history of his life and career, *The Panoramic Photography of Eugene O. Goldbeck*, which was produced by the University of Texas Press shortly after his death in 1986.

Indeed, it was only his terminal bout with lung cancer which led to a very eventual slowing of his pace during the last two years of his life. He no longer strode two steps at a time up the stairs of the studio behind his home. And the approach of the inevitable perhaps caused him to reflect further upon his philosophy of life: "All the heaven and hell we possess is right in our head; it's only how we treat ourselves and our fellow human beings that matters."

Although his energy may have been affected, however, his accessibility and enthusiasm continued as before, and only the occasional bad day prevented him from greeting any visitor with his customary "Howdy! Come on in!" or declaring that he was "still trying to be as busy as a one-armed picture hanger."

Following his death on October 27, 1986, he was mourned and eulogized by friends, the press, and fellow professionals from around the globe. Yet his wit and energy remained with us as well. On the day of his funeral, the San Antonio *Express-News* carried an editorial cartoon depicting a consternated St. Peter trying to handle a new but somehow typical Goldbeck request to take a panorama of everyone behind the pearly gates.

By his own estimate, E. O. Goldbeck produced more than 1,000,000 negatives. At least half this number is presently in his collection at the Ransom Center. Of these, at least 80,000 are the full size Cirkut panoramic negatives, which means that there are over 5,000,000 square inches of negative surface in this part of his collection alone.

Impressive quantities, perhaps, but there is more behind Goldbeck's images than the sheer weight of numbers.

Perhaps the power of E. O. Goldbeck's photographs lies in the manner in which they both embrace and defy Time. By Time, however, I do not mean merely the sense of record of past life, embellished by detail or tinged with nostalgia. Most historical photographers have done this to one degree or another, though few have possessed his verve or inventiveness.

Time, for Goldbeck, also involved the speed and dimensions of the process of photography itself. Since its beginnings, most photographic techniques have aimed at speeding up the exposure, at freezing the moment and contracting the instant. Goldbeck, on the other hand, chose to expand time and the photographic process surrounding it. With the panoramic image, he chose a large palette, one involving a wide negative/print dimension together with exposure and camera movements of long duration and process.

For all involved—sitters, viewers, customers, future generations—he provided an experience which elongated our participations, our reactions, and that initial experience itself. Concerned with individual creativity rather than artistic principles, with his own intuitive sense of how the natural world could be altered in both time and space, with participation rather than objectivism, Goldbeck's panoramas reflect a combination of creativity and collaboration which mark his love for the opportunities of shared experience. This collaboration between artist and subject flows through his work and his life, an unending sharing of the spirit of place and the sense of community with

all peoples. As he so loved and lived his life, E. O. Goldbeck also chose the medium and format which enabled him to share it most fully with the greatest number of people. And so it will continue.

"Voelcker Residence, circa 1878," by Henri Cartier-Bresson, 1965. Photgraph, 12$^{13}$/$_{16}$ x 9$^{1}$/$_{2}$ inches. *Courtesy the Museum of Fine Arts, Houston.*

# THE GALVESTON THAT WAS: REQUIEM OR INSPIRATION?

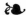

PETER H. BRINK

Dedicated to Howard Barnstone

Preface

In August 1987, Howard Barnstone, respected architect and author of *The Galveston That Was,* died unexpectedly in Houston. After the immediate shock and sorrow that I and many others felt at Howard's death, my thoughts returned again and again to this beautiful and haunting book that I and many others valued so dearly. Thus, I seized without hesitation the opportunity offered by Ron Tyler, director of the Texas State Historical Association, to prepare a paper about the book for the North American Print Conference in November 1988.

Doing the paper was, for me, an opportunity to try to answer questions about the book that had always intrigued me: How had this special book, going far beyond the usual survey of historical structures, come to be? How was the unusual combination of photography by Henri Cartier-Bresson and Ezra Stoller conceived? What was the artistic and professional approach of each, and how was this represented in the book? How was the book received initially, and what was its eventual impact on Galveston?

Finding the answers to these and other questions has been like unravelling a mystery. Fortunately, the excellent files in the archives of the Museum of Fine Arts, Houston, and Howard's own files in the archives at the Houston Public Library have added a wealth of letters and other documents to help in the search. Along with these, the generous assistance of many of Howard's friends and colleagues has been invaluable. Reference books from the Rosenberg Library in Galveston were crucial to my understanding of Cartier-Bresson.

And, in all of this, I was aided by the fine work of my volunteer research associate and friend, Betty Hartman of Galveston. For all of this assistance, I am sincerely grateful and hope that the end result is of value to all.

## Why *The Galveston That Was*?

In the 1950s and early 1960s, there remained in Galveston one of the finest collections of nineteenth-century architecture in the United States. Some three hundred blocks of the island city were packed cheek-by-jowl with hundreds of Victorian structures.

In the residential areas there sat, high above their compact yards, raised cottages, larger, more intricate frame houses, and imposing mansions. A dazzling array of porches, double galleries, crazy-quilt rooflines cut by multiple dormers, grand entryways with massive, ten-foot-high doors, beveled and stained glass, and rusticated stucco on piers and chimneys bedecked these structures. And, in those built of wood, all of this was accented with elaborate patterns of millwork, giving rise to the popular term Carpenter Gothic to describe this vernacular exuberance.

In the adjacent commercial area, three- to seven-story buildings rose in ornate walls along sidewalks already raised well above the level of the streets. Cast-iron columns and running arches, rhythmic rows of tall cypress doors, and polychrome brick set in plane over plane of detailing enlivened the façades. High above, all were crowned by massively ornate cornices adding as much as another story to the building height.

These structures represented the dreams of European immigrants, who saw in the promised land of Galveston and Texas the opportunity to build for themselves the castles, chateaux, and ornate stone masterpieces so familiar, yet so unobtainable, in their homelands. Never mind the lack of stone and masons in this new city on its island of sand; with characteristic tenacity, they built in brick, then frequently covered the brick with stucco and rusticated it all to look like stone; or, more frequently, simply recreated the glories of carved stone out of wood, paint, and carpentry genius.

These structures came into being in the middle and latter 1800s, when Galveston was the commercial center of Texas, the largest, wealthiest, and most cosmopolitan city in the state. Indeed, some sources attribute to Galveston the second-highest per-capita wealth of any city in the United States in the 1890s.

Galveston, chartered by the Republic of Texas in 1839, was founded by private entrepreneurs attracted to the potential of its natural harbor. By the Civil War, tremendous quantities of cotton and other agricultural goods were being shipped through Galveston for ports in the Eastern United States and Europe. On return voyages, building materials, manufactured goods, and luxury items

poured into Galveston for distribution throughout Texas and the Southwest. In addition, tens of thousands of European immigrants, as well as African slaves, arrived at the Port of Galveston, to stay or move on to cities and towns of the region.

This trade formed the basis for hundreds of commercial enterprises: shipping firms, cotton factors, commission houses, wholesalers, insurance companies, banks, law firms, land agents, newspapers, hotels, restaurants, and numerous retail establishments. From these enterprises, Galvestonians amassed wealth and, with their newly created affluence, designed and constructed houses and buildings to match their dreams or, almost as good, to impress their neighbors.

Many of these structures were destroyed in the great hurricane of September 8, 1900. Maps show nearly 50 percent of the city's blocks, mostly those on the Gulf side of the island, virtually wiped clean. And yet, so many structures had filled the city that an amazing quantity survived the 1900 storm.

In the years immediately following the storm, the massive seawall was constructed and, in an equally miraculous engineering feat, the grade level of most of the city was actually raised, as much as eight and nine feet in some areas. With these new safeguards the hundreds of remaining structures were able to survive subsequent storms.

The other event essential to these structures' continuing survival was, ironically enough, the opening of Houston's ship channel in 1914, and the shift of commercial momentum from Galveston to Houston and other Texas ports. Having lost its deep-water monopoly, Galveston turned to bootlegging, gambling, and prostitution in search of an economic mainstay. While these attractions were alluring for many, Galveston had virtually no economic or population growth in those years. This lack of growth ensured the survival of the older structures, which in a more dynamic economy would have been cleared for new construction.

Then, in 1956–1957, the Texas attorney general and Texas Rangers, smashing an estimated 2,500 slot machines, finally succeeded in closing down the gambling industry in Galveston, and with it much of the prostitution and illegal liquor-by-the-drink establishments. With gambling closed down, Galveston temporarily hit rock bottom while it struggled to find its economic future in other directions.[1]

In the midst of these turbulent changes, intensified by heated disputes as the city moved from racial segregation toward integration, almost no one perceived the importance of Galveston's treasury of historic structures.

1. Historical facts in the above paragraphs are drawn from or confirmed by David G. McComb, *Galveston: A History* (Austin: University of Texas Press, 1986).

Almost no one. For, amidst a community largely oblivious to these architectural treasures, two gallant exceptions existed. First, in 1954, a small cadre of strongwilled ladies, led by Mrs. Paul Brindley, saved the 1839 Samuel May Williams House from destruction. At the same time, they incorporated the 1871 Galveston Historical Society as the Galveston Historical Foundation and expanded its statement of purpose from saving documents important to Texas and Galveston history to saving historic landmarks.[2]

Second, in 1962, a group, including State Rep. Maco Stewart, succeeded in having the Old Galveston Quarter Act passed by the Texas Legislature and signed by the governor. The Act empowered a five-member commission to protect structures within a forty-block section of Galveston's East End.[3] To effect this, however, the support of a majority of property owners within the area was required, and in a special election regarding the Quarter in 1963, the proposal was defeated by nearly a two-to-one majority.[4]

Despite these two heroic efforts, widespread neglect and deterioration were slowly destroying Galveston's historic structures in the 1950s and 1960s.

## Howard Barnstone and the Book's Origins

Howard Barnstone moved to Houston in 1948 to become a lecturer in architecture at the University of Houston. Howard had grown up in Maine, graduated from Yale College, and then obtained a master's in architecture from Yale University. In 1953, he married a talented Houston artist, Gertrude Levy, who recalls that Howard "was simply bursting to explore and absorb all of Texas that he could." Howard loved the warm Texas sun, after the cold winters of Maine, and thus he and Gertrude spent many weekends simply "getting out." Soon they discovered Galveston and enthusiastically returned again and again. He and Gertrude would drive up and down street after street, discovering the old structures and delighting in the unending vernacular interpretations of Victorian styles.

Howard loved the architecture. The romantic allusions throughout the designs fitted perfectly with his love of the nostalgic. Having to seek out these neglected beauties fitted well with Howard's theory that one comes upon the work of the Muse unexpectedly, that one must be open to recognize and appreciate these surprise occurrences. It is easy to picture Howard, like a child in a candy store, dashing from one building to another, simply unable to digest all of the pleasures available.

2. Records of Galveston Historical Foundation, Galveston, Texas.
3. Galveston *Daily News*, Feb. 2, Feb. 11, Feb. 17, 1962.
4. Ibid., Nov. 17, Nov. 24, 1963.

Howard also loved the drama associated with the old wealthy families of Galveston and the leading roles they played in the intrigue of Galveston's economic and political life. For him it was high theater and only added to Galveston's allure.

Somewhere in these years of visits, Gertrude recalls, Howard conceived the idea of documenting these architectural treasures with photographs and text. How did the idea come about? As Gertrude recalls, Howard's mind did not travel in logical steps. Suddenly he would come upon a new, important idea and embrace it with his natural intuitive perceptiveness and exuberance.[5] Yet, one must ask, was the book Howard's idea alone, or did it arise from some sort of spontaneous discovery with one or both of two other important participants in the book, James Johnson Sweeney or Jean de Menil? Sweeney, formerly of the Guggenheim Museum in New York, had become director of the Museum of Fine Arts, Houston, in 1961. A museum press release of June 1962, noted that about a year before Sweeney had proposed to the museum trustees that the museum initiate a program of publications "with a book on the disappearing architecture of Galveston—the nineteenth century architecture principally, which is being demolished so quickly."[6] The release, which the Houston newspapers picked up in some detail,[7] went on to state that "We discussed this with Mr. Howard Barnstone, who is an enthusiast for the romantic background for architecture, different revivals, and mixtures of them which are peculiar to Galveston. It was suggested we start with that and we asked him to write the text. He agreed. It was agreed to find photographic documents."[8]

More than three years later a Houston *Post* review of the just-released book noted that "After a drive through Galveston with Barnstone one wintry Sunday afternoon, James Johnson Sweeney . . . concluded 'that the Museum of Fine Arts had a major duty to perform in focusing attention on this example of civic individualism of the Gulf Coast and to record it.'"[9] The other central early participant in the proposed book was Jean de Menil, president of the Schlumberger Companies and a person of vast financial resources. Perhaps more importantly,

5. The above paragraphs about Howard are based on my interview with Gertrude Barnstone, Oct. 11, 1988.

6. Press release, June 13, 1962, courtesy of the Museum Archives, Museum of Fine Arts, Houston (cited hereafter as the Museum Archives).

7. Houston *Press*, June 14, 1962; Houston *Post*, June 17, 1962, both courtesy of the Museum Archives.

8. Press release, June 13, 1962, the Museum Archives.

9. Houston *Post*, Dec. 19, 1965, courtesy of the Museum Archives. In this article, Marguerite Johnston quotes James Johnson Sweeney's foreword to *The Galveston That Was*. Similarly, see the review by Lon Tinkle in the Dallas *Morning News*, Dec. 26, 1965.

he and his wife Dominique were at the center of international avant garde thought, were major art collectors, and innovators in architectural projects. Howard had been introduced to the de Menils by architect Philip Johnson and had later designed several corporate buildings for Schlumberger Companies.[10] According to Ann Holmes, the arts editor of the Houston *Chronicle,* "A trip to Galveston with the de Menils in the early '50s was the source of Barnstone's later decision to write the book *The Galveston That Was.*"[11] If one were able to ask Howard now, he would probably attribute the inspiration for the book to the Muse. What is reasonably clear from the information available is that Howard was the driving force in this discovery of Galveston. Howard no doubt lured James Sweeney, the de Menils, and others to visit Galveston with him and captivated them with the treasures there. What is equally clear is that the book would not have become a reality without the key role of the Museum of Fine Arts and the personal and financial backing of Jean and Dominique de Menil.

## Starting the Project

The earliest information indicating that Howard was attempting to move forward on the idea of documenting Galveston's historic architecture is a letter by him dated February 9, 1960. The letter is also of interest in showing Howard's early conception of the project. In the letter, to the secretary of the Guggenheim Foundation of New York, Howard mentioned a lunch with Dr. Alfred Frankfurter and the de Menils, and then stated:

I was talking with Dr. Frankfurter and told him of my hopes to do a scholarly, yet, at the same time lively research project on the fast disappearing romantic architecture in Galveston.

Dr. Frankfurter at once suggested that I write to you, outlining the program, and indicating that he had suggested that I write. What I need is about $5,000–$6,000 to help pay for the cost of preparing measured drawings, a research assistant, and photographs. I had planned for the program to take from 9 to 12 months, and hoped for eventual publication.

The only existing description of Galveston's early architecture is a little 20-page pamphlet put out by the ladies of the local historical society.[12]

---

10. Houston *Chronicle,* Oct. 23, 1988.

11. Ibid.

12. Howard Barnstone to Dr. Henry A. Moe, Secretary, John Simon Guggenheim Memorial Foundation, Feb. 9, 1960, in Howard Barnstone files, Archives, Houston Public Library. See also Mrs. Josephine Leighton, Administrative Assistant, Guggenheim Foundation, to H. Barnstone, Feb. 11, 1960, and H. Barnstone to Mrs. Leighton, Feb. 16, 1960, in ibid.

Howard included a biographical sketch and listed several sponsors, including Jean de Menil, and asked if the Guggenheim Foundation might be interested in the project. The letter is interesting in several respects. It shows Howard as the proponent of the project and pursuer of financial support for it. It confirms Jean and Dominique's early role. It mentions photographs only in the sense of documentation, along with measured drawings and research. And, finally, its emphasis is on a study, with only a vague hope of eventual publication.[13] Howard was unsuccessful with the Guggenheim Foundation, but on February 23 of that same year, he had written for help to Mrs. E. Clyde Northen, a Galvestonian, member of the Moody family, and trustee of the recently formed Moody Foundation. He described the project in much the same way, except that he placed more emphasis on its eventual publication: "What I have in mind is the eventual publication of a definitive book with photographs, plans and historic details of all the major buildings." In addition, Howard wrote that he would use "a first class architectural photographer, such as, G. E. Kidder-Smith or Ezra Stoller, for existing buildings."[14]

The secretary of the Moody Foundation responded by advising Howard that "the Trust Indenture of The Moody Foundation does not allow for such a contribution as requested."[15] (Presumably this was a reference to the foundation's policy of not making grants to individuals, since Howard had not yet thought of having the Museum of Fine Arts or some other eligible organization be the grant recipient.)

Despite these initial setbacks, Howard found a backer for the project some time in late 1960 or 1961. That backer was Jean de Menil. The Museum of Fine Arts, Houston, under the new directorship of James Johnson Sweeney, became the organizing entity. This is evidenced both by the recollections of other participants and by the clearance of key business aspects with de Menil.[16] A later letter from de Menil to Sweeney notes that the de Menils had contributed some twenty thousand dollars to make the book possible.[17]

## The Photographers

By March 1962, the funding and the museum's role had been arranged and things were moving.

---

13. Mrs. Leighton to H. Barnstone, Feb. 19, 1960, from Mrs. Leighton to H. Barnstone; H. Barnstone to Mrs. Leighton, Feb. 23, 1960; and Mrs. Leighton to H. Barnstone, Feb. 26, 1960, all in ibid.

14. H. Barnstone to Mrs. E. Clyde Northen, Feb. 23, 1960, in ibid.

15. A. T. Whayne, Secretary, the Moody Foundation, to H. Barnstone, Mar. 17, 1960, in ibid.

16. Gertrude Barnstone to Peter Brink, Oct. 11, 1988, interview; Dominique de Menil to Peter Brink, Oct. 6, 1988, interview; James Sweeney to Jean de Menil, May 25, 1962, courtesy the Museum Archives.

17. Jean de Menil to James Sweeney, Jan. 15, 1966, ibid.

The first photographer to be brought into the picture was Ezra Stoller. Howard had previously mentioned Stoller, along with G. E. Kidder-Smith, as an example of the first-class architectural photographer that he would want for the book. In a March 13, 1962, letter to Stoller, Howard referred to a recent talk they had had about "the book on Galveston," noted that it would be a publication of the museum, and asked Stoller to suggest a financial arrangement.[18] Howard noted also that, while winter is the best time to get pictures of some houses, he "would hate to put it off that long." Stoller responded on March 21 with an informal fee proposal and with the suggestion that he make a preliminary trip to Galveston of about a week's duration, perhaps in May.[19] Howard answered delightedly on March 23, urging Stoller to "Come as soon as you can."[20]

Stoller, based in New York, was an architect by training, and was known in professional circles as an outstanding architectural photographer. He was much sought after by architectural firms and their clients to present new projects to their best advantage. He had had a one-man exhibition in the Pepsi-Cola Building in New York, and the Smithsonian Institution had displays of his architectural photographs on the list of circulating exhibits in its permanent collection. In 1961 he had been awarded a gold medal by the American Institute of Architects. Among his clients were leading magazines such as *Vogue, House Beautiful, House & Garden,* and *Fortune.*[21]

Yet almost as they spoke other events were occurring which apparently precluded Stoller's participation in the book. That same March or early in April, Jean de Menil initiated contact with Henri Cartier-Bresson, and Cartier-Bresson arrived in Houston on April 30 to spend ten days photographing Galveston with Howard.[22]

On May 18, by special delivery air mail, Howard sent Stoller "one of the most difficult letters I have ever had to write."[23] "As you know," he wrote, "the book was to have been a collaborative effort on the part of yourself as well as subjective photographs." He told Stoller that they had finally settled on Cartier-Bresson, who had recently visited Galveston. Howard continued:

The problem that has now come up is that he, Cartier-Bresson, feels that he has given adequate coverage and doesn't want another photographer to be involved. He

18. H. Barnstone to Ezra Stoller, Mar. 13, 1962, ibid.

19. Ezra Stoller to H. Barnstone, Mar. 21, 1962, ibid.

20. H. Barnstone to Ezra Stoller, Mar. 23, 1962, ibid.

21. Undated Museum of Fine Arts promotion for *The Galveston That Was,* in possession of author.

22. Among others, James Sweeney to Miss Inge Bondi, Magnum Photographs, Inc., Apr. 16, 1962, courtesy the Museum Archives.

23. H. Barnstone to Ezra Stoller, May 18, 1962, ibid.

has made this point very strongly to me and to Jim Sweeney, Director of the Museum who is the publisher, and to John de Menil who is the backer.

In view of the hesitation you indicated in your note of 28th April, would it be better if we dropped the idea of the documentary photographs and let Cartier-Bresson have his way?[24]

Stoller responded on May 21 (in full): "Sorry you had to be the axe but if Bresson has done it, it is done and I'll just change my plans and cancel the trip."[25]

## Henri Cartier-Bresson

The choice of Henri Cartier-Bresson as the photographer was surprising, to the extent that the purpose of the book was "a scholarly research on the great nineteenth-century architecture of Galveston,"[26] a "documentation" of the disappearing architecture of Galveston,[27] and, as stated in the book's foreword, an effort "to record the quality achievement of . . . Galveston during the nineteenth century. . . ."[28] For this, a photographer who was an expert in architectural documentation, such as Stoller, would seem a natural. One might not as readily choose Cartier-Bresson.

Cartier-Bresson's genius and his fame lay in his ability to capture the essence of ordinary human beings, whether of persons caught up in extraordinary events of media interest or carrying out their everyday routines in their normal surroundings. Cartier-Bresson was already a legendary photojournalist, as well as a master of the photo portrait. One need only look at "Allee du Prado, Marseille" (1932), "Cape Cod, Mass." (1947), or "Place de l'Europe" (1932), among many others, to be convinced of his genius. It is also true that, on occasion, he magnificently captured the rhythmic and spatial composition of a particular landscape, for example, the panorama of rooftops in "Near London" (1955), the "Ile de la Cite Surrounded by the Seine" (1952), terraced fields in "Bali" (1950), or the massing of structures in "Aquila dei Abruzzi, Italy" (1952). But one does not find in his work architectural photography in the traditional sense: no carefully balanced photographs of individual structures or architectural details. Why, then, was Cartier-Bresson chosen to document Galveston's historic structures?

24. Ibid. I have not been able to locate Stoller's notes of April 28, to which Howard refers.

25. Ezra Stoller to H. Barnstone, May 21, 1962, courtesy of the Museum Archives.

26. H. Barnstone to Mrs. E. Clyde Northen, Feb. 23, 1960.

27. Press release, June 13, 1962.

28. James Johnson Sweeney, "Foreword," in Howard Barnstone, *The Galveston That Was* (New York: Macmillan, 1965), 11–12.

First, he was a renowned photographer. By the early 1960s he was among a handful of photographers recognized around the world for their genius. In 1954 the Louvre had set aside a longtime policy against photography by making his pictures the subject of its first photographic exhibition. His photos had been featured in a series of books: *The Decisive Moment* (1952), *The Europeans* (1955), *People of Moscow* (1955), *China in Transition* (1956), *From One China to Another* (1956), and, in process at the time, *Photographs* (1963). He had won photographic awards from *U.S. Camera*, the American Society of Magazine Photographers, the Photographic Society of America, and the Overseas Press Club.[29] Without doubt, Cartier-Bresson's participation in the book would bring a formidable talent to the work and attract keen interest in photographic circles and beyond.

More important, Cartier-Bresson's life represented an unending quest for expression and communication in art, always reaching beyond narrow boundaries of personal circumstances or artistic technique. Born near Paris in 1908, Cartier-Bresson avoided entering his family's successful textile manufacturing business, and instead completed school and then studied with the Cubist painter Andre Lhote. He pursued literature and painting for awhile at Cambridge, and later spent a year in Africa, making his living as a wild game hunter and taking up photography, until he contracted a severe case of blackwater fever while living in a native village.[30]

Convalescing in Marseilles, Cartier-Bresson began experimenting with a Leica camera. He later recalled that the Leica "became the extension of my eye, and I have never been separated from it since I found it. I prowled the streets all day, feeling very strung-up and ready to pounce, determined to 'trap' life— to preserve life in the act of living. Above all, I craved to seize the whole essence, in the confines of a single photograph, of some situation that was in the process of unrolling itself before my eyes."[31]

For the next few years Cartier-Bresson travelled widely as a freelance photojournalist in Europe, Mexico, and the United States, often just getting by in cheap hotels and restaurants, but gradually gaining recognition. Cartier-Bresson then left photography for a few years to assist Jean Renoir in making films. Captured by the Germans during World War II, he escaped after thirty-five months in a prisoner of war camp. He joined the underground resistance in Paris, where he provided pictorial documentation of the German occupation.

29. Charles Moritz (ed.), *Current Biography* (New York: H. W. Wilson Co., 1976), 81–82.

30. Basic biographical information about Henri Cartier-Bresson is all drawn from ibid., 79–82.

31. Henri Cartier-Bresson, "Introduction," *The Decisive Moment* (New York: Simon and Schuster, 1952), second page.

After the war, Cartier-Bresson directed a poignant film about French POWs re-
turning home. The next year he helped found Magnum Photos, now the
world's largest independent photo agency. And for the next two decades he
crisscrossed the world in search of photo subjects, winning acclaim and an in-
ternational reputation. Yet, even given all this, one must still ask: how would
Cartier-Bresson's particular genius as a photographer fit with the task of docu-
menting historic Galveston? As Cartier-Bresson himself has written, "A subject
is not a collection of facts, for facts in themselves offer little interest. The im-
portant thing is how to choose between them, how to fix on a fact that bears
the stamp of profound reality. . . ."[32]

For Cartier-Bresson, always carrying his Leica camera, it is a matter of wait-
ing with awareness for the instant when human beings express the essence of
the event or situation, and do so in a visual composition of themselves and
their physical surroundings that clarifies and strengthens the expression. Thus,
Cartier-Bresson waits for what he has called "the decisive moment," the in-
stant when a particular human expression is at its purest and when the visual
composition aligns itself with that emotion. Yet it is more complicated than
this. With respect to the content which he sought to join with the visual com-
position, he wrote,

I believe that, through the act of living, the discovery of oneself is made concurrent-
ly with the discovery of the world around us which can mold us, but which can also be
affected by us. A balance must be established between these two worlds—the one in-
side us and the one outside us. As the result of a constant reciprocal process, both these
worlds come together to form a single one. And it is this world that we must communi-
cate.

But this takes care only of the content of the picture.[33]

This unified vision, the content, must then be communicated by a simulta-
neous coming together with the appropriate form:

For me, content cannot be separated from form. By form I mean a rigorous organi-
zation of the interplay of surfaces, lines, and values. It is in this organization alone that
our conceptions and emotions become concrete and communicable.[34]

This recognition of form, i.e. composition, is for him the essence of photog-
raphy. To accomplish all of this, Cartier-Bresson uses no special lenses, flashes,
or other modern photographic techniques. He even chooses not to develop his

32. Henri Cartier-Bresson, "Preface," *The World of Cartier-Bresson* (New York: Viking, 1968),
second page.
33. Cartier-Bresson, "Introduction," *The Decisive Moment*, last page.
34. Ibid.

own prints or allow any cropping or other redoing of his photographs in the darkroom. For him, the magic is in the decisive moment, and everything else is either subordinate or irrelevant. Similarly, in seeking this instant of congruence of expression and composition, the photographer should minimize his intervention on the subject: "Let your steps be velvet but your eye keen; a good fisherman does not stir up the water before he starts to fish. . . . Our job is immensely dependent on contacts with people; one false word and they withdraw."[35]

And through all of this, Cartier-Bresson's ultimate goal was not, as one might expect, reportage, or reporting, as an end in itself. As he poignantly stated, "I have written at length about reportage, because this is what I do. But through it I try, desperately, to achieve the single photograph which exists for its own sake."[36]

### Henri Cartier-Bresson and Galveston

By understanding Cartier-Bresson's genius and approach to photography a bit more fully, we may appreciate more readily why he was chosen to document Galveston's historic structures. As Gertrude Barnstone recalls, Howard was familiar with Cartier-Bresson's work, and perhaps knew him personally, through Howard's position in the 1950s and 1960s as editor of *Intercom*, the international in-house magazine of the Schlumberger Companies. Gertrude recalls that Howard was given a free hand with *Intercom* and that he did extraordinary graphics and photographs, along with book reviews and articles. Howard was on the cutting edge in these areas and very creative. She believes that he was intrigued with the idea of using Cartier-Bresson, who was so good at photographing people, in a fresh way by having him photograph architecture. It was "an iconoclastic approach," but Howard thought the freshness of the approach would be a way of getting people to see the old, neglected buildings in a new way.[37]

James Sweeney, in the museum's 1962 press release, stated that "We felt that we might work with documents from the library but in the end decided that it would be interesting to have one of the finest contemporary photographers to work on it—someone who has a sympathy with the romantic background of the material. Mr. Cartier-Bresson's name was proposed to Mr. Barnstone and the trustees."[38] Presumably Mr. Barnstone and the trustees

---

35. Cartier-Bresson, "Preface," *he World of Cartier-Bresson*, fourth page.

36. Ibid.

37. Gertrude Barnstone to Peter Brink, Oct. 11, 1988.

38. Press release, June 13, 1962.

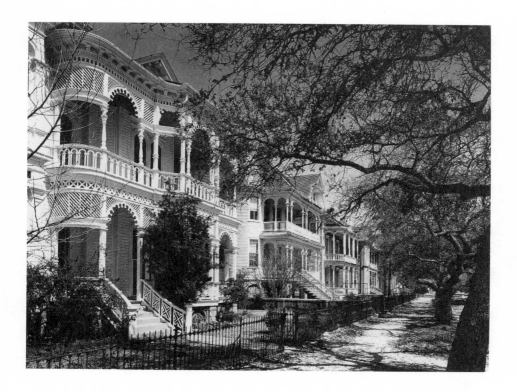

"Sonnenthiel House," by Ezra Stoller, 1965. Gelatin silver photograph. *Courtesy the Museum of Fine Arts, Houston.*

concurred, since shortly thereafter arrangements were made for Cartier-Bresson to come to Galveston. The moving force in contacting Cartier-Bresson, and almost certainly in urging his selection, was Jean de Menil. The de Menils knew Cartier-Bresson both professionally and personally. The initial letter, dated April 13, 1962, from Magnum regarding Cartier-Bresson's participation in the project noted that the agreement is based on conversations between Cartier-Bresson and Jean de Menil and also between Inge Bondi of Magnum and de Menil.[39] Indeed, in a recent letter from Cartier-Bresson to myself, he stated that "The idea of the book *The Galveston That Was* comes from Jean and Dominique de Menil who, with their enthusiasm and their usual generosity, have enabled the idea to be realized, with the aid of our friend, architect Howard Barnstone."[40]

39. Gedeon de Margitay, Magnum Photos, Inc., to H. Barnstone, Apr. 13, 1962, courtesy the Museum Archives.

40. Henri Cartier-Bresson to Peter Brink, Oct. 5, 1988.

I have found no material detailing de Menil's reasons for selecting Cartier-Bresson for this project, though one can presumably glean an indication from the reasons attributed to Howard and Sweeney.

And why, one might ask, would Cartier-Bresson want to do this project, given his multitude of opportunities? The letter from Magnum stated that "He has special regard and affection for the vitality that he finds in Texas and hopes to be able to capture in his photographs of Galveston all the many facets of this town."[41]

One should note, too, that Cartier-Bresson was never one to back away from a challenge, such as utilizing architectural subjects as a means to capture Galveston's character.

Probably more important, however, was the relationship between Cartier-Bresson and Jean de Menil. As a letter from Magnum to de Menil stated, "Henri was delighted to work with you on a project—and he would never have accepted it, had this idea not come from you. . . ."[42] This is, I believe, further evidenced by Cartier-Bresson's initial willingness to undertake the ten-day assignment for the surprisingly low fee of $2,000 plus expenses from New York, with no additional royalties.[43] It is evidenced also by the fact that Cartier-Bresson came to Galveston and undertook the assignment on the basis solely of verbal understandings and a one-page letter.

He arrived in Houston on April 30 and spent the first two nights at the de Menils' home, thereafter staying, as planned, at a hotel in Galveston so that he would be closer to his subject and able to work without interruptions.[44]

Gertrude Barnstone remembers Cartier-Bresson, who spoke fluent English, as "very direct and sweet, relating to people immediately." He always started his day by reading poetry to inspire him for the work ahead. He had "a slight touch of courtliness in his manner." She recalls his joy in his work. One morning in Galveston, Howard, Gertrude, their two girls, and Cartier-Bresson were having breakfast in the hotel's coffee shop, and Cartier-Bresson started taking photos of them all, playing with them, simply for the pure fun of it.

Asked if Cartier-Bresson liked Galveston, Gertrude recalls that he was "so responsive and perceptive as a person." He loved his surroundings wherever he was and did the same thing in Galveston, "simply eating it up."[45]

41. De Margitay to Barnstone, Apr. 13, 1962.

42. Miss Inge Bondi, Magnum Photos, Inc., to Jean de Menil, June 7, 1962, courtesy the Museum Archives.

43. De Margitay to Barnstone, Apr. 13, 1962.

44. Gedeon de Margitay, Magnum Photos, Inc., to H. Barnstone, Apr. 24, 1962, courtesy the Museum Archives.

45. Gertrude Barnstone to Peter Brink, Oct. 11, 1988.

Howard accompanied Cartier-Bresson throughout the photographing in Galveston, the two working in complete harmony in the shooting and selecting of the pictures.[46] They were assisted in their work by Tom Rice, a local expert on Galveston history and musical director of Trinity Episcopal Church.

Tragedy struck at the end of the first week of work in Galveston. That Sunday there had been an afternoon meeting of the Galveston Historical Foundation, with Cartier-Bresson as the honored guest. Afterwards there was a small party at the home of Mildred Robertson, an early Galveston preservationist, and then Cartier-Bresson had dined with Howard. After the party, Tom Rice had spent several hours at the hotel bar, waiting to see if Cartier-Bresson would join him for further conversation upon his return. In going to the men's room, Rice opened the wrong door, a door which, incredibly, opened on to nothing. He fell roughly two stories and died soon afterwards, despite extensive surgery. As Gertrude recalls, Cartier-Bresson felt terrible, in some way feeling responsible for not having joined Rice in the bar and thus, perhaps, preventing this bizarre tragedy.[47] Nevertheless, as Mildred Robertson wrote Howard and Gertrude two weeks later, Tom had confided to Mildred at the party, "Mil, this is the evening of my life." As Mildred wrote, "No one appreciated the singular experience of that Sunday evening more than Tommy, unless it is myself."[48]

Cartier-Bresson went on to complete ten days of photographing as planned, with Howard continuing to work with him in the shooting and selecting. The prints were available for Howard, the de Menils, and James Sweeney to look at during Cartier-Bresson's time in Galveston.[49]

## Henri Cartier-Bresson's Photographs of Galveston

Cartier-Bresson's photographs of Galveston show the architectural beauty of the old structures. Frequently the structures are worn, even dilapidated; occasionally they are in good repair. There is a sense of slowness about everything, a feeling of lethargy, as with a spring run down over time.

This is communicated most forcefully, often brilliantly, in those photos in which people are the central feature, with the structure as their context. The people, usually with eyes downcast and heads slightly bowed, are, except for the children, old, tired, and run down, their clothes and appearance often dishevelled. The children, in contrast, are oblivious to any problems, running about with energy, revelling in their games and play.

46. Bondi to de Menil, June 7, 1962.
47. Gertrude Barnstone to Peter Brink, Oct. 11, 1988.
48. Mildred Robertson to Howard and Gertrude Barnstone, May 19, 1962.
49. Bondi to de Menil, June 7, 1962.

"Sacred Heart Church II," by Henri Cartier-Bresson, 1965. Gelatin silver photograph, $9\frac{7}{16}$ x $12\frac{7}{8}$ inches. *Courtesy the Museum of Fine Arts, Houston.*

In the photos of buildings without people, the viewer is treated to full shots, often including foliage, but also to photos from unusual perspectives which capture the multiple angles and fanciful millwork.

A strong example of the photos in which people are the central feature is "Voelcker Residence, circa 1878. Detail of north elevation" (p. 99 of the book). In fact, the foreground of the photo is dominated by two men, one leaning on the fence, the other slowly walking by, head bowed, eyes downcast. Their bodies fuse for an instant, almost two upper bodies growing out of a single torso. Both are in need of shaves, one with a hole in his shirt, the other with no shirt, his underwear showing above his jeans. The one leaning appears to be looking toward the one walking, but the latter is not responding. The relationship, like the people, is lethargic, without energy. So, to an extent, is the Voelcker Residence. The torn screen door and worn paint are evident. Yet the house, on closer inspection, appears solid and in fair condition. For the viewer, however, the strong impression from the photo is of something run down, slowly dying. And probably Cartier-Bresson is right. Whatever the structural soundness of the house, its use and the lack of value placed on it are well evidenced by the

condition of the resident (the one leaning) and, on careful inspection of the photo, the strand of barbed wire jerry-rigged atop the length of the wrought iron fence. From the standpoint of composition, Cartier-Bresson captures perfectly, by shooting the house at an angle, the layering created by the fence, the double gallery zig-zagging across three surfaces of the structure, and two surfaces of the exterior walls. Joining the figures and the structure is a major column of the galleries, which aligns itself perfectly with the merged torsos of the two men.

Of similar impact is the photo "Vernacular Greek houses by anonymous builders on Avenue I" (p. 50). Here, the people are even more dominant: three old men seated in sprawling fashion on the porch of a frame house. The function of the porch, with columns, heavy railing and balusters, is no more than to form, with the façade of the house, a framework for the three men. The viewer's immediate impression is of people and their lives, dilapidated and lethargic. Most striking is the battered couch, its old covering so torn away that there is naught to sit on but the remnants of stuffing. This, along with the middle man, unshaven, seemingly exhausted as he leans against the house with cane extended, creates the impression of destitution, almost regardless of what the structures might look like. Indeed, the only physical problems with the structure are some worn paint on the window frame and bits of wire hanging from a shutter. Yet the point is made, and rightly so: whatever the physical condition of the structures, they, like the people in them, are cast-offs of society, left to disappear with no one to appreciate their history, architecture, or worth. From the standpoint of composition, the square-end opening of the porch forms the central organizing form, on which the strong lines of the porch railing, couch, and front of the house converge. The photo is taken from a bit above, so that the three men in a rough row and the top surface of the couch are clearly visible, almost strewn along the rectangular plane of the porch floor moving at an upward angle toward the porch's end opening. Additional depth and complexity are gained by the background of the adjacent house's porch opening and siding.

A less dramatic but beautifully done photo is "The Washington Hotel. Interior" (p. 45). Here stands the elderly proprietress, steadying herself on the gracefully curved banister. Behind her are the "Rents must be paid in advance" sign and plain wallpaper dotted with ordinary calendars and signs. Miss Havisham? No. Rather, an example of old people of moderate means making do in these structures that were once the grandest in Texas. In terms of composition, the beautiful curve of the shining bannister railing sweeps to the woman and relates the two rectangular surfaces of light-covered wall separated by the blackness of the hall opening. The only light is natural, coming from an unseen window.

A number of other photos gain meaning and power by combining people and historic structures, though the people are not as dominant in the photos as in the three described above.

"Congregation B'nai Israel Synagogue. South elevation" (pp. 84–85) includes a solitary person walking by, set against the massive façade of the former synagogue and stark cement paving of the parking lot. Even the windows of the building were blocked up after the congregation moved out. The "PRIVATE PROPERTY—KEEP OUT" sign dominates the man. He walks slowly, head bowed slightly, eyes downcast, making his way without spirit in a harsh environment. The composition utilizes the minute size of the man in relation to the massive, nearly blank wall of the building to reinforce the poignancy of the message. Even the horizontal line of the photo is tilted a bit, so that the man appears to be walking slightly uphill.

In "Flood and Calvert Building (The Block-Oppenheimer Building), 1873. Detail at entry" (p. 90), an older man and an acquaintance, both neatly dressed, stoop in the doorway of a Strand building, as if to be shielded from the bright sun, yet remain unshielded.

The use of people in the photos to help express the slowness and deterioration of the old part of Galveston is seen, with variations, in several other of the photos.

In "Commercial blocks, south side Strand" (pp. 74–75), the overgrown sidewalk and rusted cast-iron columns are complemented by a laborer, eyes down, clothing soiled, walking by.

"Sonnenthiel House" (pp. 162–163) juxtaposes both the lovely white millwork of this frame house and the gnarled live oaks with the roughish figure of a man, in loose working clothing, in the lower left foreground. At first glance the man seems to be rolling a hoop down the street, though it is soon evident that he is carrying a bicycle wheel. The grand, whimsical house is thus juxtaposed with the slightly grotesque figure, with a bit of the court jester about him.

"Bordello on Post Office Street, west of Twenty-fifth Street" (p. 212) shows an elderly black man looking out from the protection of the lattice-enclosed porch, just sitting and watching.

The delightful exceptions to these stolid people are the children, with their energy and playfulness: the young boy with his package running across the street in "Congregation B'nai Israel Synagogue. West elevation" (p. 86), for example, and the girl running up the front steps of "The Sawyer-Flood House. Detail of bay window at front entry" (p. 103).

There is one photo showing an adult where the somberness gives way to a feeling of reverence and spirituality. This is "Sacred Heart Church (II)" (pp. 200–201). Here a man stands respectfully, head bared, holding his hat, before

the magnificent symmetrical church façade, with a large supporting column running from bottom to top in the exact middle of the photo, centering everything. The photo captures a beautiful interplay of person, building, and intricate shadows.

At the same time, Cartier-Bresson gives us a large number of photos without people in which he skillfully highlights a particular portion of the structures or presents the structure as a whole. In doing this, he often utilizes an unexpected angle, a stimulating interplay among the lines of the structure, or at times a contrast with the irregular curves or softness of live oaks, palms, or other foliage. For example, "The McDonald House. 1890" (overleaf); and "The J. M. Brown Residence. Detail of front gate post" (back cover and p. 62). A good example of those photographs capturing the full façade of a structure is "The Austin House" (pp. 78–79).

There is very little record of Cartier-Bresson's impressions of Galveston. Cartier-Bresson, within a few days after leaving Galveston, did write a note to Jean de Menil, referring to their recent phone conservation. He wrote, ". . . I believe that the better way to tell you what I think will be to do a book on Galveston that expresses the strange and ephemeral life of this butterfly of the 19th century."[50] And, in response to a letter from me, Cartier-Bresson wrote on October 5, 1988, "I hope that my photographs . . . have been able to transmit the elegance, the charm, the rigor of this architecture representing a world which, unhappily, has disappeared."[51]

## Ezra Stoller Reenters the Picture

Something was brewing, however. There is, unfortunately, no information remaining as to discussions that may have transpired during that summer about whether Cartier-Bresson's photographs gave complete enough coverage for purposes of the book. The next indication in this respect is a letter of October 2 to Howard from Frank A. Wardlaw, director of the University of Texas Press. He expressed strong interest in the book, but added, "My only reservation about it is the feeling that there aren't enough of the Cartier-Bresson photographs and that they do not really adequately represent the 'architectural' exuberance of Galveston."[52] Wardlaw must have touched on a feeling that was shared by Howard, and at least acquiesced in by James Sweeney and Jean de Menil. Howard responded the next day to Wardlaw that the original thought

50. Henri Cartier-Bresson to Jean de Menil, May 15, 1962, courtesy the Museum Archives.

51. Cartier-Bresson to Brink, Oct. 5, 1988.

52. Frank H. Wardlaw, Director, University of Texas Press, to Howard Barnstone, Oct. 2, 1962, courtesy the Museum Archives.

was to have Ezra Stoller, "who is the world's outstanding architectural photographer," do a certain portion of the photographs, but that this had changed in deference to Cartier-Bresson's wish to be the sole photographer.[53]

That same day Howard, in a letter copied as usual to James Sweeney and Jean de Menil, wrote to Ezra Stoller, beginning his letter: "Man, this is a difficult one to write." Howard updated Stoller on the book's progress and then added: "As you see from the Texas letter, the weakness of a book with only Cartier-Bresson photographs which I had fully anticipated in my preliminary talks with you, have now become a factor in the position of the publishers and providing we can chain Cartier-Bresson to a stake somewhere in Tibet with a hand-knitted muffler wound five times around his head, would you under any circumstances be willing to come back in the picture and do what you and I had talked of over a year ago?"[54]

Meanwhile, according to Dominique de Menil, her husband was attempting to gain Cartier-Bresson's assent to the addition of Stoller. In any case, Howard was able to write Stoller on November 28 that he (Howard) had had a cup of coffee with Cartier-Bresson in New York and that the latter had agreed "from the point of view of the book that his coverage was incomplete and further agreed that you would be the architectural photographer as originally planned."[55]

Stoller decided to set aside his pride and accept once again.[56] Thus, in March 1963, he spent nine days in Galveston photographing, sending Howard 123 prints by the end of that month. Stoller later returned briefly to Galveston to shoot some interiors. A note by Howard in May expressed his satisfaction with the work.[57]

## Ezra Stoller's Photographs of Galveston

Ezra Stoller was trained in architecture in the late 1930s, when the influence of the Beaux Arts school was fading, and modern architecture, with its emphasis on functionalism, was being embraced. For Stoller this meant, among other things, that his approach to photography became quite function- or assignment-oriented. Rather than seeking the creation of art as a goal in itself, Stoller sought to appreciate an assignment fully and then to do the job with excellence.

In the case of the Galveston assignment, he had to set aside his training to avoid looking at the historic structures in terms of twentieth-century

53. Howard Barnstone to Frank H. Wardlaw, Oct. 3, 1962, ibid.
54. Howard Barnstone to Ezra Stoller, Oct. 3, 1962, ibid.
55. Howard Barnstone to Ezra Stoller, Nov. 28, 1962, ibid.
56. Ezra Stoller to Peter Brink, Nov. 9, 1988, interview.
57. H. Barnstone to Ezra Stoller, May 22, 1962, courtesy the Museum Archives.

"Darragh Residence," by Ezra Stoller, 1965. Gelatin silver photograph. *Courtesy the Museum of Fine Arts, Houston.*

functionalism. He had to see the structures, rather, as they were used and viewed in the nineteenth century by the people building and residing in them. To photograph them using the standards of a later period would "just be making pretty pictures."

In Galveston, the job was to document a certain culture at a certain time. For Stoller, this was never an artistic exercise; it was doing the job. He was especially interested in those photographs that gave a sense of space around the structures, or a sense of the relationship of the structures to each other and the way they were a part of the city.

Stoller recalls that there was little air conditioning in Galveston when he visited. Galveston still had the smell of the old city, with the breezes floating through the structures. It was this feeling he sought to capture.[58]

His photographs are an important addition to the presentation of Galveston architecture in the book. While Stoller's photos give the appearance of straightforward shots, there is usually more subtlety of angle and composition than the viewer is at first aware of. They provide a foundation of excellent architectural coverage upon which the more interpretive, more people-oriented photos of Cartier-Bresson may play. And, at times, Stoller produces architectural masterpieces. Without doubt, the work of each photographer is important to that of the other. With the absence of either, the photographic content and power of the book would be diminished markedly.

A number of Stoller's photographs are straight-on pictures of the entire façade of an important structure and its setting; for example, "The Menard House. Front (east) elevation" (pp. 21–22). Here the structure is exactly centered in the photo, with the large live oaks playing against the strong vertical and horizontal lines of the near symmetrical façade, and with the intricate leaves and shadows adding softness and complexity.

Equally effective in this straightforward style is "The J. M. Brown Residence, 1858" (pp. 58–59), in which shadows from the eaves and cast-iron porches give depth to the façade, and perfect framing is provided by the vertical palm trees and overhanging limbs of the live oak.

Stoller used the same approach, with a different subject, in the straight-on shot of "The Washington Hotel, 1871. West elevation" (p. 44). Here the classical horizontal and vertical lines of the façade, richly textured by the uneven wearing of the rusticated stucco and the fading of the wall graphic, create an absorbing image filling the entirety of the picture.

Similar to these are photos in which the viewer assumes he is "just looking at the building," but on closer inspection finds that Stoller has used an angle

58. These four paragraphs are based on my interview with Ezra Stoller, Nov. 9, 1988.

"Menard House," by Ezra Stoller, 1965. Gelatin silver photograph. *Courtesy the Museum of Fine Arts, Houston.*

for his photo, though in such a natural way that one doesn't notice. Examples of this technique are "The Williams-Tucker House. Front (east) elevation" (p. 26); "The George Sealy House. South elevation" (p. 179); and "University of Texas Medical School" (pp. 184–185). "The Lasker House. South and east" (pp. 176–177) is especially successful.

Stoller is equally adept at capturing the architectural character and relationships in a row of houses. He does this with a straight-on shot in "Vernacular Greek houses designed by anonymous builders on Avenue I" (pp. 52–53). He does it with an angle shot in the photo of a row of houses entitled "Extreme left, Sonnenthiel House, 1887" (pp. 158–159). This is a glorious photo, not only because of the magnificence of the subject, but because he captures the space, organization, and ambiance of the entire row of houses and their front yards, fences, pedestrian walking area, and row of live oaks.

Equally important in showing spatial relationships is Stoller's photo entitled "The Reymershoffer House, 1886–1887" (pp. 206–207), in which he captures the porch of one house, the street in front, and, across the street, two fine Victorian houses on corner lots.

Then there are some photos where Stoller shifts completely from the straight-on approach and captures the particular beauty of an individual structure through the composition of the picture. Such a one is that of the Darragh House. First, we see a competent straight-on shot by Stoller in "Darragh Residence. East elevation" (p. 151). The same structure becomes an evocative, seductive composition capturing romantic Galveston in "Darragh Residence. Northeast corner" (p. 154 and front cover).

In "The Gresham House. East, and partial view of north elevation" (p. 175), Stoller at first appears to be trying a bit too hard to be "artistic," but in fact captures successfully the intimate proximity of smaller, simpler structures and ornate mansions which at times, as here, create a single architectural massing.

At times, the work of only one of the photographers is shown for a particular structure. This is true of the Galveston News Building, with photos solely by Stoller (pp. 133, 134, and 135). Of special interest in this regard is the Galveston Customs House, of which Stoller presents a straight-on façade photo (pp. 40–41) and then an angled photo enlivened by three figures conversing in the left foreground, a photo somewhat in the Cartier-Bresson school (p. 42).

Conversely, Cartier-Bresson's initial photo of the overall structure of the J. C. Trube House is as strong architecturally as any of Stoller's (p. 180) and is followed by another Cartier-Bresson photo presenting an interesting angle of the complex roof and dormer design (p. 181).

On the whole, however, the two men's photographs of the same structures provide a counterpoint between their respective approaches. This greatly strengthens and enriches the presentation of each structure. Thank heavens the photos of each were not separated into two distinct sections of the book, as was once considered!

Most delightful in this counterpoint are the photos of Sacred Heart Church and the Lucas Apartments. In the former, Stoller provides a strong photo of the entire façade (p. 198), followed by Cartier-Bresson's magnificent photo of the double portals with a standing worshipper (pp. 200–201).

Stoller provides an excellent full façade photo shot at an appropriate angle in "Lucas Apartments, 1901" (p. 210). Cartier-Bresson's photo of the same structure (p. 211) is a magnificent straight-on shot of a portion of the façade, made intricate with playing shadows and the pattern of a barren tree.

Also wonderful in their counterpoint are the photos of the Sweeney-Roys-ton House (pp. 202–203), Heidenheimer Castle (pp. 140–143), Willis-Moody House (pp. 194–195), and Gresham House (pp. 170–172). In each case, Stoller presents the overall structure and Cartier-Bresson presents a special feature.

Given the wonderful counterpoint between the photos of Stoller and Carti-er-Bresson throughout the book, it is remarkable that each shot his photos without having seen the photos of the other.[59]

No commentary on the photographs in the book would be complete with-out special note of the fine historic photographs included from the archives of the Rosenberg Library in Galveston. These are essential in depicting major landmarks, such as the Beach Hotel (pp. 128–131) and Ursuline Academy (pp. 190–191), which were lost prior to Cartier-Bresson's and Stoller's visits. They are also marvelous in showing landmarks prior to extensive renovations, such as the Congregation B'nai Israel Synagogue (pp. 82–83).

In addition, the book includes excellent contemporary pen-and-ink draw-ings of several of the major structures. It would have been helpful if the artist, Robert Kendrick of Houston, had been credited in some way, and it would have been appropriate to acknowledge the Rosenberg Library as the source of the historic photos.

The text by Howard is a highly readable narration of the history and ar-chitectural character of the structures. It reflects massive amounts of research by Howard and others at the Rosenberg Library and elsewhere, and is a solid companion to the photographs, which are the dominant feature of the book.

## Publishing the Book

As early as August 1962, soon after Cartier-Bresson's visit, Howard began ap-proaching possible publishers for the proposed book. He contacted at least ten different publishing houses, with a variety of responses. By May 1963, Howard was proposing a joint publication/distribution by the University of Texas Press and Yale University Press, while the former was pressing hard to be the sole pub-lisher and distributor, albeit subject to seeing a completed manuscript.[60]

In November, Howard submitted an initial draft of the text to Yale, who found it insufficiently scholarly.[61] Howard then submitted it to Macmillan,

---

59. Ibid.

60. Howard Barnstone to Chester Kerr, Director, Yale University Press, May 28, 1963; and Frank H. Wardlaw, Director, University of Texas Press, to H. Barnstone, Nov. 1, 1963, both cour-tesy the Museum Archives.

61. Chester Kerr, Director, Yale University Press, to Howard Barnstone, Nov. 20, 1963, ibid.

who expressed interest.[62] During this time the University of Texas Press continued to express strong interest and asked several times to see the draft manuscript.[63] A slightly later letter confirms, however, that Howard and James Sweeney had concluded that they preferred a nonuniversity press.[64]

In June 1964, Macmillan and the museum signed a publishing contract for the book.[65] All through that fall and the following spring, the editing of the text, photographs, and illustrations continued, with Howard objecting in vain to "wholesale cutting" of particular quotes and of the original Nicholas Clayton drawings.[66] By summer they were negotiating the design of the dust jacket and going to press.[67] By November 1965, they were completing the last-minute addition of an index.[68] Macmillan promised a few specially bound copies for a November 29 preview, books available for Galveston and Houston autograph parties in December, and an official publication date of January 1966.[69]

## Howard Goes Public

More than three years before publication of the book, Howard had already begun a campaign to publicize the project and draw the public's attention to Galveston's unique architecture. Within a few weeks of the museum's announcement of the project in June 1962, Howard was being interviewed by the Galveston *Daily News.* The resulting article described the book as a study of the architecture of Galveston, noted the major participants, and even announced expected publication of the book by Christmas 1962.[70]

By October, *American Heritage* attempted to use Cartier-Bresson's photos for an article on Galveston.[71] In February 1963, Howard gave a speech to architectural students at the University of Texas. The talk, entitled "Galveston: A Last

62. Howard Barnstone to Cecil Scott, Executive Editor, Macmillan Company, Dec. 5, 1963; Cecil Scott, to Howard Barnstone, Jan. 3, 1964; and Howard Barnstone to Cecil Scott, Jan. 9, 1964, ibid.

63. Frank H. Wardlaw, Director, University of Texas Press, to Howard Barnstone, Nov. 1, Nov. 26, 1963, and Jan. 13, 1964, ibid.

64. Howard Barnstone to Henri Cartier-Bresson, Feb. 6, 1964, ibid.

65. Agreement dated June 16, 1964, between the Museum of Fine Arts, Houston, and the Macmillan Company, ibid.

66. Howard Barnstone to James Sweeney, Apr. 30, 1965, ibid.

67. Howard Barnstone to James Sweeney, Aug. 16, 1965, ibid.

68. Cecil Scott to Howard Barnstone, Nov. 3, 1965, ibid.

69. Ibid.

70. Galveston *Daily News,* July 22, 1962.

71. H. Barnstone to Oliver Jensen, Editor, *American Heritage,* Sept. 6, 1962; Joan Paterson Mills, Associate Editor, *American Heritage,* to H. Barnstone, Oct. 5, 1962, both courtesy the Museum Archives.

Look," was illustrated with numerous slides of Galveston buildings and was covered by the Galveston *Daily News*.[72]

In April 1963, the same paper reported that Howard's tentative title for the book was *Galveston: A Last Glance*. This drew an irate editorial from the Galveston *Tribune*, which asserted that Galveston's best days were yet to come and that anyone "will be ill-advised indeed to 'take a last glance' at Galveston."[73]

In July, an exhibit at the Rosenberg Library of Stoller's photos for the book with the more upbeat title of "The Great Heritage of Galveston" drew good press coverage in Galveston.[74]

In December 1964, Howard was again in the news, warning that Galveston was in danger of losing much of its historic architecture, with many historic buildings already torn down to make room for newer structures. By now the title, *The Galveston That Was*, was firmly fixed, with publication expected in fall 1965.[75]

"Isle Book Nearly Ready," headlined a September 1965 article in the *Daily News* quoting Howard extensively.[76] As guest speaker at the Galveston Rotary Club that November, Howard discussed the book and urged preservation of Galveston's old buildings by creation of a "great university." The university would both breathe new life into hundreds of historic structures in the Old Quarter and create a winter economy for Galveston to balance the city's summer resort business. Howard lamented the loss of many historic buildings in Galveston to make room for newer structures, even as the book was being prepared.[77]

## Publication

With release of the book imminent, a gala opening was held at the Museum of Fine Arts on November 30 to preview the photographs of Cartier-Bresson and Stoller and to view copies of the book itself, tightly sealed in a glass case. As the Houston *Post* reported, "Houston's social elite flocked in great numbers" to the preview.[78] The Houston *Chronicle*'s society editor noted that "vast

---

72. H. Barnstone to Thomas Daly, President, Student A.I.A., School of Architecture, University of Texas, Austin, Feb. 8, 1963, in Barnstone files, Archives, Houston Public Library; *Daily Texan* (Austin), Mar. 3, 1963; Galveston *Daily News*, undated.

73. Galveston *Tribune*, Apr. 23, 1963.

74. Galveston *Daily News*, July 21, 1963.

75. Ibid., Dec. 22, 1964.

76. Ibid., Sept. 11, 1965.

77. Ibid., Nov. 4, 1965; Galveston *Gazette*, Nov. 18, 1965.

78. Houston *Post*, Dec. 1, Dec. 2, 1965.

numbers of party-goers" had included the preview in their evening and listed prominent Galvestonians in attendance.[79]

The first autograph party for the book was held on December 19 at Trinity Church in Galveston and was a solid success, with over three hundred persons attending and all available books sold out. Howard used the occasion to press again the idea of creating a university in Galveston both to utilize the historic buildings and to strengthen the city's economy.[80]

## Reception of the Book

Critical reaction to the book was virtually all favorable. The Houston *Chronicle* called the photographs "distinguished indeed" and the text "a pleasant account" with "a fairly painless discussion" of the architecture.[81] The Houston *Post* loved the book, calling it "rare and different," and adding, "It is exceptionally beautiful. But it is also intelligent, literate, perceptive and informative."[82] The Dallas *Morning News* called it "an amazing book, certainly one of the most welcome and most solid pieces of Texana in this century."[83]

In March came a review in the New York *Times*, which called the book "handsome" and the photographs "distinguished."[84] The review focused not on the book, however, but on summarizing the book's message: the rise and fall of Galveston, the exuberant architecture and its current destruction. The *Times* failed to indicate whether the three photos featured were by Cartier-Bresson or Stoller. Additional reviews came from major Texas cities and as far away as Charlotte, North Carolina, and Wilmington, Delaware.[85] The most provocative review, and Howard's favorite, was in the Dallas *Times Herald*.[86] The reviewer wrote that Howard expressed the reviewer's own feeling, that "Galveston is a city which died in 1900. What remains in my memory is a sort of Texas Camelot, entirely more enchanting than any real city because it is a place of the mind where imperfection is repaired by imagination."

He found that Howard, Cartier-Bresson, and Stoller "have discovered a city which does not exist, if it ever did exist; a place of the past whose real history

79. Houston *Chronicle*, Dec. 1, 1965.

80. Galveston *Daily News*, Dec. 18, Dec. 20, 1965.

81. Houston *Chronicle*, Dec. 12, 1965.

82. Houston *Post*, Dec. 19, 1965.

83. Dallas *Morning News*, Dec. 26, 1965.

84. New York *Times*, Mar. 6, 1966.

85. Wichita Falls *Times*, Jan. 30, 1966; Beaumont *Journal*, Feb. 25, 1966; San Antonio *Light*, Oct. 22, 1967; Charlotte (N.C.) *Observer*, Feb. 6, 1966; *Morning News* (Wilmington, Del.), Oct. 19, 1966.

86. Dallas *Times Herald*, Jan. 2, 1966.

was its spirit." The review sensed the "brooding or fanciful" feeling of the book—fanciful in that the reader was shown a Victorian city arrested in time, though not the day-to-day, mundane life of that time. Rather, the book evoked the spirit of the city from the romanticism of its architecture, luring the reader to imagine what life could have been in this city of architectural masterpieces.

The brooding, too, is there in the book, in the nagging question, never adequately answered, of why this grandeur failed to flourish beyond its Victorian heyday. One dreams that this graceful, romantic Camelot of a city might have prevailed, both retaining this spirit and expanding in size and economic power. This is a seductive dream, but, in my opinion, ultimately self-destructive. Dynamic growth and romantic Victorian architecture in such a confined land area were incompatible in the first half of the 1900s. In reality, Galveston's failed economic expansion, as in scores of other cities, was the very reason that the marvelous structures of its past success were allowed to survive. The issue of historic preservation was best raised, appropriately enough, in the extensive review of the book in *Historic Preservation* magazine, published by the National Trust for Historic Preservation.[87] The author, James C. Massey of the Historic American Buildings Survey, warmly praised the "thoroughly professional" quality of the text and photography, and concluded that it "sets an enviable model for other cities to follow in documenting their own historic heritage." More important, he suggested that the book "will do much to boost the significance of Galveston's historic landmarks and to create the favorable public attitudes and interest essential for a successful community preservation program."[88]

Clearly, *The Galveston That Was* had succeeded in recording and documenting Galveston's wealth of nineteenth-century landmarks. Would it also, as Massey hoped, create the attitudes and interest essential to a community-wide program to preserve these landmarks?

## The Book's Reception in Galveston

Generally, Galveston gave the book a favorable reception, as evidenced by the successful book signing party, the brisk sales of the book, local exhibits of the photographs, and continuing invitations to Howard for speaking engagements. There were, however, three undercurrents of dissatisfaction.

The first of these was simply that some of the photos by Cartier-Bresson gave the impression of run-down, even derelict, people and houses. These

87. *Historic Preservation,* XVIII (Jan./Feb., 1966), 38, 41.
88. Ibid., 39.

were strong photos, and their images tended to influence a reader's reaction to the book as a whole, even though they represented perhaps six or seven photos out of a hundred in the book. Some leading Galvestonians were offended that the community they loved had been presented, in their opinion, in an unfavorable light.[89]

The second dissatisfaction was that Howard, in his introduction to the book, blamed Galveston's leaders at the turn of the century for the city's losing commercial momentum to Houston. Howard explained that Galveston's leaders simply did not want the city to grow: "It has been stated that at the turn of the century, a combine of Galveston's leaders consciously bottled up available real estate and financing and arbitrarily decided to remain the big frogs in the little pond. After all, life would remain sweeter and less arduous as they basked in their honeysuckle-scented gardens."[90] Howard concluded, with respect to the new oil industry, that "It was a conscious freeze-out. Houston wooed and Houston won. Galveston, the logical suitor, did not even bother to pay court."[91] The charge, as Howard admitted, "cannot be documented and is unsupportable at the present time."[92] This is true, and an objective answer to the question of why Houston rather than Galveston became the major city of the twentieth century would require much more extensive research. Yet the undocumented charge was made, even though it contributed virtually nothing to the book's purpose of documenting Galveston's historic architecture. And the leading Galveston families, who had taken Howard into their homes as a friend, were hurt and angry.[93]

The third reaction really had nothing to do with the book, insofar as its purpose continued to be documenting historic structures. Howard, however, loved the architecture and, while the book might document structures soon to be destroyed, he waged his campaign of press conferences and speaking engagements, suggesting a great university and other ways to breathe economic life into the old structures. The immediate reaction to this, as seen in the Galveston press, was gentle, but distinctly uninterested. Thus, the Galveston *News* praised Howard as "a brilliant architect and an artist," but contrasted the ideas of an artist with those of "a realistic businessman and city builder." The *News* felt that Galveston had previously missed the boat of economic

---

89. Galveston *Gazette*, Feb. 3, 1966; Mildred Robertson to Peter Brink, Sept. 28, 1988, interview; Edward R. Thompson Jr. to Peter Brink, Oct. 22, 1988, interview; E. Burke Evans to Peter Brink, Oct. 5, 1988, interview.

90. Barnstone, *The Galveston That Was*, 14.

91. Ibid.

92. Ibid.

93. Edward R. Thompson Jr. to Peter Brink, Oct. 2, 1988.

greatness and now had to be sure it did not miss the boat again. The paper did not see how saving historic structures could be relevant to the city's future.[94]

### The Book's More Lasting Impact

The book and Howard's preservation ideas were, nevertheless, filtering through the Galveston community. Slowly, things began to turn around. As Tim Thompson, an early Galveston preservationist, recalls:

> The book taught that the trend was downwards and nothing was around to restrain the inevitable demolitions. Barnstone did not SAY that, but Galvestonians knew it was true. Something caused them to wake up and listen to those who were talking preservation, and Barnstone should get a prize for being, if not all of it, the biggest piece of the wake-up call.[95]

One group responding to the call, in addition to the Historical Foundation, was the Junior League of Galveston. The League had Howard as the speaker at their annual luncheon in May 1966, and featured photos from the book in an exhibit in November.[96] Subsequently, in 1968, the League singlehandedly saved the Nicholas Clayton-designed Trueheart-Adriance Building (1882) from destruction and focused attention on the importance of saving the historic Strand commercial area.

In a separate effort in 1968, individual preservationists saved the West Section of the 1859 Hendley Row from demolition, although the windows had already been torn out, and donated it to the Galveston Historical Foundation. And in 1969 the Texas Historical Commission successfully nominated the Strand for listing on the National Register of Historic Places.

Meanwhile, in 1967, the Galveston Historical Foundation, with backing from the Moody Foundation, had initiated an extensive architectural survey throughout Galveston. In early 1970, it succeeded in having forty blocks of the residential East End designated an historic district, with city veto power over demolitions and exterior changes to structures. In addition, the Harris and Eliza Kempner Fund initiated a program of low-interest loans for rehabilitation of historic houses in the East End.

Most indicative that the wake-up call had been heard, however, was the 1969–1974 struggle to save and restore Ashton Villa, the Italianate residence of J. M. Brown built in 1859. The landmark's owners had appraisals showing the land worth more without the structure than with it, and threatened demolition

94. Galveston *Daily News,* Jan. 31, 1966.

95. Edward R. Thompson Jr. to Peter Brink, Oct. 4, 1988.

96. Galveston *Daily News,* May 22, 1966; Mrs. John Eckel to James Sweeney, Sept. 24, 1966.

unless their price was met. And then, in an unprecedented and perhaps illegal action, the Galveston City Council passed an ordinance forbidding demolition of Ashton Villa and four other antebellum structures. Agreement on a compromise price was soon reached and, after more years of work to restore and furnish the landmark, it was opened to the public as a museum.

In 1972, representatives of the Moody Foundation, the Kempner Fund, the Cultural Arts Council, and the Galveston Historical Foundation initiated the Strand Revolving Fund. The fund's purpose was to enable the Galveston Historical Foundation to purchase Strand buildings, place protective deed restrictions on them, and attract investors to buy and rehabilitate them for active uses.

The following year, these same representatives recruited me, a young lawyer and neophyte preservationist, to organize the Strand effort and be executive director of the Galveston Historical Foundation. One of the first things they showed me was *The Galveston That Was*. I can recall still how much I liked the book and the immediate legitimacy it gave, even before I had seen Galveston, to the urgency and importance of saving the city's historic structures.

It is true that the book is a documentation of the structures. Only years later did I realize that it was also a requiem, a final recording before their inevitable destruction. In my fervor for preservation I had not fully absorbed this, though it was stated in the foreword and more eloquently in the poem by e. e. cummings at the close of the book:

christ but they're few

all (beyond win
or lose) good true
beautiful things

god how he sings

the robin (who
'll be silent in
a moon or two)[97]

Perhaps this part of the book's meaning was obscured by the beauty of the structures brought together and presented so intensely in the book: one saw them and immediately assumed that there had to be some way to save them.

---

97. Barnstone, *The Galveston That Was*, 215, quoting e.e. cummings, *73 Poems* (New York: Harcourt, Brace and World, Inc., 1963).

Then, too, the forces in the community had changed enough by the 1970s that one's natural reaction to save them could be a call to action with a realistic chance of success.

Even after realizing the book's fatalistic view, I normally ignored it because Howard himself was usually nearby with his unflagging enthusiasm and support for preserving Galveston's historic structures. Howard's personal efforts to this end were redoubled once he found like-minded allies with whom to work.

Since the early 1970s much has been accomplished by the Galveston community with support from Houston and around the state. Some forty historic buildings in the Strand area have had their exteriors restored and their interiors rehabilitated for active uses; the area is now protected by the City as a local historic district; and an estimated two million people annually frequent the seventy or so shops, restaurants, and galleries. In the 1878 First National Bank Building is the Arts Center; in the old Santa Fe Building is a major railroad museum; and work has begun to resume commuter train service with Houston. On the adjacent waterfront is the Pier 19 shrimp boat basin; the *Colonel* paddlewheeler; and the restored 1877 barque *Elissa*, recognized as one of the finest restored square-riggers in the world, and operating as both a maritime museum and sailing vessel. South of the Strand is the Grand 1894 Opera House, now an elegant performing arts center, and the County Historical Museum in the 1906 Moody Bank Building. These areas are again linked to the beachfront with a fixed-rail trolley system, and two major events, Dickens on the Strand and Mardi Gras, entertain some five hundred thousand persons annually.

The 1891 Ashbel Smith Building ("Old Red") at the University of Texas Medical School, once threatened with demolition, has been restored and is again a central part of the school. The East End is largely intact as one of the loveliest Victorian residential areas in the nation. And the famous 1889 Walter Gresham House ("Bishop's Palace") is open to the public as a house museum.

In the central part of the city, Ashton Villa still graces Broadway as a fine house museum, the 1886–1890 Sealy Home ("Open Gates") is being restored by the University of Texas Medical Branch, the 1900 Texas Heroes Monument still stands, and nearby the 1894 Willis-Moody Mansion is being restored. The fifteen-block Silk Stocking District has been established, and a bit further west the 1876 Garten Verein Dancing Pavilion is available for rentals and the 1847 Powhatten House is maintained by the Galveston Garden Club. Nearby, the 1839 Samuel May Williams Home is restored and open as an interpretive center.

What is now happening in Galveston is a synthesis of the visions of the architect-artist, city builder, and businessman, whom the Galveston *Daily*

*News,* upon the book's publication, had assumed were incapable of agreement. The crucial elements in this synthesis include moral and financial support from the old Galveston and Houston families, developers like George and Cynthia Mitchell committed to quality restoration, dedicated and extensive volunteer leadership, high-quality staff, and public support. At present, the economic linchpin of much of this work is the discovery of Historic Galveston by hundreds of thousands of visitors. For the long term, this must be balanced more strongly by other job opportunities for Galveston residents, as well as commuter service to Houston, so that the economic base to restore and maintain the nearly 2,000 structures identified is strengthened.

Despite this major turnaround in Galveston's commitment to preserve its historic structures and ambiance, it is still painful to look through *The Galveston That Was* and see what has been lost. Five of the loveliest structures, including the Beach Hotel, had been lost in the 1800s or well prior to the book. Five more major buildings were lost from 1962 to 1965, while the book was actually in process. Among these, the loss of the 1891–1894 Ursuline Academy (pp. 190–191) is enough to drive a preservationist crazy, not to mention the 1858 Henry's Bookstore (pp. 69–72) and the 1858 Salvation Army Building (pp. 64 and 66). No wonder Howard, seeing these masterpieces come down around him, despaired at times! And, soon after the publication of the book, the 1878 Voelcker House (pp. 99–101) and the 1889 Lasker House (pp. 176–177) were demolished, and the façade of the 1883–1884 Galveston News Building (pp. 133–136) covered over.

Yet one must force oneself to remember that a full twenty-nine of the structures featured in the book stand intact today. None has been demolished since 1970. Two important ones, however, have been largely destroyed by fire, the 1855 Heidenheimer Castle (pp. 139–143) and the 1871–1874 Washington Hotel (pp. 44–46), though the latter has been miraculously restored and reconstructed by George and Cynthia Mitchell. And one must add that two of those still standing are vacant and vulnerable: the 1838 Menard House (pp. 21–23), currently owned by speculators, and the 1886 Darragh House (front cover and pp. 150–154), saved from destruction and currently for sale for restoration by the Residential Revolving Fund of the Galveston Historical Foundation.

None of this would have happened without *The Galveston That Was.* Everyone who cares about and enjoys historic Galveston today is indebted to Howard Barnstone and his allies Jean de Menil and James Johnson Sweeney. While the book was insufficient in itself to create this historical renaissance in Galveston, its elegant presentation of the beauty of these historic structures was a necessary and crucial part of awakening Galveston, as well as Houston,

to the Victorian treasure that stands on this barrier island. Presented as a requiem, the book has served instead as the primary inspiration for saving the historic architecture that it documented.

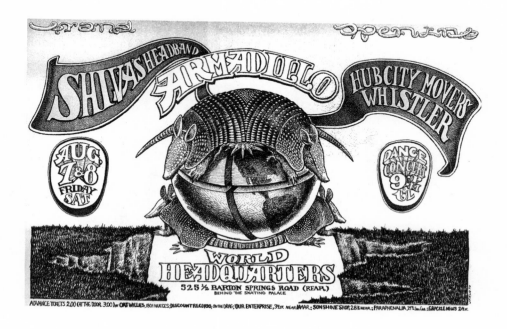

"Grand Opening," at the Armadillo World Headquarters, by Jim Franklin, 1970. Four-color Lithograph, 11 x 17 inches.

# ARMADILLOS, PECCADILLOS, AND THE MAVERICK POSTERISTS OF AUSTIN, TEXAS

ë&

## NELS JACOBSON

ustin poster artists have been causing a ruckus around Central
Texas since the 1960s, graphically documenting the spirit of their
age with a powerful and unique vision. Influenced initially by the
poster renaissance of 1960s San Francisco, which was itself a rich
mixture of art nouveau and psychedelic elements, the posterists of Austin
evolved a colorful visual language all their own during the 1970s. In the late
1970s and early 1980s, in accordance with the changing cultural arena, and as
individual artists matured according to their own personal gifts and predispo-
sitions, stylistic homogeneity began to dissolve. Thus, while retaining many of
the distinctive qualities characteristic of the 1970s Austin style, posters created
during the past decade display an ever-widening variety of innovative styles.
Due in large part to the extraordinary vitality of its music community and de-
spite the loss of its most generous early poster patrons, Austin nonetheless re-
mains today a healthy and receptive context for poster art. Building on a rich
tradition of imagination and innovation, and with the healthy sense of humor
that is their cultural heritage, Austin poster artists today continue to reflect
and reorder the world according to their own bold vision.

For years poster art in Austin has been primarily, though not exclusively,
linked to live music. In fact, Austin's modern poster history begins in 1967
with the opening of the Vulcan Gas Company, Texas's first counterculture
music hall. Inspired by the psychedelic revolution on the West Coast, the Vul-
can became the crucible within which the underground arts scene coalesced.
In early 1970, as financial woes closed the Vulcan, a new era of cultural inter-
action was commencing just across town. The Armadillo World Headquarters,
irrefutably Austin's single most significant patron of poster art, opened only
months after the demise of the Vulcan. It was during the ten-year life of the

Armadillo that Austin's most influential posterists surfaced, and it was out of the 'Dillo that Austin's purest homegrown style emerged. It has been said that Austin has more live music venues per capita than any other city on earth, and whether this is true or not, it is important to stress that posters and handbills were created for an innumerable array of open-air gatherings, night clubs, and concert halls other than the Vulcan and the Armadillo. Castle Creek, Antone's, the Soap Creek Saloon, the Continental Club, the Austin Opry/Opera House, Raul's, Club Foot, Liberty Lunch, and scores of others have all been responsible for generating many of Austin's finest posters. Yet the Vulcan Gas Company and especially the Armadillo World Headquarters are of unsurpassed importance.

The Vulcan Gas Company was important because it was first, because its posters were colorful, large, and often breathtaking, and because the club and its artists took chances without taking themselves too seriously. Though considerably larger than their San Francisco counterparts, Vulcan posters were often rendered in the psychedelic style pioneered by Bay Area artists like Wes Wilson, Rick Griffin, Alton Kelley, Stanley Mouse, and Victor Moscoso. Typically, each of these 23 x 29-inch posters advertised two or three shows in several bright colors and deliberately illegible lettering. A stunning overall effect was more important than the specific image used on any particular poster. Among the artists designing posters for the Vulcan were Gilbert Shelton; Tony Bell; Jim Franklin, who would become Austin's single most influential posterist; John Shelton; and collagist Jim Harter. Most of the posters were offset printed, though Franklin briefly experimented with a homemade silkscreen process somewhere between his bathroom and his backyard.

Gilbert Shelton is generally regarded as Austin's first modern poster artist because of his extensive work with the Vulcan Gas Company, including the logo and the grand opening poster. Nevertheless, he is best known today as creator of the Fabulous Furry Freak Brothers. Having moved from Houston to attend the University of Texas in the early 1960s, Shelton joined Lieuen Adkins and Tony Bell at the *Texas Ranger*, UT's student humor magazine. The *Ranger* was a natural incubator for the talents of these pioneering posterists, because the one constant that characterizes Austin poster art is a playful irreverence, a lively sense of humor. With a flair for cartooning, and with the help of Adkins and Bell, Shelton created such unforgettable characters as the Freak Brothers and Wonder Wart Hog. After a brief stint in New York with Harvey Kurtzman of *Mad Magazine* fame, Shelton was lured from Austin to San Francisco in 1968 by Jack Jackson, who had himself moved to the Coast two years earlier. Shelton had visions of making his fortune in poster design as he headed west in a multicolored 1956 Plymouth, the trunk overflowing with copies of his prototypical

comic book *Feds and Heads*. "I came out for a little vacation. Austin is really hot in the summer—and I just ended up staying," explains Shelton. "There were a lot of Texans here at the time."[1] Animated by Robert Crumb's *Zap Comics*, and no doubt discouraged by the rigorous competition in the poster field, Shelton opted to pursue a future in underground cartooning. In 1969 he and Jack Jackson, Fred Todd, and Dave Moriarty founded the phenomenally successful Rip Off Press. Shelton now spends most of his time in Paris but still makes occasional visits to Austin.

While Shelton's Freak Brothers have garnered worldwide attention, the first underground comic was actually authored by Jaxon, nee Jack Jackson. In 1964, with the help of friends, a keg of beer, and a friendly printer in the basement of the Texas State Capitol, Jackson put together one thousand copies of a comic entitled *God Nose*. A takeoff on the Austin *Iconoclast* strip "The adventures of J(esus)" by Frank Stack, a.k.a. Foolbert Sturgeon, the comic sold briskly at 50¢ a copy. Not known primarily as a poster artist himself, Jackson nonetheless had a profound impact on the poster work generated in San Francisco. With a degree in accounting and as the art director for Chet Helms's Family Dog entertainment group, which put on San Francisco's first hippie rock dances and ran the Avalon Ballroom, he is credited with developing the distribution system that brought San Francisco poster art worldwide attention.[2] Eventually tiring of the West Coast scene, Jackson returned to Austin to center his artwork on Texas history and the American Indian. Two of his most critically acclaimed books are *Comanche Moon*, a biography of Quanah Parker dedicated to the creators of the *Texas History Movies* comic book,[3] and *Los Tejanos*, a biography of Juan Seguín. Currently, he is working on a retrospective strip commemorating the twentieth anniversary of the Rip Off Press.

Also contributing to Austin's seminal poster progression was the collagist Jim Harter. After his first exposure to the psychedelic art movement during a trip to San Francisco in 1967, the Lubbock-born Harter returned to Texas and played an active role in poster production for the Vulcan and later the Armadillo. From 1969 to 1973 he lived in both Austin and San Antonio; it was in

---

1. Gilbert Shelton, *The Best of the Rip Off Press, Volume Four: More Fabulous Furry Freak Brothers* (San Francisco: Rip Off Press, 1980), 3. Other movers and shakers from Texas living in San Francisco during the late 1960s included Janis Joplin, Chet Helms, Travis Rivers, Steve Miller, and Johnny Winter.

2. Paul D. Grushkin, *The Art of Rock: Posters from Presley to Punk* (New York: Abbeville Press, 1987), 80–81.

3. Jack Jackson, *Comanche Moon* (San Francisco: Rip Off Press, 1979), 2. Several of Austin's poster artists cite the *Texas History Movies* comic book as a significant influence.

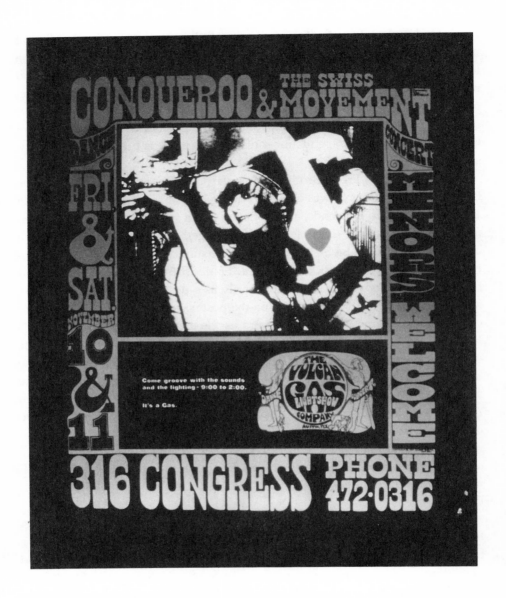

"Conqueroo and Swiss Movement," at the Vulcan Gas Company, by Gilbert Shelton and Tony Bell, 1967. 23 x 29 inches. Two-color lithograph (split fountain).

1973 that he published his underground portfolio *Die Gretchen*. In 1974 Harter moved to San Francisco and became friends with the collagists Wilfried Satty and David Singer. Since 1976 he has published several books featuring his

surreal collages of nineteenth-century engravings; and in conjunction with Dover Publications, he has assembled engraving source books for artists and designers. Harter journeyed to India and throughout Europe and finally settled in New York until 1985, publishing in that year *Journeys in the Mythic Sea,* a collection of visionary collages. More recently, *Images of Light and Darkness: A Surrealist Apocalypse* was published concomitantly with his exhibition at the Nicholas Roerich Museum in New York. Inspired by the work of both Satty and Max Ernst, Harter continues to create potent contemporary pieces out of Victorian engravings, often photo-enlarging the initial picture to a size at which he can do fine detail work. With a rapidograph pen and small brushes he then integrates the images and makes any necessary changes in the illustrations themselves, eventually reducing the finished piece to an appropriate size, usually 11 x 15 inches.

Longtime Shelton collaborator Tony Bell first moved to Austin in 1959 to attend UT. After a stint with the Peace Corps in Nigeria he was instrumental in opening the Vulcan Gas Company. Bell created several of the early Vulcan posters and worked closely with printer Johnny Mercer, often experimenting with split-fountain techniques. Says Mercer, "We kinda flew by the seat of our britches." Mercer, who printed a majority of the large-format Vulcan posters on his 29-inch Harris single-color press, was less than amused to find the posters so popular that collectors would go through his trash to find rejects. A normal run was a hundred posters. Typically an artist would furnish him with black and white board art and Mercer would shoot a negative of it and then a reverse negative for the second color run. Bell maintains that rather than trying to create art, the early posterists were concerned with achieving maximum visibility—just helping the Vulcan to survive as a venue. For a progressive club like the Vulcan, simply breaking even was a challenge; it still is. Mercer remembers occasionally being paid for his printing services with coffee cans full of coins and wadded-up bills.

Though patrons and posterists alike lamented the 1970 closing of the Vulcan Gas Company, from out of the vacuum it left arose the Armadillo World Headquarters, arguably the most influential patron of poster art this side of the Haight-Ashbury. The Armadillo occupies a preeminent place in the hierarchy of Austin entertainment institutions because, with its eclectic booking policy and hippie-idealist ideology, it spawned a substantial musical and cultural movement, the most clearly defined manifestation of which was the cosmic cowboy phenomenon. It was also important because in illustrating this movement, the Armadillo's talented pool of artists created an iconography both powerful and singularly appropriate. The 'Dillo became the hub around which Austin's post-Vulcan alternative arts scene revolved. Poster artist Danny Garrett maintains

that the uniquely open and creative atmosphere that prevailed in Austin during the 1970s was built on a threefold foundation. The Armadillo provided the "cultural epicenter"; the head shop Oat Willie's provided the accoutrements of the movement; and the art collectives Directions Company and Sheauxnough Studios functioned as the imaging apparatus.

The country rock or cosmic cowboy era that developed out of the interaction of flower children, rednecks, and Armadillo performers heralded a triumph over deep-seated prejudices and the destruction of previously inviolable aural and visual boundaries. Most importantly however, in the Austin poster panorama, the 'Dillo afforded artists an inspirational and nurturing environment, a supportive fraternity, and a mission. "It was like Camelot," says artist Micael Priest, "college, and family, and church all rolled up together." In the ten years that the Armadillo World Headquarters was open the "Armadillo All-star Art Squad" boasted the talents of Austin's most prolific and imaginative artists including Jim Franklin, Kerry Awn, Rick Turner, Danny Garrett, Micael Priest, Ken Featherston, Guy Juke, Bill Narum, and Sam Yeates. Also contributing to the cornucopia of 'Dillo poster art were Jim Harter, John Shelton, Cliff Carter, Jimmy Downey, Coy Featherston, Jose Carlos Campos, John Rodgers, Clark Bradley, Michael Arth, Cindy Weberdorfer, Gary McElhaney, and Monica White, who also created the cover art for Willie Nelson's celebrated album *Red Headed Stranger*. These artists fashioned a mind-boggling body of poster art which provides an immutable and light-hearted chronicle of the trends and values that moved a generation. And at the forefront of this cultural tide was the irrepressible, iconoclastic painter-sage Jim Franklin. Asked recently to describe what he had found in 1970 upon moving to Texas from New York, UT's Leonard Ruben did not mince words:

There were no ideas here. At best it was decoration. There was a little bit of spark. Jim Franklin and a few people like that were doing unusual posters for the Armadillo World Headquarters. They were a little off-group in Austin that were really terrific designers. They didn't call themselves designers but they were. Street people doing brilliant work. There was a kind of Texas look that was refreshing and Austin was the center of it.[4]

After brief stints in San Francisco and New York, Texas-born Franklin was lured to Austin in the mid-1960s through a chance encounter in Galveston with some of the *Ranger* crowd, including Travis Rivers, Bob Simmons, and Ed Guinn of the band Conqueroo. Soon after his arrival in Austin, Franklin helped open the Vulcan; and he was also instrumental in the founding and naming of the Armadillo World Headquarters. He designed the grand opening poster and

4. n.a., *Design in Texas* (Houston: Graphic Design Press, 1986), 20.

was the 'Dillo's original art director. Most of the posters Franklin did for the Armadillo were less elaborate than his Vulcan work and often were rendered only in black and white. Their typography was eminently readable. They were usually pen-and-ink illustrations rife with crosshatching and comic touches, and frequently included one or more armadillos posed compliantly in some unorthodox situation. Franklin floated armadillos over highways, orbited them in space, squeezed them from toothpaste tubes; he drew them climbing out of pies, as giant pickup-squashing leviathans, as soldiers, and once as a visible burp. At one point Franklin proposed redesigning the Texas State Capitol in the shape of a giant armadillo. One of his most popular cartoons depicts a colossal, albeit nearsighted, armadillo attempting to mate with the passionless Capitol edifice. As to his preoccupation with armadillos and his responsibility for catapulting the creatures from obscurity to their current status as Texas's most cherished indigenous mammal, Franklin explains: "In '68 when I was doing posters for the Vulcan Gas Company, someone asked me to do a handbill for a love-in, and I happened to be thinking of armadillos at the time, so I drew one smoking a joint." He adds that he began drawing the armadillo because it had been ignored and it struck him as a perfect and natural symbol of Texas.[5] To his surprise, the public immediately embraced it. "It was not the first public piece that I did, but it sailed right away."[6] Not all of Franklin's illustrations contain armadillos, but his penchant for surrealist satire is inescapable, as in his 1971 Flying Burrito Brothers poster depicting Orville and Wilbur Wright launching an airplane with enormous enchiladas for wings. In 1974 he reopened Austin's Ritz Theater as a music venue and from this era has survived a series of charming Franklin posters utilizing the popular snack cracker motif.

Though painting and poster work demanded most of his time, Franklin established a robust reputation as an entertainer. In addition to acting as master of ceremonies at the Vulcan and the Armadillo, he was a regular member of several local bands. Whether performing or promoting the performances of others, over the last quarter century Franklin has created a vast assemblage of entertainment-related art. With the exception of a handful of brief absences—to muralize Leon Russell's swimming pool, tour Europe with bluesman Freddie King, or pursue solitude in Moab, Utah—Franklin has rejected the temptation to forsake Austin for a more lucrative locale. He has produced some of the finest commercially effective art of this epoch and through his wry wit and articulate eye he has shaped the way the world sees Texas and the

5. Jim Franklin to Bob Simmons, date unknown, 1972 (interview).

6. Jim Franklin, "JFKLN: Artistic Contribution to Austin, Texas," proposal for "The Yellow Rose of Texas" water tower project, 1986 (typescript, location unknown).

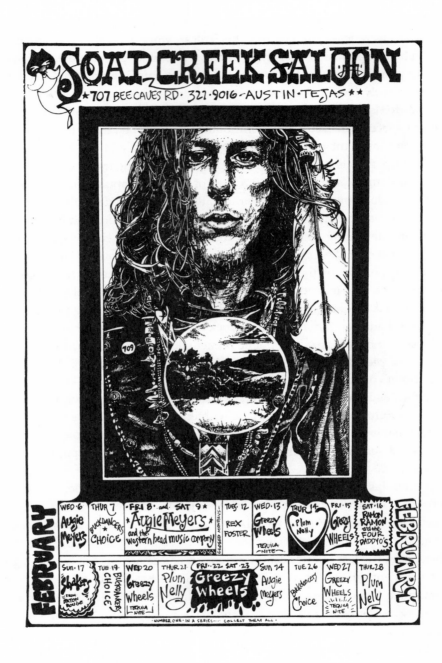

"The First Soap Creek Saloon Calendar," by Kerry Awn, 1974. One-color lithograph, 11 x 17 inches.

way Texans see themselves. It was Franklin who, with 'Dillo founder Eddie Wilson, not only dubbed Austin's most famous music hall with the cognomen of a local mammalian worm-eater, but first harnessed the energy of all those famous personalities conglomerated around the Armadillo World Headquarters and translated their vision into a palpable and enduring form. Today he continues to produce strikingly unique visual art including posters, murals, paintings, and the occasional sculpture. Several of his more recent posters, the screenprint commemorating the Dougherty Arts Center's Texas Poster Art exhibition among them,[7] are designed to be quartered and shuffled into a variety of configurations; this style he has christened "recombinant A R T."

Kerry Fitzgerald, a.k.a. Kerry Awn, initially moved to Austin in 1970 to find Jim Franklin, whose poster work he had seen and admired in Houston. Within a year he himself was creating posters for the Armadillo. It was while he was a political cartoonist for UT's *Daily Texan* newspaper, however, that the nom de guerre "Kerry Awn" first appeared as a manifestation of Awn's concern about how his parents might react to his occasionally radical cartoons. Aided by a background in the theater, Awn helped to found the consistently outrageous satirical group the Uranium Savages in the early 1970s; has been a featured performer with the Esther's Follies comedy troupe for several years; and has won enthusiastic acclaim as a standup comedian. In 1971, with fellow "Austintatious Artists" Rick Turner and Tom "Tommy Bee" Bauman, Awn journeyed to San Francisco to sell to Shelton's Rip Off Press an underground comic called *Neighborhead.* Unsuccessful in this attempt, they eventually renamed the book *Austintatious* and published it themselves, with help from Big Rikki the Guacamole Queen.

As a posterist Awn enjoys surrealistic juxtapositions and tends to a style that is more cartoonish than most of his colleagues. By dint of his work with the progressive country radio station KOKE he helped visually define the cosmic cowboy, roper-doper persona. Exceedingly prolific, Awn generated for the Soap Creek Saloon what is surely the longest-running series of calendar posters in Austin honky-tonk history. Surviving a change in ownership and three location shifts, Awn's calendars spanned more than a decade. His first calendar (features an illustration of bass player James Gurney from the band Big Brother and the Holding Company penned from a photo that had been featured on a 1967 Family Dog poster by Stanley Mouse. Initiated in February 1974, Awn's calendar series quickly gained a reputation for a certain lusty eccentricity and for the trademark style in which it was rendered, an idiom that

7. *A Decade and a Half of Texas Poster Art,* catalogue, Dougherty Arts Center (Center for American History, University of Texas, Austin); *Art Defense* (Feb. 1, 1985), cover.

Archie Green calls "absurdist comic strip art."[8] Responding once to the pejorative observation that his pieces were "too cartoony," Awn replied that he simply drew the world the way it looked to him.

Since trying to bluff his way into the Vulcan Gas Company with a ticket he had meticulously hand-counterfeited, Tom Bauman has been a consistently energetic participant in the Austin poster parade. Bauman first met Awn and Turner in art school in 1968. Over the years they developed a close collaborative relationship, out of which has sprung all manner of art, from comics to posters to the landmark Twenty-third Street Renaissance Market mural. On his own, Bauman has produced, for musicians, promoters, and merchants, a diverse variety of posters, many of which include somewhere in their design the cabalistic number 709. The exact significance of this integer is a closely guarded secret, but suffice it to say that among the brotherhood of Austin poster artists it is invoked only with the utmost solemnity and reverence.

Like many other Austin posterists, the third person in the Austintatious triad, Rick Turner, was an avid fan of Franklin's work. He did few posters for the Armadillo himself, however, because he found the prevalent style too time-consuming. An early devotee of the airbrush, Turner is, in Micael Priest's words, the consummate "Master of Sky and Clouds." He is responsible for the innovative "Burgers from Heaven" design for Darryl Rhoades and the Hahavishnu Orchestra: countless hamburgers floating in formation, like flying saucers, above the Texas State Capitol. This design proved so popular that not only was it used as a poster and an album cover, but Turner was later commissioned to reproduce it as a mural in the New York night club Max's Kansas City. An especially notable curiosity which Turner has left us is the colorful poster he produced for Austin's Inner Tube surf shop. (Austin is two hundred miles from the coast.) Possibly his most readily identifiable work is that done in the punk-collage style. As Turner explains it, "A guy started a club called New Atlantis. . . . The Violators played there and the Skunks. So I did this punk thing and got into a whole new phase of collages with old engravings mainly."[9] During his collage period Turner often collaborated with local artist Debra Ingram, a.k.a. Deb-X, and their collaborative posters and handbills were signed "Drastic." In 1981 Turner moved to New York City, where he still resides; Ingram now lives in San Francisco.

Returning home from Vietnam in 1970, Danny Garrett, like Kerry Awn, was first introduced to Franklin's art in Houston. In 1971 he moved to Austin, looked up Franklin almost immediately, and jumped headlong into the Austin

8. Archie Green, "Graphics #52: Kerry Awn's Soap Creek Saloon Calendars," *JEMF Quarterly,* XVI (Spring, 1980), 33.

9. *A Decade and a Half of Texas Poster Art,* 29.

poster melee, producing a number of exquisitely crafted posters for the Armadillo. Garrett also worked extensively with Castle Creek and the Austin Opry House. Some of his most memorable and sought-after work may be found in the series of posters he has created for Antone's, Austin's premier blues club. The intricate delicacy of his pen-and-ink style and his tendency to traditional or classically realistic illustration contrasts sharply with the comic or surreal tendencies found in many of the other Austin posterists. He is an intensely analytical artist with a gift for theory and an acute sensitivity to the interrelationships of form and language. Currently, in addition to working within the parameters of his trademark techniques, Garrett is striking out in bold and imaginative new directions. Lately he is fond of working with Prismacolor pencils and coquille paper; and he has on the table several projects ambitiously integrating emotive graphic art and global history.

In 1972 Micael Priest left his Fort Worth graphic production job at the behest of friends in Austin to help found Directions Company, Austin's first counterculture ad agency. Having worked with commercial illustrator Don Ivan Punchetz since high school, Priest brought to Austin's alternative community a sense of commercial sophistication and a gift for lifelike, action-packed caricature. A longtime fascination with "old school" sign painters and a knowledge gleaned from patient observation, old textbooks, and countless sign-painterly conversations has yielded Priest a formidable bag of graphic tricks and a marvelous facility for lettering and typography. Though color-blind, Priest is the author of a prodigious body of work in both black and white and color.

More than any other Austin artist, Priest has captured on posters and handbills the spirit of the cosmic cowboy era. With pieces for the New Riders of the Purple Sage; Kinky Friedman; the September 1972 Willie Nelson and Michael Murphey concert at the 'Dillo; the February, 1974, KFFT benefit concert; and the February 1973 Michael Murphey shows, for which he created an especially spectacular illustration of a longhaired mustang rider in space lassoing a comet, Priest has given us a marvelous reference point from which to view a colorful cultural phenomenon. "Michael [*sic*] Priest's wonderful graphics best extended the meaning of Professor Worrall's carousing cowboys (1874), Tad Dorgan's cake eating cowboys (1923) and Miguel Covarrubias's drugstore cowboy (1930)," says Archie Green. "The major artist associated with the Armadillo is Jim Franklin, but it was Priest's sardonic cowboys rather than Franklin's droll armadillos which gave a visual dimension to cosmic cowboy music."[10]

10. Archie Green, "Austin's Cosmic Cowboys: Words in Collision," in *"And Other Neighborly Names": Social Process and Cultural Image in Texas Folklore,* ed. Richard Bauman and Roger D. Abrahams (Austin: University of Texas Press, 1981), 178.

Describing what he typically attempts to achieve in one of his poster illustrations, Priest says, "I love to isolate that moment when everything comes together—freeze that moment, with some depth so it looks like you can put your hand right into it. And so the viewer can see things that the people in the picture themselves are unaware of." In a philosophical vein, he adds that he hopes to contribute to our collective consciousness something of value, something good, funny, and positive. Priest is in large part responsible for fostering the atmosphere of sharing that prevailed among the artists who began to gravitate to the Armadillo World Headquarters, a tradition which continues to this day among Austin's virtuoso posterists. As one of the Armadillo's major personalities, and Franklin's successor as art director, Priest was instrumental in recruiting many of the most talented artists to the in-house art pool, and also performed as master of ceremonies for many years. In keeping with his gifts for vision and organization, Priest joined several others, including John Rodgers and Sam Yeates, in opening Sheauxnough Studios in 1976 as an independent graphic arts cooperative, designed to fill the void created two years earlier when Directions Company disbanded. Until its own dissolution, Sheauxnough was a vortex of interactive creative energy propelled by the talents of Austin's ablest posterists, and effectively dominated the local music art industry.

One of the most gifted young artists drawn to the Armadillo World Headquarters was Ken Featherston, who had grown up in Corpus Christi with 'Dillo muralist Henry Gonzalez. He occasionally combined airbrush and pen-and-ink styles in a single piece, and his work often has a gentle, spiritual feel. His boundless energy and the speed with which he could produce an intricately penned and stippled illustration were constant sources of amazement to his friends and colleagues. Among his best-known designs are the Marshall Tucker Band's *Searchin' for a Rainbow* album cover and an illustration for Oat Willie's of an ethereal locomotive floating above its tracks in the star-spangled blackness of space. Tragically, Ken Featherston was shot and killed by a deranged patron while working security at the Armadillo in 1975.

In 1973 San Angelo musician William De Forest White found his way to Austin via Lubbock. Though he answers to De, Diz, or Blackie White, his most popular moniker is Guy Juke. He has been a member of several local bands and occasionally may still be seen around town playing guitar or keyboards with one or another of them, or fronting his own group, Blackie White and the Halftones. Yet, as popular as Juke is as a musician, he has endeared himself most to the Austin music community with his strikingly communicative poster work. Soon after moving to Austin, Juke was enlisted by Priest for the Armadillo art squad, and he produced one stunning poster after another, often

"Kenny Loggins," at the Armadillo World Headquarters, by Guy Juke, 1977. One-color lithograph, 11 x 17 inches.

incorporating into the design some subtle graphic punchline. He populates his illustrations with animals, ordinary people, cartoon characters, and movie and television personalities. In Juke's 1980 book of posters and paintings *Visual Thrills, Vol. 1* fellow artist Dale Wilkins writes, "The visual universe of Guy Juke is an amalgam of twentieth century styles set against the fragmented reality of video transcribed existence."[11] In a 1975 'Dillo poster for Asleep at the Wheel, Juke mixes realistic and cartoon characters including "a sheep at the wheel" of a vintage sedan. "Live and asleep at the wheel," a poster designed in 1979 for the Austin Opry House, features an airborne cartoon car, headlight eyelids tightly closed and a pillow in the driver's seat. In a paper on Juke and the Lubbock singer-songwriter Butch Hancock, Michael Butler writes, "The poster's graphic art work is derived partly from Disney and partly from the Warner Brothers' *Merrie Melodies* of the forties and fifties with particular nods to the work of Bob Clampett and Chuck Jones."[12] While Juke is by no means limited to the cartoon style, and in fact renders most of his illustrations realistically, the sense of delight with which he approaches such a piece is eminently apparent and contagious.

Blessed with a facile mastery of form, a magnificent command of color, and an indefatigable imagination, Juke has designed posters for most every club in Austin and a healthy percentage of the bands. Especially noteworthy is his series of two dozen or so Butch Hancock handbills illustrating Hancock's lyrics and displaying a broad cross-section of the many styles at Juke's disposal. From this series, the 1976 illustration entitled "Suckin' a Big Bottle of Gin" is possibly the earliest example of his angular style. Juke maintains that his style is still evolving. "I am, like any artist," he says, "always searching for myself—continually searching for an honest style." During the last several years, however, he has become best known for his angular cubist-minimalist style. In a *Daily Texan* interview he explains that he attempts to use a minimal number of lines and few or no curves. "The angle is whatever I make it and the way the angles pull against each other is the whole trick."[13] It was a variation of this idiom that Juke used for his notorious "House of Wax" design. Working from a still photo of the classic horror movie, he created a poster for Raul's club. The illustration of a sinister figure skulking in the shadows was later reproduced as a full-page ad in the November 1980 issue of *New York Rocker*, for which Juke also designed the B-52s cover art. When a suspiciously similar design

11. Guy Juke, *Visual Thrills, Vol. 1* (Austin: Void of Course Publishing Co., 1980), 11.

12. Michael Butler, "Art and Music and the Humorous Infinite: A Study of Guy Juke and Butch Hancock," 1986 (typescript, location unknown).

13. *The Daily Texan* (Austin), Aug. 29, 1983.

graced the cover of the Ramones' album *Pleasant Dreams*, the editors of *New York Rocker* were prompted to ask in print, "Who is this man and who created him?" In the ensuing fracas it was all but admitted that the design had been swiped and Juke was grudgingly paid a nominal sum. Probably the most startling example of Juke being plagiarized is the cassette tape of "new wave music" sporting a bootlegged version of Juke's bold Joe Ely *Live Shots* portrait being sold on Saudi Arabia's black market.

Sam Yeates graduated from North Texas State University in 1974 with a degree in drawing and painting, and moved to Austin with the intention of attending graduate school. The Armadillo World Headquarters intervened and he was wooed away from the academic life and into postering. According to Priest, by about this time the 'Dillo posters had reached a state of homogeneity such that they all had a predictably uniform look about them. Yeates produced a debut poster that so accurately mimicked this style that it created a minor sensation among the other artists, none of whom could peg just whose work it was. As Priest remembers it, Juke then did a poster as though Featherston had done it, and Featherston did one in Franklin's style, and before long all of the Armadillo artists were spinning off in their own directions, each committed to finding for himself a unique personal voice. One of Yeates's most spectacular posters was created for a Bob Seger concert at the 'Dillo. He brought the art, rendered in pencil, to printer Terry Raines and together, by using a split-fountain technique and running the poster through the press from top to bottom and then from side to side, they created a most powerful effect. The finished poster features the head of a tiger a la Ringling Brothers, glaring at the viewer out of a ferocious vortex of red and orange, mouth open and the curling neck of an electric guitar for a tongue.

Terry Raines had been an influential personality in Austin poster art long before he and Yeates printed the Seger poster. An inveterate spelunker, he began his career as a printer in 1965 printing caving newsletters. While Johnny Mercer was printing the oversized posters for the Vulcan Gas Company, Raines was printing the Vulcan handbills in an old bus parked on Thirty-third Street with "Transportes Espeleologicos" emblazoned across the side. He printed a majority of the Armadillo posters, including Franklin's grand opening poster. Today, in his shop just outside of town, his early Multilith presses stand idle, and he works instead with large Heidelbergs.

Another printer who over the years has worked closely with local poster artists is Mike Morgan. Having first met Priest in an English class at UT, he eventually worked with the artist on untold last-minute poster projects, more often than not working all through the night to meet a deadline. Printer Benny Binford worked with Morgan for several years and then went into business with

Junior Franklin, a poster designer/printer working primarily in the boxing placard style.

Both of Bill Narum's parents are artists, and he explains that he has been studying or creating art for as long as he can remember. He acquired his first printing press in the fourth grade and was printing comics the next year. His first posters date from his junior high school years. Born in Austin but raised in Houston, Narum returned to Austin in the early 1970s, bringing with him an educated eye for commercial design. He has been a mainstay of Austin's alternative graphic arts scene ever since, and has been responsible most recently for a handsome series of calendar posters for the Continental Club. Narum maintains close ties to Europe, and the album covers he has created for the popular band Z. Z. Top have reached millions worldwide.

Not every maverick poster artist in Austin worked for the Armadillo World Headquarters. As a student at the University of Texas, Robert Burns was editor of the *Ranger* during its last two years. Introduced to screen printing through UT's Drama Department, he eventually created a poster and design business which he called the R H Factor. During a ten-year period he produced a series of 135 hand-cut silkscreened posters for night clubs, bands, and alternative retail stores. Deliberately bucking the prevalent style of the day, his designs of the late 1960s and early 1970s have a clean, mainstream feel that makes them unique among the posters created during these psychedelic and cosmic cowboy years. In 1977 Burns designed and edited *Burton's Book of the Blues*, a collection of photographs by photohistorian Burton Wilson.[14] No longer an active posterist, Burns has earned cinematic acclaim as production designer and art director for an impressive list of films, including *The Howling, Re-animator, The Texas Chainsaw Massacre,* and *The Hills Have Eyes.* He moved to Los Angeles in 1978 but returned to Austin two years later. Burns remains committed to making films, and whether he is art directing, writing, or producing, his straight-ahead no-holds-barred style harkens back to the bold visual statements that characterized his posters.

Arriving in Austin in 1969, Dale Wilkins's first posters were designed for musician friends. Over the years he was called upon ever more frequently, as a member of Sheauxnough Studios or working independently, to produce posters and promotional material for bands, clubs, and concert halls, especially the Austin Opry House. Today he lists among his credentials a host of album covers for local bands, including Omar and the Howlers, W. C. Clark, Evan Johns and the H-Bombs, and the Killer Bees.

14. *Burton's Book of the Blues: A Decade of American Music, 1967–1977* (Austin: Edentata Press, 1977).

And not every posterist in Austin cut his teeth promoting music. Current-ly, there may be no more commercially successful poster artist in Austin than Amado Peña. He executed his first silkscreen print in 1960. Peña received bachelor's and master's degrees from Texas A&I University and taught art in the Texas school system for sixteen years. His present-day soft-spoken Southwestern style is a far cry from the strident political statements of his early career in South Texas.

Marty Bee-bop was a student of Peña's at Anderson High School in Austin and worked in his studio for three years. With an aggressive business sense and meticulous attention to printing detail, he has earned himself a prominent place in Austin's poster community. He has printed all of Juke's recent seri-graphs and screen prints and he produced the Texas Poster Art print by Franklin. Probably the most involved piece he has printed is a thirty-one color serigraph for the Laredo artist Wilma Langhammer.

Southwestern stylist Andrew Saldaña has also worked extensively with Bee-bop. During the several days it typically takes to print one of his seri-graphs, he virtually lives in the print shop. Saldaña is most fond of depicting children and women, and tries to communicate from the heart, with warmth and strength. Many of his pieces are rendered in acrylic and gouache and then four-color process offset printed. Several of his most moving designs in-clude "ghost horse" patterns reversed into a wash of color and possibly felt but presumably unseen by the individuals in the picture. This technique, and the use of an occasional gently curving abstract bar of color as another symbolic representation of the spirit world, lends Saldaña's work a playful, ethereal feel.

In 1980, with the advent of punk and new wave sensibilities and with the loss of the Armadillo World Headquarters as a patron, Austin poster design seemed in imminent danger of deteriorating into nothing more than a function of the felt-tip marker and the neighborhood photo copier. As new music has begun more and more to reflect an inherent resistance to tradition, exalted spontaneity, and acknowledged its own fleeting relevance, it has spawned a generation of photocopied graphics and an ever-expanding mob of poster artists and dabblers. In theory this is disposable art, born of expedience and a revolt against the meticulously crafted street art of the 1970s. In practice, how-ever, though some bands generate their own poster work with varying de-grees of proficiency, independent designers continue to produce pieces of power and quality. In the wake of the Armadillo era many of Austin's pioneer-ing posterists, most notably Juke, continue to turn out ever more ambitious art; and it is just as unique, entertaining, and relevant as the work they produced during Austin's postering heyday. Also contributing to the colorful continuum

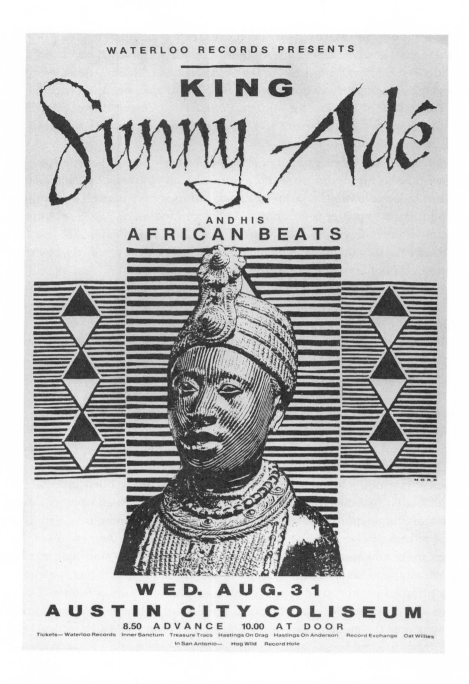

"King Sunny Ade," at the Austin City Coliseum, , by NOXX, 1983. One-color lithograph, 13 x 19 inches.

of Austin poster art are many newcomers, including Michael Nott, Edd Patton, Frank Kozik, and myself.

Bee-bop has printed several Edd Patton designs, foremost of which is his big and bold 1984 Offenders poster. At 27 x 34 inches, this band tour poster, featuring World War II fighter planes amid exploding flak, is the largest screen print produced in Austin within recent memory. Lately, working as a freelance illustrator for *Texas Monthly* magazine and various trade periodicals, Patton has been experimenting with scratchboard, and does few posters.

Mike Nott, who cites Gary Panter as an influence, was a popular posterist during the early new wave era. He lived next door to the controversial punk club Raul's and as "NOXX" designed posters and handbills for many of the bands that played there. One of his most popular posters, promoting a 1983 concert by Nigerian guitarist King Sunny Ade, made use of African wood prints. Another, for the English band New Order, featured the floor plan of a gothic cathedral in red and black. Nott now resides in Nashville and is, as a designer, enamored of computers.

My own work is signed "Jagmo." For the most part it is characterized by a strong graphic and typography that is simple and balanced. Among my most recognizable pieces are the screen prints commemorating the South by Southwest Music and Media Conference and the Texas-U.S.S.R. Musicians' Exchange, and concert posters for Milton Nascimento, k. d. lang, harpist Andreas Vollenweider, and Fela Kuti.

Frank Kozik is possibly Austin's most prolific young posterist. Born in Spain, he moved to Austin in the early 1980s and was a member of the controversial art collective the Art Maggots. Other talented members of the group included Billy Haddock, architect Paul Sabal, Andy Blackwood, and Tony Carbonee. Due in no small part to his penchant for lampooning sacred cows, Kozik's work is very popular among the more progressive alternative bands. He has recently been commissioned to create for California's L'Imagerie gallery a series of six limited edition serigraphs. The first in this series, "Que Dios Nos Perone," a large, crazy cartoon in day-glo colors, is a variation of the design he created for the eponymously titled album by the funk band Bad Mutha Goose and the Brothers Grimm.

Consistent with some types of contemporary music, Kozik's work is intended to shock and to challenge traditional standards. The same can be said of artists Biscuit, Chris Wing, David Yow, and Control Rat X. Their handiwork has often evoked strong emotions, as when a hapless Steve Hayden, owner of Raul's, was arrested in 1980 because of Biscuit's naked-cowboy "Hot and Bothered Men" Big Boys handbill. Other designers, though less visually outrageous,

have proven to be just as adroit at utilizing the contemporary poster format. Along with countless unnamed practitioners, Gary Oliver, Ronnie Stewart, Charles Webre (a.k.a. Towie), Ric Cruz, Field Gilbert, Richard Luckett, T-shirt connoisseur John "Artly Snuff" Fox, Shirley Staples, and musicians Byron Scott, Rock Savage, Chris Gates, Patrick Keel, Larry Seaman, Kathy McCarty, Billy Pringle, and especially Cam "Flathead" King have all been active combatants in the poster wars of the last several years.

As a coherent body of work, Austin's poster art defines and delineates our most recent history with an endearing eloquence. The psychedelic posters of the Vulcan era suggest the experimentation and confrontation of adolescence. They are derivative of a style born in San Francisco and evince the universal courage and vitality of youth. It was during the Armadillo years that Austin poster art came of age. Several factors precipitated the emergence of a unique Austin poster style: there was little money to print posters, and black and white rather than color was the order of the day; traditionally overused Western visual cliches were twisted and stretched into interesting new configurations; many of the posterists were avid fans of comics and animation; typographically, readability was a priority; the Armadillo World Headquarters itself generated a feeling of camaraderie and cooperation; and Jim Franklin's influence cannot be overstated. With his boundless imagination; his surreal cartooning; his popularization of theretofore unappreciated Texas symbols, most importantly the armadillo; his willingness to take risks; his nimble wit; and what Jim Harter calls his "funky irreverence," he set the tone for a generation of marvelous poster art. It is this playfulness and irreverence, the pervasive intelligent visual twist so evident in the work of Juke, Priest, Awn, Turner, and others, that most distinguishes Austin poster art, as a collective body of work, from that produced in San Francisco or elsewhere.

Today the elaborate entertainment-related poster is produced less often than during the glory days of Austin postering. More popular are the decorative serigraphs or commemorative posters of artists like Peña and Saldaña. Nevertheless, clubs and promoters will still commission the occasional concert poster, and the Austin *Chronicle* has been a consistently generous patron. Commendably, the Center for American History, the Texas State Historical Association, Shiner Beer, and Art Defense have all done much to enhance community appreciation of posters and poster art. It is inevitable that in the fullness of time artists like Shelton, Franklin, and Juke will be accorded the universal respect and admiration they deserve. For, with an ingenuous integrity and a viewpoint that is singularly Texan, these maverick designers, Austin's modern poster pioneers, have actualized graphically a reality of

which the rest of us could only dream. Their art is a challenge and an inspiration to those of us working in the field today. And it is my fervent hope that the community can give back to them some measure of the energy, vision, and commitment which they have shared with us.

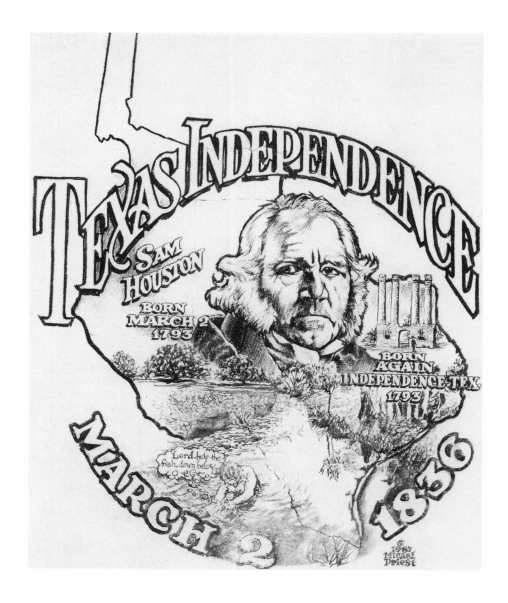

"Texas Independence," by Micael Priest, 1987. Pencil on vellum, 15 x 12 inches.

# TexStyle Art: The Evolution of Quality Silkscreened Imagery upon T-Shirts in Austin, 1968–1988

### John Henry Fox

Just as the invention of the lithographic process stimulated the widespread popularity of books, pamphlets, and posters as means of communication, the technological advances of the last twenty years in our ability to imprint images onto textiles stimulated the widespread popularity of silkscreened T-shirts and related forms of imprinted apparel as a contemporary medium of communication. The advancements in textile presses, inks, and dryers have made possible a vast increase in both the quantity of imprinted clothing and in the quality of the screened image at a cost low enough to give this field of printing staying power as an advertising and propagandizing medium.

It is this power and this popularity that gives us a heretofore untapped insight into the contemporary folkways, spirit, and aspirations of diverse cultural groups, in Texas and nationally. The popular culture as represented in contemporary Texas T-shirts and other imprinted apparel is a development from the older and traditional forms of Texas dress. Any group's customary form of dress, or visual folklore, is a badge of identity, be they Arabian nomads, bewigged British barristers, or the American urban cowboy.

"Given the socially engaged position basic to the Texas folklorists, it follows that the reporting of the lore should exhibit a concern with the ways in which they find expression."[1]

Through the employment of new textile printing techniques, a vast inventory of textile imagery reflecting contemporary Texas folk culture has been

---

1. Richard Bauman and Roger D. Abrahams, "Doing Folklore Texas-Style," in *"And Other Neighborly Names": Social Process and Cultural Image in Texas Folklore*, ed. Bauman and Abrahams (Austin: University of Texas Press, 1981), 6.

This essay would not have been written without the cooperation of the community of artists and printers involved in apparel imprinting in Austin and Houston. Contributing to this essay

produced. In this essay, my interest will be in following one particularly coherent school of images that arose in Austin during the second half of the 1960s and was responsible for the production of not only illustrations and works of artistic merit that were printed on paper, but also a large amount of screened apparel which documented, defined, and described in great detail the texture of the lives of a particular cultural group, the performing musicians of Austin, Texas.

Imprinted Apparel: A New Folk Art

Karla wore a T-shirt with a motto stenciled on the front. The motto said, "You're the reason our children are ugly," which was the title of a song sung by Loretta Lynn and Conway Twitty. Karla laughed every time she heard the song. She had thirty or forty T-shirts with lines from hillbilly songs on them. Every time she heard a lyric which seemed to her to express an important truth, she had a T-shirt printed.[2]

Pulitzer Prize-winning author Larry McMurtry introduces one of his protagonists with this description in *Texasville*, a novel set in modern Texas. It is not surprising these days to find someone described or characterized by his or her manner of dress. The use of imprinted apparel to display what an individual considers to be "an important truth" has only arisen as a cultural phenomenon within the last generation.

McMurtry, a Texan by birth, reaches beyond regional boundaries in his characterization of Karla by the T-shirts she wears. She is not unusual or abnormal in her use of clothing to communicate the feelings that are important to her. In the last twenty years, expressing what an individual feels is a "truth," important or otherwise, by wearing that "truth" on a shirt has become fairly commonplace in our society.

The most prevalent example of groups that express themselves through imprinted apparel today are those that wish to broadcast to others their support for a particular team involved in athletic competition. It is not uncommon to find local Little League teams or amateur slow-pitch softball organizations identifying themselves, and their supporters, by the use of uniforms and other types of imprinted sportswear.

One can say that this has always been true of any organization or identifiable cultural group, but only in recent times, due to the advent and rapid advancement of the modern textile imprinting trade, have people been offered

were interviews and discussions with artists Tom Bauman, Danny Garrett, Kerry Awn, Frank Kozik, Micael Priest, and De White; with shop owners Marty Beboup (Beebop Printing, Austin), Bill Livingood (Slow Printing, Austin and Taylor), and Mickey Phoenix (Calico Printing, Houston); and with printer-musician Fred Mitchim. A plethora of thanks to El Guapo. This paper is dedicated to the memory of Bill Livingood and Ken Featherston, whose lives and art pointed the way onward through the fog.

2. Larry McMurtry, *Texasville* (New York: Simon and Schuster, 1987), 11.

the option of a wide variety of affordable icons specifically designed to be worn for the purpose of representing and communicating personal thoughts, feelings and commitments by the use of strong, multicolored graphics.

Never before has folk art been utilized or thought of in this manner, because never before has folk art been given the range of options that modern technology has provided. The use of illustrations of graphics with broad societal implications targeting our basic folkways previously had been limited to paper goods, such as newspapers and posters. This approach is exemplified by the posters and street art of the 1917 revolution in Russia or by the chapbooks and newspaper illustrations that Juan Guadalupe Posada (1851–1913) produced in Mexico City at the turn of the century.

Bertram Wolfe sums up Posada's life and his contributions succinctly when he writes that Posada "was a great artist of the people, the greatest that Mexico has produced—indeed, one of the greatest folk artists in the world."[3] Posada's illustrations crystallized the essence, the primal nature, of his people, their foibles and their times. Like all the great folk artists, he captured his cultural surroundings and helped his people come to a stronger understanding of what they were.

It became obvious that there was going to be all these music shows and so damn many of them that there was going to be all these posters (and T-shirts). It gave us . . . the opportunity to describe what was going on around here in the same fashion as Posada. It would allow us to be folk artists while we were still doing it instead of having to wait until we were dead.

—Micael Priest[4]

Posada produced his engravings and woodcuts over a thirty-year period and his illustrations slowly filtered out over all of Mexico, reaching even the most rural outbacks. Times have most certainly changed. Since the end of World War I, the unprecedented communications revolution has spread our thoughts and concepts at a far greater speed and over a far greater area than previously dreamed of, and given folk artists (and society in general) an entirely new set of rules.

If Posada were alive and working today, he would have available to him a plethora of options for communication, and the use of imprinted apparel would be among the most affordable means of communicating his graphic images to his public. The times in which he lived dictated that it would take thirty years to spread his folk vision, but the folk artists of today operate under a different set of technological and temporal parameters.

The forms of communication employed by the contemporary equivalents of Posada have not previously been explored or judged by the perspective of

3. Bertram D. Wolfe, *The Fabulous Life of Diego Rivera* (New York: Stein and Day, 1963), 33.
4. Micael Priest to John Henry Fox, Oct. 27, 1988, interview.

**design #18**     **HOT KNIVES,**
                    **AN AUSTIN TRADITION**

yellow, red, and blue ink on white, yellow, gold, or blue shirt.

"Hot Knives," by Kerry Awn, 1973. Photocopies catalog, 5 ½ x 4 ¼ inches. *Photograph courtesy Marshall Davis.*

history, which certainly complicates our evaluation of their contributions to contemporary folklore.

Imprinted clothing is only a small facet of the still-evolving mutations of conceptual inputs that we have had to face over the past few decades. Imprinted apparel has rapidly gained strength and widespread popularity to become an unexpected new form of our culture's visual folklore primarily because of its innate ability to characterize any portion of any individual's sincere inner beliefs and feelings, however obscure, noble, or shallow those beliefs may be. It is this individual choice that makes the imprinted shirt, by nature, a true reflection of the feelings of the people who wear it, the essence of any definition of folk art.

Traditional folk art was never like this. Contemporary imprinted apparel now includes not only the T-shirt (available in cotton, polyester, or a blend of the two, in a variety of weights and thicknesses, with or without a pocket, and with long or short sleeves), but also baseball jerseys, knit golf shirts, nylon jackets, tank tops, chemise tops, sleeveless sweaters, sweatshirts (with or without hoods), sweatpants, windbreakers, nylon and cotton running shorts, nightshirts, bandannas, towels, tote bags, sport bags, knapsacks, socks, aprons, and even sunglasses.

Folklore then may crop up in any subject, any group or individual, at any time and place. . . . there may be deliberate efforts to combat it, as in the Westernization of China, or to revive and preserve it, but these are extraneous to what it is.[5]

## The Imprinted Apparel of Austin, Texas

In the second half of the 1960s, three separate creative movements in Austin worked with each other in an atmosphere of mutual support. The resulting artistic tripod achieved a remarkable stability and developed a unique coherence of attitude, outlook, and form from which the current Austin school of graphic design emerged. Twenty years later, this group of artists still works together and continues to evolve and refine their zesty, irreverent approach to style.

These three interlocking creative components were: 1) a fairly large core of young graphic artists; 2) technically competent printers who shared the same view of life; and 3) a community of musicians who drew upon the identical creative impulse to which the other two groups were attracted.

The musical community needed live entertainment venues to publicize its music. The venues needed the graphic artists to publicize their shows. The artists needed sympathetic printers to produce their imagery and the printers needed the entertainment venues to help pay their bills. These groups

5. Mamie Harmon, "Folklore," in *Standard Dictionary of Mythology, Folklore and Legend*, ed. Maria Leach (New York: Harper and Row, 1972), 400.

eventually coalesced and formed the core of a new type of cultural group, around which a community of like minds gathered. They stayed together as friends and as equal partners in quest of their shared goals. This new and evolving cultural group, which projected its views with such strength, resulted in the creation of an Austin school of graphic design, with a fresh, original approach to the traditional printing arts. Their important ties to a music industry soon to achieve national prominence proved crucial in the expansion of their mutual goals, and in the projection of those goals to a much larger audience ripe for assimilation into the newly emerging culture.

The approach of these people to art and to life more described than defined the surrounding community of musicians and their audience of music fans. They "jammed" and worked together in mutual support, in much the same manner as the musicians.

The artists used the same creative impulse as the musicians, but expressed it in a different medium. Accordingly, they were able to transfer the spirit of the music into nonaudial forms and take that spirit into places that the music could not go, such as on the streets or on the walls around town. Importantly, that spirit was transferred onto T-shirts, making the wearer a walking billboard.

It is rare that so many graphic artists and talented musicians have cooperated and cross-pollinated their creative passions in one town for such an extended period of time. Consumer demand for the imprinted apparel which this community produced grew tremendously and was certainly a strong factor in their continued cohesiveness as a creative force.

The T-shirt is not usually regarded as art, possibly because it is more difficult to frame than a rectangular, two-dimensional work such as a poster or album cover. But an album cover is printed in runs numbering in the thousands, and a music poster is typically printed several hundred at a time, while a T-shirt is generally printed in runs of seventy-two or 144, generating a more personal tie with the art image because it becomes a badge of identity projecting some aspect of importance to the wearer. The small production makes these multiscreened images the scarcest examples of the artist's work, since many of these images are found nowhere else.

Another reason, perhaps, that T-shirts are not usually thought of as art was well expressed by Carolyn Phillips:

Once relegated to the nether world of underwear, the T-shirt has come out of hiding forever in barely fifty years. Clark Gable started it all with "It Happened One Night" (1933). Other film idols followed to establish the T-shirt as part of their costume as sex symbols: Brando, Dean, Mitchum and down through Bo Derek in a wet T-shirt. And

whether it causes you feelings of dismay or delight, you cannot deny the T-shirt is everywhere.[6]

In Austin during the early 1970s, T-shirts were indeed everywhere, and live music seemed to be everywhere as well. Then, to a far greater extent than now, the Austin music industry was exuberantly active. Even today, Austin consistently offers more diversity of live music entertainment than Los Angeles, New York, or Nashville, the nationally recognized music centers.

As Phillips puts it, there were "relatively small numbers of T-shirts circulating among a fairly specific segment of the population (fans, performers, club employees, dope smokers, etc.)"[7]

Given this situation, it was just a matter of time before the imprinted graphic shirt design transformed itself from merely a garment and a form of low-cost advertising (virtually the only form of advertisement financially compatible with the typical band's income) into a badge of identity and a way of identifying oneself as a member of a specific community, a form of "visual glue."

Much more than we thought it was doing at the time, the art helped to define the community . . . in that, while we thought we were capturing what was already there, a lot of people viewed it as if we were projecting an ideal that people approached, actually actively approached. That seemed real funny to us at the time, but I'm sure it struck us the same way it struck the Madison Avenue guys, the same way it struck Hitler's propagandists—that we can get people to do things with just lines on paper.

—Micael Priest[8]

In Austin, poster (and T-shirt) art is inextricably tied to live music. For the last quarter century, rock and roll has chronicled the history of our generation; and in turn, posters (and T-shirts) have provided an immutable, visual representation of the trends and values inherent in our musical evolution.

—Nels Jacobson[9]

The posters (and T-shirts) promoting the . . . performances captured the heady, eclectic mood better than any other medium. They transcended banal advertising claims, depicting the lifestyle and beliefs of an Austin generation.

—Carlos Vidal Greth[10]

Mikhail Guerman, in his classic *Art of the October Revolution*, observed that

The posters of this period can give an impression of the ideas and notions of the time; the generosity and talent of the artists have made these posters not only historical

6. Carolyn Phillips, "The Illustrated T-Shirt," Austin *Chronicle*, July 13, 1984.
7. Ibid.
8. Priest to Fox, Oct. 27, 1988, interview.
9. Nels Jacobson, "Austin Poster Art," Austin *Chronicle*, July 13, 1984.
10. Austin *American Statesman*, June 27, 1987.

documents, but also poetic recollections of an era. . . . [M]any posters are notable in yet another respect: they are associated with an event itself, with a day, with an hour.[11]

He continues: "Slowly and gradually, that which has always been the very essence of art began to emerge: a new vision of a new man. It is not just a question of bringing out a man's character that typifies and personifies an epoch."[12]

In Austin's creative community, the early to mid-1970s was the era, socially, stylistically, and artistically, of the "cosmic cowboy." The diverse members of the music and art community understood that this had become the verbal shorthand for the newly emerging style of Austin music, a blend of rock and country musical forms later termed "progressive country." The label of "cosmic cowboy" was derived from the title of a song recorded by musician Michael Murphey in 1973 and performed in Austin in February of that year.

It was not just a coincidence that the imagery evident in Austin T-shirt and poster art blended stylistically with similar imagery being employed by local musicians during this same period. The art of Micael Priest is a good example of the phenomenon:

Priest had not foreseen Murphey's specific song, but had already observed and welcomed the mixing of styles. Priest was ready to draw a mustang rider in space lassoing a comet as soon as Murphey was ready to sing "Cosmic Cowboy" in Austin.[13]

Another example of this blend of art and music which gave structure to this particular community is the work of artist De White, or "Juke." Musician Joe Ely once wrote:

I first met Juke in Lubbock, that rectangular metropolis of the Panhandle. When he came to Austin he brought the harsh angles of West Texas, bent them so they would fit in his suitcase, straightened them out when he unpacked, twisted them so they could be moved through doorways and revved them up with shaky characters.[14]

White quickly became the poster artist of choice for the musician's gigs around town. To hear Ely tell it, "Juke's eccentricities fit right into what we were doing, and eventually, he made the same migration south to Austin as many of the other musicians and artists around Lubbock. Up there, all the streets run north and south and east and west. so his style seemed naturally descriptive of what we all recognized."[15]

11. Mikhail Guerman (comp.), *Art of the October Revolution*, trans. W. Freeman, D. Sanders, C. Binns (New York: Abrams, 1979), 27.

12. Ibid., 32.

13. Archie Green, "Words in Collision," in *"And Other Neighborly Names,"* ed. Bauman and Abrahams, 181.

14. Austin *American Statesman*, Sept. 2, 1988.

15. Ibid.

"Uranium Savages—Radioactive," by Kerry Awn, 1980. Pen and ink on bond, 13 ¼ x 10 ½ inches. *Photograph courtesy Marshall Davis.*

Micael Priest comments, "We were trying to pull for the more real and traditional values in communication in art, in the printing and in life, and we didn't want to be readily confused with the plastic pop-stuff you got at the carnival . . . we were trying to do things that people would have respect for and wear."[16]

16. Priest to Fox, Oct. 27, 1988, interview.

"Eighth annual corn festival," by Danny Garrett, 1983. Pen and ink on poster-board. 10 ¼ x 8 inches. *Photograph courtesy Marshall Davis.*

These artists in Austin accomplished what they set out to do. They earned the respect of the people, and the designs they created were certainly worn and ultimately worn out. There is a high rate of attrition in wearable art at present, but with over six hundred bands in Austin at last count and an established textile imprinting industry, new shirt designs are never far away.

The Imprinting Process

The imprinting trade in Austin grew slowly over the last twenty years and is an accurate reflection of the national trends in this field. The produc-

tion process has remained essentially identical throughout its existence, but recent technological refinements have been responsible for its newfound popularity.

Not surprisingly, the process of silkscreened imprinting centers on a treated rectangle of silk fabric. The silk is fastened tautly to a wooden frame and coated with a photosensitive chemical that prepares it to receive the image to be reproduced.

The image to be placed on the silk is converted from the original to a piece of clear acetate by a photographic process that creates a film positive of the image.

The film positive is placed between the coated silk and a powerful light source or arc lamp. When the light is turned on, a shadow of the image falls upon the silk.

The chemical on the silkscreen is baked by exposure to the light and is unaffected where the image's shadow falls, so when the chemical on the silkscreen is washed off by a stream of pressurized water, the fabric remains porous to ink transmission only where the image had fallen.

There are two types of ink employed in the imprinting trade: dye ink and plastisol. Both inks have the same pigments, but use a different base to convey those pigments to cloth.

Dye ink is water-based and is considered to be superior in the variety of hues and color tones that it offers. Unfortunately, it not only tends to evaporate during the printing process, but also fades when the screened clothing is washed.

Plastisol is a polymer-based ink that remains stable overnight and will not fade when washed. It is presently available in a variety of specialty ink forms, such as puff ink, which rises like bread in an oven during the curing cycle; glitter ink, which contains metal flakes; luminescent ink, which glows in the dark; and various metallic inks in addition to those mentioned above.

Two printing techniques are worthy of mention. The smear, or split-fountain, is utilized to achieve a transition from one color to another within one screen. By placing red ink on one end of a frame and yellow ink on the opposing end, the pull of the squeegee will mix the two and produce the color orange, which allows more colors in fewer screens. Mixing blue and yellow will produce a green ink, and the variety of hues and color options is limited only by the imagination of the artist and printer.

Since the color of the fabric sometimes blends with the ink being used, a method called masking is used when printing upon darker fabrics. Essentially, it involves laying down a white plastisol base upon the fabric and curing it through a flash-drying process before any of the main color screens are imprinted.

Recent advances in the trade portend continued economic health in both quality and quantity of production. The advent of the automatic textile printer

"The #10 Spamarama," by Guy Juke, 1987. Pen and ink on posterboard. 10 ½ x 8 inches. *Photograph courtesy Marshall Davis.*

eliminates the need for a human printer/squeegee puller. It offers better registration, consistency of color tone, and a smooth, even stroke.

Squeegee pressure can be set up to three hundred pounds, which allows a thinner coating of ink on the fabric. This results in better economics for the printer, because it uses less ink, and more flexibility for the artist in the mixing of colors, and eliminates operator fatigue.

New inks are being developed with a base sensitive to ultraviolet light, which will speed the drying process and eliminate the hazard of toxic fume emission while the ink is being cured. Also, the production of art should take a quantum leap in both affordability and versatility of image as computer art becomes more economical.

The images imprinted on T-shirts and other forms of apparel reflect the identity of the Austin musical community to a greater extent than any other form in the art of communication besides the music itself. They offer a unique and important window into the folklore and folkways of the times, in addition to their artistic merit.

These images should be inventoried, catalogued, and preserved for future studies of the period which they portray. Given the high rate of attrition in wearable art, time is of the essence in recognizing and harvesting the images which document our rapid social and cultural evolution.

I have begun an inventory of these imprinted Austin icons through the establishment of the AAEE, a private archive devoted to image preservation through a collection of T-shirts, posters, newspapers, and other physical illustrations. A slide library augments the archive stacks, but a small private effort such as this is only a stopgap procedure compared to what an established university or foundation library could achieve.

I hope that the worth of these images, and the knowledge of the times that spawned them, will become more widely known and appreciated while we still have the opportunity to gather this unique cultural perspective.

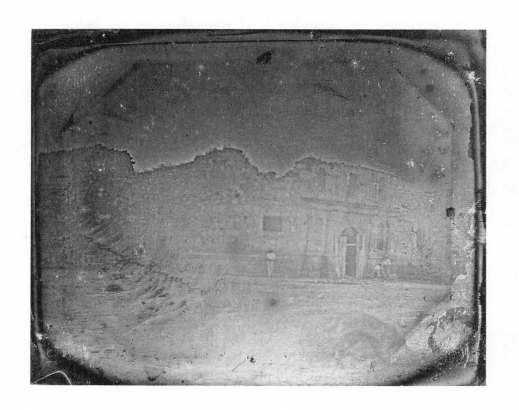

Gov. Dolph Briscoe Alamo Daguerreotype of the Alamo, by unknown photographer, 1849. Approx. $3\frac{1}{4}$ x $2\frac{3}{4}$ inches. *CN07471. Courtesy Center for American History, University of Texas at Austin.*

# FROM NIÉPCE TO NOW: THIRTY MILLION PHOTOGRAPHS IN TEXAS

ða·

## RICHARD PEARCE-MOSES

*hotographic Collections in Texas: A Union Guide*[1] describes photographs held in the state of Texas by libraries, historical societies, universities, museums, government agencies, corporations, and other public entities. A conservative estimate suggests the collections hold more than 30,000,000 individual images. The major obstacle in preparation of the *Guide* was one of scale.

The wealth of the state's photographic collections is not mere Texas braggadocio. The state's size alone contributes to the number of collections, while its central location serves as a magnet to bring in photographs from all over the country. Texas collections are unique in the dates of photographs held, beginning with the oldest surviving photograph ("View from a window at Gras," by Nicéphore Niépce, 1826)[2] and ranging to contemporary art and working archives. Virtually every region of the globe is represented through such collections as the New York *Journal-American* photo morgue, the Nettie Lee Benson Latin American Collection, and the Menil Museum. Many famous writers and politicians are represented in the Photography Collection of the Harry Ransom Humanities Research Center.

The problem of describing this vast number of photographs was compounded by the fact that many repositories had little or no documentation of their photographs. As a result, the *Guide* was often the first written finding aid for these photographs.

---

1. Richard Pearce-Moses, *Photographic Collections in Texas: A Union Guide* (College Station: Texas A&M University Press, for the Texas Historical Foundation, 1987).

2. Subsequent to the writing of this essay, a daguerreotype of the Alamo dating from 1849 was discovered, making it the oldest photographic image taken in Texas.

It is impossible to convey in words all the different photographs discovered in the state; yet that was precisely the task of the *Guide*. The problem of scale had a number of ramifications. First, resources were limited; the project had a single staff member. Second, a single system needed to be devised that would allow efficient and easy description of many different genres of photographs. Third, the photographs were of varying importance; some single images were of outstanding value, while the majority were of value only in the aggregate.

These problems are similar to those facing individual repositories with large photographic holdings. The solution to the problem of the *Guide*—the answer to the question "How are all these images to be described?"—is best solved by answering two different questions: What information will users of the *Guide* need? and How can that information be presented in a fashion that will allow the users to obtain that information? The *Guide*'s approach can serve as a paradigm for collections management in photographic collections.

Retrieval as the Fundamental Principle

In her research into computerized retrieval systems for museums, Lenore Sarasan observed that many collections had put huge quantities of information into computers but were not able to extract the information in a meaningful fashion or to manipulate it to facilitate creative research.[3] The reason lay in the fact that no consideration of retrieval was given in designing the database. Consideration of access to and manipulation of the information will dictate the data to be captured and the format of the data.

To answer the question of retrieval, the audience must first be identified. One common limitation of many documentation projects is that they have a restricted view of the user. For example, the McQuaid and Wilson *Index to American Photographic Collections*[4] uses the photographer as the sole access point; hence, the *Index* fails to provide access to outstanding collections by unidentified photographers or to repositories without photographer indices. Picture researchers, however, are not a monolithic group, and are not well served by such a single entry point to collections. People from many different professions need photographs for many different purposes, ranging from cultural geographers to topographers, from art historians to commercial illustrators.

Looking at the diversity of users, certain access points begin to surface. These include locale, personality, subject, and photographer. Bertrand Russell's observation that "Sin is geographical" should give some sense of the usefulness

3. Lenore Sarasan, "Why Museum Computer Projects Fail," *Museum News,* LIX (Jan./Feb., 1981).

4. James McQuaid (ed.), *Index to American Photographic Collections* (Boston: G. K. Hall, 1982).

of locale as an access point. Locale may be the single most important access point because of the number of subjects and events tied to a specific place. To research the Alamo, one would check San Antonio; to study the atomic bomb, one would begin by looking at the Bikini atoll, Hiroshima, Nagasaki, and Los Alamos. Cultural groups are largely defined by place. If a retrieval system can couple date with locale, the value of this access point is greatly enhanced.

Personality may be a useful access point, since many researchers are looking for photographs of specific people or photographs associated with an individual.

Although other access points often will provide lead-in to specific topics, direct access by subject is a useful access point because it is more direct, and some researchers are interested in general topics independent of locale, creator, and date.

Responsibility is essential for research by art history methodology, and the photographer is also a useful access point in some cases for subject or geographic access. Responsibility includes corporate creators and publishers of photographs.

These access points parallel the five fundamental categories of colon classification: space, time, personality, matter, and energy.[5] The *Guide* does not provide access by time, but does record the information, and combines the categories of matter and energy into subject. Packaging the information so that researchers could find it was the second obstacle.

Format of the Data

Once the needed information had been identified, some means had to be found to present it to users in a meaningful fashion. In this age of microcomputers, the *Guide* project seemed natural for some sort of automated database. Computers can offer improved access, especially in complex searches of many entries, by allowing different access points to be coupled; as noted earlier, coupling locale and date is extremely useful because of the relationship between space and time. Computers can also allow information to be updated easily.

Computers, however, have a number of problems that are frequently glossed over in an enthusiasm for their perceived potential. Such enthusiasm has often resulted in automation programs that have failed or are sorely limited.

If the information is to be retrieved in a meaningful fashion, it must be input into some sort of structure so that it can be manipulated. If the data structure is broad enough to be simple, retrieval is severely limited; if the data structure is highly complex, retrieval requires extensive and expensive programming.

5. See P. N. Kaula, *A Treatise on Colon Classification* (New Dehli: Sterling Publishers, 1985).

"James Buckner 'Buck' Barry," by E. Drane, June, 1853. Photograph, size unknown. *Courtesy Lawrence T. Jones III, Austin.*

The problem of data structure is a useful demonstration of a fundamental difference between how libraries and archives describe their holdings. In general, libraries follow rule-based systems, while archives attempt to describe their holdings in terms of the inherent organization of the materials.

Libraries have adopted Anglo-American Cataloging Rules (AACR2) for describing their holdings and MARC Format for Bibliographic Data (MFBD) to

encode descriptions.[6] Originally designed for book materials, MFBD works reasonably well for the majority of published material because of the uniform nature of the materials being described. MFBD captures the basic characteristics of the book that would be shared by all libraries cataloging that book; hence, shared cataloging greatly expedites processing book collections, because the book need be described only once, with other libraries copying the first record.

MFBD works less well for unique items and for items with characteristics unique to a library's copy. Shared cataloging has little value for rare books such as incunabula, because the characteristics of the book are likely to be substantially different from one copy of the book to another; these differences are often subtle, but of central interest to the researchers working with the materials. Often these characteristics are lumped into an unformatted 590 note with a variety of other types of information, making retrieval difficult at best, and frequently impossible. MFBD records are designed to describe single items, and do not handle collection-level records well; this is due in part to the fact that different parts of the record cannot be linked. Finally, because MFBD records were designed for the automated production of catalog cards, the format requires fairly sophisticated programs for retrieval; programming that is expensive and generally difficult to implement on a microcomputer.

Archives have resisted standards for describing collections, but allow the material being cataloged to suggest the most appropriate form for description. As a result, a repository may have lists, calendars, inventories, card files, and other types of dissimilar collection descriptions. Although these types of finding aids reflect certain basic approaches to description of materials, those approaches are tradition-based guidelines rather than strict rules.

The lack of a single descriptive standard reflects a situation radically different from a library: the materials are unique and are of vastly different natures. As a result of the lack of strict standard procedures, archives remain largely unautomated. While many repositories have adopted the MARC format for Archives and Manuscripts Control, its use is generally limited to a summary statement that can be inserted in an integrated catalog that will point the researcher to a traditional finding guide. The MARC format for Visual Materials has been adopted by a few major collections, but more significantly it has been rejected by a number of major institutions because it cannot adequately address their needs for retrieval.

A final observation on electronic databases: microcomputers seem to be everywhere and are becoming so inexpensive as to be within anyone's grasp, but in fact they are not. Dial-up databases are useful only to those people and

---

6. Although there were eight MARC formats, they were integrated into a single format in 1989.

institutions with enough money for the capital investment and long-distance access charges. The cost of a few calls to query the database would rapidly equal the thirty dollar price of the *Guide*.

Given the diversity of types of repositories, materials held, organization of the materials, and potential users, a simple data structure would be inadequate for the *Guide*, and the cost of developing an automated retrieval system that could work with a complex data structure was prohibitive.

The solution for the *Guide* was to follow archival tradition: to design a basic framework for a narrative description, print the descriptions in a form that facilitates browsing by the users, and provide additional lead-in through an index. Two collection surveys rooted in the archival tradition served as models for the *Guide*: the *Union Guide to Photographic Collections in the Pacific Northwest*[7] and the *Mexican American Archives at the Benson Latin American Collections*.[8] A third major survey, the *Photographic Guide to Canadian Photographic Archives*,[9] came out after the *Guide* was underway, but deserves note as a potential model for future projects.

The book format has a number of limitations. The information is fixed on the page and cannot be shuffled or sorted in a more useful fashion. The majority of automated book catalogs suffer the same deficit; once the specific records are identified, they cannot be placed in an order other than that provided by the catalog. Complex searches are not easy in a book format, as the user must look at each entry along one access point at a time; however, many automated book systems allow only the same basic types of search provided in a manual card system—author, title, or subject—with no combining of access points that would exploit the potential of an automated catalog.

The book format has a number of advantages, however. It is very easy to browse a book; browsing allows a patron access to information that has not been indexed. The book does not demand a rigorous or complex data structure. An important but unusual bit of provenance or an obscure but useful clarifying note regarding a subject can be stuck in parenthetically. Finally, a book is very democratic: the Texas Historical Foundation was able to produce the work for an amount of money within the budgets of many individuals and libraries without setting up a computerized search service.

---

7. *Union Guide to Photographic Collections in the Pacific Northwest* (Portland: Oregon Historical Society, 1978).

8. Maria G. Flores (comp.), Laura Gutiérrez-Witt (ed.), *Mexican American Archives at the Benson Latin American Collection: A Guide for Users* (Austin: University of Texas at Austin General Libraries, 1981).

9. Christopher Seifried (ed.), *Photographic Guide to Canadian Photographic Archives* (Ottawa: Public Archives, Canada, 1984).

Computers have brought archives an important tool in preparing finding aids: word processors. Word processing programs allow updates and additions to a text to be made easily and quickly. Word processors offer no real retrieval features, but many word processors include a routine to generate an updateable page index.

The *Guide* was prepared on a Compaq transportable computer with an 8088 chip and a twenty-megabyte hard drive. The narrative was set using the word processing program Nota Bene; this program was chosen for its ability to handle foreign language character sets, its ability to input preformatted data, and its ability to produce high-quality output from a Hewlett-Packard Laserjet printer. The output was used as camera copy.

Nota Bene can produce up to four separate indices at the page level. Because the *Guide* was arranged by record group, however, dBase III+ was used to index at that level. The database program was designed to sort the information and output it with formatting commands to the word processor; it was not designed with any automated retrieval capabilities.

Structure

The *Guide* is arranged in groups of images, and each group may be subdivided as often as is necessary to provide additional information. A researcher can scan the *Guide* rapidly, ruling out false leads as quickly as possible; a researcher can look at the top layer of groups and, if uninterested, may skip the sub-layers and go to the next major group.

The first layer is a statement of the repository's purpose, which gives the general character of the repository and the types of materials it collects. When possible, statements of purpose were drawn from mission statements.

The second layer follows a section on access policies and procedures. This second layer gives an overview of the collection as a whole in terms of the primary access points: scope of materials in terms of process format and date; locales; personalities; subjects; and photographers. Each access point is separated into its own section, which generally begins with a terse narrative giving an abstract and context of the materials in terms of that access point. A list of specific headings follows the narrative. The headings used in the *Guide* are:

Scope, which suggests to researchers whether the repository would hold a wealth of materials;

Geographic, which suggests the capture locations of photographs in the collection;

Subjects, which reproduces the headings used in the collection. If there were no local subject headings, I assigned headings based on the George Eastman House list;

People, which includes a description of individuals, families, and sociological divisions represented in the collections;

Photographers, which notes those people whose work was represented in the collection.

The third layer contains descriptions of individual record groups. The nature of a record group depended on how the photographs were arranged at the repository. Often those divisions were intuitive on the part of the person inventorying the collection. Record groups could be headings in a subject-oriented file, albums, or a collection maintained by provenance. The descriptions of record groups follow the general structure of the book: the title, an abstract containing contextual or biographical information about the record group, a description in terms of the basic access points, and a note on quantity, process, format, and dates. If a substantial number of the photographs in a record group had been published or written about, a bibliographic citation was included so that the photographs could be inspected by finding a copy of the publication; as a result, it is not always necessary to travel to a collection to view the photographs.

As was appropriate, record groups were subdivided into additional layers of more meaningful groups. Again, each subdivision followed the basic structure of the work.

The headings used in this format wasted an enormous amount of space for many collections, especially smaller collections or those with a very specific collection area. Many local history collections could be summarized briefly as "economic and social development of the community," with a few notes on the high points. As a result, descriptions of these collections were cast into a narrative style without the structural headings and grouped into the section Unabstracted Collections. The organization of these descriptions follows that of the larger collections.

Finally, the book contains indices for each primary access point: place, photographer, personal name, and subject. *Webster's New Geographical Dictionary*[10] was used for authority forms of headings for locales.

Photographers and personal names presented a problem. The project did not have time or money to do authority work: most names will appear only at a single repository, but it would have been impossible within the constraints of the project's deadline and resources to research whether those few that do repeat are the same or different individuals. As a result, prefatory notes to the name indices alert researchers to the fact that the names in the indices reflect the form in which they were found in the collection; that they were collocated only when known to be the same person or when the names were identical;

10. *Webster's New Geographical Dictionary* (Springfield, Mass.: Merriam-Webster, 1984).

and that two or more separate entries may be the same individual, while a single entry may represent more than one individual.

Subject access to photographic collections poses two particularly thorny problems. The fact that many collections have limited or no subject access to their collections is a reflection of the fact that these problems have no good solution at this time. Because of the complex nature of subject access, automated retrieval will be of great benefit in the future.

First, subject terms must be arranged so that they are easy to find. Direct access is the most common arrangement and users are familiar with it. It disperses related terms throughout the alphabet, however, making it difficult to search broader topics. For example, in a direct arrangement the headings drugstores, novelty stores, grocery stores, and shoe shops are easy to find; but in order to provide adequate retrieval for the broader concept retail stores, all these entries must be repeated under that heading. An alternative is an indirect arrangement, sorting subject headings into a hierarchy. The benefit of being able to retrieve at different levels is offset by the user's being forced to discover the principles of organization used to define the hierarchy. The *Guide* uses an indirect arrangement for subject locations and a direct arrangement for all other indices.

Second, photographs can record a seemingly infinite amount of detail. When indexing a photograph, one must ask how many details that appear in the image should be indexed; when indexing photographs at the collection level, the problem is compounded. When abstracting a group of photographs, the subject heading can become so broad as to be useless. For example, a historical society holds a collection of fifty photographs of prominent individuals in the community and the major businesses. To take the time to go into great detail indexing each name for a group of images that is a minute portion of the total is impractical; yet subsuming all the topics under "economic and social development of the community" is virtually useless, because a user would likely search for such a topic under the geographical heading.

The solution is considerably more time to build indices and, at some point, more sophisticated automated indexing systems. In the meantime, the researcher is not limited by the quality of the subject index in the *Guide;* the information may be found by browsing the entries.

Applying the Principles of the Guide to Smaller Collections

Repositories with large quantities of undocumented photographs often are critically aware of their need to get intellectual control over their holdings, yet they are at a loss as to how to go about this.

Some begin by creating a card catalog, others by starting lists; in either case, they begin by describing their holdings one photograph at a time. Unfortunately,

in large collections, item-level description is doomed to failure because of the amount of time needed to process a large number of images. Those collections that were attempting item-level description which were surveyed for the *Guide* had on average processed some 10 percent of their total holdings.

The experience of the *Guide* offers a solution. The above description of the construction of the *Guide* discusses the problems in detail. Those problems are summarized here:

Determine who will be using the collections and what types of information they will need. Don't try to be prepared for the rare or potential user; look at the repository's mission statement and the actual users, and provide an information system for them. Determine the information those users will need by considering the basic access points of the *Guide;* don't try to record every possible item of information.

Design a system to record that information in such a manner that it will be easy to retrieve. Look for something flexible and simple. Keep in mind that small is beautiful. Do use automation when it will assist: word processing functions reduce work and will facilitate revisions, and database programs are useful in generating indices.

Describe the photographs in groups; begin with the largest groups in the repository.

Create an index or indices to the descriptions to provide access.

Repeat the process over time, breaking apart those descriptions into smaller groups. Based on the previous layer, prioritize the materials to be described in more detail in the next layer.

By following these steps, a repository can print out a useful, if coarse, guide to all of its holdings relatively quickly. Over time, that first step can be polished and new information added. Each year the repository can issue a new, updated edition of its collections guide with revisions.

# ABOUT THE AUTHORS

⁊⊛

KATHERINE J. ADAMS is assistant director of the Center for American History at the University of Texas at Austin, a position she has held since the Center's creation in 1991. She served as assistant director of the university's Eugene C. Barker Texas History Center from 1981 to 1991.

BEN HUSEMAN was a research and curatorial assistant at the Amon Carter Museum in Fort Worth, Texas, from 1983 to 1991. He is the coauthor of *Eyewitness to War: Prints and Daguerreotypes of the Mexican War, 1846–1848* (1986) and the author of *Wild River, Timeless Canyons: Balduin Möllhausen's Watercolors of the Colorado* (1995). He currently resides in Carrollton, Texas.

DAVID HAYNES is the director of production at the University of Texas Institute of Texan Cultures at San Antonio. He has been interested in the history of photography, particularly as practiced in Texas, for a quarter of a century. His *Catching Shadows: A Directory of Nineteenth-Century Texas Photographers* was published by the Texas State Historical Association in 1993. The late JAMES PATRICK MCGUIRE was the acknowledged authority on pioneer German artists in Texas. He worked as a researcher and administrator at the Institute for Texan Cultures from 1967 until his death in 1992. His research on ethnic groups in Texas resulted in numerous books, pamphlets, exhibits, and lectures. His last monograph, *The Hungarian Texans,* was published by the Institute in 1993.

CYNTHIA A. BRANDIMARTE is director of Cultural Resources at the Texas Parks and Wildlife Department in Austin, Texas.

FRANCINE CARRARO holds a Ph.D. in American studies from the University of Texas at Austin and an M.F.A. in art history from Southern Methodist University. She is currently an assistant professor in the art department of Southwest Texas State University. She is the author of *Jerry Bywaters: A Life in Art* (University of Texas Press, 1994) and has also contributed to *Collecting the West: Catalogue of the C. R. Smith Collection* (University of Texas Press, 1983) and *Henry Farny, 1847–1916* (University of Texas Press, 1988), both edited by Richard Saunders. She has also curated exhibitions on Russell Lee, William Lester, Everett Spruce, and New Deal post office murals in Texas.

DAVID FARMER is at the DeGolyer Library of Southern Methodist University, Dallas.

RICHARD COX took the bachelors and masters degrees in American history at the University of California at Los Angeles and completed a Ph.D. in art history at the University of Wisconsin in 1973. He has written extensively on the history of prints and American painting of the early twentieth century. He is a professor of art and coordinator of art history studies at Louisiana State University.

KENNETH B. RAGSDALE holds master's degrees in music and history and the Ph.D. degree in American studies from the University of Texas at Austin. The former director of educational services for the Texas State Historical Association, he has published three books on Texas history: *Quicksilver: Terlingua and the Chisos Mining Company* (1976), *Wings over the Mexican Border* (1985), and *The Year America Discovered Texas: Centennial '36* (1987). Ragsdale, a resident of Austin, is currently working on a manuscript about the Big Bend of Texas.

ROY FLUKINGER is curator and head of the Photography and Film Department at the Harry Ransom Humanities Research Center at the University of Texas at Austin.

PETER H. BRINK is vice president for programs, services, and information of the National Trust for Historic Preservation. From 1973 to 1989 he was executive director of the Galveston Historical Foundation, the community-wide preservation organization which spearheaded the preservation and revitalization of Historic Galveston. He is a graduate of Dartmouth College and Harvard Law School. A version of his paper has been published as the afterword to a new edition of *The Galveston That Was* (Rice University Press, 1994).

Chicago native NELS JACOBSON came to Austin in the late 1970s. In 1983 he founded Jagmo Studios, a design firm specializing in graphic art for the entertainment industry. He has published a number of articles on the Texas concert poster phenomenon. He served as art director of the South by Southwest Music and Media Conference from its inception in 1987 through 1992 and directed the hanging of "The History of Austin Music Through Poster Art" exhibition in conjunction with the 1992 grand opening of the Austin Convention Center. He is currently pursuing a law degree at the University of Houston.

Longtime Austin resident JOHN HENRY FOX holds Bachelor of Architecture and Master of Architecture degrees from the University of Texas at Austin, and lived and worked with the early Austin artist/musician/printer community. His firm, Deep Eddy Arts, was founded to showcase the visuals of this community. He curated a show of the Weigl family's wrought ironwork and a retrospective assemblage of handmade boots by the legendary Charlie Dunn. Fox researched *Cryin' for Daylight: A Ranching Culture in the Coastal Bend* by Louise S. O'Connor (1989), and has served on the board of directors of Texas Student Publications.

RICHARD PEARCE-MOSES is at the Arizona State University library in Tempe, Arizona.

# INDEX

*(Illustrations are indicated by boldfaced page numbers)*